Totem Poles of the
Pacific Northwest Coast

Alert Bay village about 1920 The house posts at left symbolize the Thunderbird surmounted over grizzly bear crests. The pole at the far right was carved by Mungo Martin for a Nimkish Kwakiutl patron.

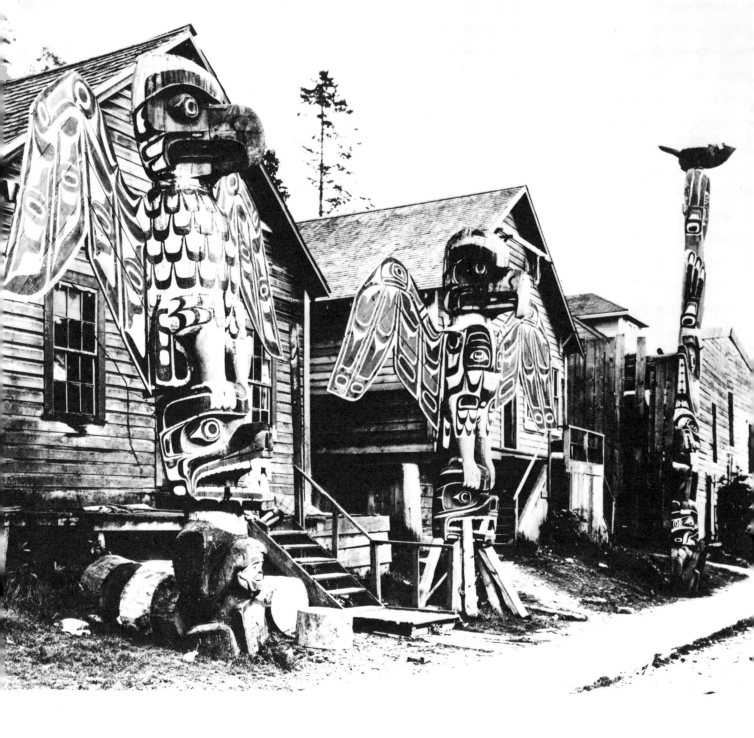

Totem Poles of the Pacific Northwest Coast

Edward Malin

with illustrations by the author

TIMBER PRESS

Portland, Oregon

Copyright © 1986 by Timber Press, Inc. All rights reserved.

Paperback edition printed 1994, reprinted 1998, 2002.
Printed in Hong Kong

Designed by Sandra Mattielli

ISBN 0-88192-295-1

A catalog record for this book is available from the Library of Congress.

TIMBER PRESS, Inc.
The Haseltine Building
133 S.W. Second Avenue, Suite 450
Portland, Oregon 97204-3527, U.S.A.
www.timberpress.com

Contents

To the pioneer photographers of the past—
especially Messrs. N. Chittendon, E. Curtis, G. M.
Dawson, E. Dossetter, G. T. Emmons, R. Maynard,
C. F. Newcombe, I. Powell, and M. Barbeau—
whose efforts made this book possible.

Acknowledgments

This book was a labor of love, but a number of people helped along the way. I would like to acknowledge my debt to each of them.

First and foremost, my thanks to Richard Abel of Timber Press for encouraging me to take on this task. Without his enthusiasm, patience, and moral support I would surely have faltered along the way.

I thank Maurie Clark of the Clark Foundation, Portland, Oregon, for the generous travel grant that enabled me to pursue research in distant archives and museums in Chicago, and in Ottawa and Toronto, Ontario. To Dennis Alsford of the National Museum of Man in Ottawa my gratitude for the courtesies he provided. I wish to express appreciation to Ms. Liz Virolainen of the Photographic Division of the Provincial Museum, Victoria, for her helpful assistance. Special thanks go to Robert Hart, General Manager, Indian Arts and Crafts Board, U.S. Department of the Interior, Washington, D.C., for arranging my return to the Pacific Northwest in 1963 and for also providing information about recent trends in totem carving in the state of Alaska.

Lake Oswego, Oregon
November 22, 1985

Introduction

This book is about totem poles, the remarkable carved columns raised by the Native Americans occupying the North Pacific Coast of North America. This practice extended from the southeast corners of Alaska southward through what is now the Canadian coastal province of British Columbia almost to Puget Sound in Western Washington State. It is not an ancient practice, though it probably is older than previous writers and specialists had estimated.

Totem poles have been a part of my life for the past 38 or more years. I have studied the poles stored in museums and public parks throughout much of Canada and the United States. I have examined others standing or collapsed *in situ,* poignant reminders of once prosperous native villages which disappeared not very many years ago. During these years I have visited 26 of the 55 villages mentioned in this book. I have sketched the poles, photographed them, dissected their forms for design elements, and analyzed them stylistically. I have worked with my colleagues, a handful of scholars, to understand the poles. In short, the matter of Northwest Coast totem poles has never strayed far from the center of my interests.

This interest was sparked during the final stages of World War II when, as a member of the U.S. Navy, I was perusing a much-thumbed magazine on Canadian travel during a lull in Caribbean operations. I came upon a photograph of a totem pole village located somewhere in a remote corner of Vancouver Island, Canada. I looked at it for what must have been several minutes. On subsequent days I returned to that magazine to look again. I told myself that one day when the war was concluded I would search out that village and see those poles for myself. I became interested in the people who carved them as well as the cultures of which the poles were a part. I was determined to learn more about them when the opportunity came my way.

After World War II an opportunity presented itself during a break in freshman studies at the University of Colorado in 1946. I traveled to the Northwest Coast, working my way northward from Victoria by hustling rides aboard passing salmon trollers. I became stranded in a logging camp north of Campbell River, somewhat short of my objective. Then in the night a passing freighter came to my rescue. The ship's captain agreed to take me aboard and drop me off at the wharf of that long-sought Indian village. According to the navigation charts the place was called Alert Bay. I did not realize it at the time, but the captain meant his offer quite literally. In the wee hours of that August morning the freighter glided toward the wharf at Alert Bay. The captain stood on the bridge while I hovered near the railing on the starboard bow. Then he ordered me "Jump!" and I landed in a sprawl on the planks, my baggage following quickly behind me. The ship turned and went on its way.

I was alone. It was about 4:00 in the morning. There was a great silence except for the lapping of the waves on the pilings. A glimmer of light revealed the beginning of a new day. I cautiously walked the plankwood and dirt street, judiciously

avoiding the barking dogs I had aroused. I headed towards the graveyard. There I recognized the dim silhouettes of those long searched-for totem poles. The poles stood in the soft light, erect but starkly silent. Nearby I heard the voice of a bald eagle. The raucous cries of restless ravens reverberated within the graveyard. Gradually a myriad of faces emerged, staring down from those poles. There were creatures with large beaks and gigantic spread wings, animal faces, sea monsters, and even human beings. Who were they? Did they have names? What did they represent? Why had they been placed in the graveyard and not along the village steet as illustrated in the photograph in that magazine? (Frontispiece) What purpose did they serve the living? Were there other functions implicit in the forms? I did not know the answers to any of these questions then but the interest created by that one photograph became an obsession and impelled me to one of my life's pursuits.

I have never forgotten that experience. I was hooked! The quest had begun and its intensity has never diminished despite the interruptions and vagaries of fortune. Alert Bay led me to Fort Rupert; which in turn led me to Quatsino Inlet to the west, near the tip of Vancouver Island's north coast; Skidegate, Skedans, Cumshewa, Haina, Masset followed in quick succession; then Yakutat, Klukwan, Chilkoot, Hoonah, and Angoon in Alaska.

There was no end in sight. I went to Blunden Harbour, Kalokwis, Gwayasdums, Memkomlis, the villages called Kitwancool, Kispiox, Kitwanga, Gitsegyukla along the upper headwaters of the Skeena River. I went back to some villages three and four times to look again, search out, examine what had been missed on previous journeys. Between field trips throughout the length and breadth of this totem pole region I read the accounts of explorers and anthropologists, talked with colleagues and carvers, and studied the early photographs. All these pursuits have coalesced into the present effort, the writing of this book.

METHODOLOGY

A superb resource for the analysis of totem poles are the files of the historic photographs extant in various museums and research centers. With the development of photography in the mid-1860s a number of pioneer photographers gravitated to the scene, men who made their way into the far corners of the Northwest Coast. The territory was in the throes of political ferment and economic growth such as it had never previously known. Its spectacular scenery and many hidden treasures lured the adventurer and naturalist as well as the photographer. These pioneers visited the native villages strung out from one part of the region to the other. They photographed and left a legacy covering a time period of a little over 100 years. Considering the logistical problems involved in travel and the cumbersome nature of the equipment at hand, theirs was a considerable achievement. We are indebted to all of them— Messrs. Maynard, Dossetter, C. F. Newcombe, Emmons, Dawson, Chittendon, O'Dwyer, Powell, and Barbeau—for what they recorded. Subsequent generations have a great treasure to learn from, observe, appreciate, speculate and ponder on in their photographic records.

In preparing this book I turned to the photographic archives as a principal tool to analyze the stylistic and design components of totem poles. We might refer to this approach as photographic ethno-history. The photographs extant are frequently dated, mostly from records kept by the photographers themselves. These dated photographs provide researchers with time capsules to analyze the emerging poles within the context of the Indians' changing situation, including their decline and collapse. We are able to trace the raising of new poles and note their changing styles. Studying the village settings enables us to visualize how the now-abandoned places might appear while the Indian culture was still healthy and vigorous. Photographs do not lie. Much information can be derived from them. A profound sense of discovery, even awe, is experienced when a particular photograph reveals a hidden truth, some scrap of information not previously known or recognized. How vibrant, dynamic, alive those now all-but-forgotten places must have been in their heyday! How vigorous the cultures and the people who envisioned these seemingly endless variations of forms! They were driven by boundless energy and enormous talent.

I have examined about 25,000 photographs in the preparation of this book. Approximately 15,000 were studied in the ethnographic archives of the Provincial Museum, Victoria, British Columbia. Another 8,000 were studied in the Canadian archives at the National Museum of Man, Ottawa, Canada. Between 1,000 and 2,000 photographs from other sources were examined, such as those at the Field Museum of Natural History, the personal files of friends, and my own collection. The largest proportion of these photographs are from the 1880s to the early decades of the 1900s.

These dates bracket both the collapse of totem pole practices in some areas of the Northwest Coast and the emergence and flowering of pole raising in other parts of the region.

While photographic research can be an exhilarating pursuit providing vital insights and disclosing little-known facts about the past, it has its hazards as well. While many photographs bear reasonably accurate dates, dates assigned to others may be inaccurate. Then there are those with no dates at all. Certain dates may be inconsistent with what the researcher already knows about a particular place. It was extremely helpful to my research studies to visit the numerous native villages in this book in the mid-1940s, 1960s, and several times in the 1970s.

Unfamiliar names were often recorded erroneously, or inadvertently switched in the photographic records because they sounded so much alike; i.e., the problem of Haida settlements at Kasaan and Kaisun, two distinctly different places, one being in the Queen Charlotte Islands; or to give still another example, those at Tsawatti and Nawitti, Kwakiutl villages near Vancouver Island. Place names are sometimes labelled or not captioned at all. The early photographers, understandably perhaps, were more preoccupied with the taking of the photographs or the correct operation of the cumbersome equipment at hand than with recording the correct name of the places they were visiting. The spelling of native names has always been an obstacle and causes great confusion; at times names could be puzzling and downright misleading.

THE PRACTICE OF RAISING CARVED POLES

The raising of carved wood poles or columns is not a rare occurrence in human history. The Indians who lived along the Northwest Coast, therefore, were not alone in the utilization of sculptured vertical surfaces for social and other rites. For centuries many different peoples throughout the world carved and raised large vertical columns for various purposes. The threads which bind them together are the ideas that were associated with pole raising: to honor the deceased leaders and give their names special prestige and respect.

A cursory review of these global pole raisings reveals places as divergent as Nigeria and the Cameroons in West Africa and the Malagasy Republic, formerly Madagascar. There the tribal peoples raised wood columns depicting their leaders in various accomplishments. The carvings were placed for followers to acclaim and give homage to the great men of the tribe. Moving eastward from the Indian Ocean to the western Pacific these practices become more commonplace. Poles were raised on the island of Nias, off the coast of Sumatra. They were found among the Dyaks in central Borneo, and in several corners of that colossal island, New Guinea. From the Asmat tribes located in the southwest corner of New Guinea to the Abelam and neighbors in the central headwaters of the Sepik River region of the north, one sees them. The Asmat in particular raised large poles, in excess of 30 feet in some instances, covered with ornate sculptures and polychrome painted surfaces. From New Guinea eastward to Ambrym and Malekula, in the New Hebrides and into New Ireland we learn of the former use of spectacular vertical sculptures. In New Ireland the native peoples once produced extremely complex, polychrome—not to say almost surrealistic—poles integrally associated with their mortuary rites. Eastward across central Polynesia carved columns can be found intermittently as far as New Zealand during aboriginal times.

However, in its most spectacular forms and in the intricate nature of its patterning, in the sheer monumental size, height, and girth of the logs used, and in the variety of forms they took, the Northwest Coast Indian tribes were the supreme masters and users of carved poles. Their forms, their surface design treatment, the complexity of their symbolism placed Northwest tradition in a class by itself. Here the totem poles achieved an artistic significance without parallel in human experience. Totem poles were one of the culture's crowning accomplishments.

Where the customs associated with pole raising originated, if they originated in a single region at all, we cannot say. Was there a common point of origin far back in time or did the practice emerge independently in several diverse cultural and geographic regions within various time episodes? I take the position of multi-origins. However, this is not the focus of the present effort. It must remain for other scholars and future researchers to grapple with that question.

DEFINING THE TOTEM POLE

Some years ago I recall a lengthy conversation with perhaps the most astute student of totem poles at the time, Dr. Viola Garfield of the University of Washington. One evening discussing our

mutual admiration for the Indian arts, Dr. Garfield emphasized repeatedly that anthropologically-speaking, the poles from the Northwest coast were not totems at all. It was far more to the point to refer to them as carved columns. Of course, over the years she lost the battle to change the nomenclature as her later publications disclose because the term "totem poles" was too deeply entrenched in the literature. Even so highly regarded a scholar as Dr. Garfield could not persuade writers to abandon the term.

What is a totem? In hundreds of tribal cultures throughout the world we find people who regard an object, often an animal, a plant, bird, or even a supernatural creature, as a special symbol. The social group embraces this symbol as belonging entirely to them and they identify with it throughout their lives. Their origin stems from such creatures. It is their "totem." The relationship, different though it may be from group to group and people to people, is based on their feelings of special respect mixed with awe, and most importantly, of avoidance, so as not to disturb, harm, or cause misfortune to befall their totem. Elements of this phenomenon were associated with the pole raising of the Northwest Coast Indians but only elements! The concept with the carving and raising of poles in its fullness was unevenly distributed among the various tribes.

What then is a totem pole? The totem pole of the Northwest Coast Indians was a large carved column raised by a lineage or clan for the purpose of commemorating an event, historical or mythological, within an entirely social (not religious) order. Some of the symbols might have totemic meaning. But the vast proportion of symbols relate to a group's social affiliations and status. Some poles depicted only single while others related multiple episodes associated with the historic or quasi-historic traditions of a group.

Since the poles incorporated countless symbols that were not totemic, the term totem pole, as Dr. Garfield pointed out, technically is a misnomer. We intend to use the words totem pole or carved column to refer to the same thing. If I had employed the term carved columns little interest would be shown in what follows. But totem poles—that is another story.

Totem poles, then, are not only a subject of artistic and cultural interest today. They represent the evolution of powerful forms of immense intrinsic complexity dealing with the fundamental forces which shape the human condition. They are intimately bound-up with numerous facets of life: kinship ties and associations; birth, maturity, and death; inheritance rights and privileges; class distinctions and honors; personal values and motivations—an intricate web of social relationships and attitudes with long standing traditions. They could be regarded as double entendres to those who viewed them; subtle or blatant, intimidating or comforting, implicit or explicit in their messages. The viewer's understanding and perceptions evoked by the poles would depend in part on where he stood relative to the culture of which he was a part, outside the bounds or securely locked within them. This multi-dimensioned story unfolds in the chapters that follow.

PART ONE

CHAPTER I

Totem Poles and Native Culture

THE PEOPLE AND THEIR ENVIRONMENT

The prehistoric occupation of the Northwest Coast by ancestors of present-day Native Americans probably stretches back several millenia. It occurred relatively late in the settling of Ancient America. It is possible that settlement took place more by gradual infiltration of small groups of people than by large population migrations. Wandering bands may have come directly from the west and north, that is, via the Aleutian Island chain, having already acquired some of the skills necessary for living along the coast. Others may have come to the coast from Alaska's interior corridors in the late stages of the last Ice Age. With the melting of glacial ice accompanied by rising sea level, sites of these earliest settlers were inundated.

The ancestors of these settlers could also have been migrants who moved cautiously westward, exploring the great river valleys of the Northwest—the Columbia, Fraser, Thompson, Skeena, Stikine, and Copper—that flow from the interior of the continent to the Pacific Ocean. Regardless of the routes that might have been taken or the time spans involved, the ancient peoples who settled on the Northwest Coast acquired through trial and error, circumstance, observation, and acute insight the means of developing a distinctive way of living unlike that of any other group of Native Americans in this vast Western Hemisphere.

As the coast dwellers evolved more efficient ways of coping with a coastal environment, they spread beyond the coast itself to occupy some of the numerous outlying islands that previously had been beyond their grasp. With each passing generation the settlers became more proficient both in building seaworthy boats and navigating the awesome tidal currents and dangerous rocky coast which mark the region. They began to exploit the various forms of sea life found in profusion beyond the shoreline. Various groups became increasingly specialized in the exploitation of the resources which they used. Thus they developed a riverine culture, a coastal culture, and a maritime way of life. We must bear their distinct natural resource orientations in mind as we retrace the differences in practices of each group. Only in the last several hundred years did each group clearly develop those regional and resource differences which became the distinguishing marks of each group.

Several extended families occupying and utilizing a communal site began to identify themselves as belonging to a single unit, a tribe. The tribe spoke a common language or dialect, shared a specific territory and social customs, and had a sense of belonging together. On the Northwest Coast the tribe and the village became one and the same thing.

Many such tribes evolved on the Northwest Coast in historic times. Some grew and prospered in a region of rich natural resources and became very powerful. Others held their own for a time then lost their vitality, atrophied, and died out. Still others left their traditional groups to seek opportunities elsewhere either more remote or more accessible to growing European connections.

In short, I am suggesting that into the historic period—the period between the 18th and the 19th centuries—the picture of the Northwest Coast native culture is one of continuous flux, comparable to a kaleidoscope, changing patterns and colors with each turn and time period.

The Native Americans of the Northwest Coast spoke seven distinct languages with many local dialects making communication between tribes very difficult. These language divisions were Tlingit, Haida, Tsimshian, Bella Coola, Kwakiutl, Nootkan, and Coast Salish. But the various tribes were separated even more markedly than by language differences. Cultural differences, the feelings each tribe cultivated about itself as being unique and special, a sense of social superiority over other villages, created an even wider gulf. This elitist outlook was strongly entrenched and a dominant characteristic shared by all the Northwest Coast peoples.

THE SEA AND THE LAND

Geographically, the Northwest Coast is an ocean and forest world. The sea penetrates deeply into the mainland at a hundred points to create enormous inlets and fjords of spectacular dimensions. It is a place of wondrous beauty but also of occasional terror as sea storms crash against the mountain barriers. The winters are eerie and dark with dull steady rains falling from leaden skies for months, but with sparkling, sun-drenched summers. Impenetrable forests grow to the very edges of the high tide line. Large, extensively forested islands stand off the mainland, a few larger than some states of the Union. Countless others are mere rocky and wooded dots. It is the wettest place on the continent as winter storms inundate the coastline. The moisture and mild climate produce phenomenal tree growth all the way to timberline. Natural forces cannot be ignored in this part of the world. But nature is benign as well as intimidating; the spectacularly rewarding fluctuations of tides, between 25 and 30 feet, produce an abundance of foods close at hand to garner with minimal effort.

The Northwest Coast begins near the 100 mile long Malaspina glacier north of Yakutat Bay in southeastern Alaska and extends southward to the mouth of the Columbia River country in Oregon. However, the carving and raising of totem poles were restricted to the region between southeastern Alaska to parts of northern Vancouver Island. The custom was not practiced uniformly among all the tribes within this region. Some tribes took to the

practice relatively late and in modified forms; others were the pace setters influencing their neighbors at different time periods. Some tribes who seldom practiced the custom in the 18th and 19th centuries adopted it in the early 20th century.

From earliest times the Northwest Native American way of life was based on fishing for the five species of salmon that came at different times to spawn along the countless rivers and streams. Salmon was king, dominating the lives of the people. Salmon augmented other resources acquired from the sea and provided the foundation for prospering cultures.

From the rich forest cover red cedar trees (*Thuja plicata*) as well as hemlock, spruce, alder, and fir grew in profusion. From these resources native inhabitants created a rich and bountiful material world, the envy of other peoples. In addition, they built substantial villages of houses with massive frames made from cedar trees, that dwarf the family dwellings of our society. These homes afforded the people (for those times) the luxury of protection from the elements.

In an evolving maritime culture it was of utmost importance to build efficient, safe, and navigable transportation. Dugout canoes of cedar were made by professional craftsmen. The canoes varied in size from ten to as much as 60 feet or more in length, depending on their purpose. A rich and powerful family had need for several types: smaller vessels for food foraging, larger for trading missions, and the largest for maritime journeys, war expeditions, and whaling excursions which carried them far offshore.

From the ubiquitous red cedar people produced a variety of products designed to meet their daily and seasonal needs—not only the enormous house beams and planking for the long houses, but also boxes and chests for the storage of food, clothing, and ceremonial paraphernalia. Bark and roots were utilized in basket weaving for household uses: matting, garments, diapers, even shrouds for the dead. Not the least important, the red cedar provided the material for carving totem poles. Poles dwarfed all the man-made objects of wood in native North America.

The northern tribes gradually differentiated from those living southward in social customs and economic activities. Specializations appeared along the coast ranging from house types to burial practices, from fishing technologies to shamanistic rituals. One area had a local specialization in subsistence pursuits, another in religious rituals and social dramas; still another cultivated under-

takings involving esoteric symbolism. There was a great deal of trade between the coastal tribes as well as between coast and interior or riverine dwellers, all of which served to stimulate growth, productivity, and specialization. But acquisition of items symbolic of wealth became increasingly the focus of the coastal tribes.

Some tribes hunted grey whales in the annual migration, trading excess meat and by-products to others. Other tribes monopolized the runs of eulachon or candlefish which favored specific coastal environments. Eulachon oil was highly prized and used for both domestic and inter-tribal social activities. Mountain goat wool was a rare commodity and highly prized. Its source was the inaccessible, often dangerous, alpine habitat. The wool was traded by successful hunters to coastal tribes who wove from it garments and robes to clothe members of aristocratic families. Halibut fishing was a deep sea activity inaccessible to coastal and riverine dwellers. Those living near the halibut banks of the west coasts of the Queen Charlotte Islands and Vancouver Island specialized in catching and smoking it for trade. A few tribes gleaned nodules of raw copper found within their territories along river beds. Copper had important symbolic significance, being used only secondarily for tools. Certain groups coveted the northern style or Haida type canoe, paying dearly to acquire them. The southern style or Nootka type canoe, of equal merit, was in demand by others residing nearby. Such examples can be multiplied tenfold.

Food was given a prestige value by Northwest Coast Indians in addition to its fundamental nutritional value, so the owners of salmon spawning streams used stockpiles of salmon not only to insure their survival but also to enhance their social status, cement alliances with neighbors, or buy off potential enemies. The owners of halibut and cod and seal sites did the same in the distribution of these prestige commodities. They acted as middlemen in controlling the movements of goods along the few trade routes between the coast and interior dwellers as well as along the coast. In this way the chiefs also enhanced the fortunes of their families, increased their political power, and spread their name and fame far beyond their tribal territories.

While all the coastal peoples had access to the resources of the sea, upriver groups suffered less favorable circumstances. The environment was harsher, raw materials less abundant, and the spectre of famine during the long cold winter occasionally haunted them. However, these interior tribes were viewed by scholars as a part of the Northwest Coast tradition despite the fact their villages were often located a 100 miles or more from the sea.

All the tribes within this broad region recognized that the possession of wealth was at the heart of their lives. It was their *raison d'etre*. The acquisition of wealth represented power. Wealth made life worth living because others sat up and took notice of it. Raw materials derived from both the sea and land constituted wealth. Territories yielding special products—clam beds, berry or seaweed gathering grounds, mountain sheep and mountain goat hunting territory—were wealth. Rivers, bays, and salmon streams were wealth. Rocky promontories and islands offshore—seal and sea lion rookeries—were wealth. The cultural thrust of all the tribes was the acquisition of wealth in impressive abundance. The accumulation of commodity wealth both by gathering and trading were a people's best insurance against adversity and intimidation by others and were the source of tribal prestige. Wealth was protection in power struggles. The frequent feuds within tribal groups and wars between tribes often stemmed from illegal use of property, the taking of wealth coveted by one group but exclusively claimed by another. The cultural drive for wealth made for volatile relationships.

THE TRIBES

The native inhabitants occupying this region were grouped into a number of loosely organized units. Each unit claimed a particular territory which they viewed as given them by ancient ancestors who were supernatural beings. Each established a permanent village which served as the nerve center for their winter social and ceremonial life. Often villages had been established and occupied for centuries; more were established relatively recently while still others were settled in the mid-1800s to trade in fur pelts with the clipper ship trade to China. Regardless of the tribe, through the myths of their origins and the reasons underlying their formation at various villages, the people shared one paramount characteristic: each had developed a special feeling about themselves which we can characterize as a sense of exclusiveness. Even geographically close neighbors were not immune to such a sense of themselves not diminished by proximity to linguistically and culturally similar peoples.

The northernmost tribes were collectively known as the Tlingit, but the term is an oversimplification. The term "Tlingit" connotes a

linguistic rather than a cultural division as there was little unity or shared sense of identity between the tribes comprising the group. Until relatively recently, in fact, people from different villages would not respond to the term Tlingit as one of identity. One's genuine identity was with one's lineage house and the village of one's birth. Historically, the Tlingit people were composed of 14 different tribes (see tribal map). The northernmost is called the Yakutat. Near them were the Chilkat tribe who lived at the head of the Lynn Canal, perhaps the most famed of the Alaskan tribes. Their village was called Klukwan (old, honored town). The Auk and Taku tribes were small groups residing in the vicinity of present day Juneau. The Hoonah lived on Chichigof Island while the Angoon Tlingit occupied Admiralty Island. The Sitka people inhabited Baranof Island. There were others. The Kake (Keq) people occupied Tuxikan but later abandoned it in order to found Klawak; the Stikines who resided upriver moved in 1834 to a new town established at Fort Wrangell (plate 20A). The most southerly Tlingit were the Sanya and Tongass (plate 18) near present day Ketchikan.

As is obvious tribes have not always resided where they were first encountered by Europeans. The contacts between the Tlingit and Europeans began in the mid-18th century and increased substantially in the next few decades as Russian explorers and fur traders moved southeastward from forts and settlements they established in the Aleutian Island chain. Although the Russians were the first Europeans involved with the Tlingit, their impact on native life was ephemeral, short-lived, and of a negative quality. The Tlingits were extremely suspicious of Russian motives and resisted penetration into their territories from the 1790s onward.

South of the Tlingit territory the next major grouping were collectively known as the Tsimshian (T'sem=inside; Ksian=Skeena River) who occupied the northern-most part of the British Columbia coast. They were divided into three major divisions totaling about 26 tribes. The first division is known as the Coast Tsimshian. Fifteen tribes occupied many of the offshore islands as well as the adjacent coast. There is substantial evidence to suggest a great deal of mobility between tribes as they had established villages in several different sites prior to their later historic settlements. The most important were the Kitkatla, and the Fort Simpson groups.

The second Tsimshian division is the Niskae or Nass River people. Four tribes resided in this river

valley in impressive settlements such as Angidah, Gitwinsilk, Gitlahdamsk, Gitiks, and the largest, Githadeen. What villages they were! Yet the reader may never have heard of them. The Nass River people were aristocrats in the mold of their Coast Tsimshian brothers. To judge from what they left behind when their villages were abandoned, they were supreme artists and sculptors. The villages crumbled leaving some salvagable remnants which gradually found their way into museum collections. The coastal group were a maritime people, powerful, richly endowed with natural resources, with a particularly marked penchant for trading. Drucker (1965) referred to them as the "opulent Tsimshian," among the wealthiest of them all.

The third division resided along the middle and upper headwaters of the Skeena River and were known as the Gitksan (People of the Misty River). Seven tribes resided along its banks in important villages such as Kitwancool (plate 13), Kitwanga (plate 16), Kispiox (plate 14), Gitsegyukla (plate 15), and Gitenmaks near modern Hazelton.

The three divisions nurtured quite dissimilar destinies by the end of the 19th century. The coastal tribes were converted *en masse* to Christianity through missionary zeal; the Nass people abandoned their villages and scattered to numerous Canadian European settlements; only the Gitksan maintained their age-old sentiments and tribal links while resisting change from the outside world. Interestingly, the Gitksan were probably the least well-off of the Tsimshian people.

It would be a difficult task indeed for a writer to minimize the role and position of the Haidas. Located to the west of the Coast Tsimshian, across 80 or more miles of Hecate Strait, the Haidas were seafarers in culture and outlook, rich and powerful, warlike and feared. They exerted an extraordinary influence on their mainland neighbors. As daring voyagers, they would journey in the 1850s in their superbly crafted dugout canoes the 600 miles to Fort Victoria on trading expeditions and return, all the while engaging in some marauding depredations on other tribes along the way. These were extensive and dynamic people possessing impressively built villages scattered hither and yon over three large island groups. At one time they may have numbered over 10,000 souls (Krause, 1956) residing in the Queen Charlotte Islands and adjacent Prince of Wales Island. The Haidas were travelers, artists, canoe and house builders of monumental proportions, as well as totem pole carvers on a scale unequaled anywhere at any time

in the entire world! The historian concerned with the Haidas must be willing to undertake a single-minded pursuit, but it brings rich rewards. Focusing upon the Northwest Coast tribes as I do without zeroing in on the Haidas is like trying to orchestrate a Tchaikovsky symphony without stringed instruments.

The Haida homeland was in the vicinity of Graham and Moresby Islands in the Queen Charlotte archipelago. The Kaigani, the northernmost of the three divisions, built large settlements on Prince of Wales and Dall Islands. They later consolidated their influence at Tlingit territorial expense. The Kaigani settled at Howkan (plate 12), Sukkwan, Klinkwan, and Kasaan (plate 11), the latter probably the largest of the Haida villages in the north. On Graham Island, the second division centered around a considerable settlement at Masset (plate 3), with smaller towns clustered not far away at Kung, Yan (plate 10), Dadens, and Kiusta. The third division, known as the Skidegate Haida group, consisted of several tribes with large and impressive villages. In addition to the imposing Skidegate settlement (plate 2) there was Haina (plate 6), on Maud Island located across the bay, Chaatl, and Kaisun (plate 8) to the west; and Cumshewa (plate 4), Skedans (plate 5), and Tanu (plate 7) to the south. In the southernmost extremity of the islands stood another formidable place, Ninstints (plate 9). All have disappeared into the mists of the past save Masset and Skidegate. If there is a major museum in any part of the world with a collection of totem poles, the chances are high they were rescued from some villages on these very islands.

The Haidas carved hundreds of totem poles of different types, most of which crumbled beyond salvaging. But Haida culture began to collapse by the mid-1870s as people died by the thousands from diseases introduced by Europeans against which they had developed little immunity. Whole villages were abandoned and literally disappeared. The villages we have named are but a small part of those known to have existed a century or more before. The survivors fled to other places for protection and succor while the sea, wind, and rain began to reclaim what was left behind. Scores of magnificent poles and the houses with them disintegrated with time. One of the haunting, unforgettable experiences of my life occurred in 1948 when I stood on the beach one late afternoon in utter shock and horror before the rubble that was once Skedans. Houses, poles, even mortuary poles, all crazily tilted or fallen one upon the other in one final agony and death!

Haida culture rocketed into prominence at the end of the 18th century. Hardly eighty years later it had spent its brilliance. The tribes sank from a formidable power to oblivion, from being the scourge of the coast as far as Victoria to a tattered remnant. The story leaves us to ponder the vagaries of history in which events bestow survival on one group, oblivion on another. Yet Haida influence is so great I must devote many pages to the role they played in the development of totem poles.

South of the Tsimshian on the mainland were several tribes known by the name Northern Kwakiutl. They were the Haisla and Haihais groups, all once greatly influenced by their Tsimshian neighbors in aboriginal times. They came under the influence of European culture and missionary zeal in the latter half of the 19th century and quickly lost their group identities.

Between the Northern Kwakiutl and the Southern Kwakiutl lived a collection of small tribes who remain little known save for one major study written by McIlwraith (1948) and one salvage report by Stott (1975). These were the people residing in the Bella Coola River valley and along Dean and Burke Channels. Linguistically, the Bella Coola people spoke a language akin to those tribes who resided far to the south on the British Columbia coast, and known collectively as the Coastal Salish. They represented a foreign enclave in the midst of the Kwakiutl peoples but are included with the Northwest Coast tradition because they early took on a veneer of northern Northwest Coast culture, grafting elements onto their riverine traditions to give it a distinctive stamp. While Bella Coola settlements were plentiful, forty or more in number, most were little more than hamlets. The best documentation we have is for three villages of some distinction: Komkotes (Bella Coola) seen in plate 27, Talio, and Kimsquit (plate 28). None were remotely as large as most Haida or Tsimshian settlements. Bella Coola production of totem poles was also limited. Their role seems more as recipients of coastal influences than as innovators. Bella Coola perceptions and creative genius were channeled into other creative expressions such as highly imaginative oral literature which centered upon the past, and a concept of humanity purposefully created by a group of divine artists who reside with their creator in the sky world.

West and south of the Bella Coola were the Southern Kwakiutl. They were highly diversified from maritime to river type cultures. We can identify 20 Southern Kwakiutl tribes scattered over the northern quarter of Vancouver Island and the

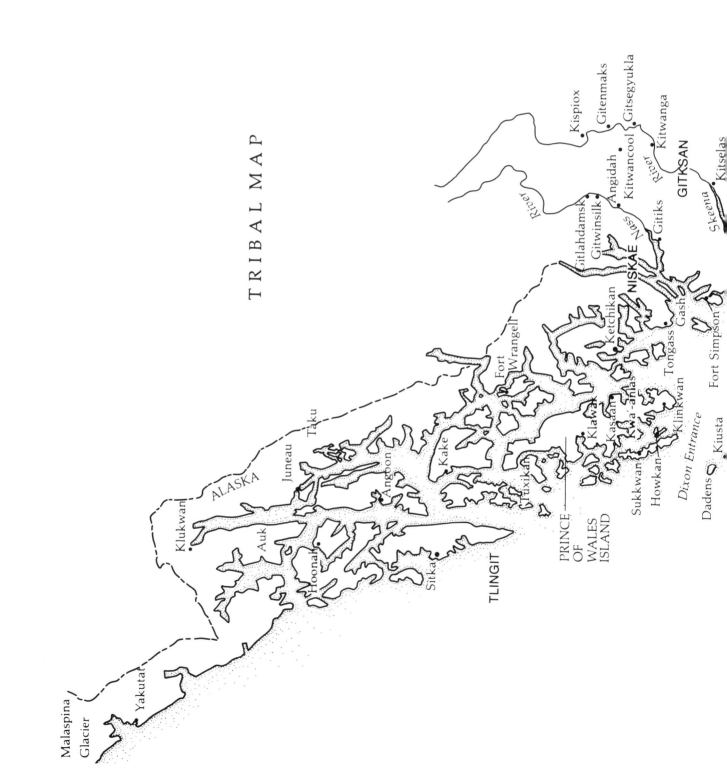

TRIBAL MAP

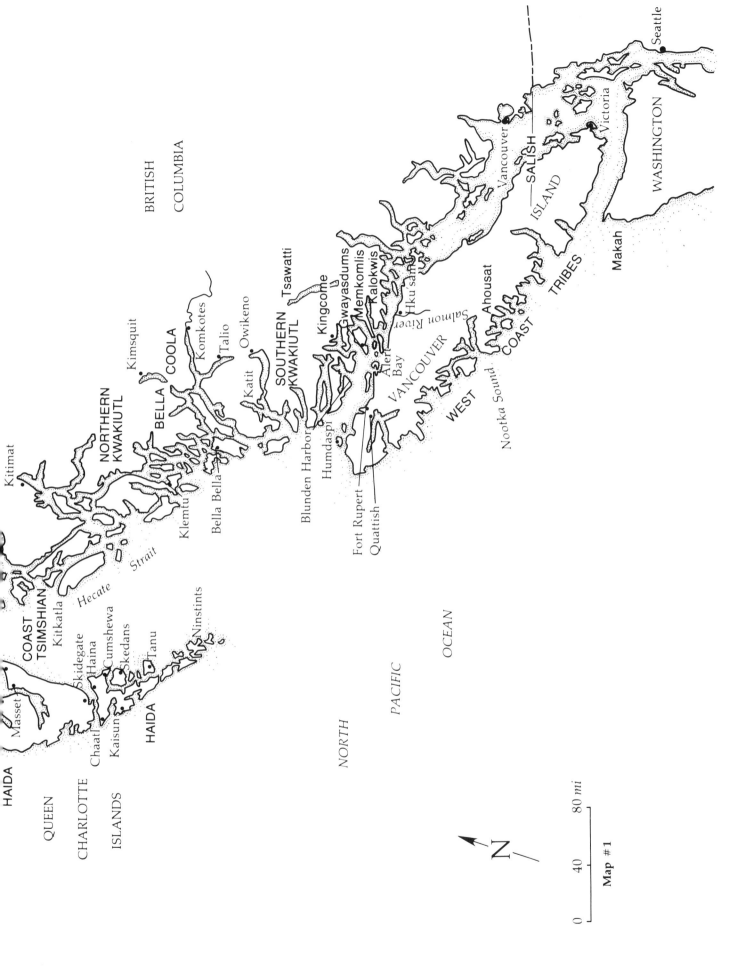

HAIDA

QUEEN

CHARLOTTE

ISLANDS

Kitimat

Masset

COAST
TSIMSHIAN

Kitkatla

Chaatl
Skidegate
Haima
Cumshewa
Kaisun
Skedans
Tanu

HAIDA

Ninstints

Hecate

Strait

NORTHERN
KWAKIUTL

Klemtu

Bella Bella

Kimsquit

BELLA
COOLA

Komkotes

Talio

Katit

Owikeno

Blunden Harbor

Humdaspi

Fort Rupert

Quattish

SOUTHERN
KWAKIUTL

Tsawatti

Kingcome

Gwayasdums
Memkomlis
Kalokwis

Alert
Bay

Hku sam

Salmon River

VANCOUVER

WEST

Nootka Sound

COAST

Ahousat

TRIBES

Makah

Vancouver

SALISH

ISLAND

Victoria

WASHINGTON

Seattle

BRITISH

COLUMBIA

NORTH

PACIFIC

OCEAN

N

Map #1

0 40 80 mi

adjacent mainland in the 19th century. The Bella Bella people, maritime neighbors of the Bella Coola, were the northernmost of these Southern Kwakiutl. The Owikeno tribe nearby settled at Katit in Rivers Inlet while to the south of them lived the Gwasala people. The Nakwatoak tribe settled at Ba'as, (Blunden Harbour, plate 26) perhaps in the 18th century. The Tzawatanoak lived at Gwayi, Kingcome (where Margaret Craven's book *I Heard the Owl Call My Name* had its setting). The Kweksutenok tribe resided at Gwayasdums (plate 24) on Gilford Island; the Mamaliliqala built Memkomlis on Village Island. Other tribes were scattered elsewhere in this region: Kalokwis village at Turnour Island; Tzawatti along Knight Inlet (plate 21); Hku'sam near the mouth of the river near Kelsey Bay. A renowned people, the Nimkish, left their settlement along a river on the north coast of Vancouver Island around the mid-1850s and settled on the shores of a small island not far away which came to be known as Alert Bay (Plate 22). Thirty miles to the west the Hudson's Bay Company established a trading post in 1849 near Hardy Bay in order to exploit a newly discovered coal seam which promised profit. It became known as Fort Rupert (plate 25). No sooner than completed, four independent tribes from villages established elsewhere moved to Fort Rupert, lock, stock, and barrel, to take advantage of European trade goods obtainable there. They established a turbulent settlement outside the fort's walls. One year a settlement did not exist; the next a considerable one emerged. One can imagine the calamity and rivalry that ensued.

A few miles northward at Hope Island the Nawitti tribe founded Humdaspi (plate 23). Southward along the west coast of Vancouver Island to Quatsino Inlet were other villages belonging to four different tribes. The fortunes of three were such that they disappeared quickly in the late 19th century. The surviving group, the Koskimo, settled at Quattish which was abandoned in the late 1950s.

The Southern Kwakiutl were a maritime people pursuing pelagic game (whales, seal, sea otter, etc.) with great skill. They were a center of innovation, accommodating to foreign settlers and amenable to changes in their material and spiritual existence in spite of determined effort to retain the critical core of their spiritual heritage. They created new styles of artistic expression and play a vital role in our study.

We now come to the West Coast tribes of Vancouver Island. There were eighteen known tribes tucked into various bays and inlets, their backs to impregnable forests; their focus, the ocean horizon. They were vigorous seamen, the equal of the Haidas. West Coast tribes hunted the grey whale and other sea mammals. Some were deep sea fishermen. They were divided into three subgroups: the northern group consisted of five tribes. The central group numbered seven, while the southernmost group made up the remainder, plus one, the Makah people, who many years earlier probably migrated and settled the Cape Flattery region of the Olympic Peninsula. When English, French, Spanish, and particularly Americans contended for dominance of the Pacific Northwest, focusing first on the dominance of the fur trade, the West Coast tribes experienced critical and finally ruinous changes. Tribal fortunes declined with the demise of the sea otter herds and tragedy became commonplace. The introduction of Western diseases also took a fearful toll. Spread of Western settlements was rampant. Few genuine native communities survived into the 20th century (plate 29).

There remains but one other group relevant to the subject of the book, albeit their place is peripheral rather than central, that being the Coast Salish tribes of southeastern Vancouver Island and the nearby mainland. In custom and social practice they were somewhat removed from their neighbors to the north, particularly with regard to totem pole carving and related cultural activity. They did practice some small wood sculpture in which humans and animals were depicted but the symbolism lacked the meaning associated with poles farther north. I include them only for comparative purposes and to clearly delineate the boundaries between the Northwest Coast carving traditions. Among the Salish were Comox, Cowichan, Squamish, Saanich, Musquean, and Sechalt tribes.

THE VILLAGES

The heart of the Northwest Coast culture was to be found within the villages which nestled among the countless islands and coves along the mainland. These grew to impressive prominence in the middle and late 19th century, their great plank houses and totem poles thrusting high above the shoreline. This was their Golden Age. The most commanding sight approaching a village in these times were the massive columns with their complex symbols for all visitors to see.

By Western standards native villages were not large, ranging from a few hundred inhabitants to a little more than 1,000 souls in major settlements such as Fort Simpson, Skidegate, and Masset. Each

village was a socio-economic rather than a political unit. The allegiance of its members was never in question as it was the rallying point for tribal sentiment, protection, and identity. Indian settlements were markedly unstable due not only to changing economic circumstances but also abandonment, on splintering and breaking away of members, all leading to the creation of new settlements, reflecting changing alliances and cultural perceptions. Dadens, a major Haida village, for example, was created in the early 19th century on a site formerly settled then abandoned. Haina, another Haida town, was established between 1860 and 1870, the result of two groups from Kaisun and Chaatl resettling. Blunden Harbor was settled after the people abandoned their settlement at Tigwaxsti; Fort Wrangell was a Russian trading post to which the Stikine tribe moved in 1834; Fort Rupert was quickly occupied by four different tribes in 1849, migrating from established villages on islands to the east; Fort Simpson was occupied by numerous tribes who abandoned traditional settlements elsewhere. Since the pattern seems well established for these native settlements it is possible the ultimate answer to the age and spread of totem pole practices will remain elusive, perhaps locked up forever in those long-abandoned places. Villages, as I have mentioned earlier in this chapter, may have at best a history of little more than 200 years; many are considerably more recent than that.

Village sites were chosen by the leaders of the tribe and had to meet certain criteria. One was its close proximity to dependable subsistence resources, including fresh water. Since food resources were subject to intrinsic cycles and fluctuations, a people might have to move residence in order to insure their continued survival.

Second, the sites had to provide protection from surprise attacks by enemies. This was particularly true during the early and mid 19th century when inter-tribal raiding accelerated as a result of the introduction of firearms. I was amazed when traveling with a guide to the Kwakiutl villages at Gwayasdums and Memkomlis at the maze of channels and passages that had to be navigated, some hardly wide enough to accommodate the boat. When I asked why the village had been established in such difficult terrain, his answer was simple enough. "Protection." I had a similar experience visiting Blunden Harbor which was located in a long and very narrow inlet, hardly distinguishable from dozens of others along that part of the coast.

A third requirement was protection from the elements, including the fierce winter storms that churned the sea into a frenzy with bone-chilling winds. Villages also required a sheltered beach if possible in order to accommodate dugout canoes, the sole means of transportation. Villages were built near low-lying hills which sometimes provided some protection from storms. Generally, a village consisted of a single row of houses built on a terraced bench paralleling the beach but well above the high tide mark. There were exceptions to this, of course, such as a second row of houses behind the first which faced the beach. Villages near rivers also required a raised terrace in order to protect them from the rapid rise of water during the spring run-offs from melting snows. Otherwise, the rivers would play havoc with the settlements. Sometimes the one street was a boardwalk of planks set in front of the houses and extending from one end of the village to the other. The forests behind the houses were usually leveled, providing the timbers and boards for the building of the village. If old photographs reveal a denuded forest zone behind the settlement, chances are good that the village was built relatively recently. This cleared area also served as the latrine for the people while the beach was the refuse receptacle from which daily tides carried away the debris.

The beaches in front of the villages were usually of coarse gravel rather than sand. Canoes were beached on it at high tide then covered with cedar bark mats to prevent splitting or drying in the sun. Some places like Blunden Harbour were built over huge middens of shellfish reflecting hundreds of years of intermittent or long-term occupancy.

From the beach a series of steps made of split logs led the visitor to the house terrace. The terrace might be as high as 40 feet above the water indicating the prudent planning necessary to safeguard the community from storm-driven waves.

Regardless of the tribe, the permanent village was occupied during winter months only, usually between October or November to May or June. In the summer months the people left their homes, separated into smaller units such as the nuclear family and moved to temporary fishing camps. During the fall months in particular the racks of drying fish spread out along the terrace was a common sight. Pungent odors enveloped the village. When temperature inversions occurred or when the air was quite still, the smell and smoke of burning cedar logs from the hearths cast a soft grey pall over the houses, settling over the rooftops like a blanket to blot out the hills and surrounding mountains.

I once spent a week at Quattish, a Koskimo village, after the people moved to their summer fishing camps at Forward Inlet. I recall the waves gently washing the beach at flow tides; the subtle blends of forest and sea tones; trees and their branches heavily ladened with mosses; barnacle-infested rocks protruding sharply above low tides. There was the occasional bald eagle; myriad gulls and ravens competing for scraps; even an occasional frisky killer whale might enter the inlet to be seen cavorting in the waters offshore. Very tranquil scenes, these. But the tranquil atmosphere belied the human dramas played out within such villages, the smoldering emotions that surfaced from within their long houses. Inside these clan or lineage houses tales unfolded akin to those in our own society; rivalry for power, status, and prestige; vaunting pride; large or petty jealousies; ambitions thwarted, festering resentments; injuries and insults real and imagined; vendettas planned and vengeance achieved or frustrated; feuds consummated; amorous triangles.

The Northwest Coast society was not made up of equals. Social class differences were sharply delineated, based on an individual's order of birth and inherited wealth. Each village had commoners, its aristocratic families derived through inheritance, as well as some slaves, most of whom were outsiders. Extended families lived together in a single long house. They typically numbered from 20 people to as many as 40 in the families of the most powerful. All occupants in the house, except the slaves, traced their ties lineally to an ancestor who founded the family long ago. Old, established houses had venerable names. Allegiance of its members commanded greater loyalty than to the village itself of which they formed a part.

HOUSES AND HOUSE NAMES

Each village was composed of from 10 to as many as 30 or more houses, depending on the size and power of the tribe settling it. Houses were raised from cedar posts capped by beams that weighed in excess of two or three tons each (plate 1). Among the Haida, Coast Tsimshian, and Kwakiutl groups construction was on an enormous scale, using foundation beams of immense girth and weight in red cedar wood (fig. 1). The interior of some northern houses had three different levels. At the bottom-most level was the fire to warm the house and prepare the meals. Light came only from the fire or during the daylight hours from between the wallboards and from the smokehole centrally located in the roof. The unpainted cedar sidings weathered quickly to a silver grey and was never painted. An exception arose among the leading families of some villages who painted family crest designs in bold earth colors on their house fronts, but this practice was limited geographically.

Every house had a history of vicissitudes, all of which were of considerable importance to the tribe and were represented in the poles. They reflected the lineage and clan affiliations, social rankings, and positions held by the family within it.

Houses of the powerful were often named, the names being related to the family's ancestry or preoccupations with status. Among the Tlingit, for example, houses were named after the animal and bird crests of their lineages; or they reflected episodes in the lives of ancestors. There was the Whale House as well as Whale Blowhole House, Raven Bones House, Grizzly Bear House, Eagle Feet House, and Killer Whale Dorsal Fin House to name a few. House names were family rights as

Figure 1

Drawing from *The Northern and Central Noothau Tribes* by Philip Drucker.

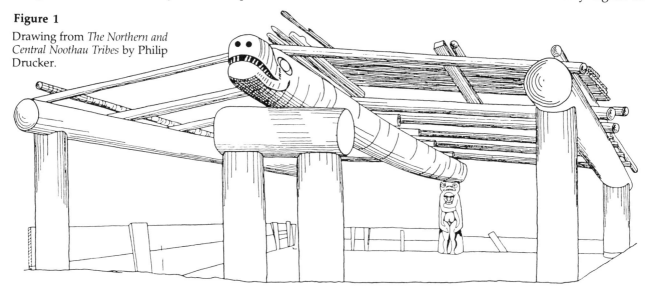

surely as other tangible property and were just as fiercely guarded and protected from infringement (Olson, 1967).

At Skidegate the houses of highest ranking chieftains, including Chief Skidegate's home, were located in the center of the village. All were of imposing size. Of the approximately 30 houses standing in the 1870s the names do much to capture the ethos of their owners and the native culture: The House At Which People Are Ashamed To Look (because of the wealth of its occupants); House Upon Which Storm Clouds Make A Noise (so tall the clouds collide with it); House That Chiefs Peep at From A Distance (out of fear of its owner's power). Other examples include Grizzly Bear Mouth House, House In Which People Must Shout To Be Heard, and Thunder and Lightning House. There was one called House of The Stormy Sea, and one with the unexpected twist, House of Contentment.

Kwakiutl house names, on the other hand, referred generally to the positions occupied by their owners in more blatant terms. Among them were Yakoglas, (Giving Away Wealth), Nimogwis (The Great One), Nigaytzi (Great Mountain House), and Siwida (House to Whom People Paddle to acquire the wealth given by its leader). One house at Fort Rupert had a different twist, with a double entendre. It translated Where the South East Wind Blows, referring to the proneness of those living inside to be windy; also "passing wind."

In the villages of the northern tribes, among the Haida and Coast Tsimshian in particular, each house was flanked by a variety of sculptured columns. Some were attached to the house front itself; others were placed several feet in front or to one side of it.

One type pole was uncarved except for a solitary figure at the top. Other poles were carved with a series of vertically oriented figures from top to bottom in which the family's social history or clan episodes were represented. The majority of the figures, however, did not represent totems. Examples of these pole types are depicted throughout the section that follows.

THE ANTIQUITY OF TOTEM POLES

The earliest evidence of monumental wood sculpture stems from observations made in the logs of early explorers and fur traders who visited the coast between the 1770s and early 1800s. While these accounts confirm some form of carved column existed they present a conflicting picture. Some observers reported carved poles and provided sketches and illustrations of exactitude. However, some seem to have seen nothing of the sort. How could this be?

The discrepancy may have resulted from the limited geographic spread of pole usage during this period. It might not yet have caught on with large numbers of tribes. Contacts between the explorers and natives did not often occur at the winter villages but at seasonal camps. Some European fur traders exchanged goods with natives while under sail, hardly offering an opportunity to record village characteristics.

There is no point in presenting the reader with a litany of examples of these discrepancies. A few will suffice. Starting chronologically, among the first explorers on the coast were Quadra and Maurelle of Spain who visited the Sitka Tlingit tribe in 1775 at Baranof Island. They saw no poles. Scarcely twenty years later the Russian Lisiansky reported seeing many mortuary type poles of the Sitka tribe containing ashes of dead leaders.

Captain Meares in 1788 described seeing wooden images in the Queen Charlotte Islands which he called idols. Portland and Dixon in 1787 do not mention them but acknowledge that they avoided villages entirely whenever possible.

The crew of the ship Eliza made contact with Haidas at Langara Island in 1799 in the village identified as Dadens. The journal reported large poles described as mortuary poles. The earliest illustration we have is a Haida pole found in Bartlett's journal in 1791 describing an entrance pole (to a house).

Malaspina, the Spanish explorer, in 1793 wrote that he saw at Lituya Bay near the Tlingit village of Yakutat a mortuary type pole depicting a very large figure of an animal, possibly a grizzly bear, sitting upright holding a box. It was accompanied by sketches made by the artist Tomas de Suria. Captain Vancouver observed a double-type mortuary column and also described house and detached poles seen in the Queen Charlotte Islands. Ingraham's journal in 1790 described two upright pillars in front of a Haida village that he estimated to be 70 feet in height. But a visit to Kiusta in 1799 makes no mention of poles in front of the village but the log does tell of some standing to one side. In other words they were not a part of the village itself. Other explorers reported seeing no poles but observed that painted house fronts were commonplace. Meares in 1788 and Haswell and Boit in 1799 reported seeing portal poles in a chief's house among the West Coast tribes at

Clayoquot, Vancouver Island.

In 1825, 20 years subsequent to the previous accounts, the Russian explorer Kotzebue reported seeing no poles at Sitka, a Tlingit village. Were the sites the same or were they two different places? We don't know for certain. Captain James Cook, in his voyage in 1778 does not mention seeing poles, but the scientist attached to his expedition, Webber, illustrated two posts from the house of a chieftain located at Friendly Cove on the west coast of Vancouver Island.

We cannot rely on these reports alone since they are filled with discrepancies. I believe they also reveal that the explorers and fur traders were far more preoccupied with other matters and did not pay too close attention to all that was observable. While totem poles were not a widespread phenomenon in the latter part of the 18th century, the significant point is that *in some places* they *were noticed!* They were hardly the overwhelming sight reported in the 19th century accounts but limited in number to one or two in each village, if that. These were no forests of totem poles to overwhelm the eye of the visitor during this period.

While totem poles were present the early reports strongly suggest that pole carving at this time was in an embryonic stage, not yet common enough to have spread the length of the Northwest Coast. The explorers identified some types such as a memorial pole or a mortuary pole. Both might imply similar functions and have limited sculptural surfaces. But in some accounts still another type of carved column was reported. This was the house post, a carved vertical column erected inside the house itself. I believe these two simplified types of columns were the early prototypes and were genetically related to forms that were to emerge later with far greater complexity in design and diversity of details.

Anthropologists generally agree that a long tradition of wood carving was to be inherent within this culture. Northwest Coast life was rooted in a technology of production, achieved with a remarkable degree of success. The skills and ingenuity of the people were channeled into making boats and houses which, like the poles themselves, were limited in quality and complexity by the very nature of the tools that produced them—stone hammers, wood mallets, antler wedges, beaver teeth knives, and for cutting tools an occasional rare iron-bladed adz or knife painstakingly acquired from the desultory trade contacts with Iron Age peoples of Siberia. Once modern tools in greater abundance were available to the craftsmen through contacts with Europeans, the technology took a quantum leap forward so totem pole carving proliferated and gradually spread to other regions and other tribes of the coast.

Another problem centers around the question of what constitutes a totem pole? Marius Barbeau, that indefatigable collector of poles for museums, defined them in a monumental study entitled *Totem Poles* (1951). His was an extremely narrow definition with which many scholars have taken issue. Barbeau called the totem pole the detached pole, the so-called heraldic pole, standing by itself and separate from the house (figure 25 being an example). Other types of carved columns that are illustrated in his study, those poles attached to the house fronts, the mortuary pole, and those standing inside the house, he did not view as being truly totem poles. Barbeau states that the so-called totem pole (his definition) was relatively recent in age. It was not present on the Northwest Coast until the introduction of European-type iron tools which then stimulated the making of these monumental carvings. This argument does not of course square with the descriptions of some types of poles already provided in the journals of European explorers.

I disagree not only with Barbeau's narrow, restrictive definition but with the period to which he ascribes the appearance of carved columns as well. What are we then to call the early types of columns? Barbeau brushes this question aside and makes no attempt to resolve it. He also gives little attention to the techniques involved in making various types of poles. They seemed of relatively minor importance to him. On the other hand, all carved columns were large, though they varied in height from 10 or 15 feet to as much as 80 feet; they were carved from red cedar logs (with the exception of the northern Tlingit where red cedar was not readily available). The poles were raised under carefully determined rules and protocols; designed to be viewed in a vertical orientation. Regardless of the differing functions that were served, carved poles required the use of the same types of tools, the same craft skills, the same tool techniques, the same considerations of space and depth. Equal energy and skills were required to select, cut, and transport appropriate logs and the final installation of the completed pole. In contrast to Barbeau's approach I consider all types of monumental carved columns as totem poles.

In rejecting Barbeau's narrow definition I believe that pole carving was of greater antiquity in the coastal Indian tradition. No great art form evolves full blown out of the blue. It develops through slow experimentation into a tradition that

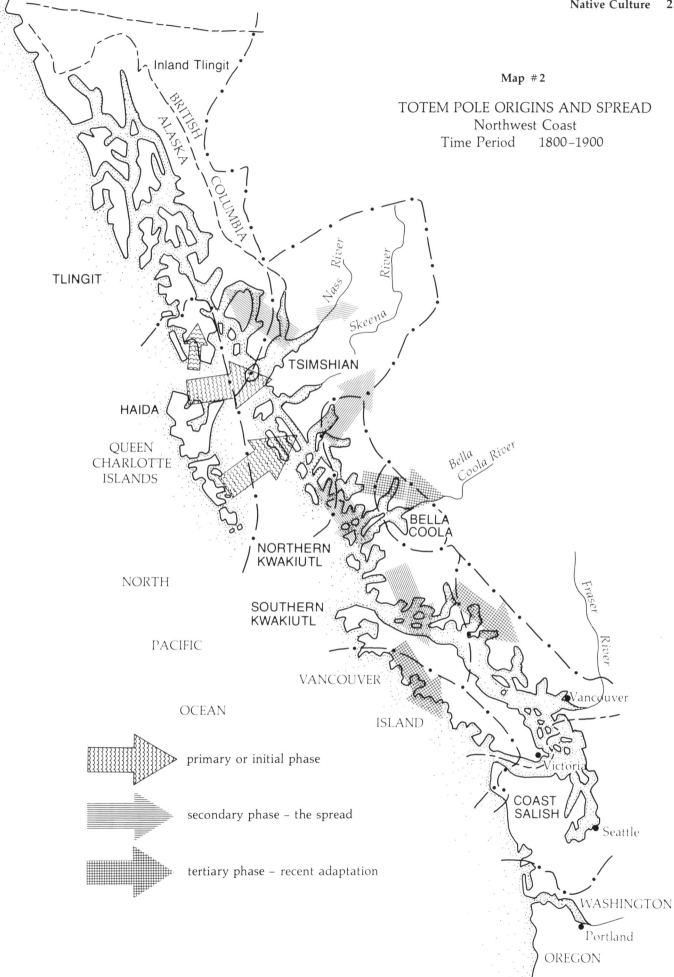

Map #2

TOTEM POLE ORIGINS AND SPREAD
Northwest Coast
Time Period 1800–1900

Inland Tlingit

BRITISH COLUMBIA

ALASKA

TLINGIT

Nass River

Skeena River

TSIMSHIAN

HAIDA

QUEEN
CHARLOTTE
ISLANDS

Bella Coola River

BELLA
COOLA

NORTHERN
KWAKIUTL

NORTH

SOUTHERN
KWAKIUTL

Fraser River

PACIFIC

Vancouver

VANCOUVER

OCEAN

ISLAND

Victoria

COAST
SALISH

Seattle

WASHINGTON

Portland

OREGON

primary or initial phase

secondary phase – the spread

tertiary phase – recent adaptation

meets very fundamental human needs. Pole carving undoubtedly had its origins several generations or more prior to European contact, perhaps even hundreds of years earlier. It had grown slowly and was limited in types as well as in practice to the most powerful of families within a village which had the wherewithal to have them made. Further flowering was restricted by the very nature of the tools the craftsmen used to create them.

The spread of totem pole carving and the gradual stylistic florescence that followed decades later resulted from several historical factors which became operative at a fortuitous time. However, the critical point is that the design and distinctive symbols associated with pole carving were already in place and perfected though certainly on a modest scale. This view is supported by the accurately dated collections of stunning Tlingit ethnographic materials housed in the museums in Leningrad and Moscow, U.S.S.R. (Siebert and Forman, 1967). The early Russian explorers and intellectuals were stunned by the virtuosity in handling wood. The pieces in these museums were

surely created by craftsmen a few generations or more prior to the early 19th century museum collecting phase. By the latter time it only remained for the native craftsmen to move from these smaller restricted forms, simpler if you will, to the large, more complex conceptions in order to launch the pole carving mania that followed. This creative explosion developed out of the acquisition from European traders of the tools that made larger and more intricate craft work possible.

Traders ushered in the frenetic sea otter fur trade which changed the life of the people for all time. Enter the Golden Age, a period from the 1780s to the 1830s, when the European traders stimulated the native economy, centering around the golden harvest of sea otter pelts. Profits soared and appetites soared with them. Associated with the golden harvest came increasing European expansionist policies. The trading companies contended with each other for dominance of the wealth that could be harvested. The Russian America Company in the north, the Hudson's Bay Company and Northwest America Company in the central and southern regions—all grappling for the

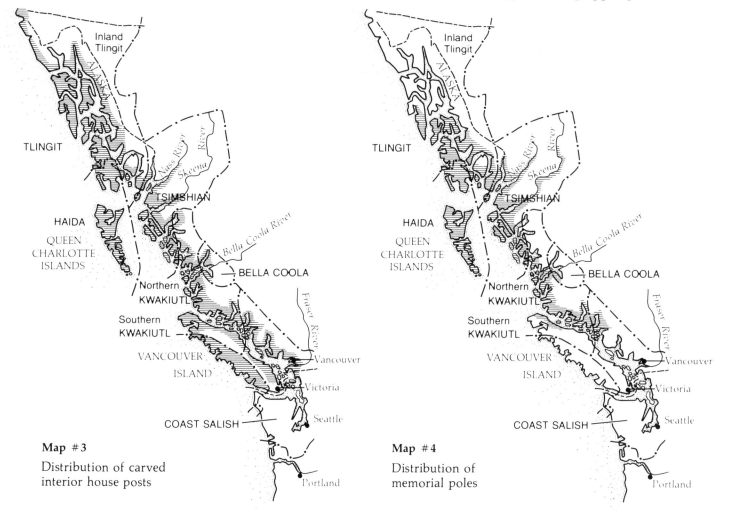

Map #3

Distribution of carved interior house posts

Map #4

Distribution of memorial poles

most favorable position. The natives were only too happy to oblige in the traffic of furs, to cooperate in gathering all the spoils that were transformed into a type of wealth they coveted but never before dared to dream about. All the people aspired to this wealth, not just their leaders. And so radical changes began to appear in the culture that whetted even further the natives' definition of wealth. Trade goods in exchange for furs flowed into the villages in never-ending tides to a point of inundation. The seduction of material goods began in earnest and included seemingly limitless amounts of iron-bladed tools, firearms and powder, food fads, copper sheets, pots, nails, clothing of outlandish styles, even rum. It tickled the already proud vanities of the tribes, driving them beyond any reckoning to acquire goods. Each tribe competed to enhance its wealth and honor tribal pride. Wealth fueled feasting competition which in turn magnified earlier practices such as potlatching. Family honor, prestige, power, position, and vanity elevated competitors to yet higher positions. Becoming the rule among the powerful, such practices gave newly found ambition to even

commoners that they too might rise above their circumstances of birth. Games of one-upmanship increased as one group or tribe pitted themselves against others.

One of the tangible results of this flow of material goods into the villages was the stimulation it provided to totem pole carving. Unexpected wealth encouraged the practice of pole carving. Carving spread from tribe to tribe and into the lands where it had not previously been the custom. After all, poles are impressive sights! People must raise them in order to impress others. They did not want to be left behind, to be considered the ne'er-do-wells of the country. They had names to uphold!

While pole raising had its origins in pre-European past, it was limited to two early types, the simple memorial pole honoring deceased leaders, and the decorative house post installed within the house itself, often as an integral part of the house constuction. On the basis of these prototypes, other totem poles emerged in historic times. In other words, the prototypes plus iron tools plus prosperous economic times (the fur trade),

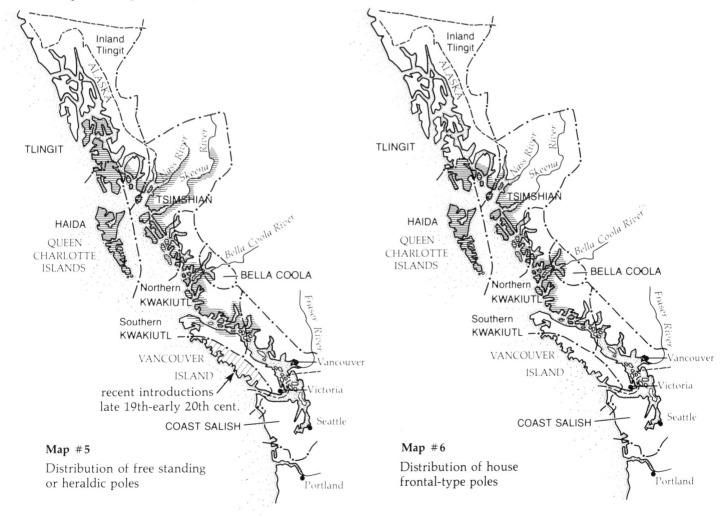

Map #5

Distribution of free standing or heraldic poles

Map #6

Distribution of house frontal-type poles

equaled a "bandwagon effect" which gained momentum and spread far beyond the points of origin.

As map #2 indicates I locate the origin of totem pole carving within the Haida culture on the Queen Charlotte Islands. The observations of explorers confirm their presence beyond a shadow of a doubt, as well as its general rarity in other places. Olson (1967) recorded intriguing comments of older informants during his ethnographic researches that the Tlingit people acquired their ideas of raising totem poles from the Haidas who introduced them long ago.

In the Queen Charlotte Islands some types of poles evolved which were not emulated elsewhere. On the other hand, simple memorial and house posts were present, being an extremely old practice found almost universally, from Tlingit country southward to the West Coast tribes and Salish peoples. They were the commonplace type, particularly in areas where the fully carved exterior pole never took hold. But it was the Haidas who carved in such volume and on such massive, overwhelming scale, using trees of such impressive

height and girth, they aroused the envy, even jealousy, of other tribes who saw them. Visitors came away from such sights in shocked wonder! Being a competitive people they could not stand to be left behind. They too wanted to raise poles in order to proclaim their worth to others.

From the Haidas the practice reached the Coast Tsimshian who adopted it but imposed distinct tribal characteristics on the carvings. They in turn influenced those tribes living along the Nass River, their nearest neighbors. The Nass River people in turn stimulated and influenced pole carving eastward up the Nass to the upper Skeena River country as a result of their close ties. At the same time the Coast Tsimshian influenced the southern Tlingit groups though not those living farther to the north. Likewise, the Coast Tsimshian influenced their Northern Kwakiutl neighbors who in turn stimulated the Southern Kwakiutl tribes at a later date. The Bella Bella were also recipients from the Northern Kwakiutl who in turn stimulated those living eastward in the Bella Coola Valley.

Each region developed in time its own stylistic characteristics, preferences, content, symbolism, color uses, as well as techniques. The boom was on! The additional maps provided in this chapter plot the distribution of the types of poles—mortuary, house frontal, and heraldic—which, with the heretofore mentioned prototypes, are the subject of the chapter that follows.

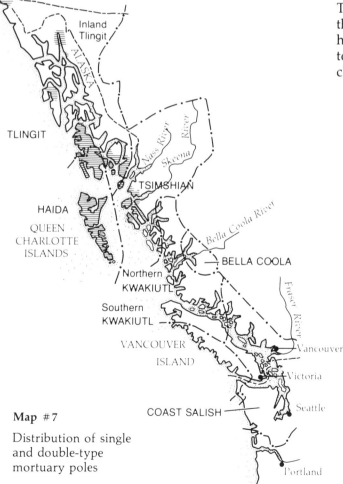

Map #7

Distribution of single and double-type mortuary poles

CHAPTER II

A Forest Of Poles

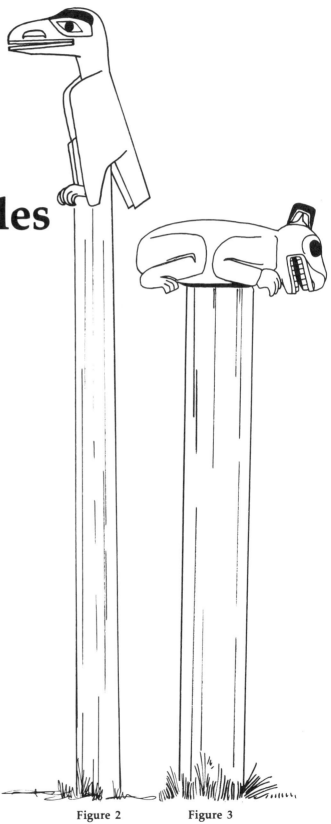

In the middle of the 19th century the entire Northwest Coast was in ferment as contending European and American influences altered the destinies of the native population. During this period some tribes rushed to the forefront of social and economic change while others waned into history. The fortunes of the villages I have singled out in Chapter I mirrored such changes. Today, in some places hardly a vestige of the past is to be seen. Many villages have completely disappeared. Yet in their heyday these places housed powerful families and produced dynamic life styles fueling the people with energy, accomplishment, and pride.

On the other hand, villages which in the 18th century had been but small things and of little significance in the world of the Northwest Coast Indians flourished and became centers not only of wealth but also new cultural focus.

Pole raising was not uniformly practiced from tribe to tribe even into modern history. Some villages one hundred years ago appeared as a forest of poles paralleling the shorelines (plates 2, 3, 4, 5, 6, 7, 9, 11, and 13). Masset and Skidegate had over 70 poles; Skedans more than 50; Tanu, one of the largest villages, at least 50 and more. Others raised only a few or none at all (plates 23, 24, 25, 26, and 27). The latter picture can only bring to the reader, who may have been nurtured on the notion that all Northwest Coast Indians raised totem poles, up short.

I believe there was an evolution of poles as surely as social, political, and other institutions evolved there and in other societies. We can chart

Figure 2 Figure 3

this development of totem poles through the examples that have survived in the villages which surged forward in unsettled times. The tribes occupying these villages acquired iron tools from the boom in European settlements, resulting from the development of the region's vast resources.

Chronologically, we begin with the simpler poles that were extant and captured in early photographs, the prototypes I call them. We then move through their secondary development to the final phase, the flowering of diverse types with their spread into the 20th century.

THE PROTOTYPE POLES

The Memorial Pole: The oldest poles were a simple, uncarved shaft or one displaying a single figure. They were raised as a memorial to deceased tribal leaders. The practice was deeply entrenched among the tribes and probably goes back many hundreds of years.

Memorial poles displaying a solitary figure represented the leader's clan or lineage identity and as such were viewed with great honor and awe. Nineteenth century photographs reveal their widespread presence in the villages though they are often dwarfed and consequently little noted by the taller, more spectacularly sculptured columns which followed in the second period. Examples of memorial poles are seen in figures 2, 4, and 5 as crests of raven and eagles respectively. Figure 3 is a grizzly bear while figure 6 is a human, possibly symbolizing the deceased leader. Simple memorials were raised in the Tlingit area as grave markers. The memorial pole was not ornately sculptured. With the tools available a single carved figure was an ambitious enough project.

The red cedar log chosen for such memorial poles was tall and thin, contrasting dramatically with the sizes and diameters used in later periods. Such a pole, rarely exceeding 30 feet in height, was easily transported to the site. No great effort, no sophistication was necessary to raise it. Such simple methodology is consistent with the limited material wealth available to commemorate the event. The solitary figure carved at the top distinguished it from simpler poles for some distance from shoreline, thereby setting a precedent for impressiveness. The figures were bold in execution. While they lacked the complex surface designs and patterns associated with later poles they probably already bore painted surfaces which highlighted anatomical features and increased their visual impact.

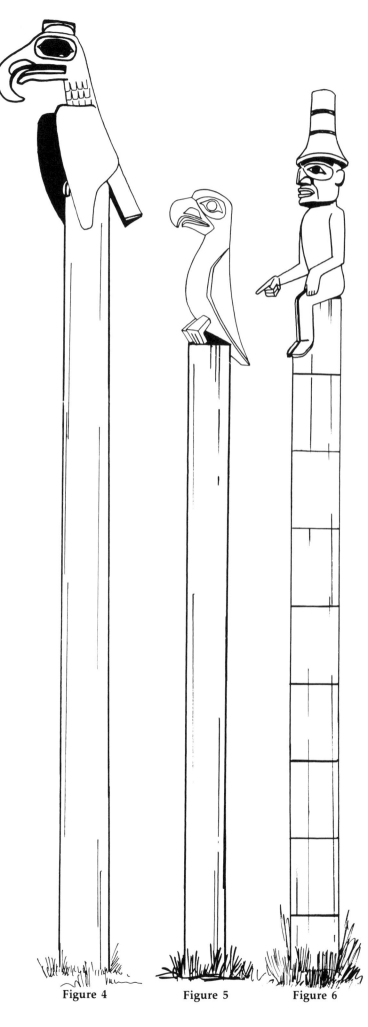

Figure 4 **Figure 5** **Figure 6**

The House Pole: A second type of traditional column is the house post. Historical sketches indicate their presence in villages in the late 18th century. House posts probably antedate memorial poles. These posts were placed inside the houses of prominent clan and lineage groups where they served the dual purpose of supporting the house roof and displaying the lineage crests of the occupants. In the most impressive houses there were four carved posts, two at the front and two in the rear of the house. In some instances decorated and carved secondary or corner posts were also raised to supplement the major posts. In any case, house posts stood as integral parts of the interior construction. In the northern region false posts were often employed, usually to cover the undecorated posts which held up the main frame. As map #3 indicates, the distribution of house posts was widespread and appears to be among the oldest and most entrenched examples of wood sculpture found in the region. They are recorded being present from the northern Tlingit country southward as far as the Coast Salish tribes during the 19th century.

Being sheltered inside the great lineage and clan houses for generations on-end contributed substantially to the preservation of house posts. Some older Indians once told me that in very early times it was the practice of the people to take along with them their house posts as prized possessions when a move was necessary. The great posts were then set up in the new village site.

But with the collapse of native cultures and the forced abandonment of many traditional villages, the protective frames of the house roofs rotted out within a few years resulting in exposure to moisture and insects. Even under such conditions it took considerable time for them to be undermined and toppled (plates 48, 49).

House posts differed from memorial poles in that they were not erected to honor deceased relatives but rather to record the crests associated with the family fortunes and history, having been in the possession of the family for generations. Since their carvings are more detailed and more complex and their height restricted, they were broader and more massive in diameter than memorial poles. A few exceptional house posts were over 20 feet in height.

The crests depicted on house posts included animal, bird, and human figures, or a combination of all three, depending upon the property and lineage claims of their owners. Figure 7 is a Tsimshian post from Gitselas Canyon on the Skeena River. The photograph on which this

Figure 7

Figure 8

illustration is based was taken before the turn of the century. The house had already toppled and was in an advanced stage of decay. A carved human figure is shown in a squatting position with hands resting on the handle of a canoe paddle firmly planted between his feet. It is approximately 12 feet high. Figure 8 is from a house at Quattish village that had collapsed before the end of the 19th century. It, however, clearly reveals a Kwakiutl chieftain holding a facsimile of a stone knife poised to strike an enemy or a slave. Figure 9 shows a matched pair of house posts from Bella Bella in the form of a whale or blackfish. Its flukes are folded back to meet the face. Notice the notches cut into the tops of each pole in which the main roof beams rested. A similar motif is followed in figures 10 and 11, depicting vertically-oriented sea lions holding up horizontal house beams. These are approximately 12 to 14 feet in height and are painted. Figure 11 has designs representing ocean waves with foam (seen as circles) breaking over the sea lion's back. Its tail displays a copper to symbolize the owner's wealth.

In contrast to the Kwakiutl examples, those of the Coast Salish are far simpler in form. Figure 12 is a post with a human figure on it from Quamichan Salish in Southeastern Vancouver Island. Figures 13 through 17 are posts with more complicated elements. Figure 13 is from Humdaspi village and

represents a grizzly bear in a protective stance, holding a human ancestor in its paws. The bottom figure is a human being holding a copper in each hand, the wealth associated with the lineage. The overall height is about 20 feet. Figure 14 by contrast is a beaver house post from Skedans, containing at the top a large eagle crest and a beaver crest below. Two small figures enmesh with the larger ones. Figures 15, 16, and 17 illustrate other types of interior house posts. The three are representative of the Tlingit, 15 being from Yakutat, 16 from Wrangell, and 17 from Klukwan. Part of the Wrangell post appears to be damaged, but all three depend less on three dimensional sculptural qualities and more on flatter, two dimensional rendering. Other Tlingit posts are, however, very sculptural (plate 44). Figure 17 represents the extreme length to which some posts were decorated. This one has conventions symbolizing the frog, more accurately a toad, now safeguarded within the Whale House. They are about 10 feet high and among the most highly prized examples of Tlingit art.

To the Tlingits the house posts were every bit as valuable and status-laden as the tallest exterior poles raised by their neighbors, the Haida or Tsimshian (Olson, 1967). The posts served as reminders to those who occupied the dwelling of their ancestral origins and lineage achievements.

Figure 9 Figure 10 Figure 11

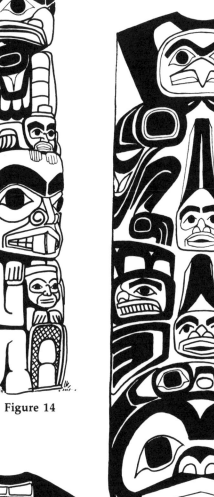

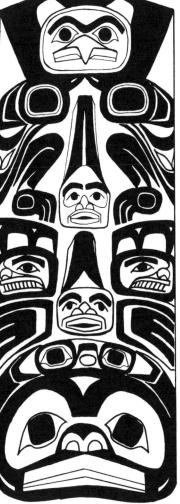

Figure 12

Figure 13

Figure 14

Figure 15

Figure 16

Figure 17

30

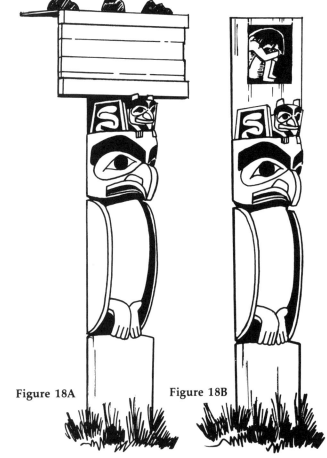

Figure 18A **Figure 18B**

They were the source of extraordinary pride and honor. Needless to say, the house posts also reminded guests and visitors of the backgrounds and achievements of the host family and as such were viewed not only with the highest regard but also envy.

Mortuary Poles: The differences between mortuary poles and memorial poles have been blurred, resulting from the sketchy and often inadequate understanding of some writers. Most authors have treated both types of poles as memorials that honor deceased leaders. This is largely true, but by this definition all poles—including those which depict clan legends and myths—were also memorials to ancestors and their past greatness. However, I believe there are substantial differences between these various pole types both in terms of form and function.

The mortuary poles in the forms we know them, historically at least, are a more recent development, appearing in their most complex form after the appearance of the simple memorial and interior house posts. They were tied to an improving economy resulting from the acceleration of wealth and goods flowing into the family coffers from trade with European and American fur companies. One way this wealth could be explicitly demonstrated was by commissioning carvers to create ever larger and more visually striking

columns to mark the site at which the symbol for accumulation of that wealth was interred. In contrast to memorial poles, the mortuary poles required an increased volume of sculpture requiring more figures, while remaining of roughly the same height. They were raised in front of the houses of their owners, following commemorative feasts to honor the dead. Most important, they functioned as repositories for interment, combining a crypt and tombstone, if you will. Memorial poles were not conceived to fulfill all these uses.

Among the Tlingit people the back side of mortuary poles, and the front side among the Haidas, contained a hollowed-out space or cavity at the top. Into these niches the ashes or physical remnants of the deceased were placed. If the leader's body had not been cremated, it was manipulated into a fetal position, wrapped in several layers of cedar bark mats, and laid in a box of cedar wood which in turn was set into the niche, as illustrated in figures 18A and 18B. These illustrations represent two views of a single mortuary column from Cumshewa village (plate 4). The crest design is that of an eagle surmounted by a small bear whose paws rest on the forehead of the eagle; its hind legs lock into the eagle's ears. Figure 18A shows the boards used to cover the cavity; 18B is with the boards removed. Usually boards covering the tops of memorial poles were weighted down with rocks so that heavy winds did not blow away the crypt's covering.

These poles shared another characteristic. They were often wider at the apex than at the base, in order to provide greater space for the crypt area. Note the width at the top of the pole in figure 21 in contrast to its base. Incidentally, only the elite members of the clan or lineage were buried in this manner.

How do we know the physical remains were placed into these hollowed receptacles? For one thing, the ethnographic data are explicit; another is observations from my personal experiences. When I visited Skedans and Cumshewa in 1948, I had literally to pick my way around a carnage of toppled mortuary columns in each place. There were human skeletal remains scattered from one end of the village to the other lying beneath these fallen monuments. Human skulls were strewn everywhere, a sight not easily forgotten.

If the deceased had been cremated the ashes were placed in a cedar box and left in the niche before fastening the board. Both types were covered with boards, one having an undecorated surface as illustrated in figures 18A and 19; the decorated type as seen in figures 20 and 21.

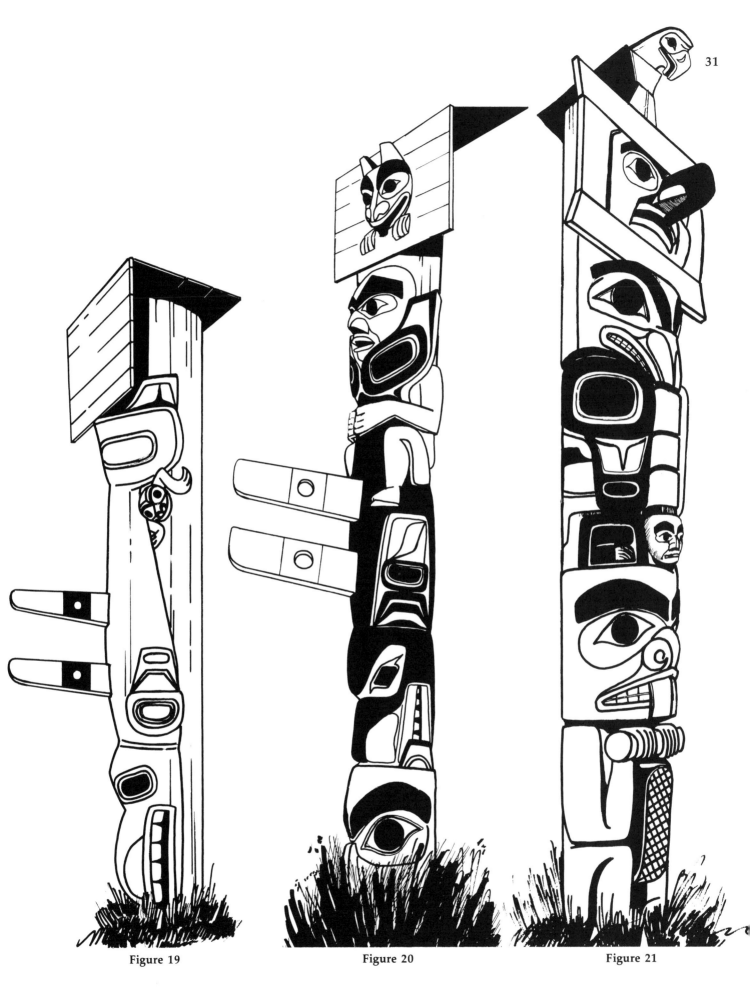

Figure 19 Figure 20 Figure 21

Several crests were prominently sculpted on mortuary poles, some of which illustrate myths associated with the deceased's ancestral backgrounds (fig. 20). A fine example from Tanu village (fig. 21) is covered with large figures representing an eagle perched at the top, followed by a large hawk's face (one author identifies it as a thunderbird) which covers the cavity, then a whale, and a beaver (bottom). It reveals the Haida mortuary practices at their best. The height of this pole is about 30 feet (see also plates 9, 30, 31). Figure 19, on the other hand, reveals a single vertical sculpture of a double-finned killer whale as it appears in a dive, its flukes high above the ground and just under the undecorated board that covers the cavity. A small frog partly obtrudes from beneath each fluke.

In addition to the single mortuary, the Haidas employed a second type which required the raising of two large poles placed fairly closely together and connected by a large box-like structure which bridged the poles at the top. Into this box the ashes of the deceased or the body itself were placed. There are few extant examples with carved surfaces of the elaborate scale seen in figure 21.

Mortuary poles have a more restricted geographic spread than the early prototype memorial poles. (Map #7) This might be accounted for in a number of ways; cultural resistance to taking over the custom of other tribes or the relative recency of its development. Among the Haida villages, such places as Skedans, Cumshewa, Ninstints, and Tanu, to name but a few, many mortuary poles are recorded. At Skedans alone there were 21 at the time it was abandoned, over one-third of the total number of columns known to have stood there. At Ninstints 26 of the 41 poles were mortuary types. This suggests continuous usage for many years. On the other hand, other Haida villages had few of them; at Yan 8 of 61 poles were mortuary types; at Kung, none; at Kiusta 3 out of 25; at Haina 4 of 29 poles.

Tlingit mortuary poles were also commonplace but according to Oberg (1973) the bodies of their deceased leaders were not placed into them, only their ashes. Tlingit poles were smaller, more slender, and did not display carved box-like covers as on the Haida poles. Figure 22 illustrates a Tlingit example from Tongass showing a large mammal over figures below it with limited surface carving. Figure 23 reproduces a mortuary pole standing in front of Chief Shakes' house at Wrangell. Notice the large dorsal fins on the killer whale at the top end, and the human figure, probably representing Notsilane, who created the killer whale people.

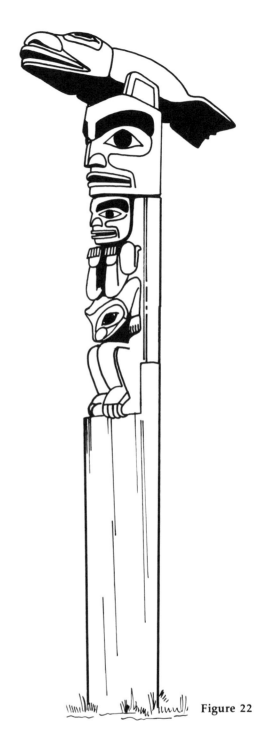

Figure 22

Figure 24A was recorded in the 1880s from Chief Kootenah's house at Tongass. Like the previous two mortuary poles, the niches made for holding the ashes are placed in the rear of the pole which faces the house. While this pole is not tall, it is very impressive indeed. The uppermost figure is an eagle crest, with a human figure below it, possibly representing the deceased chieftain. The lower horizontal figures located on each side of the pole rest on a slightly elevated scaffold and represent two killer whales, additional clan crests. The dorsal

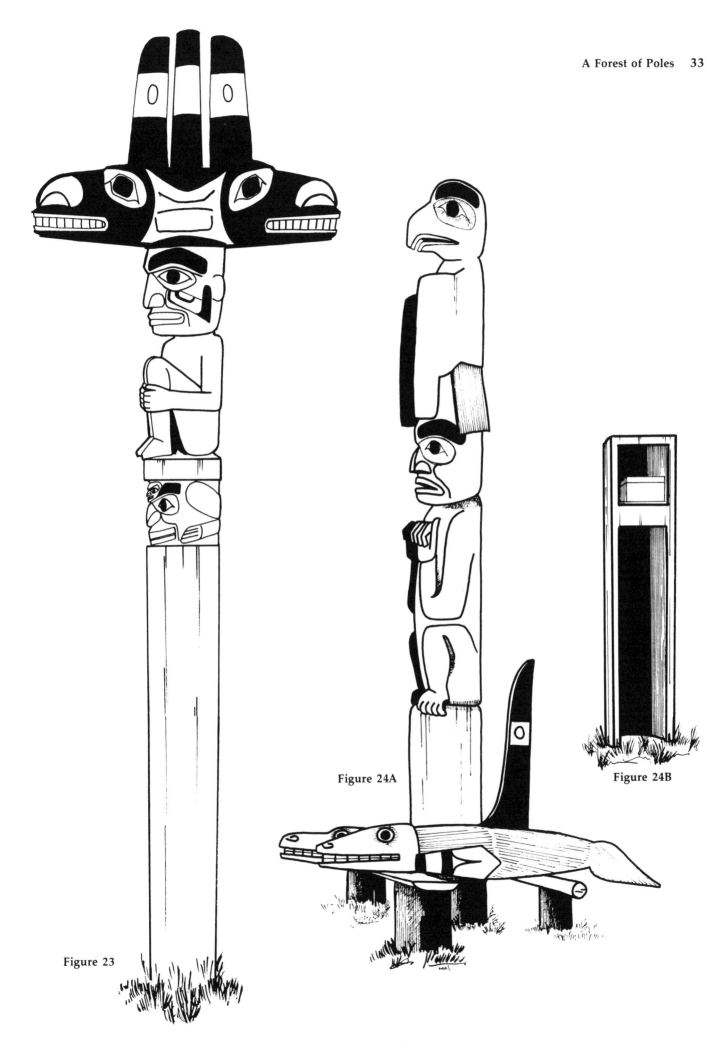

Figure 23

Figure 24A

Figure 24B

fin on one is clearly visible while that of the second is hidden behind the vertical shaft. Figure 24B, from an abandoned Alaskan site, shows the back side of such a pole with the niche in which the ashes were housed. Tlingit and Haida tribes used the mortuary pole far more frequently than other tribes of the Northwest Coast. The custom, while present among the Tsimshian, thins considerably and fades rapidly southward.

The Heraldic or Free-Standing Poles: At the approximate time these complex mortuary poles were developing into a common practice, other styles of poles were taking shape. Experiments in new ways to present social messages surfaced, all of which proclaimed ever more emphatically the prerogatives and status of various clans and lineages. One of the emerging styles was the heraldic pole which was larger than the prototypes heretofore used. The heraldic poles stood free from the houses, some many feet in front of them. They reached their apogee in the mid–19th century as more and more figures were added to poles of increasing heights and ever larger diameters (fig. 30, 34A). These are the poles Marius Barbeau identified as the "true totem pole." He further advanced the theory that the receipt of European iron tools led to the flowering of native carving on a monumental scale.

The heraldic poles became the story telling poles. Whereas the single crest pole announced to the public the deceased person's clan affiliations, the heraldic pole revealed much more. It proclaimed the creatures associated with the owner's mythological and historical past. It is in these poles we see the varied tales and momentous events recorded in cedar.

A variant of the heraldic pole, a fusion of the memorial and the emerging heraldic type, was a column with a single figure placed at the top (thus resembling a memorial column) and a single figure carved at the bottom. The intervening space was left uncarved or carved into evenly spaced geometric designs of uniform length. These variant poles suggest the acquisitions not only of new and better tools but also increased carving skills.

These latter poles occasionally contained niches for cremated ashes, thus also having a mortuary function. Some examples are seen in Tlingit poles in the southern area of Alaska. A few were raised by families who lost members of high rank through some accident or misfortune but whose bodies were not recovered; i.e., a drowned-at-sea person.

Figure 26 portrays a Kaigani pole of the variant type from Howkan, representing a grizzly bear at

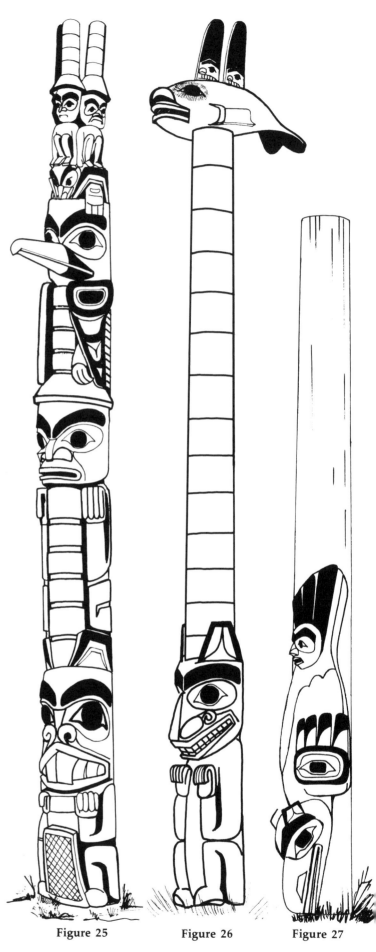

Figure 25 **Figure 26** **Figure 27**

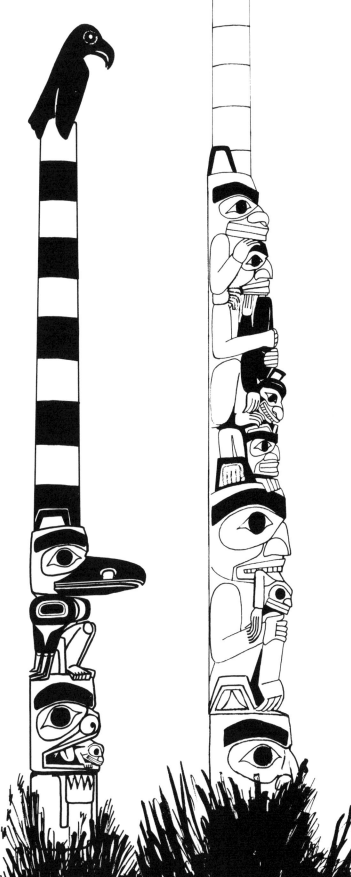

the base. A killer whale with two dorsal fins is the top figure. Figure 27 from the Tsimshian village of Kitkatla shows a diving raven, representing the culture hero in a mythological episode.

Early photographs from Haida and Tsimshian areas indicate that this type of pole was a common sight in settlements containing a melange of other poles. Likewise, they are found in the upper Skeena River villages and in Tlingit settlements adjacent to the Tsimshian and Haida neighbors. They were absent elsewhere.

At a later date the heraldic pole appeared as a trickle influencing the Kwakiutl tribes, then gained more acceptance. They spread to the Bella Coola valley and finally to some West Coast villages on the eve of the 20th century.

It is the heraldic pole that provides the basis for publicly displaying the ownership of important stories that deal with the respected ancestors. They are the poles that herald supernatural experiences associated with bird and animal kingdoms, with mixed marriages between ancestors and animals, superhuman achievements of power, and the acquisition of symbols of wealth which provide the basis for the descendants' notoriety or status. While these stories seem endless in their variety and complex in their symbolic associations of human kind and the rest of the animal kingdom, they were the fuel that fired their possessor's pride, spurring them to the competitive race for status that announced them the winners.

To provide a basis for further comparison between different heraldic poles, the reader is referred to figures 28 through 41. Figure 28 from Skidegate is a fine example with two figures at the bottom, the lower being a grizzly with a frog (toad) in its mouth, surmounted by a sitting raven. This is particularly interesting because the raven's beak, ears, and wings disclose its bird-like nature while its legs are without question human, complete with toes. This is not an uncommon way of representing mythological creatures, part-bird, part-human (see figure 79 for another example of this conversion). Raven is a culture hero of epic proportions, having magical powers of transformation. The upper half of the pole is a free geometrically divided space to the top figure, a perched eagle, its wings resting at its sides. Equally-spaced segments in the free space area are called skils.

Figure 29 is from Yan. The top portion is divided into a series of skils, followed by a grizzly holding another bear depicted as a human being who grips a third bear which faces downward on the pole. The large figure above the bottom figure appears to be human, holding a frog in its mouth.

Figure 28 **Figure 29**

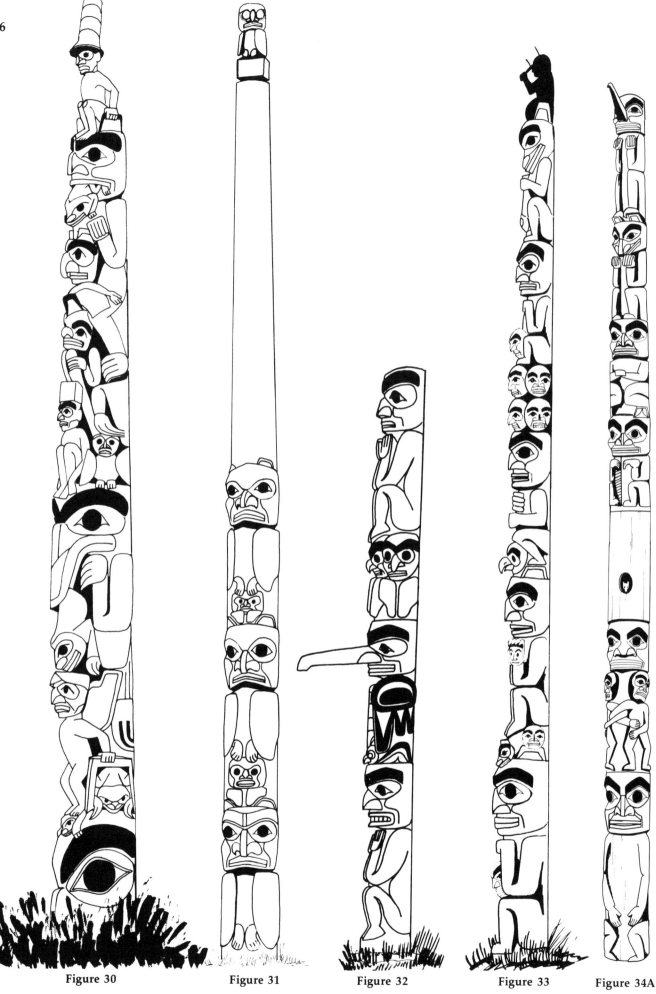

Figure 30 **Figure 31** **Figure 32** **Figure 33** **Figure 34A**

By virtue of this figure's ears, however, which are located at the top of its head, an animal is implied. Directly above the animal's head is another human face but with ears again placed at the top of its head, also indicates that an animal is intended. The bottom figure is so covered with underbrush as not to be distinguishable. The primary message associated with this pole is a story or series of stories associated with the family history.

In figure 30 we see a Kaigani pole from abandoned Kwa-anlas village. Here is one of the most complex poles I have recorded, yet the details are typically those associated with Haida heraldic art. It contains fifteen distinct figures and possibly more were the undergrowth not obliterating its base. Typical of Haida poles is the watchmen, the small human figures sitting at the top.

In contrast to Haida practices, Tsimshian poles, of which figure 31 is a good example, reveal another style. This one is from Kispiox located on the upper Skeena. The three lower figures are owls and are essentially duplicated one above the other, followed by free space much of the length of the upper portion. The top figure is another small owl standing on a symbolic mortuary box. It contrasts sharply with figure 30 in the lack of detailed surface sculpture and skils as well as the absence of a variety of figures. Figure 32 is from Gitlahdamsk on the Nass River and shows a style in which human figures predominate. They are portrayed in sitting position with open palms facing outward in front of the chest. The large beaked bird is mythological, the small eagle figures, three in number of which two can be clearly discerned, are additional crests related to the pole's story. The Nass region is of major importance because some of the finest as well as tallest poles in existence are found there.

In contrast to figure 31, figure 33 from the Nass is enormous, over 60 feet in height. The Nass was a frenetic center of heraldic carving in the mid–19th century—stimulated by Haida influences—a place where the tallest poles were seen. But it was a short-lived explosion. Scarcely fifty years later the custom disappeared entirely as the Tsimshian population—at least those surviving the ravages of introduced European diseases—converted to various Christian religious faiths. In figure 33 twenty-one different faces and figures can be counted in this remarkable example. Tall, extremely narrow for their height, and delicate in the arrangement of the figures, Nass River poles contrasted sharply with the massive diameters and intimidating volume of Haida production.

Figure 34A from Gitwinsilk village on the Nass is another Tsimshian example. In this excellent pole called "Bear's Den," human figures predominate. The second from the bottom figures are human, reproduced as a band, one on each side wrapped around much of the log's diameter. A roll-out illustration providing greater detail of this particular section is seen in figure 34B.

Figure 34B

The central part of its length is left in free space except for a small cavity (the bear's den) out of which a small bear cub's face appears—a delicate touch seemingly unique to the Tsimshian artists. The two top figures represent a bear and a mosquito. Since the undergrowth surrounding this pole was so dense at the time the photograph was taken, the lower portion of the bottom figure is rendered conjecturally.

Tlingit examples of heraldic poles are more uncommon—many of those that survived the vagaries of culture change were ultimately lost through a combination of time, zealotry, and neglect. Figure 35, however, shows two fine old poles that once graced the front of Chief Kadishan's house at Wrangell. Both eventually collapsed but were later copied and once more raised in front of the new house of his descendants (plate 20B). However, the quality and nuance of the originals were lost, as the copying left much to be desired. This is a common result when carvers attempt to replace masterpieces, as I will point out in more detail in Chapter VI. Figure 36 is a small heraldic pole typical of southern Tlingit types. It is from Tongass village and represents Bear Mother, a Tlingit woman who was carried away by a grizzly bear who became her husband. The two smaller figures are her children, the result of this supernatural union.

In contrast to the northern tribes, heraldic poles among the Kwakiutl were initially more crudely carved. It was as if the craftsmen were groping with the various elements of design they had seen elsewhere but had not yet fully mastered. These early forms represented human and animal figures in simple juxtaposition, one above the other. Figures

37 and 38 are valuable examples because they are from Tzawatti village and are dated in the mid–1870s. Figure 37 is a shaft with three quarters of its height in free space, as is found in memorial columns. The figure next to the top is a squatting human and may have a caricatured significance. The top figure arrests our attention because it represents a standing male wearing Western type clothing including a black derby hat. While the pole was probably raised to commemorate some significant event that occurred here it is more than likely lampooning a foreigner.

Figure 38 is in excess of 50 feet in height, judging from the surroundings in the photograph from which the illustration is taken. Two lower figures are Kwakiutl chieftains holding coppers (the lowest figure is not outlined clearly because of obstructions in the photograph). They hold shield-like objects that represent coppers which symbolize family wealth. The same chieftain is rendered perhaps twice as is often seen in some Tsimshian poles. The top figures are mythological, the young thunderbird or Kolos at the top and the spirit or Ogress of the Forest below. Later heraldic poles reveal superior sophistication in the handling of this vertical space.

Examples 39 and 40 reflect this increasing preoccupation with heraldic poles and the enhanced skills associated with carving them, particularly in the period just prior to the turn of the 20th century. In figure 39 from Alert Bay village a large human face (an island?) is seen at the base while the greatest length is centered on a diving blackfish with a laid-back dorsal fin and prominent ventral fins. The flukes are held in the talons of the thunderbird whose outstretched wings give a sense of powerful flight. Figure 40 is from Kalokwis and is a more complex treatment of the total space, in sharp contrast to those from Tzawatti. From the wide base the pole narrows dramatically to the topmost figure which represents a hawk. Below it is a human figure biting the tail of a wolf below, which in turn is biting the flukes of a blackfish. Below the blackfish or whale are grizzly bear, eagle, and a human. The latter possibly represents the founding ancestor.

We conclude our review of heraldic poles with one example from the Bella Coola area. These people carved few poles. Those extant represent a style quite divergent from their coastal neighbors. Poles are short, less sculptural, more squat in appearance (fig. 41). Notice the crude rendering of the watchman at the top, which, in size is incongruous relative to the ponderous portrayals of raven and humans below it. Bella Coolas preferred

Figure 35 Figure 36

Figure 37 Figure 38 Figure 39 Figure 40 Figure 41

house frontal poles to heraldic types; at least many more frontal poles were present in their villages when the early photographers visited.

The function of heraldic poles was primarily social. They were concrete reminders of the social standing of the families who paid mightily to raise them. Unlike other type poles raised at potlatches, heraldic poles took a year or more to carve because of their great size and complexity of surface designs. They therefore required a great deal of wealth to commission and additional large expenditures to celebrate the occasion of their being raised. They are the myth or story telling poles and commemorate events of signal importance to the lineages who claimed them.

House Frontal Poles: Another category of totem pole which I believe emerged and flowered during the period of the rapid changes of the Golden Age is house frontal poles. These stood flush against the front of important houses rather than several feet in front or to one side of them as did the heraldic poles. Not just any family in a village had one. Both heraldic poles and house frontal poles prominently displayed crests belonging to illustrious owners but the latter stood framing the doorway to the house. The houses which could mount frontal poles often had their primary ceremonial entrance through the large portal located in the base of the pole (plates 32, 33, and 45). If no entry was carved into it, the pole was set to one side of the front of the house supplemented by a European style swinging doorway. One writer suggests, that the portal pole was earlier than the pole placed to the side of the entry. The hollowed out portal of the entry pole considerably weakened the strength of the log so that an enormous log was a necessary prerequisite to designing and installing it. The house frontal was conceived as being a part of the house structure itself so they were erected fully carved at the time the house was being built.

The tallest, broadest, most numerous, but not to say the finest examples of totem poles are seen in house frontal poles. The finest anywhere were those in the Haida villages, the early masters of this type. House frontals were commonplace in village after village within the Queen Charlotte Islands. Some of the best examples, salvaged for museums, reveal their imposing heights and detailed surface sculptural treatment. On the other hand, very few frontal poles appear among the neighboring Tlingit; the most widely photographed example is at Totem Bight village near Ketchikan. There are a few other examples among the Tsimshian groups but they are nowhere as common as those found among the Haidas. There is an artist's sketch of three house frontals standing side by side at Fort Simpson around 1860.

Let us look at a few outstanding examples. Figure 42A is a Haida frontal now preserved in the rotunda of the National Museum of Man, Ottawa, Canada. It is from Haina village where many colossal poles once stood. It is a masterpiece. The lower figure is identified as a grizzly bear whose belly is split open forming the entry into the house. Figure 42B is the detail of the house portal to enable adults to pass through the doorway to the house interior. The grizzly is surmounted by six skils which rise one above the other over its head almost the length of the second figure. This is a human form con-

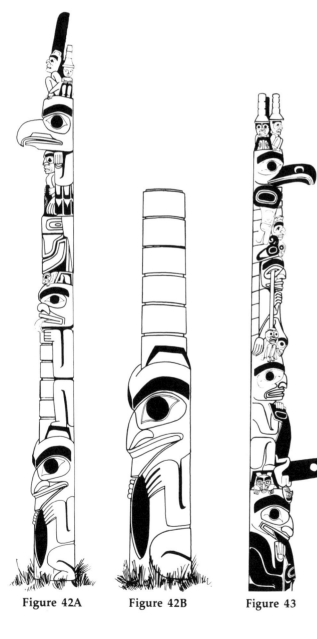

Figure 42A Figure 42B Figure 43

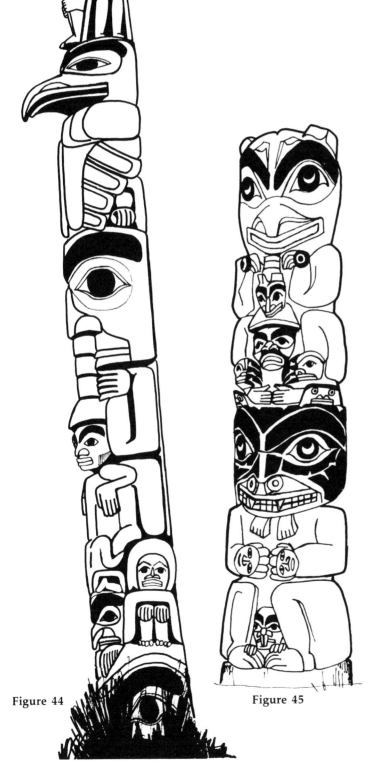

stituting part of the story associated with the pole. Above the story figure's forehead sits a small frog. This giant pole culminates in a dominant eagle form with large projecting beak. The arms enfold a smaller figure which grasps a dorsal fin. Two watchmen sit at the top, one to each side of the pole but separated from each other by a large central human figure, a third watchman, from whose head projects a prominent dorsal fin.

Figure 43 is a classic house frontal pole from Tanu (plates 7 and 50) and is one of the finest in existence. My first acquaintence with it was by way of a story then said to be associated with a mythological figure called Weeping Woman. The central figure, a woman, holds a large frog in her hands, reportedly one of her children, whose face points down the pole. From each of her eyes a long narrow shaft descends paralleling the frog and culminating in small human-like figures wearing doleful expressions. These represent her tears. The knees on these tiny figures are drawn up to their chins. The base is a sea grizzly bear devouring a sea mammal head first. The composition of this pole is made extremely complex through the small creatures which appear from ears, as well as from spaces below the eagle located below the watchmen figures. Each of the watchmen wear potlatch hats with three skils.

Figure 44 from Kaisun village is partly obscured by heavy brush so many details are not visible. The central figure here is a human wearing a hat with skils attached which reach to the nose of the large human figure behind them. Three watchmen are perched above the large eagle figure, each with hats containing skils. Notice the feathered wings of the eagle as well as the figures tucked between the ears of the lower figure.

In contrast to the abundant Haida frontal poles, Coast Tsimshian utilized few of them nor did those they carved have the diameter of Haida poles although they were of comparable heights. Figure 45, from Harvard's Peabody Museum, is of considerable diameter but unusually short. I suspect this example is a section of the original, having been cut into several parts in order to display in the room of the museum. It, however, does not have a portal and was therefore probably placed to the side of the house entry. Both figures represent grizzlies, but notice how the front paws of the lower figure and the hind paws of the second figure are depicted with faces. This is a characteristic often seen with greater frequency on Haida poles. I therefore suspect the influence was stemming from the Haida to the Tsimshian and not the other way around.

Figure 44

Figure 45

Southward, house frontals appear among the Northern Kwakiutl and are among the best surviving objects of their size. Figure 46 from Katit village represents a large cannibal raven, a mythological figure and important crest. It is associated with men's social sodalities. The figure dominates the entire pole. The entry forms the mouth of a figure below which is not easily identifiable. The owner of the Katit frontal went to further lengths by adding the vertical wood sculpture that supports the projecting beak of the raven. It is a human figure wearing Western clothing including a tall hat and also a facial beard. His hands are in the pockets. He stands on the head of an upright, very alert-looking bear. This sculpture must have been a visitor's eye-stopper in its time.

Figure 47 from Bella Bella village is similar to 46 and an excellent example of late 19th century Kwakiutl frontal poles. But it differs in size and diameter as well as ingenuity from the famed Chief Wakius pole located at Alert Bay (fig. 48A). The base of the latter huge house frontal is a raven whose massive beak opened and closed by means of ropes manipulating the beak from inside the house. When the beak is opened it reveals a portal which leads into the house (fig. 48B). Entering the residence of so powerful a person was both a humbling experience and an acknowledgment of its owner's social rank. The figures above the raven are grizzly bear, cannibal raven, a human, wolf, killer whale, and thunderbird—all family crests.

Figure 46

Figure 47

Figure 48C

Figure 48B

Figure 48A

Figure 48C is still another striking house frontal from Gwayasdums called the sea monster house.

Other examples that follow come from the Bella Coola villages. Figures 49, 50, and 51 (see also plates 27 and 28), are small compared with the Haida examples. Bella Coola designs are not well integrated into the space available as in the manner of Haida or Tsimshian poles. The base of figure 49, which is from Komkotes village, is a large bear whose belly forms the portal into the house. Above it is a sun symbol and an eagle with bird figures bordering its sides and sculptured in low relief. A human figure framed by two land otters is located at the apex with an appendage resembling a lightning serpent's head. Figure 50, also from Komkotes, combines a delicate—almost fragile—standing figure (a watchman?) with a ponderous, almost bloated-looking face below it. A raven with a large projecting beak stands at the bottom, above the portal space. Figure 51 is somewhat more elaborate than number 50 and comes from Talio. The portal is in the form of a gigantic open mouth of an unidentified face, surmounted by two promi-

nent faces, the topmost being with a projecting straight beak. There are a series of geometric lines emanating from the lower mouth to each side of the pole. The topmost figure of this unusual pole appears to be a raven standing on a large round disk which represents the sun. The Bella Coola frontals are a far cry from the smooth-flowing, interlocking, integration of large and small forms of the Haidas.

Other Vertical Sculptures: While all the above types of poles command our attention we should be cognizant of a secondary group of columns often mistakenly identified as totem poles.

Among them are grave markers. They are carved from cedar logs 10 to 12 feet in height and placed by the graves of those recently buried (fig. 52 and 53). Since native custom did not include

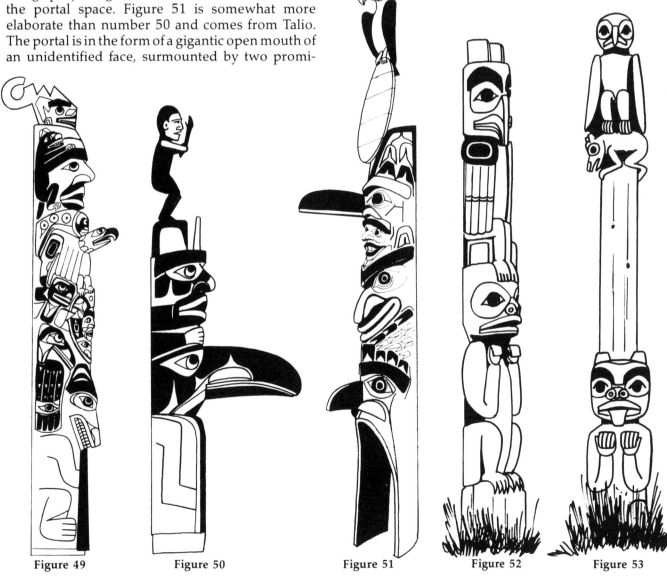

Figure 49 Figure 50 Figure 51 Figure 52 Figure 53

ground burials until after the arrival of Europeans, these markers appear to be a continuation of an ancient practice modified to new circumstances. The old carved figures are placed beside the deceased who are buried according to Christian practice in a particular section of land designated as a cemetery. The columns are smaller both in size and number of figures carved, most frequently they contain one or two—rarely three or more—figures. A few Tlingit groups in Alaska who carved no totem poles did use such markers. The people from Tuxikan village, for example, once had over 125 grave markers dotting their graveyard sites prior to its abandonment in 1916 (plate 37). Some of these were later salvaged, copied, and set up in a non-Indian setting, the public park in Klawak.

Another type of wood figure approximating life size was utilized by the Kwakiutl tribes and the West Coast people for social and ceremonial purposes. These are the so-called potlatch or welcome figures. They represent the host, or professional speakers acting on his behalf, welcoming guests to the ceremonies. They might be in either friendly, caricatured, or intimidating stances, sometimes even belittling guests that arrive. Figure 54 is a chief of Kingcome village speaking to his guests at a potlatch. The hands at the mouth emphasize his welcoming speech (see fig. 88B). Figure 55 is a larger-than-life portrayal of the Tzonoqua, the Forest Ogress, also representing an important family crest, in the act of welcoming guests. Such examples are far more characteristic of the central Northwest Coast tribes than of those living to the north of them.

To sum up, we see all five types of totem poles—memorial, house posts, mortuary, heraldic, and house frontals—utilized among the Haidas in the 19th century. Not only were they present in all the villages, but were deeply entrenched in most of them as integral manifestations of the culture. This fact further suggests that their use was rooted in greater antiquity than other coastal tribes. Among the Tsimshian, for example, we see all five types in only a few villages and in far fewer numbers, with the exception of a few villages along the lower Nass River. The Tsimshian exhibited a decided preference for only two types of poles—the heraldic and memorial poles. In other words, regional preferences were established early and often prevailed throughout the 19th century.

Among the Tlingit tribes, on the other hand, far fewer exterior columns were raised. The southernmost Tlingit utilized some columns for memorial or mortuary purposes, still fewer of the heraldic or frontal poles. House posts, of course, were the most

widespread column found and seemed to have been extensively found in every Tlingit group. Three of the five types of totem poles were used in moderate numbers among the southern Tlingit: house posts, memorial, and mortuary poles with a scattering of heraldic types. Olson (1967) has pointed out that the Tlingit considered all poles to have a mortuary function.

Among the southern tribes no poles were used in the 1850s and 60s while a few appear sporadically in the 1870s, attesting to the emergence of a new practice among them. Most tribes in the southern areas seemed to utilize interior house posts and for considerable periods earlier. Later influences brought the heraldic, house frontal, and memorial types so that by the 1890s and early 1900s they were appearing in ever-increasing numbers. The Haida mortuary type poles never took hold among the Kwakiutl. Rather, the people practiced tree burials, securing the boxes containing the deceased high in limbs of sturdy cedar trees. Gradually, under Christian influences, this custom was displaced in favor of ground burials with combination memorial and heraldic poles raised beside them.

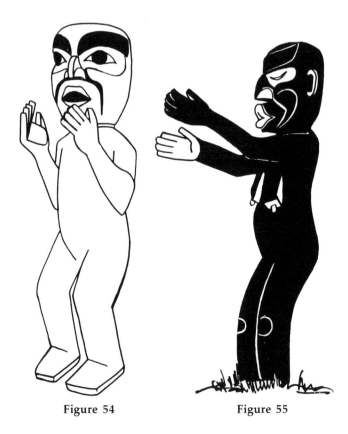

Figure 54 Figure 55

THE SUBJECT MATTER ON POLES

By this time the reader has been exposed to a bewildering variety of forms and symbols in totemic art. The figures were, however, not randomly chosen by the people for inclusion into the columns they raised. Each family had to have specific rights to each of the symbols employed, acquired by an involved set of rules governing such acquisitions, and duly validated by way of a series of social obligations witnessed by the tribe and outsiders alike.

The primary symbols served as references to episodes in a lineage or clan's history as well as their myths and stories which were integral parts of their heritage. Symbols depicted culture heroes as well as early ancestors who may have been human beings but might also have been members of the animal order. Animals and birds played important roles as benefactors and founders of the group, and were utilized in the crests of many families. Crests and their symbols were also exchanged through generations of alliances, payments of indemnities for wrongs done, and intermarriage.

Each tribe along the Northwest Coast developed its own style of rendering as well as placement of symbols on the columns. Some areas preferred animal forms to human depictions, others emphasizing the supernatural rather than the mundane world. The subject matter on the poles can be dissected into more specific elements which enable us to examine in a manner more comprehensive and with better perspective the richness of the people's vision of their universe. The illustrations that follow focus attention on the little details that otherwise might be missed when examining the columns in their entirety.

The native ethos centered on the importance of the past with heavy emphasis on the Mythic Era at the time the earth was created and the peopling of its various regions. In contrast to our Western notions of focusing on the future, their perceptions emphasized the ties with the generations that preceded them and the historic events associated with them. Animals and birds were equated with human beings in this world order. All creatures within it were viewed as being on an equal footing with humankind rather than occupying lower rungs of the developmental order. More importantly, animals and birds were considered by the people to have human counterparts. There were killer whale people, grizzly bear people, wolf people, even salmon people. In order to grasp a dimension of this perception I will focus on the distinguishing elements of these creatures who peopled this environment. The reader can better appreciate their significance and more easily identify them when viewing the poles.

The most commonly depicted creatures were in themselves symbols of tribal lineages, clans, or even larger units into which most members were divided by birth. As crests these symbols became rallying points to which the members of a group pledged their loyalty and allegiance. Among the foremost crest symbols was the raven, the large, black impressive bird of the northlands. As a mythical character, Raven was portrayed as a male. He usually stood upright in posture with a large straight beak coming to a point, with wings kept at the sides as seen in figure 56. Occasionally he was also shown in a diving position as in figure 27. Regardless of the posture or surface decorations on wings, tail feathers, or legs, the beak provided the identification.

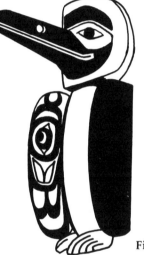

Figure 56

By contrast, the eagle, another major crest, might have identical characteristics to the raven except for the beak shape. The eagle's beak has a sharp curve culminating in a point and turning back to the face. Like the raven, it too may have ear appendages (fig. 57A, B, and C). The thunder bird, in contrast, was portrayed as a larger eagle with outstretched wings, large beak, and large ears which often resemble horns.

Among the land creatures the most important family crests include the grizzly bear, the wolf, beaver, and frog. The grizzly is easily identified by the short snout, its large mouth often widely or partly open with sharp or rounded teeth, small ears and tail, an occasional placid rather than fierce countenance, and long, narrow tongue projecting downward from the mouth. Figure 58 shows an upright grizzly biting a frog which it holds in its paws.

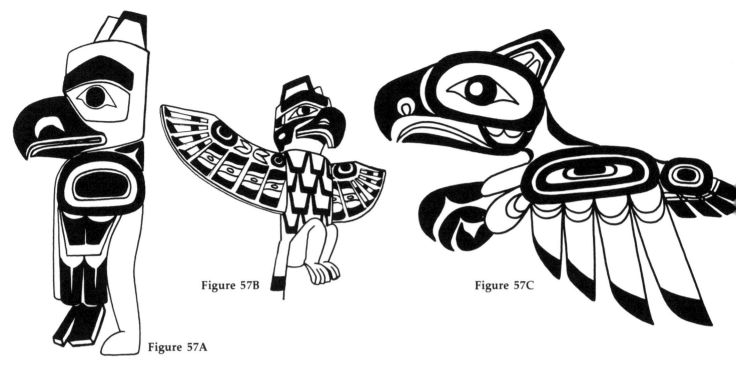

Figure 57B

Figure 57C

Figure 57A

A wolf appears similar to a grizzly but is portrayed as thinner in form with a longer but more narrow snout with sharply pointed or rounded teeth. Its ears are long and slender as is the tail. The limbs also are less robust in contrast to the bear's legs as seen in figure 59.

The beaver is one of the easiest crest figures to recognize. It is always in an upright stance with paws holding a stick. The mouth is large with prominent teeth, the largest being the two front or incisors. The tail rests on the abdomen and is cross hatched. Occasionally another face appears on the tail combined with crosshatching. Figures 60 A and B catch these characteristics as well as the small hat with skils attached that often is shown between the beaver's prominent ears.

Frogs are among the most common symbols on poles both as crests and story figures. They also serve as space fillers in the assorted crevices and corners of a composition. They are easy to identify by their broad toothless mouths, big eyes, crouched position, and pleasant countenance as in figure 61. They invariably look out from a position or downward on totem poles, an example being the diving frog in figure 62A which reflects a particular Tsimshian tale. There are also flying frogs as in figure 62B.

Sea mammals reflect the mystery and power of the many awesome creatures from beneath the ocean surface with which the natives were on such long-term familiarity. Foremost among them was the whale 'sometimes called the blackfish' and killer whales. Both appear very similar except for

Figure 58

some subtle differences. The whale had a flat face with rounded teeth, a modest dorsal fin and prominent flukes, a circular hole above the forehead representing its blow hole was often rendered as a small human-like face. Its countenance was seldom fierce. In contrast to the whale, however, the killer whale had fiercer features with sharp teeth, a prominent dorsal fin projecting high above its back, large flukes and a prominent blow hole. Figures 63 and 64 highlight these characteristics.

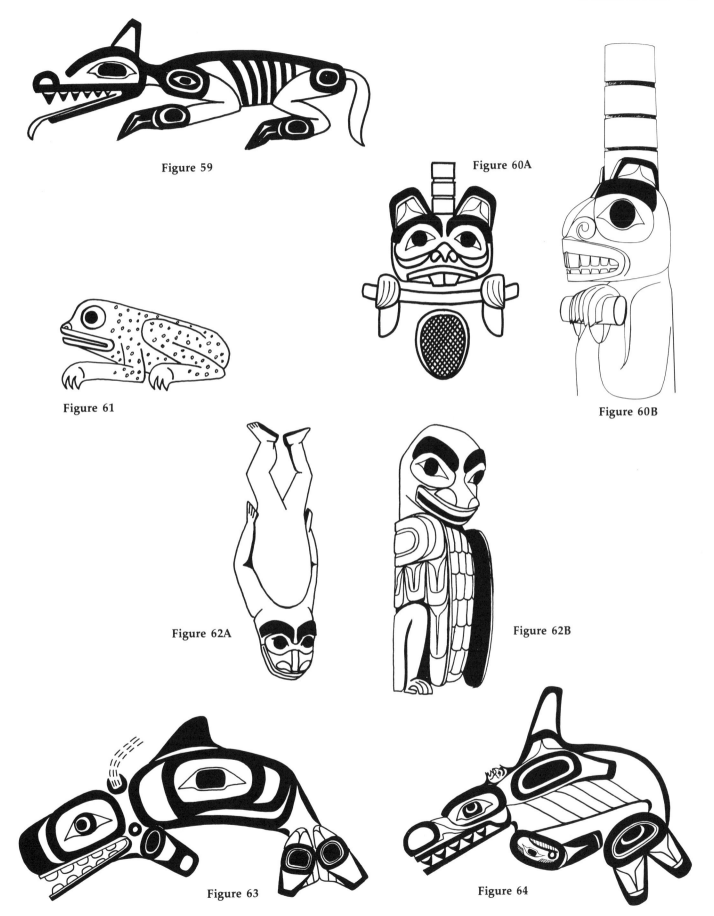

Figure 59

Figure 60A

Figure 60B

Figure 61

Figure 62A

Figure 62B

Figure 63

Figure 64

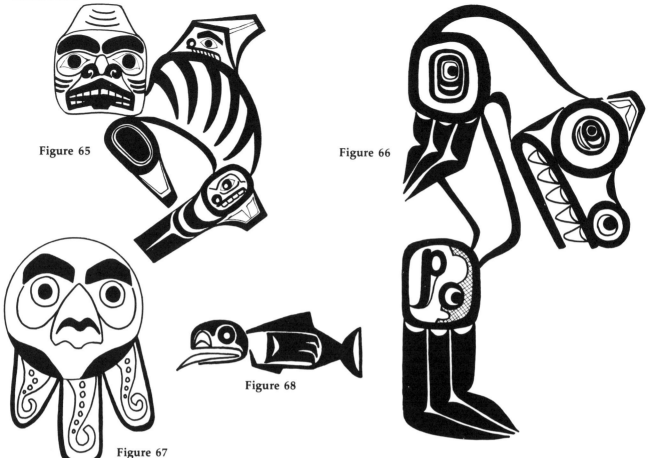

Figure 65

Figure 66

Figure 68

Figure 67

Another sea denizen that is occasionally encountered was the shark or dogfish. Its fierce look was accentuated by its sharply turned down mouth with teeth, the series of gill slits on each cheek, the vaulted forehead, and prominent dorsal fin, unmistakable characteristics. Figure 65 is a stylized example. Sharks, like the preceding illustrated crests, play a part in the iconography as story characters.

The grizzlies, wolves, and eagles also have sea counterparts in mythology. They can frequently be recognized by the familiar characteristics plus a large dorsal fin for grizzly and wolf and flippers for hind legs. The sea eagle while possibly having a dorsal fin may not have other traits easily identifiable.

Other crest symbols or story figures are encountered in a secondary series of creatures, no less important but more rare than those previously described. Among them are sea creatures, sky creatures, and inhabitants of the mountain environs. Among the sea creatures are the seal or sea lion with short, flat snout, prominent flippers instead of wings or limbs, teeth that may be rounded, and small ears. They are not crests but will frequently be seen on poles as a part of a story (fig. 66). The octopus (fig. 67) is easily recognizable by the

dangling tentacles and sucker cups although the round face may be rendered near human rather than animal-like.

Salmon are not rare on totem poles and several examples are included throughout the illustrations in this volume (fig. 68; also 108, 127; plate 19). Since it is the most important fish of the Northwest Coast it hardly would come as a surprise that it plays an important role in the mythologies of the people. In fact there is hardly a story in which this remarkable creature does not have a role to play albeit usually one designed to satiate another's appetite. Occasionally salmon are portrayed with the beings with whom they are associated in stories.

The sea otter is another story figure rather than a crest. It has features similar to a wolf but smaller in scale. Its hind limbs are flippers rather than legs. Sea otter are not encountered often on poles but are easily recognizable (fig. 69).

Its counterpart in the sea is the sculpin (fig. 70), a spiny, unattractive-looking fish which may represent a crest for some groups in the north, otherwise usually equated with undesirable qualities. These scaly, rock-bottom creatures may be prized as food for some fishermen but they are viewed with disdain by the natives.

Some artists may combine two sea creatures into a composition as seen in figure 71, that of a sea lion holding a sculpin by its tail. A hidden message is implicitly stated here, the sea lion being a symbol of tremendous wealth because of its food potential, the sculpin inedible as well as prickly and dangerous.

Among the sky creatures in this category are numerous birds and insects, including the mosquito and dragonfly, as well as the sun and moon. Hawks probably are the most commonly rendered of this group, sometimes as filler spaces but more often as a crest design. They frequently decorate the front part of Haida mortuary poles. Aside from being much smaller than the birds described previously, their beaks project outwardly only in a modest way then turn back sharply to touch the upper lip or mouth. They may have small ears attached to the head (fig. 72).

The mosquito has small wings, a long, narrow nose, occasionally a fierce look about it (fig. 73). The dragonfly on the other hand has a broad face with big eyes and wide mouth with no teeth. It has patterned wings which are attached to a segmented body and a diminuitive tail. Small arms may appear from under the face (fig. 74A). The stylizations do not always conform to the rules as seen in figures 74B and C. The dragonfly on a colossal 81 foot totem pole from the Nass is seen as one of many figures. The example depicts the commemoration

of a deceased leader named Mountain Chief. This crest has a human face with a long nose and seven small faces that surround it on three sides, as in a halo. According to Barbeau, who collected it, the faces represent the chief's clan headdress that he wore at potlatches and other ceremonial occasions.

The cormorant and crane may infrequently appear as story figures rather than crests but it is extremely difficult to distinguish them from the raven (fig. 75). To do so requires the viewer to have some knowledge of the story before being able to decipher the symbol. Another bird, the owl, is rarely seen on poles. The exception, to my knowledge, are those at Kispiox village on the Skeena River. One reason may be the owl's association in the natives' mind with the coming of death and was, therefore, a foreboding and avoided. Why Kispiox is the exception I do not know.

Sun and moon occur as symbols in mythology but a rendering is easily recognized. The sun usually has a human face with a sharply curved hawk-type beak coming back to the face, together with five or seven rays which project from all sides, as seen in figure 76. The moon is shown as a halo with a human face or figure sitting within a circle (fig. 77). Both sun and moon are occasionally found as lineage crests and story figures on poles.

Among terrestrial creatures that are crest symbols or story figures the mountain goat is

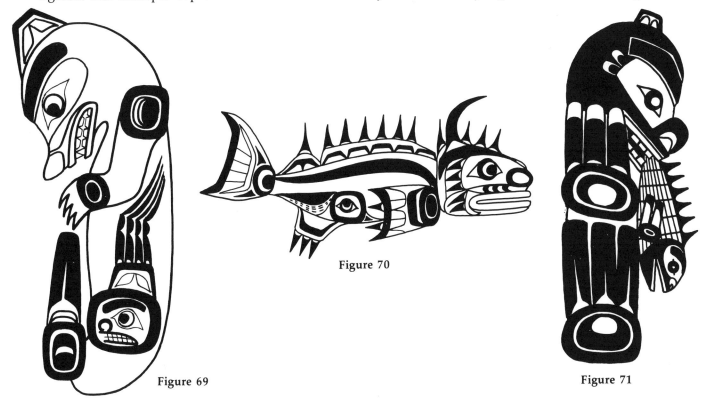

Figure 69

Figure 70

Figure 71

prominent. A one-horned goat recalls a creature in a cataclysmic upheaval during the Mythic Age while the two-horned goat represents the crest of some lineages in the northern area. The cloven hoofs easily distinguish it from either wolf or bear (fig. 78A and B).

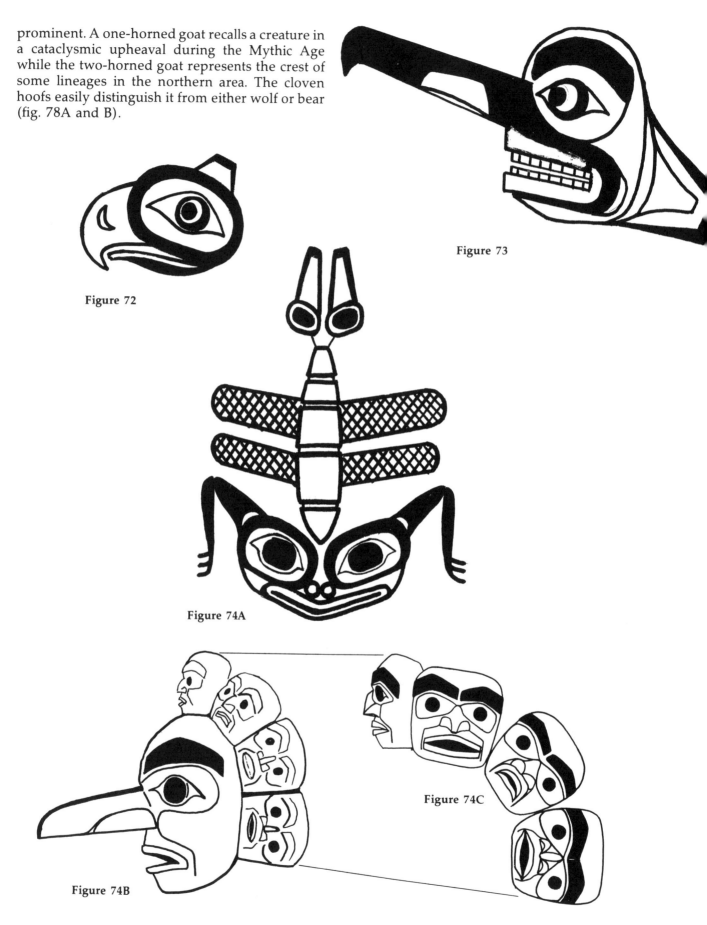

Figure 73

Figure 72

Figure 74A

Figure 74B

Figure 74C

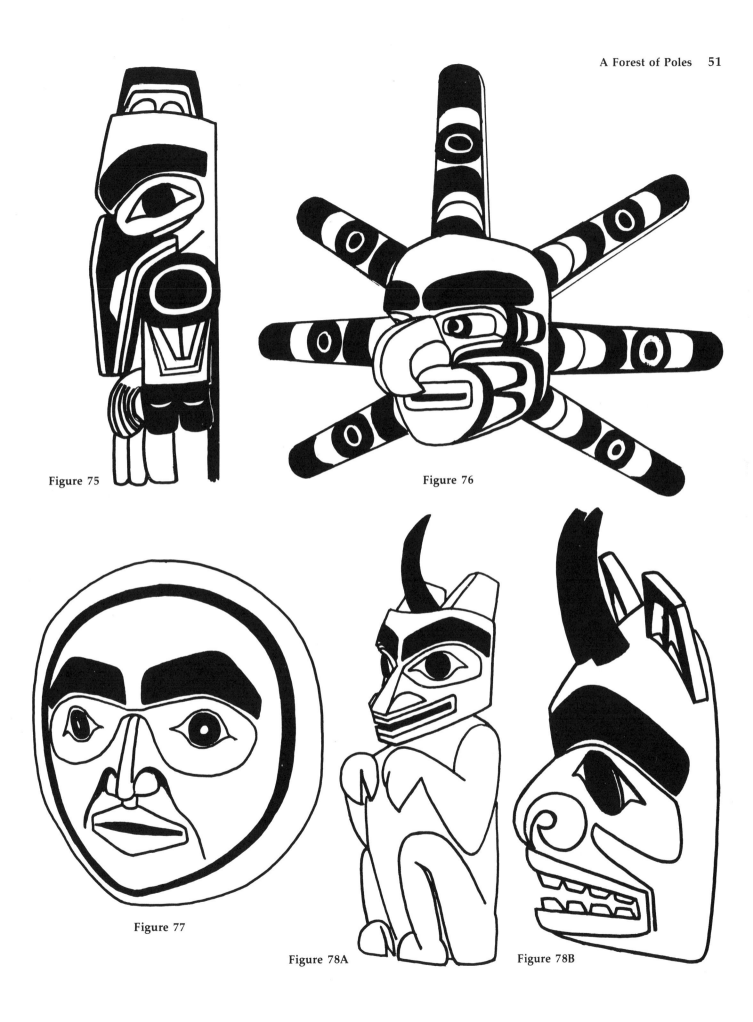

Figure 75

Figure 76

Figure 77

Figure 78A

Figure 78B

Human Beings: Humans may be depicted with animal or bird characteristics, while birds and animals may be given distinctly human features including faces, limbs, fingers, and toes as seen in figure 79. This shows raven with bird wings, holding his beak in his hands which reveal the digits and the feet which reveal the toes. They may have animal or bird faces but human bodies, or it may be the other way around. Creatures can and often do change their forms because they occurred in this state during the magical age of the past when it was possible to do such things. They had powers of transformation. An eagle, then, might also appear in human form.

Humans may be shown with arms and legs whereas the bird in the human form may have wings while the inner parts of the wing may disclose human-like hands; human legs rather than bird-like legs are seen in figure 80. Animals have four limbs with the forelimbs being human, the hind limbs animal-like with clearly distinguishable claws. Animals have either a short or long snout and ears are placed at the top of their heads. Birds are given prominent beaks, the shape depending on the species.

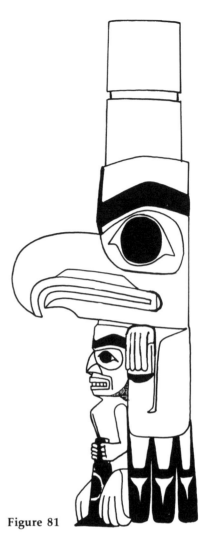

Figure 81

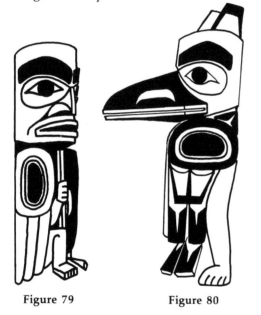

Figure 79 **Figure 80**

Figure 82

A human face may have a set of ears at the sides or no ears at all but a blow hole on its forehead indicating it represents a whale rather than a human. A fin may cross the chest of a figure. Wings may be attached at the elbows to an otherwise human form, or the other way around. A birdlike creature with human hands having wing feathers attached from the elbow to the upper arms is pictured in figure 81. The talons may be those of a bird or they may be human fingers.

In addition, animal and bird benefactors are frequently depicted as human beings. Regardless of the creature, they are often given human postures—sitting, squatting, or standing. They are never depicted lying down but occasionally shown head first down the pole.

Rarely is a figure placed in a kneeling position. The humans are devoid of clothing. Male figures are far more common than female though little attention was paid to the obvious sexual dif-

ferences. One typical exception is the Forest Ogress, Tzonoqua, whose pendulous breasts are one of her trademarks. Human figures range in size from single forms eight to ten feet in height to those broken down into small groupings a foot or more high, such as the alternating bands of figures—3, 4, or even 5 in number—which are spread out around the diameter of a pole as seen in the roll-out example, figure 82, about a foot in length.

A whale may represent the mammal or an ancestor who founded the traditional village at the time he was a whale and not a human. The raven may represent the culture hero who, as a bene-factor of mankind, created the universe, or he could be raven the crest symbol of the leader of a clan or groupings of clans.

A human figure may represent an ancestor or a character from mythology who played a vital role in the origins of a particular group. One figure may represent the ocean; another that of a rocky island where the action involving the ancestor takes place; a third connotes a being called Cedar Bark Man who created the bark used for the sacred winter dances; still another, a rival chieftain holding his belly in pain from the enormous amounts of food distributed at a rival's potlatch. With our present understanding of the Northwest Coast myths, figures with human forms may not be identifiable.

The knees in humans, animals, or birds are frequently flattened as in figures 83 and 88B. To assist the reader in determining the creature intended it helps to look at the posture to recognize elements therein, then at other elements of physiognomy, determining whether they are specific features of this world or supernatural world inhabitants.

Faces: The appropriate faces—snouts for animals, beaks for birds, squashed-in faces with blow-holes on the foreheads for mammals—also have prominent nostrils, full curved eyebrows, mouths with developed lips, and, with the exception of the mammals, prominent ears. Eyebrows—the major shapes of which are seen in figure 84—are provided for every creature including inanimate objects that are rendered in tangible form.

Figure 84

Ears are important indicators and both animals and birds have them, but they are shorter in bears and beavers than in wolves, whose ears are long and slender. Extremely long ears culminating at the top in a spiral-like twist—almost a horn—are

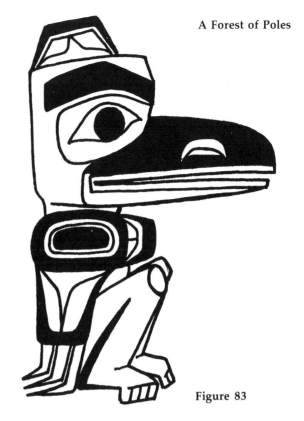

Figure 83

reserved for a thunderbird or some very special eagle character. They symbolize the extra-ordinary auditory powers of those creatures. If the figure is intended to be human, the ears are placed at both sides of the face; if animal they are located at the top of the head. In order to depict a creature's dual nature, a subject may be given two pairs of ears, human and animal. Ears are not only devices for auditory needs but also enhance decorative space within the ear itself. Among the northern styles in particular, ears are filled with many different creatures which seem to emerge from them—tiny bears, little frogs, charming, sitting or standing human figures with carefully defined arms and hands with fingers; occasionally their bodies and lower limbs are also added in such restricted space (fig. 85 A, B, and C).

Figure 85A Figure 85B Figure 85C

The type of eyes given the figures will vary from tribal groups in the north to those residing southward. In the north eyes may be large, rounded forms, with very large pupils carved in a plane that gives the viewer the impression the figure is looking directly down at him. Other areas such as the Kwakutl region reveal smaller eyes,

rendered as a flat surface, with a great deal of color surrounding it. Occasionally, another face emerges from within the socket, a face within the eye, peering out from, or just over the rim of, the lower lid, as seen in figure 86A.

Other eye shapes that will appear on creatures ranging from humans to supernatural beings include but a few of the following: 86B, a salmon-eye design, or ovoids in black as in figure 86C, or painted eye designs as in 86D, E and F.

Figure 86A

B

C

D

E

F

Mouths: In human beings the mouth is animated and expressive, often partially open as if in anticipation of momentous happenings. Lips are prominent, clearly delineated, often sensual. They may be partly open in order to reveal another creature obtruding from within. In larger creatures the teeth are large, rounded, and in rows. Sharply pointed teeth are reserved for the fiercer dispositions of certain animals such as wolves, grizzlies, and killer whales although there are also examples of the latter creatures with more placid features and smooth, rounded teeth. Frogs are shown toothless.

Eating was an activity of immense social importance among these people. It was also associated with ceremonial occasions involving ostentatious displays of surplus wealth not the least of which was food. Feasting was essential to their sense of propriety, hospitality, and generosity to guests, strangers, and enemies alike. The portrayal of figures devouring other figures is commonplace, having significance far greater than ordinarily meets the eye. As double entendres they involve acts symbolizing the destruction of potential enemies or vanquishing rivals who might try to challenge an eminent family's position. Biting seems a particularly important theme and is one of the most commonly portrayed actions seen in Haida and Kwakiutl poles. An animal bites a dragon fly; a whale bites a seal; a grizzly bites a frog; a human, a whale. On the other hand, what might appear to be biting may be wholly symbolic of something else. A creature may simply be holding another being in its mouth in a protective way, the smaller figure obtrusively emerging from it as in figures 87 A, B, C, and D.

Associated with biting, an animal or bird—even a human being—may be shown biting not another creature but an inanimate object such as a copper, the rectangular, shield-like forms which represented the wealth (and power) of the families who possessed them (fig. 88A and B). In 88B a chief is depicted beckoning to guests while he holds a copper to his breast. In figure 89 a bear representing a clan sits in an upright posture holding a copper between its front paws and appears to be biting the top of it, or, if not biting at least holding on to it in a more determined fashion than its paws alone allow.

Animals such as bears and sharks may also be shown in sculpture wearing lip plugs which might be confusing to the viewer as they may be incorrectly interpreted as the creature's tongue. The wearing of labrets reflects an age-old custom reserved exclusively for women of highest rank

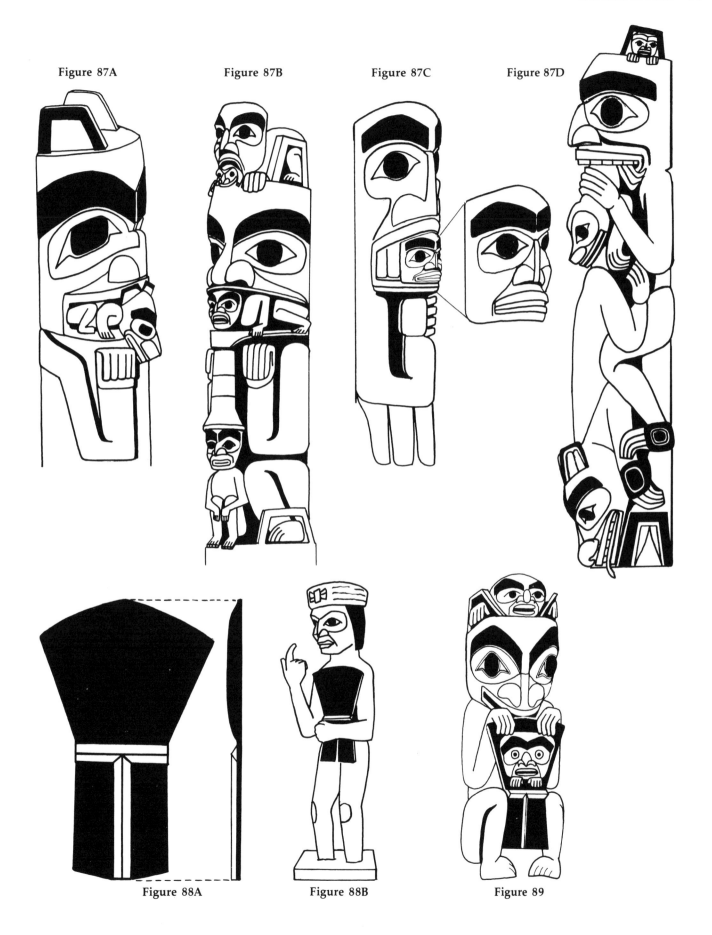

Figure 87A Figure 87B Figure 87C Figure 87D

Figure 88A Figure 88B Figure 89

within the tribe. But a shark's face with a labret may bring to mind an episode in history involving a woman who was carried away by the shark people and eventually became one of them.

Occasionally figures on the poles interact with others in the composition. The face of the topmost figure peers down as another creature below looks up to it, an example of which is seen in both front and side views on figures 90A and B. Here we see a humanlike face looking at the raven below, whose beak penetrates the upper figure's mouth. Both heads are contained within the hind flippers of a sea lion.

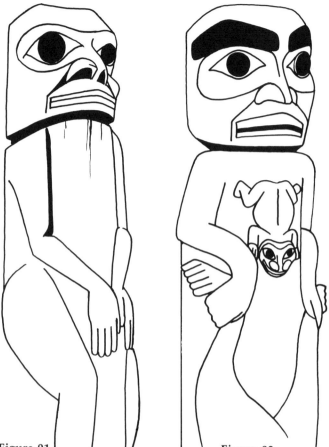

Figure 90 A **Figure 90 B**

Figure 91 **Figure 92**

Hands: When the human figure is unencumbered by holding other creatures the arms are placed at the sides, across the chest, or held straight up in front of the body with the palms turned outward to the viewer. The digits are clearly discernible; grizzly bear, beaver, wolf, etc., paws are visible but with the claws well defined, as are bird talons or the cloven hoofs of the mountain goat seen in figure 78A.

Human figures may sit tightly compacted in a knee-elbow position or with hands in front of the body as if covering the genital area (fig. 91). Humans also hold staffs or clubs for despatching fish. Hands may hold the knees or they may hold another animal or bird as seen in figure 92. They frequently hold coppers in front of their bodies. One example in the house posts section of this chapter holds a stone slave killer knife (fig. 8).

There are instances where one of the story figures holds a harpoon illustrating the action associated with a mythic figure named Salmon Boy (fig. 131B). Hands may be carved separately from the figure's body, then attached to it so that the human is seen with arms outstretched in a welcoming (or some may interpret as menacing) fashion. In figure 93 the wide-sweeping arms of the Tzonoqua spirit communicates its fearsome—no, awesome—power, but as a crest symbol it is shown welcoming guests to a host's potlatch.

Tails: On animals the tails may be long and slender as with wolves or short and stubby as with bears; beavers have large, flat cross-hatched appendages while the mountain goat has a short tail. In an upright stance the longer tail is brought up from between the hind legs to rest against the abdomen. Tails may also be given decorative surface treatment such as eye designs or faces which mirror the face of the animal the tail represents. It may also have a human face. A bird's tail is rendered with certain stylized feather patterns but restricted to the space available. In a similar fashion

Figure 93

Figure 94

Figure 95

a whale in an upright stance will have flukes drawn up to the head or they may rest on the body, that portion facing the viewer.

Facial Hair: When Westerners are depicted they are represented with heavy beards of a wavy character. The hair of natives is carved in long straight parallel bands. Occasionally the area above the upper lip of the human figure is painted to represent a mustache. Tlingit and northern Kaigani poles more frequently caricature Europeans with prominent hair and beards than are seen elsewhere.

Clothing: Human figures are seldom depicted wearing garments. Rarely a human form may wear a belt or dancing apron as part of a costume. No footgear is seen; indeed, native life provided no such amenity until European practices were well established, the exception being the inland Tlingit who borrowed and used a moccasin-type footcover acquired from neighbors living in the interior hinterland. House chiefs were shown

wearing conical type hats, sometimes referred to as potlatch hats, as seen in figure 94. The skils on the hat each represented a feast or potlatch the owner of the hat or the clan leader had presided over. People might also wear ceremonial paraphernalia on their heads as badges of rank. These include cedar bark ropes, an insignia of coveted membership in a tribal sodality (fig. 95). Europeans, on the other hand, were often shown in western clothing appropriate to the period including jackets extending to the knees, long trousers, and shoes. Tlingit artists represented Russian intruders in such clothing and carvers took great pains to accurately portray the hirsute characteristics.

Emotions: There are numerous examples of emotionally-laden behavior in the sculptures. The culture of the Northwest has scores of characters whose very appearance communicate deeply-felt attitudes. The range runs from gross humour to haughty pride and arrogance. The depiction of raven, for example, recalls both the crest symbol of numerous lineages in the northern groups as well as the culture hero of ancient mythology. They reflect episodes of his myriad escapades and foibles—acquiring daylight, losing his beak and being outwitted by halibut fishermen, marrying Fog Woman. These and countless other stories, some hilarious, many poignant, brought pleasure

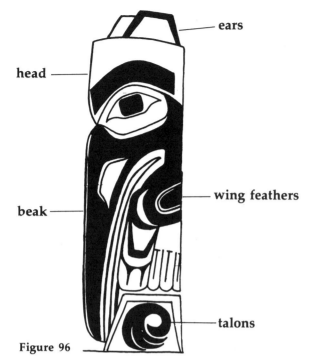

Figure 96

ears

head

wing feathers

beak

talons

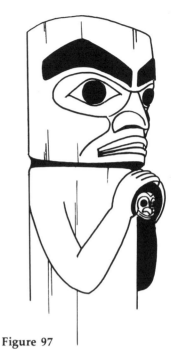

Figure 97

Figure 98

to the people familiar with the raven myths. From his many names, including Da Woo Chun, "oder-iferous raven feathers," people derive more than a smile; they arouse deep chuckles as well as an ineffable glow within their hearts (fig. 96).

Another humorous incident is reflected in the artist's rendering of the comic and highly improb-able predicament of the frog caught under the great weight of the diving whale's flukes on the mor-tuary column seen in figure 19.

I have alluded to the emotions expressed in the house frontal pole from Tanu depicting the woman weeping over her frog child's death in figure 43. There are also eloquent moments captured in wood revealing tenderness toward smaller crea-tures, exemplified in one Tsimshian pole in Giten-maks village (modern Hazelton). Here a person holds a tiny frog cupped within the palms of the hands (fig. 97).

Were we to pursue additional examples we would find many themes; leaders vanquishing rivals; trance-like states of persons seeking spirit powers; the dignified mien of a deceased leader.

Watchmen: Many poles show small human figures resting atop large poles. Typical of Haida poles in particular, these are the watchmen. They sit alone or in pairs, as well as in groups of three, with knees drawn up close to their faces, arms holding the legs or at rest by the sides (fig. 98). They wear conical type hats with from two to as many as nine skils. Their faces are generally alert reflecting anticipation or watchfulness. The watch-

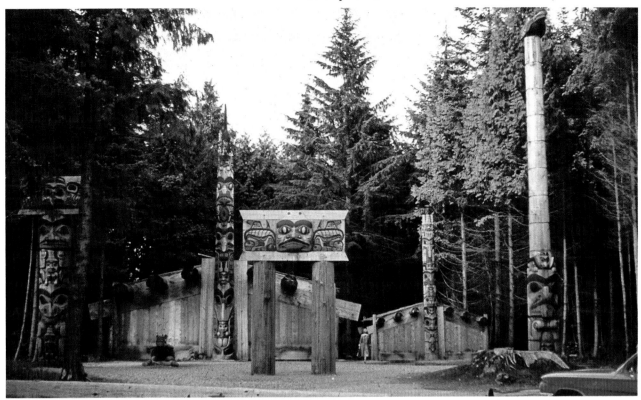

1. Haida Village was built in a forested area on the campus of University of British Columbia in Vancouver by modern Haida and Kwakiutl carvers. It was later moved to a site adjacent to the Museum of Anthropology.

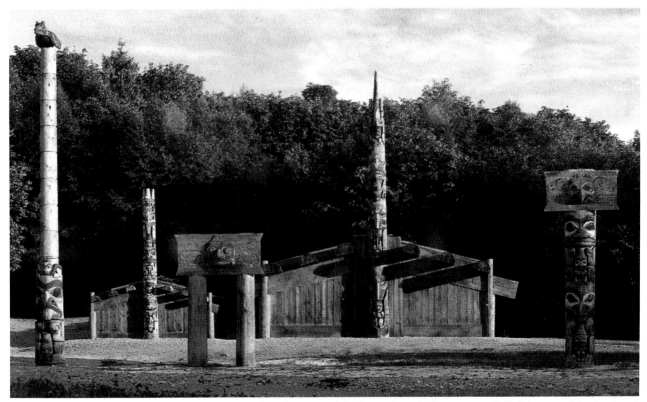

2. Haida Village in its most recent location in the Museum of Anthropology in Vancouver, B.C. It is one of the best and most graphic representations of old Northwest Coast villages of the 19th century.

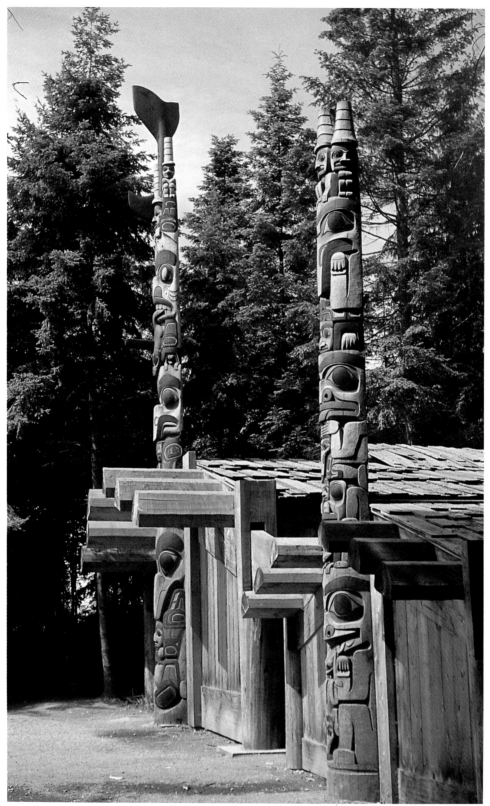

3. Haida village at the original site on the campus of the University of British Columbia. This view shows the clan house with house frontal pole on left, and pole in front of mortuary house (right).

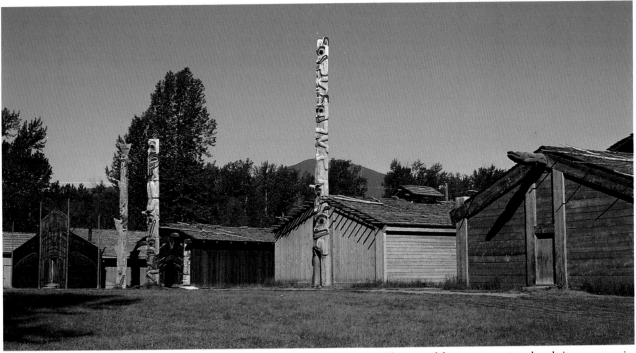

4. Ksan is located at the confluence of the Skeena and Buckley rivers amid some of the most spectacular alpine scenery in Canada. Several houses, large poles, and a museum and crafts center are located in this modern cultural center.

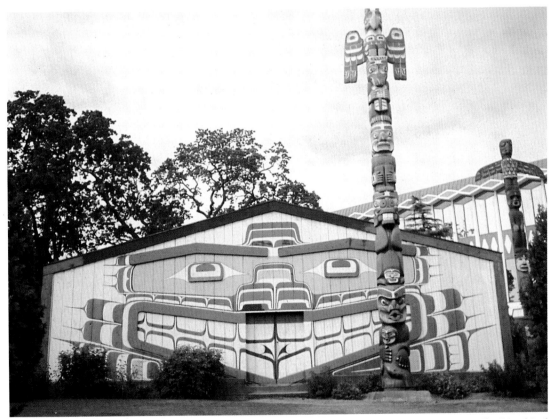

5. Thunderbird Park is centrally located in Victoria, B.C. and a major tourist attraction. The Kwakiutl house and pole were created by Mungo Martin and his team of totem pole carvers before 1960. The house painting represents the face of a sculpin, the figures on the pole constitute important crests of the Martin family.

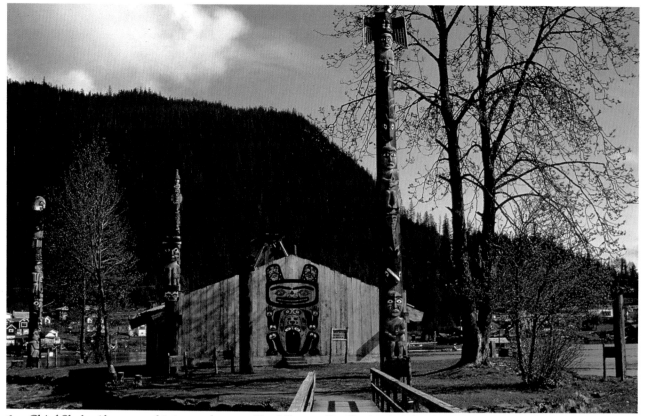

6. Chief Shakes' house and totem poles near Ketchikan on Revillagigedo Island, Alaska, is an important center for the preservation of Tlingit art. It is one of the most popular tourist places for those interested in Tlingit art heritage. *(Alaska Division of Tourism)*.

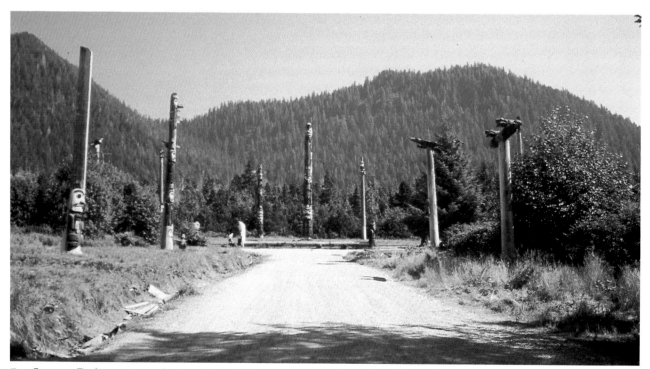

7. Saxman Park contains a cluster of Tlingit totem poles located near Ketchikan, Alaska. Poles were acquired from several abandoned settlements including Tongass, Gash, and Village Island. Together with Shakes Island and Totem Bight Parks, these constitute a sizeable concentration of Alaskan Tlingit sculptures.

men are supernatural beings that stand guard over the owner's house. They are thought to give warning when danger lurks. They are not crest symbols.

While watchmen figures are most often associated with Haida poles they occasionally appear on Tlingit and Tsimshian poles. They seldom appear beyond these areas, however. Skils—the hat rings—are commonly shown on Haida poles and are often intertwined with animal or other creatures who also wear them. The message communicated by skils is the wealth of the owners and the prestige derived from the family involvement with potlatching.

Coppers: Depicting coppers on carved columns was a widespread practice and reveals how old and entrenched the concept of wealth was within the culture, extending as it does from Tlingit territory southward to and including Coast Salish tribes. The flat, somewhat rectangular, oddly shaped objects (fig. 88A and 88B) are symbolic of clan or lineage wealth. They represent specific sums of currency in later 19th century history although earlier, during the time of the Hudson's Bay Company's expansion on the coast, they were equated in value with that trading company's blankets. Each blanket was valued at fifty cents and the Indians accumulated thousands of them. Like modern loans and interest activities, they too might rise and fall in value depending on their owner's acumen or recklessness within the economic climate. Coppers did change hands and the history of some reveal continuous changes in ownership. When they were destroyed by their owners at potlatches, it was, as it were, the ultimate act, displaying utter disdain for one's wealth.

Coppers ranged from about 44 inches in height and 22 inches in width down to a little over half that size. Coppers had names. The late Mungo Martin, a Kwakiutl chieftain from Fort Rupert, once allowed me to sketch two he had in his possession. The larger one was named "Big Blackfish," the smaller was called "Only One Going Up In Price." In 1948 the value of Big Blackfish Copper was $2,010 Canadian currency while the smaller one had a worth of $1200. Mungo was not an exception. Several chiefs in the area also owned coppers in the mid 1940s and 1950s.

Coppers were covered with a thick layer of black paint or graphite on which a crest design associated with the copper's name is etched or engraved.

On poles the copper designs may either represent real or fanciful coppers. According to Mungo the "T" is the foundation copper and is called in the

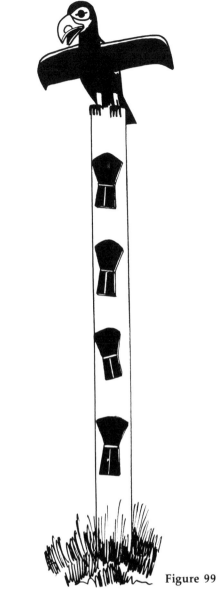

Figure 99

Kwakiutl language "gwa'las." It is never destroyed as it forms the basis for attaching a new copper resulting from a successful effort to rejuvenate a family's fortunes. This information, however, seems not to square with a later event in which Mungo himself broke the lower part of his Blackfish copper in a dispute with another person.

Among the Haidas during the latter 19th century a copper represented hundreds of blankets (hence dollars) in value, a fortune for those times. One or more coppers might occasionally be nailed to a family's totem pole at the time it was being raised, the message being both a boast and a warning. An example photographed at Masset village in 1878 discloses an eagle with outstretched wings sitting atop a slender column on which were nailed four coppers, one above the other (fig. 99). At Skidegate coppers were commonly nailed to poles, judging from those discerned in early

photographs. At Cumshewa two coppers were nailed to two separate poles but in a horizontal rather than vertical orientation, which may have some hidden meaning. A Haida pole is carved with a man holding a copper in each hand. There are many more examples.

There are numerous examples of coppers carved on Kwakiutl poles, which, like Haida and Tsimshian columns, celebrate the symbolism associated with this ostentatious display of lineage prerogatives and power. A Kwakiutl house pole shows a chieftain holding a copper high above his head; another a grizzly bear biting into the top part of a copper; a chieftain holding a copper close to his chest (fig. 88B). A copper was substituted for a human corpse ages ago during secret society ritual dramas, ceremonies that involved the initiation of new members into an exclusive order. Notice figure 21 in which a genuine copper is attached below the eagle located at the top part of this mortuary column.

Appendages: Many anatomical parts are added to the composition of the figures on totem poles. Most noteworthy are the additions of large beaks to the birds: eagles, ravens, hawks, thunderbirds, woodpeckers, even mosquitos (fig. 80 and 100). Some interior house posts identified as ravens or cannibal ravens (mythical monsters) may also have movable beaks attached to the faces, which, when manipulated by strings hidden within, allowed their articulation with a resounding clacking staccato, all of which added other dimensions—animation, surprise, drama—to the proceedings conducted within these households.

Whales require additional parts such as dorsal and ventral fins which were either minute or prominent in size. A large dorsal fin is necessary to identify a killer whale (fig. 64). Two identical dorsal fins (and as many as five on some killer whales) identifies a killer whale with supernatural qualities on figure 20. Dorsal fins may be added to the backs of wolves, grizzlies, and eagles to make them sea denizens.

In addition to beaks, some birds were carved with large ear appendages (fig. 100). Beaks, ears, wings, and fins are frequently carved separately from the figures and later attached. A cavity is made in the pole that will then accept the appendage. The part is mortised into place and covered with pine pitch so that the fit will be snug and tight. Once secure it may also be pegged or nailed for added strength (fig. 101).

Other appendages noted on totem poles are the rays emanating from a sun's face as seen on the topmost figure of a pole standing at Alert Bay

Figure 100

Figure 101

village (fig. 138) and at Courtenay, B.C. (fig. 144 center figure).

Among the Tsimshian, scaffolds were occasionally nailed to the upright pole and a small box, possibly once associated with mortuary practices, placed on them. Other items attached to the poles include small model canoes containing tiny human, and larger marionette-type figures with movable arms and legs (plate 40). A typical example of these additions is seen in figure 102, a Tsimshian pole from the Nass, which represents a shaman or Indian doctor wearing a bear claw head piece, a symbol of his occupation. Separately

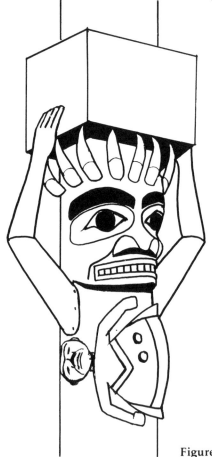

Figure 102

carved hands are skillfully mortised and nailed into the pole to hold the box containing the shaman's magical paraphernalia.

As poles aged the first casualties of wind and storm were the appendages. Once ripped from their poles they were never replaced, just as once a pole collapsed it served no purpose other than providing fire wood for the hearth of the lineage house.

Supernatural Spirits: The world as the people perceived it was populated by countless special spirits. It would be a formidable task to list them all because there were hundreds, each with their specific power, attributes, and physical characteristics. But the most common in native traditions and mythologies are periodically depicted in highly symbolic ways on the poles. Many of these spirits were benefactors, meaning they were approachable for power under prescribed circumstances. They were also included to reflect critical episodes in family histories. The themes relating to these episodes with spirits were repeated over and over again with each lineage's pole raising. They were never forgotten. Each region placed special emphasis on certain characters.

I have already alluded to the Forest Ogress, Tzonoqua, as well as the thunderbird and a young brother, no less a crest than the big bird. The latter two were often depicted on poles holding whales which is their food in their talons. There was Geeksem, (First Man) the founding ancestor of several groups (fig. 103). He was dressed in ceremonial robes made of red cedar bark as both a head dress and neck rings, visual symbols of membership in a tribal men's society. Another is the Sisiulth, a double-headed serpent which, if good fortune is encountered, will bring rare luck to the viewer (fig. 104A). The Sisiulth may be depicted having a central face with a serpent motif on each side or it may take the shape of the vertical pole, with the central face above the two serpents which parallel the pole below it (fig. 104B).

I have mentioned the whales and killer whales as ordinary creatures that inhabit the sea environment but there were supernatural whales and killer whales also. These were extra powerful beings that have double dorsal fins. One authority mentions Haida crests having five fins lined along the dorsal side of these whales. Mythological episodes also provided for other types of supernatural creatures. There was a sea grizzly, a sea wolf, and an undersea eagle. The sea grizzly and sea wolf have similar facial characteristics to their land counterparts but combined forelegs of the land animals with flippers for the hind legs (fig. 105). They also had large dorsal fins projecting out of their backs.

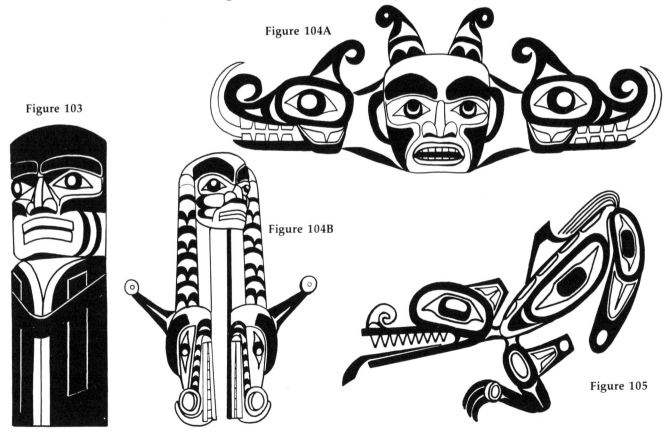

Figure 104A

Figure 103

Figure 104B

Figure 105

Figure 106

Figure 107

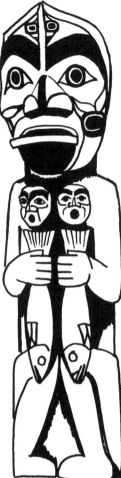

Figure 108 Figure 109

From time to time other creatures are depicted occasionally on poles. One is the starfish (fig. 106). These also serve as crests for families.

Among the various tribes Raven was portrayed in various disguises which often reflected his role as a trickster as well as a culture hero (fig. 96). As would be expected, women also played important roles both during the Mythic Age and in later tribal histories. There was Cloud Woman with four tiny figures around her head representing puffs of clouds.

Flood Tide Woman was another creature who brought different raven families into being. And there was Fog Woman, also known as Salmon Woman (fig. 108). She created the salmon, then bestowed them on an unappreciative Raven, the culture hero. These women were of high status. In order to depict such positions they were shown wearing labrets, as in figure 107. There was Mountain Eagle, a clan benefactor, as well as Crystal Proboscis, a giant mosquito, who menaced the progenitors of a tribe far back in time (fig. 109). Another mythic character is a one-horned mountain goat (fig. 78A) and Strong Man, known as Kahashi or Dirty Skin. He demonstrated his

supernatural powers by lifting and tearing to pieces the enemy, a giant sea lion (fig. 110). The subject matter also recorded journeys into the sky world as well as those into the forbidden zone, the Underworld. One who took that journey was known in some tales as Gunarh or Nasimgyet (fig. 111). The holes in the dorsal fins identify the creature as supernatural.

Inanimate objects are no less a subject for crests or characters in myths as animate creatures. They too are endowed with spirits. Take for example the tree snag, a monster who may cause death by drowning and may otherwise be equated with drifting logs (fig. 112).

With these characters and scores of others too numerous to mention here, we acquire some awareness of the richness and diversity of the subject matter on the poles. The mythologies of the Northwest Coast tribes related the comings and goings of the creatures that existed on the earth in times past, many of whom were directly tied to human ancestors, tribal histories, and destinies. These are the subjects that provide the exuberance and vitality for continuity with the past traditions.

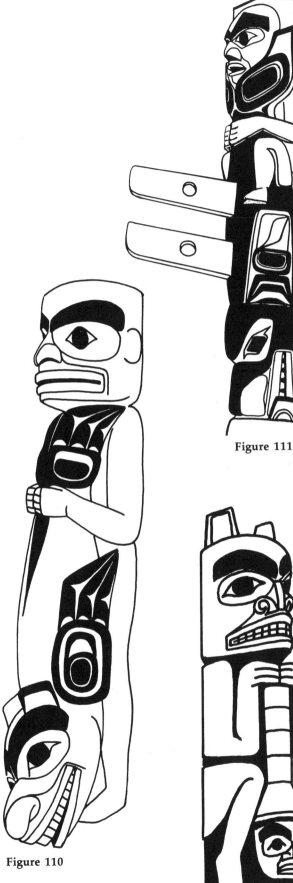

Figure 111

Figure 110

Figure 112

Space Fillers: One of the delights in examining the compositions in the poles is the unexpected surprises the artists provided the viewers. They tucked into little corners and crevices a myriad of small animals, birds, insects, or human-like figures. These space fillers are used in assorted surfaces, particularly among the Haidas and some Tsimshian groups. We see figures ensconsed in the ears, between the limbs, grasping dorsal fins, peering from blow holes, hugging the tails, on the undersides of animal paws. Who are they? What do they represent? All are dwarfed by the larger characters depicting crests, myths, or historical events that make up the substance and purpose of the poles. We have little information on who they were and what they represented. We do not know what the carving artists had in mind.

I suspect these figures may have been explained to the audience invited to witness the raising of the poles. A recited story was a part of such events. Undoubtedly not only the major characters on the poles but also the secondary figures were fitted in in some way to flesh out the narrative. We do not, however, have any recorded data about them, so the details are probably lost forever. Smyley, (1973) in his excellent study of the Koona (Skedans) poles, believed it is no longer possible to know exactly what the small figures really mean.

Scale: One final characteristic associated with subject matter must be dealt with. This is the irrelevance of the scale of the figures portrayed. The laws and realities of nature were secondary to the role the figures played in the family's history; therefore, if a frog represented a clan crest, it was given far more prominence and hence size than a human being of less importance in the family heritage. Mosquitos may be the size of humans because of the role they may have played in early history; bears larger than whales, whales smaller than humans; humans may be dwarfed beside a wolf or a thunderbird. All of this may be disconcerting to the viewer first attempting to understand the perceptions of the artists or the values inherent in the culture, but the general rule is: the larger the figure the more prominent it was in the family history.

With this summary of the subject matter of totem poles in hand, we can turn to a detailed examination of the various tribal styles and the totemic characteristics associated with each group along the Northwest Coast.

CHAPTER III

Stylistic Characteristics

We have established that tribes and subtribes shared many practices associated with the raising of totem poles, but regional preferences and expressions emerged. These differences asserted themselves in distinct stylistic attributes throughout the 19th century, the result of a number of currents and influences stemming primarily from the Queen Charlotte Island sources.

Specialists in Northwest Coast cultures are able to examine a mixed bag of salvaged poles and generally distinguish them as to tribal provenance, if not the particular village from which they came. How is this possible? Are there means by which experts can make such distinctions?

In short, the answer to these questions is yes, indeed there are. For one thing, we can compare the poles as to size, arrangement of figures, types of figures, use of space, and surface details. These elements provide many useful clues. There are in addition other traits specific to each tribe's practices which help identify a particular pole's origin and place. The sum of all these elements defines the style of pole. Style, then, is the key to unlocking the mystery of a pole's identity—be it Haida, Tsimshian, Tlingit, Kwakiutl, Bella Coola—and yes, even a fake!

While each region influenced its neighbors to some extent—sometimes in subtle, sometimes in overt ways—differences do exist in the styles associated with each tribe. We can categorize these differences and, if needed, the similarities, bringing them together to provide a corpus of propositions to analyze and classify the unique stylistic stamp of each tribe.

Analysis is made somewhat more difficult by stylistic changes which occurred over time as new ideas—even new tools and modern paints—were introduced, received selectively, and integrated within the established tradition. Furthermore, some families borrowed renowned carvers from other groups to carve poles to meet their specific lineage and social needs. A given pole was not necessarily carved by a resident of the village in which the pole was raised.

Since I am of the view that the earliest totem poles originated among the Queen Charlotte Island groups, I will establish Haida stylistic features first in order to use them as a basis for establishing the differences with and between the mainland tribal groups.

THE HAIDA STYLE

Sculpture in wood was a highly specialized activity reaching a spectacular culmination in totem pole carving, boat construction, and house construction. Haida achievements in these undertakings were nothing short of monumental, the result of a surge of creative effort that was surpassed by no other groups. So not only do I use them as a *basis* for comparison with other Northwest Coast peoples by focusing on origins but also because of their sheer excellence.

George MacDonald (1983) reported, as the result of his mapping of Haida village sites, that just under 500 exterior type totem poles stood in 18 villages in the Queen Charlotte Islands alone. This

figure excludes the Kaigani Haida who occupied Prince of Wales and Dall Islands in southeast Alaska which would add roughly 100 more. Such an enormous output provides us with a glimmer of the extraordinary artistic (not to mention social) activities that occurred within this region during the 19th century. No other region on the Northwest Coast—so far as presently known records disclose—remotely approached such a formidable assemblage of undertakings. Three quarters of this production originated in only nine villages. These included settlements where several poles stood in front of the dwelling of every influential family. Since poles remained standing as reminders of past events until natural forces brought about their collapse, these collections of poles involved the activities of a single, perhaps two—or at the most three—generations during the periods of expansion and climax. Two poles usually stood in front of a dwelling as heraldic types; a third served as a house frontal; a fourth or possibly fifth as memorial or mortuary types. In short, four or five poles were associated with each dwelling in a community composed of from ten to twenty or so houses. In terms of production, Haida output was impressive. Indeed, it was unmatched or never equaled by other coastal tribes. The vast extent of Haida pole use and production was unique!—and so provides the first principle for distinguishing tribal poles.

A second characteristic relates to the massive dimensions of Haida poles. Their heights and diameters are astounding. Standing next to one is like comparing a sapling to a California Redwood (plates 6, 10, 30, 32; fig. 116). With the possible exception of a relatively few poles from the Nass River villages, Haida poles are the tallest and of the greatest circumference. Among the largest known specimens of red cedar stands were those of the Queen Charlotte Islands. This is not surprising since the annual rainfall exceeds 150 inches and the islands enjoy a relatively mild climate providing an ideal environment for phenomenal growth rates.

In examining Haida poles it is often difficult to distinguish one form from another, not only because of the profusion of subjects depicted but also as a result of the stylistic practice of merging subjects. The drawings in this chapter will help the reader distinguish where each of the parts fit into a composition. Figure 96 breaks down the anatomical elements of a raven. Another example is the profile view of a pole from Yan depicted in figure 29. Notice the arms of the bear (top) rest on the head of the creature below which represents another bear whose forelimbs embrace a smaller, vertically-oriented cub. The latter's front and hind

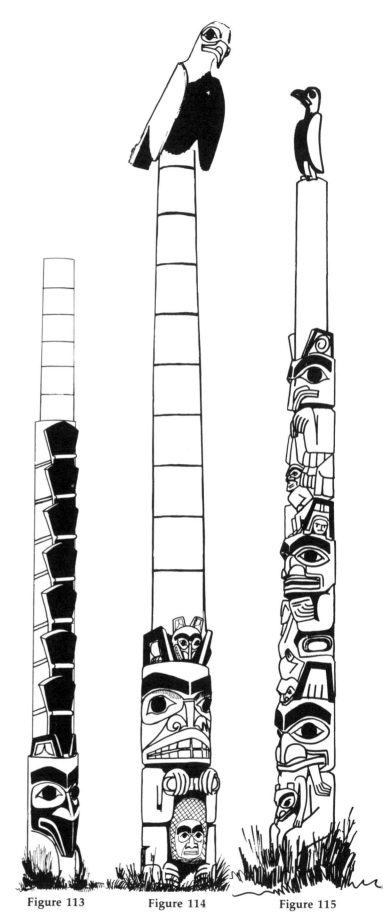

Figure 113 Figure 114 Figure 115

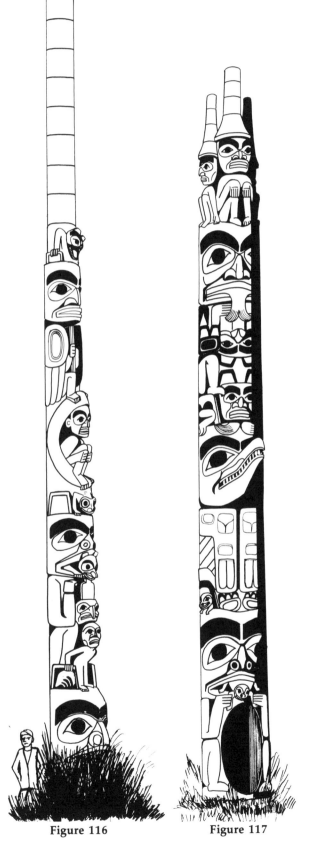

Figure 116 **Figure 117**

limbs rest along each side of the upright figure that holds it. Taken together all three are components in a myth theme associated with Bear Mother, an ancestress. The figure below the cub has two pairs of limbs. The fingers from one pair rest on the forehead of the creature below it while the second pair grasp the ears.

As we become accustomed to such spatial relationships we are better able to distinguish primary from secondary figures. We gain insight and are more aware of the compositional problems resolved by the artists in creating such complex creatures. We can appreciate the exquisite mastery of tools and materials to realize the sharp, crisply-executed lines. We can begin to comprehend the flow of figures, the harmony and balance of the designs in the complex patterning.

Haida poles—even decayed, weather-beaten, broken, and collapsed remnants—invite careful scrutiny because of the insights they provide: the handling of light and shadow, mass, volume, contrasting dimensions, symbolism. These elements, formal and representational, were effectively orchestrated into a sculptural symphony. Elements were not allowed to jar the eye but flow in a natural pattern. The representation of the symbols employed were required to be aesthetic, and representations acceptable to the people in reflecting the ties with past traditional values. Yet they also had to be distinctly original to evoke powerful responses regardless of the audience. The artists of the Queen Charlotte Islands left ample evidence that they rose to such challenges again and again, and triumphed!

Let us examine the story pole from Dadens depicted in figure 116. The large figure near the top represents Raven with a human face but with wings to reveal his bird origin. Notice Raven's human hands grasp the beak he has removed from his face, reflecting a mythical episode. Raven's feet rest on the figure below which is identified as a berry picker. She is associated with the myth of Bear Mother. She sits within a moon crest. Below is a small frog as a space filler while the larger figure that follows represents a bear. This depicts the Bear Mother in animal form holding one of her cubs in her mouth. A second cub, rendered by the artist in human rather than animal form, stands between her legs. Notice the interlocking flow of larger figures. This is an important identifying feature of Haida style, see also figures 87B and 124.

In the profile view shown in figure 30 from Kwa-anlas village, we see a far more complicated composition resulting from the additional figures incorporated into the space. This pole epitomizes

the classic Haida style in its interlocking arrangement of figures. The larger figures are for the most part rendered in static and controlled poses. Aside from the devouring gesture involving the smaller figures, there is not much action taking place. The smaller figures, on the other hand, seem to spring out from the cedar wood. Their faces are alert and active. The position of the arms and legs are in balance, adding to the tension of action. While these smaller space-filler figures are action-laden, the prominent ones sit in passive repose. Notice how the human figure above the lower one in figure 30 seems ready to spring forward. This also seems to be the case with the watchman poised at the top.

Stylistically, Haida poles emphasize animal and bird crests and characters almost to the exclusion of human subjects. Figures 21, 28, 30, 42A, 115, and 117, for example, contain no human representations whatever. Instead, there are whales, eagles, ravens, bears, beavers, in conjunction with less frequently employed subjects, representing symbolic or story themes. These are repeated with endless variations. They constitute the flesh covering the skeleton of the pole.

Haida poles also employ a wide range of creatures drawn from a rich mythology. The repertoire of characters, episodes, and interrelationships depicted in sculpture are far more varied than among other tribes. Notice how often certain figures are placed upside down on the totem pole: i.e., the frontal figure 117, from Haina with raven's tongue connected to the split-tongued creature above it. Notice also the profile figure 43 from Tanu, a human form locked into the dorsal fin belonging to killer whale.

Only when we approach Haida poles closely do we become aware of the enormous range of surface details rendered both in low-relief sculpture and in painting. We may have suspected that such profusion obtained but close observation confirms it. This is another important feature of the Haida style. The attention that was given to the formlines placed on bird wings, tail feathers, fins and flukes of sea creatures, seem infinite in variation. Painted patterns accented these anatomical features. Notice the patterns painted on bird wings in figures 25, 28, 42A, 43, 44, 96 and 117. These details are generally obliterated after a few years of exposure to the elements but they were nevertheless, essential elements when the column was to explicate their full meaning when completed. We can still reconstruct some of those which embellish the pole surfaces explaining its symbolism.

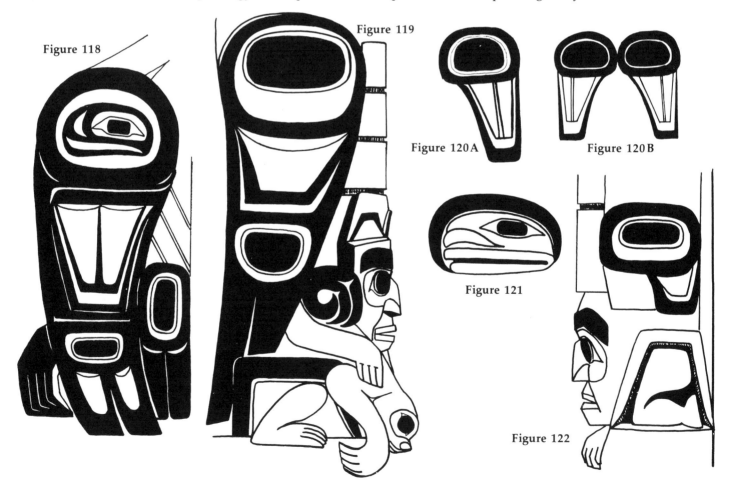

Figure 118

Figure 119

Figure 120 A

Figure 120 B

Figure 121

Figure 122

Wings on eagles, ravens, cormorants, even dragonflies, might have patterns as complex as the surface design features in figure 118. These conventionalized elements are identified as the wing joint, wing, feathers, tail feathers, and bird talons. I have discovered no two patterns are alike. The freer manipulation of these elements by superb artists gave each pole originality in an otherwise tightly controlled tradition of figural representations.

Figure 119 reveals the complex relationship between surface elements on a wing design with other elements. In this particular example, taken from a pole originally at Tanu, the wing of an eagle with its talons (outlined in solid black) form one part of the composition, interlocking with the human face which is wearing a hat containing three skils. The hands hold the forelimbs of a frog which is positioned below it. Notice that the human figure's legs are placed inside the ear belonging to the creature below. Equally important is the eye design or inner ovoids within the larger ovoid patterns located on the wings. In my view this innovative use of the parts of the forms constitutes

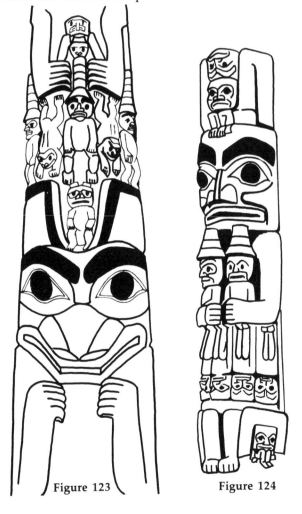

Figure 123 Figure 124

one of the most distinctive features of Haida art because, though they are common elements, they demonstrate the creative vision of the artist executing the eye designs.

Surface designs associated with many creatures—whales, killer whales, sea monsters, for example—also portray patterns of fins and flukes comparable to those seen in figures 120A and 120B. A variation of the face shown in figure 121 also adorns wings, fluke patterns, and whale dorsal fins. The mouth is easily distinguished as are the nostril and eye patterns. Some writers have referred to such commonplace ovoid patterns as conventional space fillers. Notice a similar convention in figures 64, 65, 66, 69, 85A and 148. I have been unable to learn or plumb the significance of this particular design.

In figure 122 we see a small creature with a human face bent under the weight of numerous skils which rise above its head. This figure may carry the hidden symbolism of wealth overcoming an enemy or rival. The fingers rest on the edge of the pole below its chin while the legs are doubled back into the space provided by the ear design of the figure positioned below it. In order to clearly visualize the great range of details necessary for interpretation, the reader must closely approach the poles. Neither a distant view nor photographs do justice to them as the details blur or disappear when looking at the pole in its entirety.

Returning once again to the interlocking character of Haida designs, I want to point to two additional examples provided in figures 123 and 124. In the first we see a part of a pole from Hiellan, a village near Masset. The section between the lower figure's head and the upper figure's legs contain ten small creatures. Five are carved along a horizontal band stretching across the frontal circumference of the pole, a feature commonly seen on Tsimshian poles. Two are diving frogs; three appear to be watchmen wearing potlatch hats containing several skils. A frog is also prominent in each ear of the lower figure. Several poles from Cumshewa village carry similar bands of small figures. All demonstrate the Haida preoccupation with filling surface space by including additional figures. They probably have no direct bearing on the symbolism inherent in the larger crests depicted yet they are certainly a part of the overall composition and aesthetic effect.

Figure 124 depicts part of a pole from abandoned Ninstints village in which we see the strong interlocking character of Haida sculpture at its best.

In association with the preference given bird

and animal subjects, parts of the anatomy may be given small faces to symbolize joints. Called eye joints—wings that connect to shoulders, legs that connect to hips, feathers to wing bones—they may also symbolize power beyond the ordinary. They are also sometimes used for purely decorative effect as space fillers. An example is found in the beaver pole from Masset seen in figure 125A. Notice the inside of the forepaws containing such faces. A close-up example with greater detail is provided in figure 125B.

Other characteristics in Haida style are watchmen usually positioned at the tops of the poles but occasionally relegated to other sections (as in the lower figure in fig. 87B). The Haidas commonly utilized coppers as symbols of power and wealth. The reader should refer to Chapter II in which I point out the frequency with which metal coppers—the genuine ones—are nailed to poles standing outside the dwelling of an important family. They represent the special privileges claimed by the occupants.

The most unusual example of coppers decorating a totem pole as status symbols comes from Skidegate. This memorial pole is illustrated in figure 113. A raven crest is seen at the base followed by seven coppers vertically arranged one above the other. These culminate at the top with six consecutive skils. The pole was raised reportedly in the mid-19th century by a man to honor his wife's raven crest family.

Notwithstanding the painted surface designs applied to large wings, fins, and fluke appendages, Haidas showed considerable restraint in the use of paints and in the choice of colors. Paint of native manufacture was restricted to emphasizing facial characteristics and limbs of subjects. Black was confined to eyebrows, eyes, and ear contours; a vermillion red was applied to lips, tongues, and occasionally nostrils. Teeth were left unpainted or occasionally given a pale white. The space surrounding the orb of an eye was emphasized with a soft blue-green quality. I discovered that skils were occasionally painted alternatively black and white as were large dorsal fins of some killer whale figures. That is it! No more paint! The remaining surfaces of wood were left unpainted, allowing the warm, rich cedar grain to emerge in the surface. Shortly thereafter the wood weathered to a rich silver-grey patina.

Abalone shell inlay—providing vibrant iridescence—was sometimes added to accent certain features, particularly the breast feathers of birds and the eye sockets of important subjects. The rich blue-green variety were favored over the pale

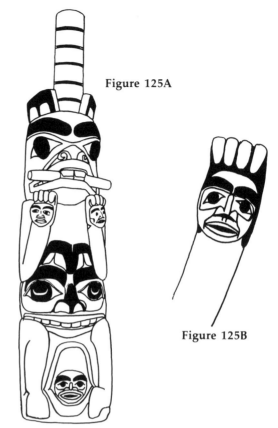

Figure 125A

Figure 125B

counterparts. The shells were highly esteemed as they reached Haida country at considerable cost. They came to the Haida by way of aboriginal trade routes from as far south as the coast of Baja California. One mortuary pole at Haina was decorated in abalone.

Haida totems never repeated a figure on a pole, nor the position of arms or other limbs, a characteristic which as we shall see was in sharp contrast to Tsimshian practices. The entire width of the tree trunk was used for the figure; the heads of the large subjects usually being as wide as the shoulders and hips.

The backs of exterior poles were generally hollowed out with either V or U-cuts during the initial stages of the carving by removing the heartwood. The pole was not only made much lighter and so easier to move and erect, but also helped reduce the lengthwise cleavages—the multiple cracking—that distorted the overall appearance. Removing the bulk of the wood also prevented quick rotting, not that it mattered much as the poles were not raised to last.

The figures at the top of a few Haida poles project beyond the pole horizontally contrasting with the vertical axis of the body of the pole. These elements were carved separately and added to the pole before it was raised. An example is the eagle atop the mortuary column represented in figure 21. Note also the Wrangell mortuaries, figures 23 and 3.

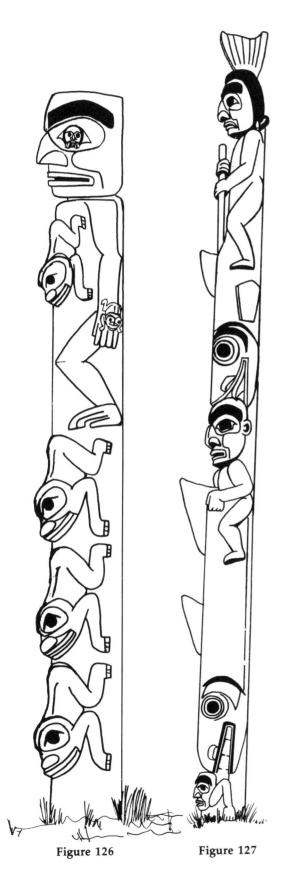

Figure 126 Figure 127

THE TSIMSHIAN STYLE

It may be more accurate to suggest that there was no one Tsimshian style but a series of substyles, depending on the region. These substyles parallel the three great tribal divisions: Coast Tsimshian, Niskae or Nass River, and Gitksan or Skeena River. Tsimshian pole production never matched that of the Haida, although a considerable number were raised in the last half of the 19th century. Adrian Jacobsen, who journeyed to the Tsimshian villages between 1881 and 1883, notes in his diaries that 50-foot totem poles stood before each house in Kitkatla, which had not yet been significantly influenced by Europeans. But he expressed dismay over Fort Simpson, the largest coastal settlement. Instead of a beach-lined totem pole village he saw a modern European-type community with a centrally located Gothic-style church. Changes were rapidly inundating the coastal tribes.

A photograph taken in 1910 by G. T. Emmons of Kitwancool bears some resemblance to the Haida villages filled with poles (plate 13), but seemed more the exception than the rule.

If we were to call the profusion of interlocking figures presented on Haida poles exuberant, varied, and busy, Tsimshian poles were subdued, sparer, and less varied both in symbolism and in pole types illustrating myths and lineage histories. Both heraldic and memorial poles were most common and house frontal and mortuary poles were seldom enacted. The villages of the Coast and the lower Nass Tsimshian carved extremely tall but very narrow columns in contrast to the thick poles of the Haidas, figures 33, 34A, and 129. Red cedar trees grow abundantly in the region but did not attain the diameters found in the Queen Charlotte Islands. There were some exceptions, of course.

Nass River poles were extremely well carved and filled with both large and small figures, figures 34A, 129, and 130. At one period the villages there—Gitiks, Angidah, Gitwinsilk, and Gitlahdamsk among others—must have produced a treasure trove of columns. Stylistically they differed from the Haida in several important ways. A large percentage were only partially carved, leaving extensive surfaces empty. Some displayed a single figure at the base, topped by a great length of free space culminating in a carved figure at the top—in the manner of Haida memorial poles. There were, of course, many fully carved poles, but these differed from Haida in that the figures were not densely crowded onto the pole but were spread out in more relaxed, freer, and more open posi-

tions. Figures were not locked into or jammed close to other figures.

Tsimshian carvers also handled space differently than the Haidas. Figures were not only separated from each other; they stood, squatted, or sat in relaxed manner. The blocked-out masses containing such large figures were expansive and uncomplicated by the small interlocking figures or the crisp details prevalent in Haida work. They suggest the artist proceeded by carving each figure in block-like fashion then set them one atop the other—of course, they carved a single tree stem but seemed to conceive their compositions in clearly delineated blocks.

The same figures were not only repeated two and three times along their vertical axis but also appear much smaller than their Haida counterparts due to the reduced diameter of the poles (fig. 31, 33, and 126).

Other distinguishing characteristics emerge as well. The large figures were separated from each other by small bands of horizontal figures—two, three, even five in number—set across the width of the pole (fig. 33, 34B, 82, and 130). These more complicated surface treatments might include only one such band of figures (fig. 82 roll-out) or a series of two or three bands, each separated by a major subject. These interspersing zones of smaller figures not only produce a visual pause but endow the subjects with a greater clarity and lucidity as well. Thus in examining the entire length of the pole, the viewer's eye pauses as it moves from one large form to several smaller forms then back to a large form again (fig. 128, 129, 130).

The human figure is the preferred subject rather than animals and birds. In sharp contrast to the rare place human figures have in Haida types, drawings derived from the Gitksan poles illustrated in figures 80, 82, 97, and 131A, B, and C shown below are common. Notice the greater economy of line and form than used in Haida counterparts.

Tsimshian carving is also less conventionalized, tending toward greater naturalism. Tsimshian poles commonly incorporated small figures, animal and human, as space fillers both on large and small subjects. While not as profusely scattered as on the Haida poles, they are positioned in the ears, on paws, over foreheads, and between the legs of dominant figures, as seen in figure 132.

A feature of signal importance in distinguishing Haida from Tsimshian carving is the sensitive rendering of human figures in the latter. One frequently sees exquisitely modeled examples of gentle expressions of tenderness directed toward other creatures. This quality is in marked contrast to the Haida creatures aggressively devouring lesser beings. The Tsimshian delicate style and arrangement are exemplified in figure 97, a human gently holding a frog in the palms of the hands. Notice also the hands of the tiny figures commonly placed on poles whose faces express differing emotions as in figures 82 and 134. A human subject may also be split, each figure occupying part of the pole, as in the split-person design shown in figure 34B.

Tsimshian artists also provided other surprises. Figure 126 is from a pole located in Kitwancool. The large figure represents an ancestress named Geekyamps, the Frog Woman. Notice her eyes as well as the palms of her hands. The hands are turned outward in a most unnatural manner. Tiny frogs are attached to the palms. Referring once again to the eyes, notice the pupil in each eye is composed of a miniscule human face with fingers holding the lower lid (fig. 133 and 86A). If attention was not directed to such charming details—and there are many—one might miss them completely.

Tsimshian poles do not always have the elaborate surface patterns associated with body and wing parts exemplified in Haida models seen in figures 118 and 119. A few poles in the coastal settlements suggest strong Haida influences but, though the Tsimshian mastered the techniques, they did not imitate Haida aesthetic values or carving techniques. Like the Haida, appendages were added to further identify animals and birds. Figure 109 of a monster mosquito on a pole in Kitwancool and figure 127 with dog salmon fins from a standing pole in Kitwanga represent two of many such examples.

The Tsimshian used colors with greater frugality than the Haidas. Features on facial areas were indeed accented with paint as were some body parts such as frog skin patterns and the fur on animals, but for the rest of the surface paint was sparingly used. Potlatch hats with attached skils are less often depicted as are coppers, the wealth symbols (fig. 129). Tsimshian poles are generally not hollowed, making their life-span precarious. While Tsimshian did not employ the Haida style mortuary pole, some mortuary function was apparently served by the occasional boxes attached to platforms held in place with pegs driven into the pole proper (fig. 128 and 129).

Of the three divisions of the Tsimshian, the Gitksan or Skeena River tribes appear to have adopted pole raising customs later than Coast or Nass River groups. They probably received the practice from their Nass neighbors with whom

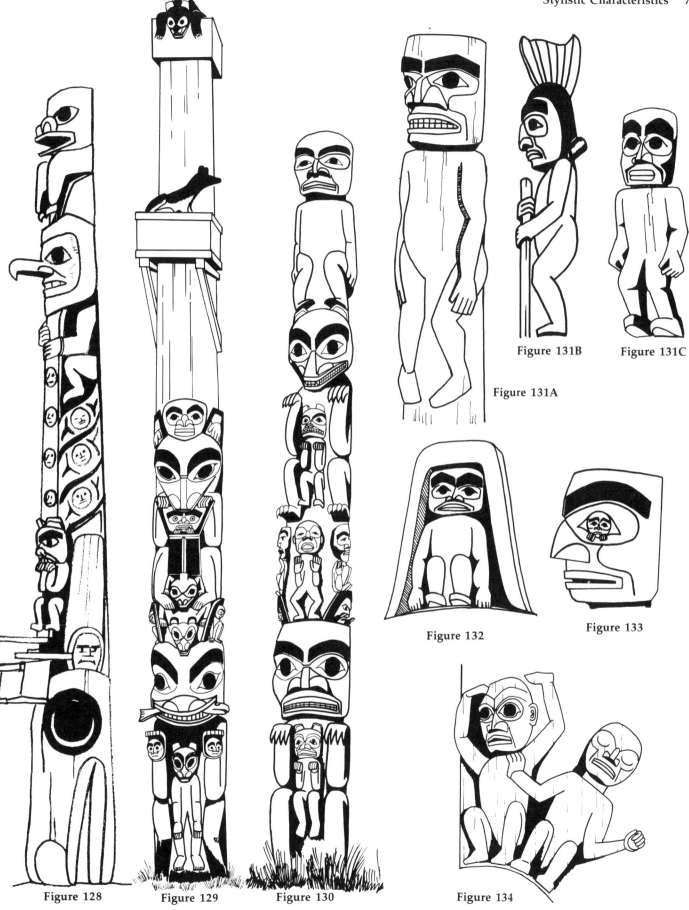

Figure 128 Figure 129 Figure 130

Figure 131A

Figure 131B Figure 131C

Figure 132 Figure 133

Figure 134

they had long-established reciprocal ties. Since the Gitksan villages—Kispiox, Kitwanga, Kitwancool, Gitsegyukla, Gitenmaks—were located more than 150 miles upriver from the coast, good cedar logs were not easily obtained. Gitksan poles are therefore extremely thin and in no way comparable in height or girth to Nass River poles. Additionally, the wood was of poor quality, being covered with countless surface knots not only making pole carving extremely difficult, but also compromising their general appearance.

While there are a number of individual poles in these villages that are genuine masterpieces (plates 38, 39, 40, and 42), the overwhelming majority that have survived to the present are only rough and crude facsimilies of superior examples produced in the Nass River region. The figures in many examples barely emerge from the log due to the shallow carving techniques employed. Others are crudely done, having an unfinished look. The carving is not deep, crisp sculpture but rather is barely revealed. This is in sharp contrast to Haida and other Tsimshian examples.

Despite the shortcomings of a number of poles, many standing in Kitwancool can rightfully take their place among the best the Tsimshian produced, if for no other reason than from the sensitivity and gentle qualities the artists bestowed on the figures (plates 39, 40, 42). Some of the finest examples of carving and artistic skill are seen in the horizontal bands of figures that spread across the width of the poles. Faces are as sensitively modeled as the famed Tsimshian masks and include the repetition of human faces devoid of other anatomical features (fig. 74C and plates 40 and 42). Expressions vary from smiling to grim countenances.

THE TLINGIT STYLE

This style was centered along the southern Alaskan border or panhandle region adjacent to northern coastal British Columbia. It was more closely tied to Tsimshian than to Haida styles. The Nass River tribes seemed most influencial in spreading pole carving to the southern Tlingits. Moreover, these groups, living in close geographic proximity, shared many common cultural expressions. Incidentally, none of the Tlingit villages showed the classic Northwest Coast village pattern involving totem poles as exemplified by Haida and some Tsimshian settlements.

The Tlingit tribes settling at Tongass, Fort Wrangell, and Cape Fox villages accepted the practices of totem pole carving and raising most fully. The practice fades rapidly beyond these places with only rare appearances farther north. The tribes living on the off-shore Alaskan islands raised few poles, and those were mostly smaller timbers which informants identified as grave markers. Most of the totem poles raised during the 19th century in Alaska—with the exception of the primary villages named above—were carved by Kaigani Haida artists and are Haida in origin rather than Tlingit. A large proportion of these have long disappeared, a subject to be discussed in a following chapter.

The Nass River was the focal point of cultural transfer and exchanges into Tlingit territory, just as the Dixon Entrance and Hecate Strait were pathways by which Haida practices reached the Tsimshian. Cultural contacts crystallized around the Nass for very good economic reasons. The Nass estuary was the great gathering place for harvesting of eulachon (candlefish) runs, a valuable—even necessary—dietary supplement. Tsimshian gathered this wealth and traded there, drawing large numbers of Haida and southern Tlingits. Through early associations such as these, Haida influences first penetrated Tsimshian strongholds and later infiltrated the regions of both Tlingit tribes to the north and Gitksan to the east.

In both height and scale, Tlingit raised modest-sized poles, seldom reaching more than 30 feet. They lived near the northern limits of the red cedar forests; consequently, suitable trees were not easily available, forcing them to make due with what they had, principally yellow cedar. Aside from the ubiquitous interior house posts which were widely adopted in all the Tlingit villages, the Tlingit directed their attention primarily to memorial and mortuary-type poles to meet social and spiritual needs. Heraldic poles as well as house frontal poles, while present in some villages, were not widely used. The Tlingit word for totem pole—Kaka'kedi'h—Olson points out (1963), means "coffin" or "outside box" and probably points to the primary reason for raising poles for mortuary functions.

The largest and most commonly recovered examples center around such recent villages as Wrangell, Tongass, and Gash, the Cape Fox people's settlement. The Tlingit people admired the work of the Tsimshian artists and often commissioned them to fulfill their carving needs when they could afford such services. The wealth implied in hiring carvers from other tribes also added to their prestige. Stylistically, there was a high degree of similarities between the poles of the

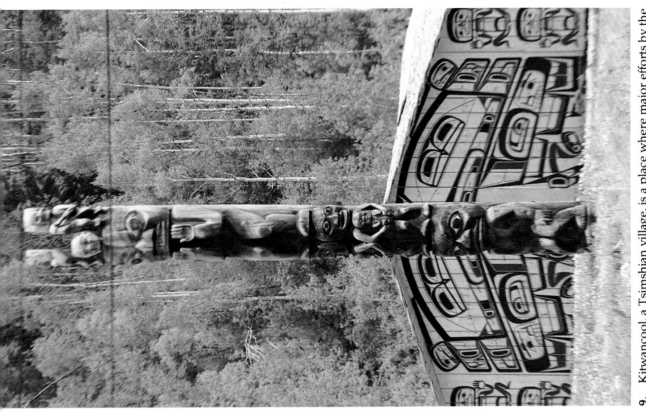

9. Kitwancool, a Tsimshian village, is a place where major efforts by the people to preserve and restore old poles are taking place. It is one of the important centers located on the upper Skeena River of British Columbia. The photograph was taken in 1979.

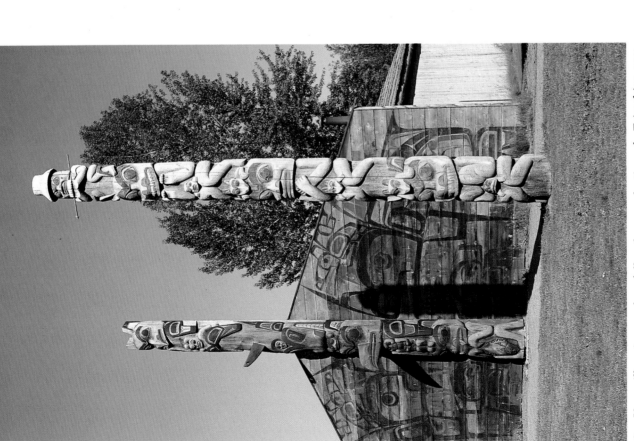

8. Ksan village is a modern full-scale reproduction of a Tsimshian community located near Hazelton, B.C. It has served as a center of Tsimshian social and cultural activities in the 1970s and 80s.

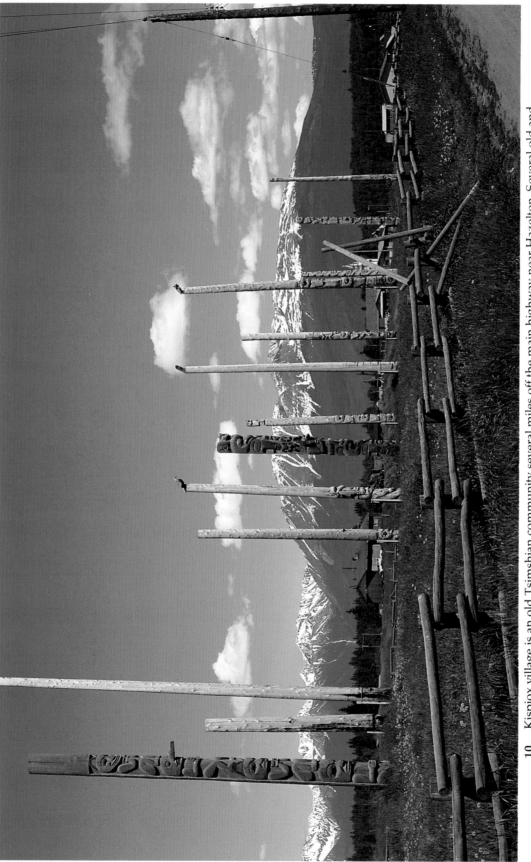

10. Kispiox village is an old Tsimshian community several miles off the main highway near Hazelton. Several old and more recent poles have been preserved at this site.

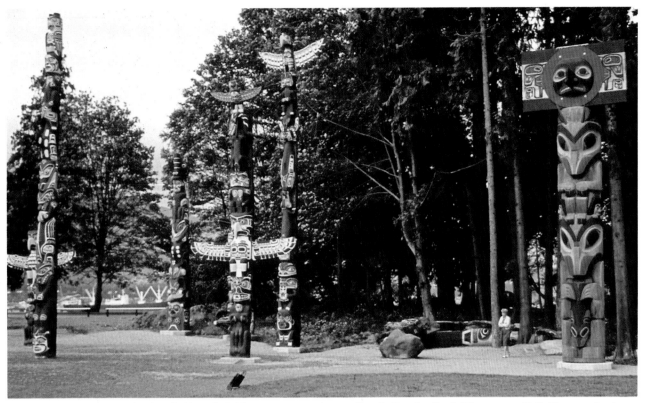

11. A view of Kwakiutl poles (left) and Haida mortuary pole standing in Stanley Park, Vancouver, B.C. These poles have been a center of interest for many tourists and residents alike for years.

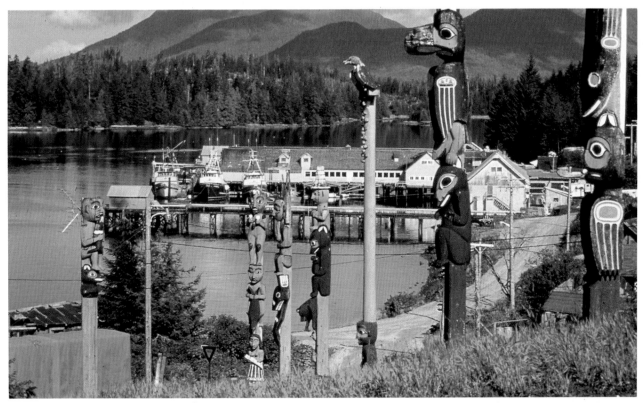

12. Klawak Totem Park on the West Coast by Prince of Wales Island is the site of poles raised from the abandoned Tlingit village of Tuxikan located to the south. They were formerly used as grave markers. *(Alaska Division of Tourism)*

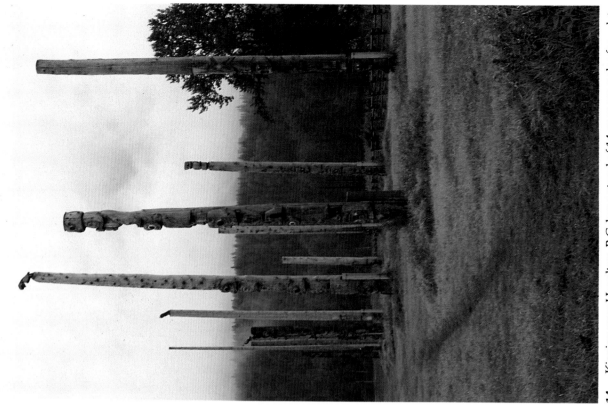

14. Kispiox near Hazelton, B.C. has a stand of 14 or more poles from late 19th to mid 20th century. These poles remain on the site of the original village which has since been moved a quarter mile from the river.

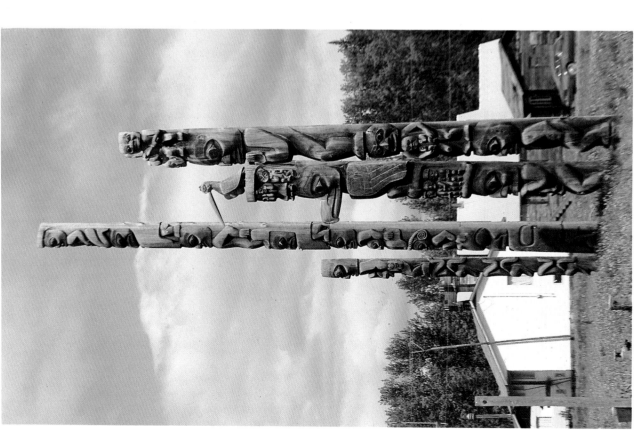

13. Kitwancool village is one of the villages in the upper Skeena River region where the restoration of historic old poles has been an important activity shared by the Provincial Museum and the people of the community.

two groups for just this reason. Writers generally agree the Tsimshian were the teachers, the Tlingit apt pupils.

The basic Tlingit pole is an uncarved log bearing a single figure posed either at the base or the top. It was detached from the house and usually stood in front of it (plate 18). Wrangell had several such poles as well as the more fully carved heraldic poles. There were also a number of smaller grave markers present. Tongass poles were primarily plain shafts as well, although several elaborately carved poles were also noted. Chief Kudena's house was unusual. It had no fewer than six partially carved poles in front, serving as memorials to deceased relatives. The Cape Fox Tlingit raised several fully carved columns as well as many smaller undecorated types. Tuxikan, a town with a considerable number of small grave markers, raised no large columns (plate 37). None of these villages compares with the magnitude of Tsimshian production. Northward of these Tlingit settlements, poles are rather rare or nonexistent. Neither Sitka nor Angoon had any; the Hoonah people in 1889 had but one; in Klukwan and Yakutat there were one each. Small mortuary columns were reported in these places, however.

Tlingit subjects included animal, bird, and human forms with the first two predominating. The human figures appeared with less frequency than among the Tsimshian. Like the Tsimshian poles, the arrangement of the figures was in blocked-out spaces, placed one above the other with little use of small intervening figures to serve as space fillers. Figures 22, 126, and 127 are examples. Contrast figure 35 with figures 36, 52, 53, 136, and 137. Little attention is paid to interlocking arrangements and smooth transitions from one figure to the next as one sees in Haida examples. Furthermore, since the poles are smaller and very slender they appear to have a delicate, almost fragile, appearance.

In Tlingit columns the top figure generally symbolized the most important lineage or clan crest of the owner (eagle, fig. 24A, 35; raven, fig. 35, 137; killer whales, fig. 23, 136). They are usually related to mythological themes treasured by the families arranging the carving of the pole. The Tlingit poles share the Tsimshian practice of naming each pole thus helping to identify it. Names are usually taken from the major character depicted at the top.

Skils and coppers are occasionally seen accompanying the figures (fig. 35 and 137). In other words, these symbols were less widely used as decorative or symbolic spaces, the farther from the Haida center of diffusion.

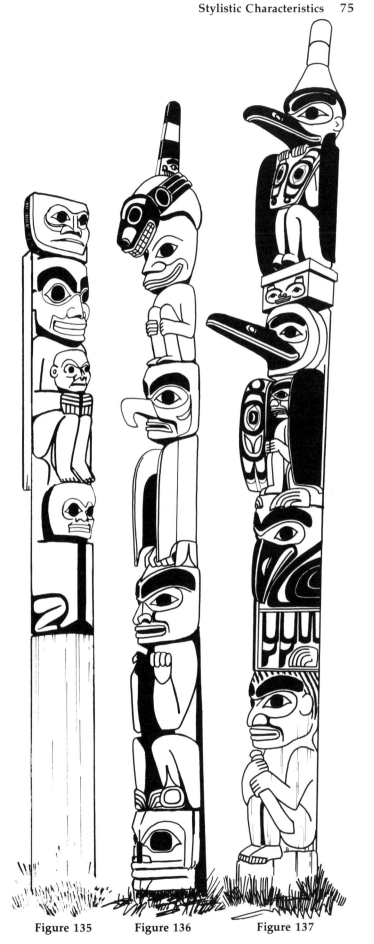

Figure 135 Figure 136 Figure 137

A major point of difference is the heavier reliance the Tlingit placed on the use of paints, together with the more extensive palette of employed colors. The artists greatly elaborated the details on wings and body parts of the subjects depicted. Little of the natural wood was allowed to show through, revealing a distinct difference from Haida and Tsimshian models. Notice also the Tlingit utilized appendages much more frequently to enhance the size of the figures. The mortuary figure of the killer whale in figure 24A, that of the killer whale atop figure 136, and the large projecting raven beaks in figures 35 and 137 are typical examples.

Tlingit poles were not hollowed out, thereby following the general Tsimshian practice. Many are also squared at the lower parts of the trunk, rather than being left in the round. The reduced size, height, and extensive use of paints all provide clues distinguishing characteristics of Tlingit style.

All three northern peoples—Haida, Tsimshian, Tlingit—were part of an established artistic tradition that is called The Northern Style. The southern Tlingit constitute the periphery of this tradition. But the Northern Style influenced numerous tribes to the south where it wrought profound changes in the cultural life of tribes.

THE KWAKIUTL STYLES

It is necessary to distinguish two time phases as well as two separate tribal groupings when considering the Kwakiutl style. One group were the Northern Kwakiutl, the other the Southern Kwakiutl. The northern group occupied territories adjacent to the Coast Tsimshian and were considerably influenced by them in both social organizations and ceremonial practices. We can follow their history only for a brief time up to the middle of the 19th century. Unfortunately, their tribal life was swept away at approximately the same time Tsimshian fortunes and population were declining dramatically. Western influences, including mass conversions to Christianity, deeply penetrated these tribes. Historically, a considerable lacunae therefore exists relative to the nature of their pole carving. Precious few examples have survived to the present. Franz Boas, the famous anthropologist, wrote in 1923 that the entire Northern Kwakiutl way of life had disappeared (Olson, 1955). A few members resisting Western influences moved either to the Tsimshian village at Klemtu or to Bella Bella where they ultimately merged with Western Settlers. Olson's research in 1935 through 1949 among these remnant popula-

tions disclosed they once raised carved and painted figures to serve as memorials to their deceased relatives.

The Northern Kwakiutl used a memorial-type pole minimally carved but with painted boards having family crest designs that were placed on platforms near grave sites. The Northern Kwakiutl knew about house posts and also raised welcome figures—replicas of chiefs and lineage crests several feet high that were placed on the beaches in front of the village in order to welcome guests. These practices suggest a sense of elementary pole design was present from early on, but since Olson could find no evidence of totem poles among them, it is possible these groups never went beyond such small, simple columns.

The Southern Kwakiutl tribes, in contrast, play a more prominent role in the development of totem pole styles. Here we must distinguish two developmental time frames: an earlier period of prototype poles continuing to the 1870s and '80s, and a second phase that includes the last decade of the 19th century plus the first two decades of the 20th.

In the region of Owikeno and Bella Bella, where people are akin to the Southern Kwakiutl both linguistically and culturally, the picture becomes more concrete with the appearance of both prototype poles and poles of greater complexity. The heraldic types and house frontals make their initial appearance among them. While these types are not widely dispersed geographically we can locate examples of the forerunners which gradually spread to other areas. Note the house frontal pole from Bella Bella in figure 47 from this period. While we are unable to attribute such poles to the Northern Kwakiutl for want of adequate information, the testimony of Olson's informants cannot be ignored.

The fate of tribes which constitute the Southern Kwakiutl on the other hand contrast sharply with their northern relatives. These groups living in greater isolation from Western influences successfully kept their social organization and institutions intact in this period. Their circumstance provided them with a respite from the pressures generated by government agents and missionaries alike, a reprieve not afforded their tribal neighbors to the north.

The Southern Kwakiutl remained aloof from the embrace of Christian culture and values save for the acceptance of Western tools, materials, etc., which were advantageous to them. The Kwakiutl defended traditional social institutions with a vengeance by resorting to various subterfuges as

well as renewed emphasis on institutionalized activities such as potlatching. A continuation of customary building practices, acceptance of new styles of clothing, and the integration of new elements of material goods also stimulated totem pole carving. Carved columns began to appear with greater frequency in the late 19th century and increased in tempo until pole raising literally exploded with frenzied carving in the early 20th century.

It is interesting to return briefly to Adrian Jacobsen's diaries for a historic comparison. He visited several Southern Kwakiutl settlements in the early 1880s. He notes his disappointment in what he saw, reporting nothing of significance in the way of totem poles, at least nothing that approached the Haida and Tsimshian practices.

He records the presence of small memorial and house posts as well as the beginnings of heraldic and house frontal poles. The years following his visit appear to be crucial for the increased activities associated with pole development. The intensification of potlatching was one such activity; another was the influence of Tlingit families from Tongass village in Alaska settling in certain Kwakiutl villages. At about the same time the influential Southern Kwakiutl artist from the Tlawitsis tribe, a leader named Hayharnoos, adopted some Haida carving elements. Hayharnoos was the grandfather of a respected leader named Henry Speck (Ozistalis). Moving from a residence on Turnour Island (Kalokwis), this gifted man settled in Alert Bay and introduced Haida and other northern style characteristics into Kwakiutl art.

This Southern Kwakiutl renaissance surfaced in a village on a small island located in the Johnstone Strait between Vancouver Island and the mainland. As villages go it was not old. The Nimkish band had abandoned their former settlement on Vancouver Island and had chosen this place as their new home. It was called Ee'lis and later became known as Alert Bay. Photographs dated from the mid-1860s disclose that this newly completed community was composed of 11 houses nearly identical in size and of traditional architecture. They were lined up in a single row paralleling the shoreline. The forest behind the houses had been decimated to provide the timber for construction. Not a single carved column is visible. Whether the Nimkish left poles in their former village is an intriguing question that will forever elude an answer.

Photographs dated 1873 disclose additional activities at Alert Bay. House fronts had been painted with large traditional designs representing the family crests of the occupants. This practice appeared earlier though sporadically among occupants of more northerly villages. Despite this obvious adoption of the northern style, no evidence of carved columns appears anywhere in Alert Bay.

Yet, surprisingly, within the next 25 years the village became awash with poles.

This frenetic activity is heralded in a few other Kwakiutl villages where a few poles had made their appearance. The prototype poles are present in very limited numbers, suggesting that they took root at an earlier time, perhaps by the middle part of the 19th century. We find a few poles standing at Tzawatti village in Knight Inlet (plate 21). One pole is reported at Humdaspi on Hope Island (plate 23). The impetus for raising poles grew out of this period. Alert Bay established itself as the center for a flurry of pole carving. It has remained the active center to the present day. It is the only community in Kwakiutl country where a large and significant number of poles have been preserved representing both earlier and later styles.

In the decades that followed, Alert Bay became the pacesetter. The people raised heraldic and house frontals along its single plank-covered street (Frontispiece; fig. 39, 48A, 138, and 139). The number of poles increased. Waves of influences spread to other villages which endeavored to emulate the cultural resurgence centered in Alert Bay.

During this second phase poles appeared, though in a more modest way, at Fort Rupert, Kalokwis, Memkomlis, Gwayasdums, Quattish, Kingcome, Humdaspi, as well as lesser known places such as Harbledown Island and Hku'sam, situated on the Salmon River north of the present city of Campbell River (plates 22, 23, 24, 45). A generation of pole carvers emerged who found employment for their creative talents in these villages, the most prolific being Charlie James, Mungo Martin, and Willie Seaweed.

Now that we have established the time for the appearance of such totem poles in Kwakiutl territory, we can examine the stylistic features.

During the first phase to the 1890s, Kwakiutl poles were simple columns, unlike the complex poles found farther north. They were roughly hewn and utilized large-sized figures separate from one another in blocked-out spaces arranged one above the other, as seen in figures 37 and 38. The subjects were human as well as animals.

There were only elementary attempts at modeling in the round. Comparing the poles to house posts reveals that the anatomy of the human

figures was heavy-limbed with faces often round and ponderously fleshy. There were no interlocking relationships between large and secondary figures and there were few of the latter. Little attention was paid to surface decoration. Paint was used only to highlight anatomical features. The figures had a rigid stance. Coppers were represented and some coppers had crest designs painted on them.

In the following period, the first decades of the 20th century, Southern Kwakiutl poles underwent a major transformation. The poles appeared more frequently and with a combination of elements based both on earlier characteristics wedded to newly introduced elements of Haida design. The style became known locally as the Haida-Kwakiutl style of carving. The poles increased in height and width. Heraldic poles appeared with increased frequency, proclaiming crests and stories of resident families. House frontals also appeared but to a lesser degree (plates 22, 24, 45; fig. 48C). They were not hollowed out.

An increased number of figures began to fill the entire length of the poles though still positioned in the traditional manner, one above the other. The size of the crests or other figures portrayed was proportional to the position it occupied on the pole; the largest tended to be placed in the lower portion, the smaller toward the top. They were charged with more distinctive individual expressions brought out in part by the freer application of colors. Paints were also used to accent and heighten the emotions expressed by the subjects and to highlight features. Large figures appear with smaller ones between them in a manner vaguely similar to the Haida interlocking arrangements. More complex patterns were given to the surfaces, particularly facial features on humans, wings and breast areas of birds, flukes and fins of fish. In other areas the Kwakiutl remained conservative. They did not incorporate the Haida eye style with its large convex orbs. Kwakiutl eyeballs are flat, being on the same plane as the vertical plane of the pole itself; moreover, Kwakiutl eyes on figures tend to be much smaller than their counterparts in Haida or Tsimshian art for that matter. Many appear decidedly disproportional to the size of the rest of the figure.

The effort to emulate Haida designs in paint rather than with high relief carving is obvious. Paint supplanted the carvers' tools in attempting to duplicate elements of Haida formlines and eye patterns. Look at figures 39, 40, 48A, 138 and 139 from this period, for example. Compare them with the earlier poles from Knight Inlet which lacked

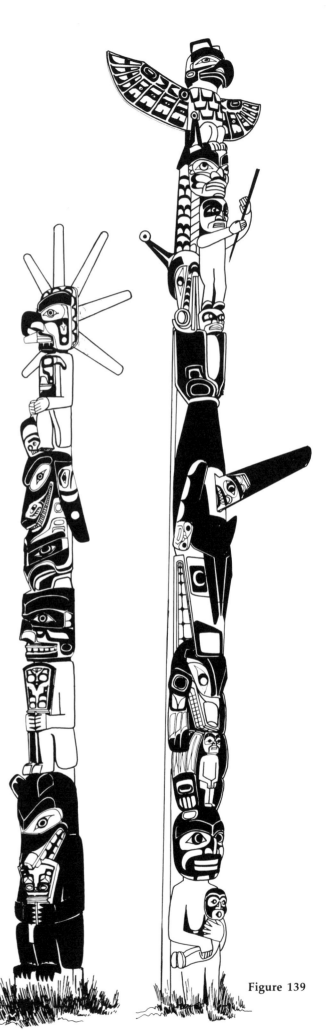

Figure 138

Figure 139

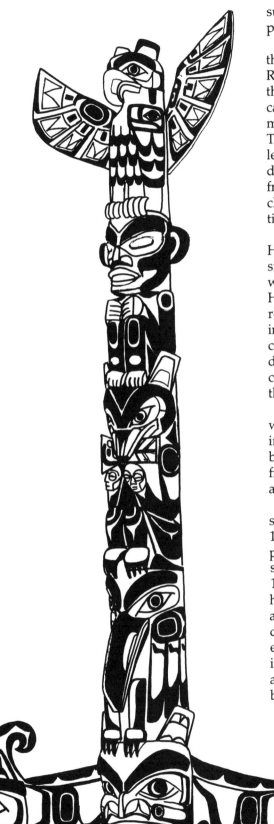

such characteristics. Notice the change in surface patterns.

During this phase Kwakiutl carvers improved their skills. They also became more adventurous. Rather than being bound by the hard and fast rules that governed the work of Haida carvers, Kwakiutl carvers adopted a more flexible position, experimenting with new ideas, new colors, new forms. They showed less concern for formal patterns and less restraint in forms and they improvised a great deal. They made their own rules which resulted in freeing their imagination to meet with the larger challenges at hand—the integrity of their traditional culture.

While Kwakiutl poles are smaller than their Haida and Tsimshian counterparts, they are considerably larger than those of the Tlingit. Equal weight was given to human and other creatures. Human figures were almost exclusively male, representing chieftains or leaders holding coppers in order to protect their families from threats; chiefs standing in speech-making poses and displaying heirloom coppers or standing in their ceremonial robes to communicate to the viewer their inherited rank and social prerogatives.

When animals or birds appear as crests they wear fierce, often intimidating expressions, warning outsiders of their powers. Notice the grizzly biting the copper in figures 138, 140; raven in figure 145; the thunderbirds in figures 39, 48A, 143 and 145.

Some creatures are bizarre: a supernatural spirit, the double-headed serpent seen in figures 139, 140, and 143; Tzonoqua, the forest spirit and purveyor of great wealth, portrayed with outstretched arms, plate 46; figures 55, 93, 140, 141, 142, 145. She is shown also at the base of figure 139 holding an infant. This pole portrays her as an ancestral symbol rather than a spirit, cradling descendants in her protective embrace. Another explanation suggests the elusiveness of rigid interpretations: it represents Tzonoqua the spirit and her child, half Tzonoqua and half human, being held in his mother's arms. The crest

Figure 140

displayed in this manner was often a synonym for the founder or early ancestor as well as patron of the lineage. The Tzonoqua in figure 141 is represented with a copper painted on the upper portion of each arm. In plate 46 she holds two coppers: wealth, power.

Another stylistic characteristic of this period was the tendency to cover the entire pole with a coating of white paint after the carving had been completed. The artist next applied the colors required for each figure in order to further accent the expressiveness of features and the designs associated with each figure. In addition to the traditional colors—shades of deep red, black, white, and a light blue-green—the Southern Kwakiutl began to use greens, yellows, shades of orange—colors never before used and certainly with no ties to tradition. They took to colors with enthusiasm in order to embellish the work. See the painted fins in figures 39, 40, 138, and 139. Notice also the paint around the faces of human figures as well as the designs applied to the coppers in figures 138, 141, and 145.

Kwakiutl carvers relied heavily on appendages to increase the sense of height and massiveness of supernatural crests owned by their patrons. Many of the animals—grizzlies, eagles, thunderbirds, whales—bear fierce expressions. They were also much larger than examples found in most Northern Style carvings to make them more striking. The thunderbird's wings have a great outward thrust; the cannibal raven's gigantic beak thunders with activity; the killer whale's pectoral and dorsal fins thrust widely to the sides and forward. Note the powerful outstretched—even menacing—arms of the Tzonoqua, figures 93, 142. At the top of figure 138 sits a sun crest, the projections representing its rays. Figure 143 illustrates a pole depicting a chief as a commemorative figure holding a staff used in potlatches.

During this second phase poles were anything but subtle, having instead a sledge-hammer effect. The Kwakiutl artists had achieved their objective. They overwhelmed the viewer—all the more desirable, it would appear, for village leaders to impress strangers and guests alike who entered such sanctuaries.

One more stylistic phase of this period must be examined. It encompasses the period from the 1940s to the present, and reveals yet another dimension of the dynamism we have come to expect from the Kwakiutl people. We will consider the modern period of totem pole carving in the final chapter.

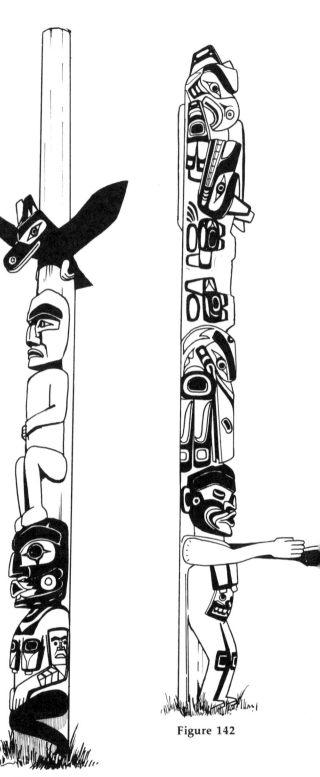

Figure 141

Figure 142

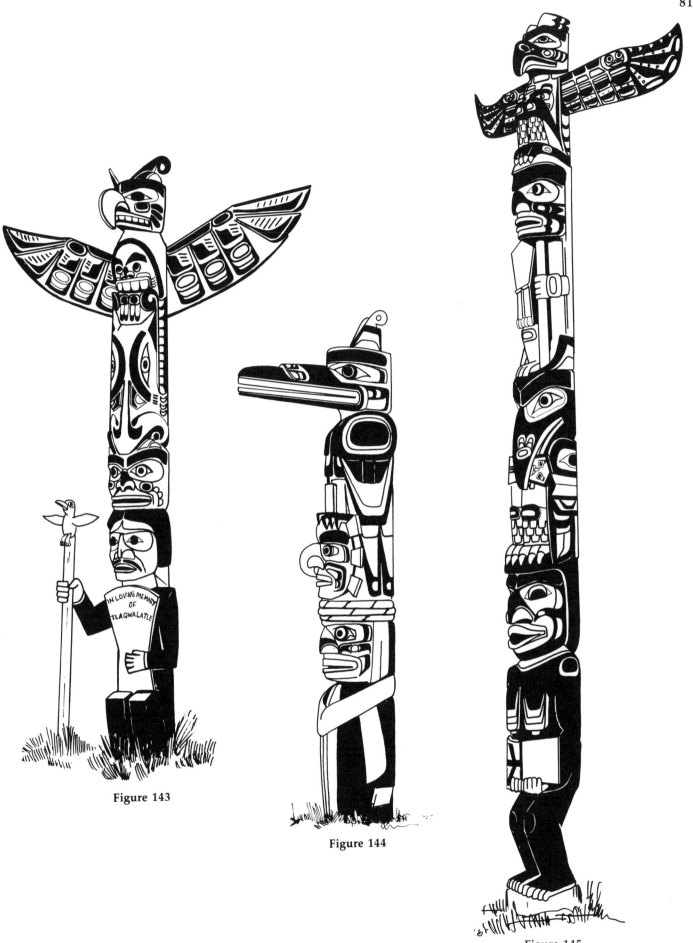

Figure 143

Figure 144

Figure 145

THE BELLA COOLA STYLE

With this group we reach the easterly border of totem pole carving analogous to the Tlingit to the north. The 40 hamlets and villages that once comprised the Bella Coola group took late to pole carving, and the practice did not strongly penetrate their ranks. A likely source of transmission was the Bella Bella tribe, which occupied the coast to the west of the Bella Coola. The latter stood apart from much of mainstream Northwest Coast culture.

The Bella Coola were an anomaly in many ways in terms of their traditions and social organization, which differed markedly from those of their neighbors; both their metaphysical views of the universe, and their sophisticated mythology involving many supernatural beings were regional aberrations. While they raised a few columns in the latter half of the 19th century, poles never played a significant role in their social practices. Stylistically, the poles departed radically from those of their neighbors.

Bella Coola carved columns are short, rarely attaining a height of 15 feet, squat and fat. Faces resemble the people's masks for ritual purposes. Poles, therefore, were not only not imposing but also represented a critical departure from coastal practices. Among those raised were small memorial poles placed by grave sites much as other groups had done. They also used interior house posts covered with carvings. In the three most important places, Talio, Komkotes (Bella Coola), and Kimsquit, they painted the walls of their house fronts with traditional designs (plates 27 and 28). Perhaps they thought it was unnecessary to raise poles because, in practice, painted house screens were equally prestigious, acquiring for their owners the same status and dignity associated with raising a pole elsewhere. A similar attitude, it will be recalled, prevailed among the northern Tlingit groups in Alaska, which may help explain the rarity of poles in these villages.

One writer mentions Bella Coola mortuary poles as memorials. But such poles never contained the ashes of the deceased as with the Tlingit and Haida. To my way of thinking, these poles are then memorial in function, not mortuary. A plain pole was occasionally set by a grave site topped with a small crest figure or a copy of a copper as seen in figures 146 and 147. House frontal poles, on the other hand, were very significant to them. Few heraldic poles have survived. The example illustrated in figure 41 is the only one I have successfully tracked down in the records. It was probably not over 18 feet high; the diameter seems out of

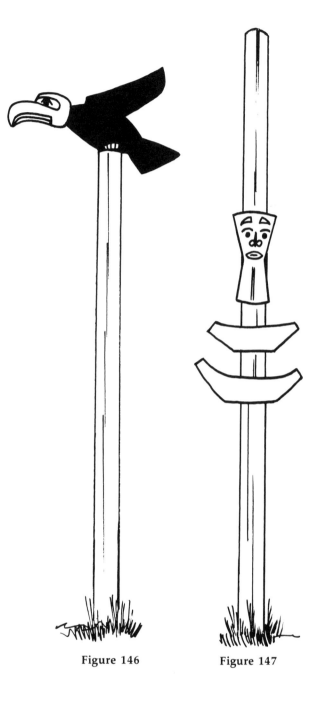

Figure 146 Figure 147

proportion to its height—a distortion, a monstrosity as compared to poles elsewhere.

Bella Coola carvers portrayed humans, animals, and birds. They seemed unconcerned with the overall unity of symbols we have come to associate with the coastal groups. The usual conventions are not present, making the designs more difficult to decipher. It seems the carvers grafted alien elements to their established artistic perceptions. The results are figures whose design and form are not well integrated and difficult to understand in the classic terms. What did the carvers

have in mind? Eagles can be identified, as in figures 49, 51, 146, and 148. A sun symbol is seen in figures 49 and 51; a grizzly, figure 49; stream otters, figure 49; raven, figures 41, 49, and 50. Other crests are more elusive. Note the intriguing space-filling design seen in figure 121 earlier in this chapter relative to the house frontal pole from Komkotes village seen in figure 148. The theme is repeated no less than eight times for both sides of the pole. The face is depicted both vertically and horizontally, as the illustration reveals.

In ways similar to Kwakiutl adaptations, Bella Coola carvers apparently allowed themselves a great deal of latitude both in conceptualizing the forms the subjects took and also the colors applied to them. Human faces arrest the eyes by the very nature of their physiognomy: large fleshy noses, sagging jowls, an almost gross heaviness of facial features—all very reminiscent of the masks they carved for their social and ceremonial life (Malin, 1978).

The surface carving is shallow. Figures rarely emerge deeply in the round. There is a great deal of low relief surface detail with formlines both broad and narrow flowing in different directions then converging at a common point. There is little use of free space to provide logical resting spots for the eye, nor is there space provided to separate one figure from the next. There is a crowded, bunched-up—even chaotic—overtone to the patterns emerging from the figures presented (fig. 41, 49, 51).

Color is heavily utilized in Bella Coola poles, among them a cobalt-blue as well as a bright yellow. These paints are not restricted to definite stylistic features but seem to be used freely to suit the fancy of the artist. They lack the stylistic integration usually associated with the unique Northwest Coast stamp. It would be very difficult to mistake Bella Coola columns for those of any other Northwest Coast group, so radically do they depart from the tradition.

The seven Bella Coola poles illustrated—believe it or not—constitute the bulk of known surviving examples. The historic photographic records suggest there just were not many poles of any types. If I might also add a personal aside, I had a great deal of difficulty in preparing the Bella Coola illustrations. Not only were there few to choose from, but those available lack the clarity necessary to make for a close analysis. Their mystifying handling of design space, breaking with the established Northwest Coast rules governing such expressions, became a tantalizing problem to resolve.

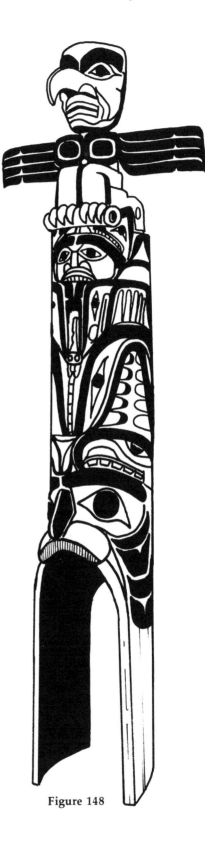

Figure 148

WEST COAST STYLE

With the West Coast people, also known in early records as the Nootka tribes, we reach the southerly watershed of totem pole practices. Like the riverine inhabitants of the Bella Coola valley, these groups did not originally raise large carved columns. The few heraldic poles known are of recent vintage. There is little in the records, either historical or photographic, to suggest the presence of such poles during the Age of Exploration in the late 18th and early 19th centuries. The stimuli for carving them came very late, the result of contacts and influences stemming from Kwakiutl neighbors to the north. But West Coast native culture was already doomed; rapidly changing customs, diseases, depopulation, and culture collapse were to decimate the people.

There is, however, solid evidence for an earlier appearance of house posts in such villages. The most famous prints from the period of Exploration are Webber's line drawings of a chief's house which Captain James Cook and party visited in the neighborhood of Nootka Sound during 1778. Erna Gunther (1972) succinctly summarizes the incident:

> . . . and at the end of the house there are crossbeams supported by two carved upright posts. Each has a large human face with a mouth rounded as though the figure were calling into the distance. The post on the right has a smaller face carved beneath the mouth, and the other has a horizontal band at his waist through which about a dozen arrows are drawn. . . .
>
> When Webber started to sketch them a man who seemed to have authority covered them further. Webber thought bribery might be effective so he cut a brass button off his coat and gave it to him. The figures were uncovered for a short time and then hidden again. Another button was given and the same procedure continued until all the buttons were off the coat. Then the figures remained uncovered (pp. 28–29).

Photographic records reveal no poles at Nootka Sound or Ahousat village (plate 29) in the 1860s. Friendly Cove, a village nearby, had one modest pole standing in 1896, while in 1924 a chief known as Captain Jack had two poles carved and raised near the front door of his Western style house. Modest poles of human figures holding coppers, as in figure 149 from Clayoquot village, are dated from the first part of the 20th century.

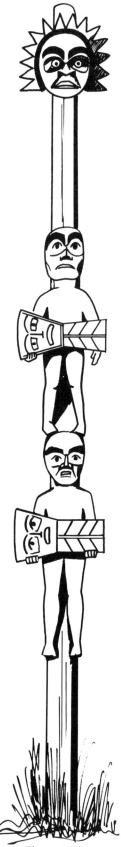

Figure 149

Together with poles such as figure 150 they could be called heraldic types. There are a few scattered here and there in museums; others have disappeared.

While the figures carved are suggestive of Northwest Coast Indian design—a sea bear, a raven, a human figure, coppers—they are a far cry from the carefully modeled, substantial work with the entrenched iconography of the people farther north. Furthermore, the West Coast tribes did not subscribe to the crest system of the tribes living northward; hence, such traditional designs, when used at all, were poorly conceived and poorly integrated into the vertical space used to accommodate them. What poles were present were not hollowed out. They were of modest size and were decorated with paints acquired from modern sources.

West Coast tribes raised welcome figures much as the Kwakiutl groups did, but such figures were actually rooted in practices of the southern section of the Northwest Coast. With both sculptural types available to them, the West Coast people obviously had an established wood carving tradition. But they worked best on a modest rather than monumental scale. They carved ritual and ceremonial masks, delicately figured rattles used for dance ceremonies, as well as other ritual paraphernalia. One exception was the superb seaworthy dugout canoes of 40 or more feet in length that were used for maritime trading and whaling expeditions. But carving on a scale required for totem poles like those raised by northern neighbors had not become an established tradition before the way of life collapsed. As a result even their small initial attempts lacked harmony in composition, a fine finish, and a sure grasp of the aesthetic qualities required to depict the creatures from their environment—supernatural wolves, lightning serpents, thunderbirds, as well as forest spirits and sea dwelling creatures, which were repeated themes in West Coast sculptural forms.

It is possible the explorers made few contacts with the widely spread settlements during this period, so columns of modest figures—house posts among them—might have been lost. Whatever the case, the West Coast tribes fared badly under the onslaught of Western traders. Those elements of tribal culture which they had managed to preserve in the 18th century were quickly swept away in an engulfing tide of change which the 19th century thrust upon them.

We have now examined a broad cross section of carved columns from the northern to the southern boundaries of their use. In addition, we have come to the point of being able to decipher their content and to distinguish the stylistic characteristics intrinsic to each pole-raising group. Now we must turn to the questions of how these poles and their symbolism were integrated into the philosophical views, social activities, and perceptions which created one of the most intriguing cultures humankind has devised.

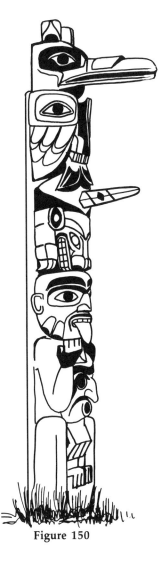

Figure 150

CHAPTER IV

The Social Role of Totem Poles

In approaching this chapter my thoughts go back to my first rendezvous with totem poles in 1946. I had been surprised Alert Bay village was no longer as the Canadian travel photograph had depicted it. True, 50 years had elapsed since the photograph was taken but what met my eyes was worlds apart from what I had expected. The majestic columns that once graced the fronts of the lineage houses had been sold, to be re-erected in other environments—public parks and museum halls in Victoria and Vancouver. A few had been cut down by the owners, providing fuel for their homes. With the exception of two thunderbird house posts (Frontispiece) which had been placed astride the entrance of the local school and a badly damaged heraldic pole standing forlorn at its original site, all recent poles had been relegated to the graveyard in the center of town. The traditional house styles had been supplanted by small, western-type cottages complete with glass window facades.

The real shock was to come upon a jack-straw pile of poles fallen onto the soggy carpet of grass and weeds in the graveyard. Why had the Nimkish people allowed them to collapse? They had been well carved, the figures remained identifiable, even the painted details were visible. Didn't they care about them any longer? Were they considered worthless? What could be done to preserve them? The thought of their imminent disappearance was devastating.

I tried to imagine how they appeared when they stood upright. As I walked from one column to another, my eyes fell upon a small memorial pole

that had broken apart when it collapsed. The pieces, however, were undamaged. I picked them up and attempted to put them together again. They formed the figure of a raven with a long, narrow beak and large appendages serving as outstretched wings. It was a powerful carving that had once stood over a grave.

After putting the pieces together I attempted to stand the pole on a more stable base. At that precise moment some Kwakiutl men walked past the graveyard. They reacted first in astonishment and then with laughter. They were probably thinking, "That dumb White Man! He's trying to raise a pole. How foolish of him."

Needless to say, in a community comprising but a few hundred people such as this, everybody knew about the incident by nightfall. Residents must surely have considered me slightly deranged.

Everyone knows—that is, everyone but me—that no one raises a fallen pole! When it falls, it remains down. Raising a new column requires the expenditure of great wealth, but raising a fallen pole has no merit and is ludicrous. The pole is worthless!

When I started asking questions about the fallen columns I opened a Pandora's Box—a swarm of questions confronted me. Cultural attitudes; differing views of history, morality, etiquette; relativity of values; even the nature of cultural conflict—with none of these was I prepared to deal. In my naiveté, I directed questions to people who could not (and probably would not) answer them. At last I was referred to a 70-year-old Kwakiutl named Luther. I was told he spoke English well and

might be able to help me.

I asked Luther about the poles in the graveyard. Although he was in frail health, he proved a patient and helpful person whom I provided with a number of chuckles. In his gentle way he led me to questions that had never occurred to me prior to this meeting. Answers could be found in looking at the social life and perceptions of his people, but, he added, these were not easy matters to learn about. I never saw Luther again. When I returned the following year he had died.

Luther responded to my questions with his own. Why should poles be endowed with a permanence? Nothing exists permanently. Clans and lineages remain but their fortunes change (the European impact on native life, for example); status and wealth fluctuate; husbands, wives, children leave prematurely (mortality rates had been very high in the previous two or more decades); even a single human being's spirit changes. Some say, he went on, it becomes transformed into a sea lion, for example, and takes up life anew in the sea. Once poles have been raised their mission is completed. To preserve them as Westerners might preserve historical monuments serves no meaningful need in the Northwest society.

Northwest Coast culture was founded on the extraordinary abundance of resources readily available in their environment. From these resources a life style developed of conspicuous consumption. The people worked to acquire their wealth and in turn gave away that wealth in acts of public magnanimity to raise their social status. Resources and wealth were not viewed as something to be "saved" in the Western sense. If the people observed traditional safeguards—restraint, proper propitiatory ceremonies, rituals—the resources on which their wealth depended would renew themselves. Then new poles would be carved and raised again.

One paradox followed another. For example, one morning I encountered a man busily cutting up a 30-foot log for firewood. Upon closer examination I was shocked to find it was a fallen totem pole. Two weeks later in Fort Rupert, I watched and photographed a renowned Kwakiutl artist, the late Mungo Martin, carve a 20-foot totem pole. One person destroying a pole; another creating one—and all in the time space of a relatively few days. There certainly was a great deal more happening than I understood at the time.

Answers to such questions began to emerge as the institutions and perceptions which nurtured the totem pole carving complex were more thoroughly understood.

THE POTLATCHING SYSTEM

The foundation of social activities on the Northwest Coast centered on a practice that gave the culture one of its unique characteristics, distinctiveness, and thrusts—the potlatch. As the central institution of these people and one highly regarded, potlatching probably antedates Western influences on the Northwest Coast by centuries, if not a millenium. It was a widespread custom among the Northwest tribes, even though practiced in different forms with different expressions, in varying intensities from north of the Tlingit people (the Eyak, for example) southward to the Olympic Peninsula and lower Puget Sound. The farther north one traveled from southern Vancouver Island, however, the more complex were its patterns and the more intense its meanings.

Writers have interpreted this remarkable institution differently depending upon the tribal practices they observed, yet all of the accounts may be on the mark. Potlatching took on myriad forms, had many shades and hues of character, and had an inherent dynamism that stimulated continuous adaptation and change. Historical circumstances restricted its spread among some tribes while stimulating and otherwise modifying it among others. Sometimes potlatching assumed forms of tribal rivalry so powerful that the rite led to the killing of low-class slaves and the wholesale destruction of property. But these practices were aberations from periods of intense tribal rivalry rather than the general character of potlatching.

Potlatching does not lend itself to a succinct description. For the purposes of this chapter, providing the backdrop for its role in totem pole ceremonies, I will outline its salient features.

Potlatches are social events given by a host, with the support of his extended family, his lineage, or his clan, for non-kin guests, members of the opposite side of his tribe, or other tribes. Such occasions dwarfed ordinary events in that huge quantities of food and other resources were consumed or given away. Food may include hundreds of pounds of dried salmon, smoked halibut and clams, dried seal and sea lion meat, whale meat, dried berries and sea weed. In more recent history additional foods such as store-bought sacks of flour, crates of oranges and apples, and sacks of sugar, were utilized as well as being items for gift-distribution. To present an affair of such magnitude the host group had to stockpile large amounts of food as well as gifts, the latter sometimes numbering in the thousands. Goods, food, and entertainment were orchestrated into a ceremony of great

formality, sometimes lasting days on end. The food prepared and distributed in a potlatch was on a scale little seen and seldom appreciated in Western culture today.

Small wonder some writers have described potlatching as an institution designed to distribute the wealth of a host, a form of social security, as it were—a scheme for spreading-the-wealth, a food-distributing system in times of need. I, however, think its social character must be emphasized because I believe that this was the principal intent in such undertakings. The motivations underlying it were social; the objectives were social; the end results were social.

The heart of potlatching was to be found in the opportunity it provided families to compete with others in a culturally-accepted framework for eminence and recognition. Such recognition resulted in an enhanced familial social ranking. Families, clans, or entire tribes could and would potlatch depending upon their obligation and/or objectives. Each level of social grouping was graded in region-wide rankings by the success of previous potlatches. Obviously rankings changed as each family tried to outdo those in higher positions. Vast stores of accumulated surpluses had to be given away in successive potlatches to simply maintain if not improve the familial/clan/tribe rankings. With this ever increasing munificence, the family/clan/tribe publicly expressed pride resulting from ownership of its names, crests, and other property.

Potlatching was the forum in which families demonstrated their ownership of names and crests as well as the extent of their material possessions. It reaffirmed the status and honors they had previously acquired. The potlatch publicly proclaimed the nature and extent of the host's property and sanctioned such claims. It enhanced a family's honor and reputation. And it maintained or improved their social standing both within their community and in the eyes of tribal neighbors.

Potlatching was of fundamental importance not only socially but also economically. Maintaining or increasing one's acquired status required giving away all the wealth the host and his supporters had accumulated. These goods and edibles went to outsiders, never to the host's people. Food, hand-made gifts, and trade goods of great variety changed hands. Everyone, save the host's people, left the ceremony materially better off—from the guests, who numbered in the hundreds, to simple bystanders.

Numerous examples might be given to illustrate the pervasive role of potlatching. Of major importance were potlatches given to honor a recently deceased leader and to augment his successor. Tribal law dictated that the vacant position could only be filled following such a rite.

A leader wanting to respond to the taunts and insults heaped upon him by members of a rival clan or tribe, a common form of social intercourse in a status conscious and competitive culture, gave a potlatch to which he invited the tormentors in order to silence them. Thus he upheld his name and his lineage's honor. Such was tribal law.

Potlatches provided the means by which a family claimed counted positions of honor or the prerogatives associated with such honors. If claims were not challenged, the acquisition of these honors were publicly validated through a potlatch.

A Kwakiutl once provided me with another example. A tribal leader confronted with a fractious political group might mount a potlatch as a means of formally putting his views on public record and stiffling the opposition who would have no recourse but to acquiesce or answer with another potlatch.

One writer has suggested that potlatching evolved as a substitute for warfare after intertribal raiding was outlawed. The theory is that property was substituted for weapons in fighting; however, apparently this hypothesis simply doesn't square with other interpretations recorded by observers. For example, some tribes residing in close proximity to others who competed viciously in potlatches rejected such confrontational rivalries. Their potlatching customs were amiable rather than antagonistic, peaceful rather than contentious.

Potlatches were sometimes presented by groups in a series, one tribe inviting outsiders to their festivities and in turn being invited as guests, a form of reciprocity prevailing among them. In this way, a series of continuous equalizing exchanges took place over a considerable period of time.

In contrast, although all potlatches were exceedingly costly affairs, when competition turned vicious they led not only to the consumption of vast amounts of wealth but also to the destruction—wanton, arrogant destruction—of whatever resources were left, hurling the hosts and their families into poverty beyond the financial breaking-point. Ah, but what prestige!

Each step in a potlatch—regardless of motivations and outcomes—was blanketed with an aura of formality and dignity, requiring a special etiquette. The rank and status of each guest had to be carefully considered to avoid disputes between guests. Strict rules governed the seating of guests

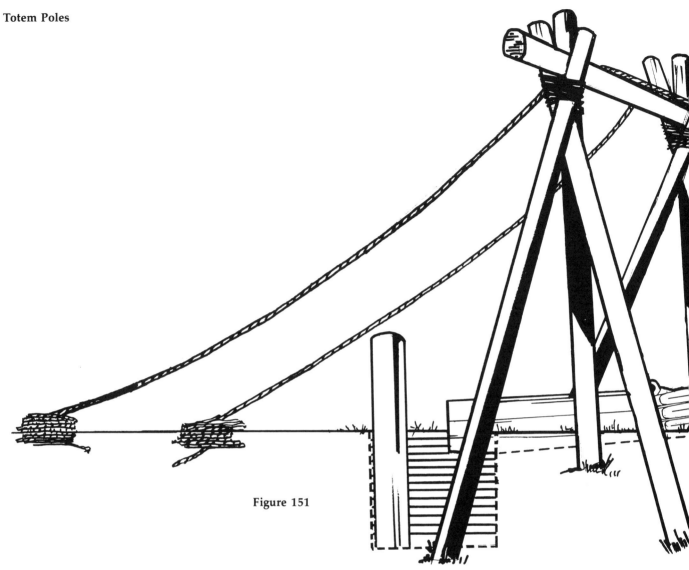

Figure 151

during the ceremonies. The words used by the host to address each of the different ranks of guests must be carefully chosen, great subtlety is involved in the gradations of gifts distributed to each guest—even the eating utensils provided to guests of different statuses were carefully considered.

Potlatching was of such importance, fulfilling such deep and significant cultural needs for recognition, that it was targeted for destruction by the European settlers. Since it formed the bulwark of tribal social values and identity, government representatives and missionaries were determined to stamp out the practice. It was viewed as not only abhorrent to Christian behavior but dangerous to civilization. Efforts to root it out, however, were never fully realized, so potlatching is now making a genuine comeback.

POTLATCHING INVOLVING TOTEM POLES

Potlatching was not confined to those tribes who raised totem poles since many tribes did not carve or raise poles, but all the Pacific Northwest Indians potlatched. On the other hand, for any client who with his kin group planned to raise a totem pole, a potlatch was a necessary prerequisite. Without a potlatch the pole would lack meaning and significance. Raising a pole could be a social disaster, resulting in loss of face for the host and his people if all the complicated social and cultural factors marking this society were not carefully integrated. Potlatching must be planned in every minute detail. A pole-raising potlatch required long-range planning on the part of the host and his people. Considerable planning was necessary just to arrange for the carving of the pole—who was to carve it, what crests and symbols were to be used, where it was to be located and raised, etc. The

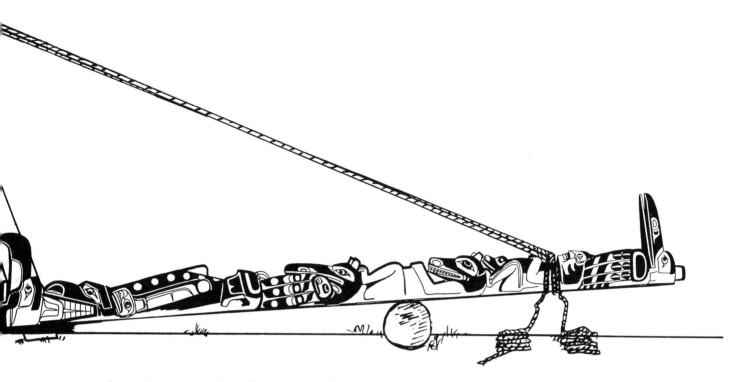

carver selected was pivotal to the success of this potlatch.

After the appropriate carver had been located and commissioned, other activities were coordinated. Food had to be planned and the gifts had to be gathered or made by craftspeople. Invitations had to be sent by messengers informing guests of the times for the occasion.

A year or longer was required to carve a totem pole of only moderate size. Heraldic and house frontal poles—unlike the less ornate memorial and mortuary types—commonly incorporated many figures because they were story-telling columns. They might illustrate but a single story, or each figure might represent a different story associated with a family's history. The messages, graphically rendered, helped bring about the success of the potlatch. The innovativeness of the artist was of paramount importance. Tlingit poles, for example, occasionally depicted figures representing clan secrets since they are not decipherable in terms of any known Tlingit legends or clan histories. These referred to incidents which the guests were honor-bound not to mention.

One or more figures on a pole might represent an implied apology for a past wrong in which amends have been made, the incident being considered closed.

The Tsimshian occasionally gave two potlatches when they raised a pole: the first when the log arrived in the village preparatory to carving; the second—and by far the most impressive potlatch—at the time it was raised. At Kitwanga, a potlatch was given for a pole that had fallen but this seems more the exception than the rule.

While ultimately the totem pole became a part of past ancestral history, it served as a reminder of a glorious event as long as it stood. It reflected the prominence, status, and virtue of the family who paid for it, and they took due pride in their achievement.

RAISING A POLE

Since I must re-create the past in order to explain it, let me describe a hypothetical potlatch celebrating a pole raising.

The day of the raising has finally arrived. Guests have gathered by the hundreds during the last day or two from near and far. The bustle of activity shatters the serenity of the wilderness. Those who have been engaged to assist in raising the pole include scores of men who are also guests. Helpers are rarely a part of the host's family. To do

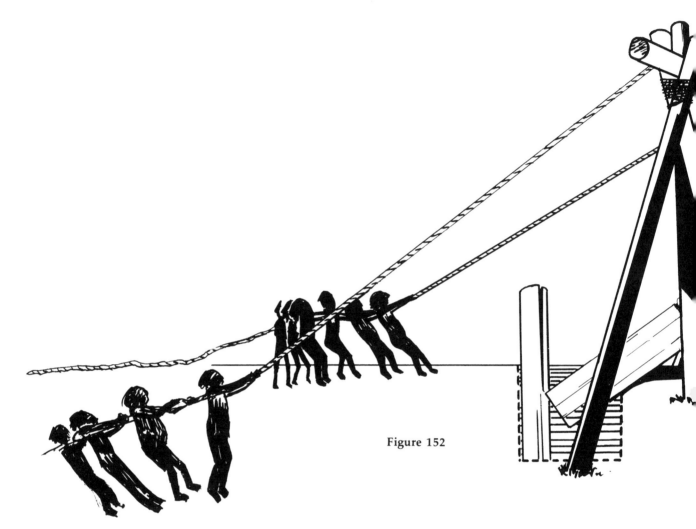

Figure 152

such a thing would be demeaning. In return for their help the host will be obliged to pay each in accordance with the rank and position that they occupy in their respective tribes for the assistance they render. It is a time when the host can demonstrate an enviable and highly prized virtue, open-handed generosity.

The completed totem pole rests on log rollers, having been maneuvered from the beach where it was carved to the place where it will be formally erected. A hole has been prepared by the helpers. It is between 6 and 8 feet deep, varying somewhat according to the height and diameter of the column as well as the level of the water table. A channel or trench has been prepared extending from the base of the pole to about 15 feet along the column, slanted in a 10 or 15 degree gradient (fig. 151).

Days earlier a scaffold of sturdy timbers about

20 feet high had been raised by the hole. The necessary ropes, consisting of three-ply strands of twisted cedar bark, are placed at strategic points nearby. Some of the ropes are thrown over the crossbeam of the scaffold and attached to the upper portion of the column while others attached at the same place are left free on the ground. Supports of several slim timbers of various lengths are placed nearby for propping.

The host and his kinsmen, dressed in their finest attire and carrying the symbols of their crests, rank, and position, approve the site. The artist or carver is among them as an honored guest, dressed in formal clothing for the occasion with adzes, cutting tools, and other paraphernalia suspended from his neck and waist, symbolizing the role he has played.

The host, or an orator especially designated to

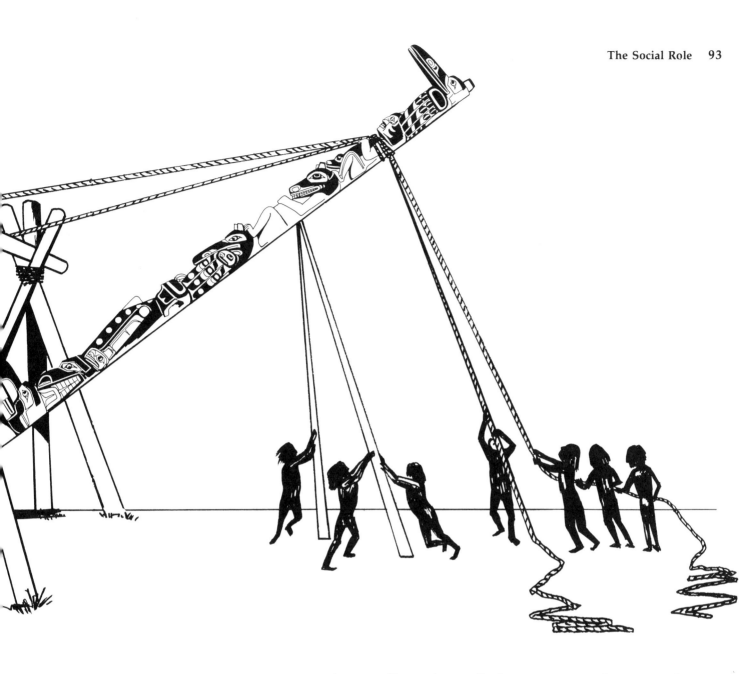

speak for him, now shouts encouragement to those who have assembled to help raise the pole. He exhorts the people to be diligent, to complete the task at hand with great care, to work in unison with the others. They are directed to their assigned places. The drama about to unfold is suffused with tension as well as anticipation. The hour of destiny is at hand. The event must be savored for it took years in coming. Perhaps it is the culmination of a leader's life experience, the apogee of a family's social activities, or the long-awaited revenge on rivals who had gained prestige at the expense of a clan.

Raising the carved column takes several hours and is a drama played out with a myriad of implicit, and hence unstated, as well as explicit messages. The proceedings now enter the critical second phase (fig. 152). The people at the left of the illustration pull the two ropes that cross the scaffold and connect to the pole. They pull with all the strength they can muster. The pole creaks and trembles as raw energy moves it from its temporary resting place in the trench. The helpers in the right of the illustration (fig. 152) prop the upper portion of the pole with notched timbers to support it as the pullers take a new purchase on their ropes. The helpers shown at the extreme right maneuver the two attached ropes in spread-eagle fashion to guide the pole and keep it from swaying. A hush falls over the guests. Will the ropes hold? Will the pole oscillate violently and possibly topple? A fallen pole is an utter disaster for the host and his family. It might necessitate hosting an even greater potlatch to erase the memory from the minds of the guests.

The host, or his orator, again comes forward. In

order to keep the pole from falling, more speeches are required. The speaker continues to urge the helpers to try harder, to gather their strength for further exertion. The pole inches upward, a little at a time. There is another pause to rest, to gather new energy. More speeches follow from visiting dignitaries. In this phase, seen in figure 152, a holding pattern near the crossbeam has been achieved. Since the column weighs several tons it must be continually propped and kept restrained from going askew. One wrong move and the pole will come crashing downward, possibly crushing some notable guests. Notice the base or heel of the pole has now slid partly into the hole. It rests tentatively against a small upright timber placed there to direct the heel downward into the bottom. The log groans under the pressures on it. When the heel has dropped safely into the hole one major milestone has been passed. It now remains to raise the pole to a full vertical position and adjust its direction to face the water and finally secure it in the ground.

It should be noted that the entire operation can unravel in the second phase, shown in figure 152, unless all the materials and the crew involved play their respective parts with great precision. The ropes must be undamaged and durable in order to accommodate the stress of raising such an enormous timber. The crews pulling the ropes at the left of the scaffold must work in unison. The people who change the placement of the props steadying the pole must be alert and vigilant, moving quickly to change the supports. The helpers at the extreme right can under no circumstances allow the pole to skew away from them.

During the final phase, (fig. 153A and B) the small timber in the hole is removed. The column is steadied by means of the several ropes attached to it, and additional props are placed to support it elsewhere. As soon as the column is perpendicular and faced toward the sea, others help at a fever pitch to fill the hole with large boulders and earth. Boulders secure the pole to prevent tilting and keep it from being prematurely uprooted by winter storms. Generally, the use of scaffolds for raising poles was more commonly seen in the northern Northwest Coast area while an assortment of ropes and smaller log supports were used in the southern areas.

At the precise moment the pole comes to its proper vertical position, a sense of elation—even wonder—pulses through the crowd of guests. The pole soars skyward. Few people walk away unaffected by the experience. During this time the host—or his professional speaker—narrates with special eloquence the stories represented on the

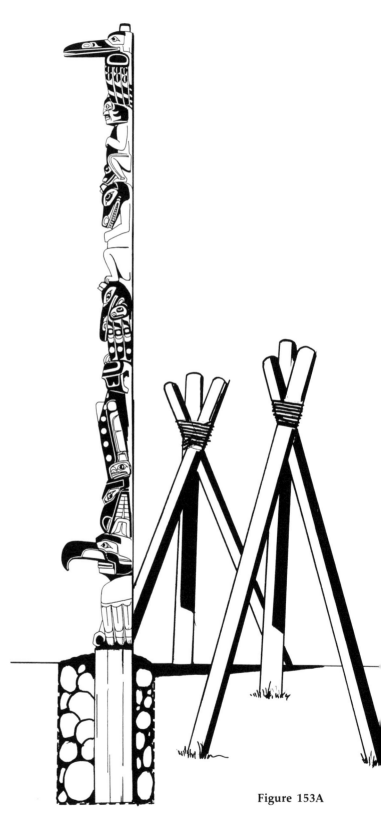

Figure 153A

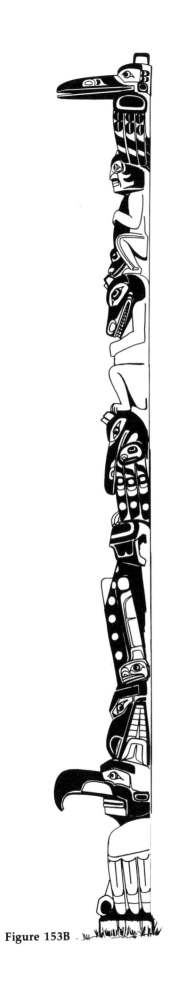

pole. The telling of these stories and legends may last hours, requiring periodic pauses to allow the guests time to refresh themselves. They must be energized with additional food, liberally distributed. The raising of the pole represents the culmination of such a potlatch. Gifts are brought forward and munificently distributed; even commoners who witness the event receive them.

I wish to point out that when the pole is about to drop into the hole, as seen in figure 152, some hosts, in order to proclaim their utter disdain for their wealth and other possessions, have a slave—perhaps even two—executed and dropped into the hole (slaves being an ostentatious form of wealth). The evidence for such a practice is only thinly substantiated. Traveling accounts occasionally refer to the breaking of coppers by the host after which the pieces were thrown into the hole prior to filling with earth. A copper was called a substitute for the slaves that otherwise would have been dispatched. Coppers, however, were considered far more valuable than slaves.

The totem pole I have chosen to illustrate raising techniques (fig. 153B) was an historically important one. It is drawn from a copy of an original Tlingit pole belonging to the Hunt family of Tongass village, Alaska. The copy was raised in 1905 in Fort Rupert, a Kwakiutl village. The potlatch celebrating its raising was impressive. The ceremony and pole were designed to proclaim the family's prominent northern origins, implicitly challenging those who had called their origins into question. It was raised by David Hunt to honor his great-grandmother, the daughter of a renowned Tlingit chief, and was known as the Hunt "Raven" pole. The carver was Charlie James, a Kwakiutl.

Unfortunately this pole no longer exists. Between the years 1946 and 1950 I visited Fort Rupert four times and walked by it daily but never bothered to photograph it because the details were poorly preserved and the appendages had fallen off. By the mid-1950s it had fallen to the ground. It was then cut into several pieces which were eventually acquired by Glenbow Museum in Calgary, Alberta.

THE HOST'S ROLE IN POLE RAISING

While broad, simple generalizations applicable to the different tribes are subject to numerous exceptions, I must nevertheless attempt to limn out the continued steps in the preparations for carving a totem pole. The host negotiated with the carver of his choice to create the pole. While the chief is the

Figure 153B

negotiator, the pole is never his property alone but is shared with members of the kin group—be they of his lineage, or the larger clan group, or a still larger unit characteristic of the most northern tribes, the moiety or half of the tribe. In short, a totem pole belongs to all members of the group looking to a particular leader as their representative.

Property and ownership rights, which included not only material but also nonmaterial elements (songs, crests, family history, dances, names), were highly developed in Northwest Coast culture. So just as appropriation of material property belonging to others was viewed as theft so was the display of crest symbols, etc., not belonging to a family considered a heinous crime.

A pole depicted the crests and other important events that were fiercely held property of the kin group sponsoring the pole raising and potlatch. The carvings never represented property belonging to or common to others but were restricted to symbols belonging to the sponsor. Inevitably, disputes arose as to who had the right to claim or own what. These quarrels were settled through negotiations or, on occasion, by further potlatching. The group mounting the costliest potlatch which the opposition could not exceed was acknowledged the victor and their claim validated. There were occasions, however, when claims and the resulting potlatching escalated dangerously, particularly among some Coast Tsimshian and some Southern Kwakiutl tribes, not uncommonly resulting in inter-clan feuds.

How were crests, so treasured, acquired by their owners? There were many ways. The most commonplace means was to be born into a group which possessed one to many crests. The child upon reaching maturity as a leader was entitled to own and use them if he was firstborn. The crest was a potent symbol of a person's identity which he carried with him through initiations, marriage, and ultimately death. All villages of the Tlingit tribes, for example, were divided into halves called moieties. Each of these moieties was one or the other of two important crests, one moiety being the wolf, the other the raven. No person's identity was associated with both. The Tlingit counted further divisions, breaking the moiety into still smaller units or clans, each of which had other crests: eagle, grizzly, dog salmon, dogfish, killerwhale, frog, mountain goat, beaver, or woodworm. In other words, each member of the Tlingit tribe owned not only the crest that denoted his tribal identity but also one designating the clan of which he was a part. Other crests were accumulated through yet other means.

In a manner similar to the Tlingit, the Haida also used a dual organization of halves, eagles and ravens. The eagle group clans each possessed a special crest—eagle (again), beaver, hummingbird, skate, sculpin, or raven (once). In the raven moiety or half, there were whale, sea wolf, grizzly, frog, killer whale, snag, and so on.

To complicate matters further, the neighboring Tsimshian also established formal tribal divisions with associated crests, but the tribal system was based on a different organization which, for the sake of simplicity, we will call clanships. Tsimshian crests were killer whale, eagle, frog, blackfish, raven, frog-raven, fireweed, and so on. But unhappily for our Western logic there were, for example, many raven crests, not just one, and these were scattered among various clanships. However, each clanship raven was different from those of the other clanship ravens. To try to clarify this confusing situation, just as the eagle and killerwhale crests were different from one another because they represented the clan legends describing their origins, the differing ravens of the Tsimshian clanships represented, in theory at least, different origins also.

The Haidas acknowledge that some of their crests came directly from Tsimshian sources, examples being the mountain goat and grizzly crests, both of which are mainland animals and not found in the Queen Charlotte Island habitat.

The crests representing the lineage or clan affiliation outweighed in importance, emotional significance, and psychic identity the crests which were associated with the larger tribal unit, strange as this may seem.

In addition to these family crests, which numbered two, three, and occasionally more, other crests were owned by specific families. Most commonly these additional crests were acquired through inheritance from ancestors who claimed to have received them as gifts from supernatural benefactors. A special category of crests among the Tsimshian were gifts believed to have been bestowed on ancestors by spirit powers, called Naxnox ("x" pronounced as in German "ch") spirits, who were encountered. The crests may also symbolize the original ancestor in animal or bird form before transforming into a human being.

Spirit crests were passed on as a part of the dowry of a woman from an aristocratic family when she married. Crests were acquired when one group paid another for damages incurred for one wrongdoing or another—paid by transferring one or more crests—or in raids on neighboring tribes, the

victor claiming the victim's crest property.

Occasionally, a tribal chief could command the resources to erect a number of poles in his lifetime. Indeed, Barbeau has identified several who did so. Some had potlatched as many as six times, a remarkable feat. Historical accounts identify several—the so-called Great Names—who possessed both the prestige, hereditary rights, and wealth to enable them to do so. The wealth they and their followers expended to make such ambitions to greatness was, by standards of the Northwest society, staggering. But often these groups fell to total bankruptcy.

Once a plan to raise a totem pole had been set into motion, the host and his relatives having chosen the carver, the patron then spent long hours in consultation with the artist. For both the host and the carver the making of the pole required a long period of commitment—not just the time and cost involved in the actual carving but also in passing on the proper knowledge about the patron's past. The dialogue between the patron and his carver was of utmost importance to the success of the project.

The patron must movingly—even eloquently—impart his ancestral story and the meaning of his family's crests to the carver. In other words, the patron provided the "fuel" to move the artist to action. On the other hand, the carver had to be responsive, sensitive, diplomatic, and imaginative relative to the events about which he was learning. The patron dramatized such stories—with the appropriate dialogue—in the hours and days they spent together. Not a blade, not an adze, was raised until the carver gained a full appreciation of the rich assortment of tales and stories, which he would keep in mind while carving the significant features. He had to fully understand the important symbols and the decisive messages the patron wished to have incorporated, so they could be properly and coherently emblazoned on the log. The pole had to trumpet these elements, however subtle and arcane, and to do so required not just the artist's skill but his deep comprehension of what was to be said and how.

The patron's ambitions rested in substantial measure on the carver's intellectual power and carving skills. Though there existed a large status gap between the host and the other members of his kin group, such a difference between patron and carver was not apparent. The relationship was rather more as that between more equitable persons, for the carver himself was a person of worth because he was able to command respect due to the status and rank he possessed within his tribe.

Carvers of established merit and proven reputation were held in great respect, for they possessed both a powerful intellect and a profound understanding of the culture in which they worked. Carvers were not only privy to a range of information about their patrons and the power bases they occupied but they also possessed a clear and deep understanding of the wellsprings of their culture, its history, and its inherent meanings—all of which they were able to articulate in full measure through their mastery of the skills of their craft.

The host's options were controlled by several important factors. Tribal custom forbade hiring a carver—were one available—from his immediate side of the kin group or tribe. He must instead seek a carver from the opposite tribal group or, better yet, one from another tribe. Secondly, the patron had to demonstrate the full extent of the magnanimity which in this first instance will be replicated in all subsequent phases at the event. The more he paid for having the totem pole carved, the greater the wealth expended on the potlatch, and so the greater the regard and importance accorded him for the undertaking.

It was usually assumed that the patron was responsible for securing the log. Moreover, he was obliged to supply the carver and his immediate family with their worldly personal needs during the period of planning and carving, even if the project took two years or more to realize. The carver's residence in the village was usually in the house of the patron, and the food and other personal necessities came from the patron's household. Lodging and food were considered only a part of the payment, the balance being paid upon completion of the pole or at the potlatch itself. The final payment consisted of large amounts of materials, trade goods, and blankets, as well as cash.

The carver worked with many different woods native to the British Columbia and Alaska coasts, depending upon the commissions—masks, utensils, boxes, canoes, etc. There was, however, one master wood for totem poles, and it was reserved for them. This was the Western red cedar. The northern Tlingit, those at Yakutat and Klukwan, lived considerably outside the region where red cedar grows, but they imported it at considerable expense for their interior house posts.

Carvers I have known speak about red cedar with expressions bordering on veneration. They refer to its characteristics with affection and warmth: the grain, textures, subtle fragrances—all are a joy to the senses. It splits easily along predictable lines, has different qualities when

moist and dry, yet it is highly resistant to moisture and can last for upwards of 50 or 60 years exposed to the elements. Cedar has differences in hardness; the dark red cedar indicates the wood is harder to work with tools, while soft upland cedar (rather than coastal cedar) is far more workable. There is a great deal of sap stored in red cedar, far less in yellow cedar. When red cedar dries it hardens and is extremely strong. Its surface can take a great deal of abuse. Red cedar seems to have a spirit of its own.

The quality of the cedar log to be chosen was a major consideration: how fine and how sound were its growth rings? Was there evidence of dry rot? What was the condition of the sapwood before the log is cut down? Was it filled with knots? The best cedar was sought in the darkest recesses of the rain forest where it had grown in limited light. Such a tree has fewer knots. The wood from such trees also better resists rot, giving the timber a life of 60 years or more. Noticeable temperature differences in wet and dry seasons favor the development of rot while trees from deep in the forest where more uniform temperatures prevail seem to resist rot better.

The most crucial part of the pole for susceptibility to rot is located about one foot below the ground level (after it has been placed in the hole) to between 6 to 8 inches above it, parts most readily attacked by rot. It is at this point that rot is accelerated by moisture and dampness, weakening the pole sufficiently to lead to its eventual collapse. The life expectancy of a totem pole is 50–60 years except when it has been housed indoors. I was surprised to see that some poles in the forsaken Haida village of Skedans were in good condition despite the fact that it had been abandoned almost 50 years before. Cedar trees had grown over them, providing enough protection for large stretches of carving to survive.

Since the patron provided the pole, it was in his best interest to obtain the best one possible. The search party, made up of his kinsmen, were charged with locating an appropriate tree. Ideally, a tree near the water was selected so after it was felled and the limbs removed it could be dragged on log rollers to the edge of the water and floated to the village. The log was then guided ashore at high tide and secured. It was covered with several layers of cedar bark to protect it from light and air to retard drying, a condition anathema to the carver. A shed might be built over the log to provide the carver both privacy and shelter during inclement weather. At all times, but especially during the milder seasons, the log required continuous care—sheath-ing it with bark to thwart checking, pouring water over its entire length to keep the moisture in the wood, and hence facilitate carving.

A 40-foot log of 4-foot diameter is impressive indeed. Imagine then a 60-or 70-foot log of 6-foot diameter being taken from a rain forest and delivered to the patron's front door! Indolent and lazy the Northwest Coast natives were not!

THE WOOD CARVER'S ROLE

Among the Pacific Northwest Coast tribes the wood carver was a specialized though not usually full-time profession. Carvers were highly respected and well-paid craftsmen. They were unusually gifted, for in addition to their carving skills they were composers of songs, mask makers for the traditional theatrical dramas, dancers, and orators for ceremonial occasions. Carvers were among the most culturally perceptive members of the society, being not only well traveled as a result of their varied commissions but also being privy to the tribal histories and lore of the leading families of several neighboring tribes.

The decision to take up the carver's profession was not lightly entered into. Only young men willing to endure a rigorous apprenticeship with an established craftsman could realize this noble calling. An apprentice could attach himself to a master carver related by an established kinship tie, usually upon recommendation by the young man's personal tribal elders who recognized the promise of a well-born youth. Above all he had to be well connected, having a tie in a hereditary line to acquire good names, crests, and high-ranking status in a heavily class-conscious society. The master craftsmen taking on such a young man usually received compensation from his apprentice's parents or sponsors.

Carvers were always males despite the fact women were held in high regard in Northwest Coast culture. The esoteric nature of the subject matter with which carvers grappled precluded women from dealing with them. The recent movement in the 1950s and '60s which includes the training of women carvers has no parallel in the period of a century or more. The late Kwakiutl carver, Ellen Neel, worked as a carver in the 1940s and '50s by asserting her kinship ties with an established carver, Charlie James, her grandfather. She was a strong-willed woman, determined to learn carving for entrepreneurial reasons. A few other women are carving today but none have achieved the eminence that Mrs. Neel realized.

Apprentices placed themselves under their master's supervision for 10 or more years, gradually acquiring the skills and cultural understanding of their instructors. They were assigned projects of increasing complexity, all under the teacher's watchful eyes. An apprentice was instructed in how to make tools. He familiarized himself with established traditional and formal elements of the craft, as well as the complex rules that carvers were expected to observe. He studied nuances of the tribal crests. He acquired an intimate understanding of the properties associated with the different woods used for various types of carving as well as the technical skills required to work with the wood. He learned through observation and doing under the critical eye of the master craftsman—rather than through lectures and discussion.

After years of such training a promising apprentice was offered his first commission. While a small thing within his tribe's traditions, it enabled him to embark on an independent course.

The master carver utilized a wide range of tools, each made by himself specifically for his own hands and having subtle but important differences in shape, size, and blade contour. Iron-bladed tools were introduced in the late 18th and early 19th centuries by Western traders and gradually found their way into the artists' inventories of equipment, replacing the traditional bone, shell, stone, and copper tools.

The first and indispensable tool used on a totem pole was the elbow adze (fig. 154). The carver possessed a large number of elbow adzes employing a variety of blade edges from straight flat to curved surfaces. The prototype of the iron-bladed elbow adze was a far less efficient cutting tool composed of jadeite, serpentine, or nephrite stone ground to a fine edge and fitted to a haft made from the crook of a tree branch of alder or maple.

The blade was lashed to the haft with rawhide or cedar withes. Iron-bladed tools gradually replaced these cumbersome types. A carver usually required a half dozen or more elbow adzes for the task at hand, each for a specific purpose, each with different striking edge and blade width. The straight metal edge was useful for working flat surfaces. The curved blade in various radii were necessary to handle a variety of rounded or sharply curved surfaces. Plate 54 shows the carver utilizing such a blade to shape fingers of a figure. Adzes of this type were the basic tools for removing large volumes of unneeded wood and giving the pole its rough outline. In addition, they were used to rough out the basic forms contained on it. The adze was used as shown in plate 54 or with both hands in a sustained chopping motion in the manner of a hoe rather than the swinging motion of an axe.

Another tool of immeasurable importance to the carver was the so-called D-shaped adze (fig. 155). It takes its name from the shape of its handle or haft. With metal blades attached, they were utilized to achieve a finer surface and to create details that would be difficult to render with the larger elbow adze. D-shaped adzes fitted the carver's hand snugly and firmly to facilitate smaller features and undercuts. The blades were generally straight-edged and varied from ½ to 2 inches in width. Most carvers used them ambidextrously, shifting the tool from one hand to the other as required by the figure, all the while maintaining a sturdy rhythm in cutting. No carver worked with only a single tool of this type—his tool box typically contained a half dozen or more. The handles were frequently carved with intricate figures of a symbolic nature, done by the owners to bring good luck to their endeavors. The D-shaped haft or handle required a sturdy material such as whale bone or a fine-grained alder wood to sustain the continuous shock of hours of striking against the wood surface.

Figure 154 Figure 155

While these were the basic tools, no totem pole carver could work without a variety of other tools, primarily carving knives, stone mauls and hammers, and antler chisels. A variety of smaller single- and double-edged knives were utilized, some with blades 4 inches in length, others a mere inch or two, but each designed for very specific purposes. The shorter the blade, incidentally, the greater the control over the carving. Better control was achieved by cutting towards the body rather than away from it. There were left-handed and right-handed blades as well as both straight and crooked edges as seen in figures 156A, B, and C. Iron-bladed knives and axes were welcome additions to native technology. Not only carvers but also the people generally recognized the superiority of iron over stone and bone.

In addition to cutting and pounding tools, the carver's standard equipment included: small stone mortars and pestles for grinding the paints used to finish the carving, paint brushes, and various templates for applying a variety of eye patterns.

In the 19th century unbelievable prosperity swept across these shores, the likes of which the people had never seen before, nor since. Carvers were an integral part of this bold new direction. As the vogue in totem carving took hold, demand increased, spreading from one group or tribe to another. Hence, the ranks of carvers and apprentices grew to meet the increased demand for their work, a demand that carried with it the need for increasingly innovative ways of communicating the patron's past.

THE CARVER'S APPROACH TO THE POLES

Keithahn wrote in *Monuments in Cedar* that the carver had little personal liberty in his work, his contribution to the totem pole consisting only of the carving skill, manual dexterity, and knowledge of tradition. The artist, he wrote, was told what he was to create by his patron and he followed orders, offering little input of his own. Such a view is nonsense as it reduces his role to perfunctory acts. It is of course true that the carver had to learn the myths and the crests associated with his patron, but otherwise, he was free to interpret them and integrate them into a composition of his own making. The carver was not a mere copier, his path and perceptions rigidly controlled by someone else. Within the traditionally established patterns for rendering animal/bird/human beings, there were many interpretations possible, and forms could be strikingly and originally portrayed. For example, there is no single mold for envisioning a tree snag (a crest symbol). Grizzlies or thunderbirds were not rendered in a single, set representation, nor were the Ruler of the Sea, Sea Eagles, or the faces of supernatural beings. While the carver was not free to depart radically from traditional ways of perceiving such creatures, he *was* free to establish new insights and interpretations. That was his challenge. The exercise of creativity is often all a matter of resolving traditional conventions with new insights. The same resolution of traditional perceptions with new interpretations occurred in the history of Western Art.

The Northwest Coast carver had freedoms as well as restrictions though they were not freedoms of the Western artists. His choices included the way he might render an historical episode, the expressions and body stances of its characters, the position of arms, legs, flukes, wings, as well as what was associated with them. It included facial expressions and the use of colors. It included further the textures and patterns in the final adzing that completed the pole. The range of expressions seen in the last 100 years or more in totem pole sculptures attest to the artist's innovative spirit—examples that are found *in situ* as well as those stored in museum halls.

No single carver approached the task of carving a totem pole in a set, established fashion. Each

Figure 156A **Figure 156B**

worked out a method that best suited him. It is useful to describe the basic considerations and problems each carver had to resolve.

After the log had been trimmed, the bark peeled, and knots removed, it might be hollowed out at the back to facilitate moving it during the carving process. Hollowing out the entire length removed the heartwood and was geographically limited to the Haida craftsmen for the most part, as most Tsimshian, Tlingit, Bella Coola, and Kwakiutl poles were left in the round.

Armed with the crests and stories associated with the patron for whom the pole was being carved, a plan was worked out for its design. The design had gradually crystallized in the carver's mind during the long sessions with the patron. Pencil and paper drawings were not made until the early 1900s when a few artists used them. Charlie James, the Kwakiutl carver, occasionally made a small model in wood in order to analyze its design and composition prior to doing the actual pole. The carver studied the space contained within the log as well as the relationship of the crest designs and story figures. What additional symbols might be feasible? What about space-filler motifs? How well did the figures "fit" into the overall composition? Did the designs infringe in any way upon established ownership rights of other lineages and clans? The carver had to be knowledgeable enough to avoid such problems. Would four, five, or even six or more figures be required to tell the story the patron wished and would they fit the space of the log? Should the large figures be limited to three, using smaller figures in the remaining spaces? Could subordinate figures be used? Which symbols were of paramount importance? These questions had to be resolved before the carving could begin.

The first step was to stretch a string or cord along the middle of the horizontally placed pole from top to bottom, marking the line with a piece of charcoal, dividing the pole into two halves. Tradi-

tionally the figures were bilaterally symmetrical. The contour line helped the carver maintain the symmetrical balance for each figure. With charcoal he next laid out the crest shapes and symbols across the length of the pole starting at the top and working downward, as in figure 157A. He had to keep in mind the frontal nature of the pole when it stood upright. Laying out the figures in this way helped him focus on balancing each half of the figures, bringing the hands, feet, paws, and wings toward the center.

The charcoal outline was viewed and modified until the design of the pole was finally settled. In figure 157A the design of a 50 foot Tsimshian pole from Gitlahdamsk on the Nass is roughed in. The figures have been roughly measured for size and space. Some carvers started carving downward from the top figure, adzing the general shape of each figure in descending order to the bottom. Among the Tlingit the top figure was usually started first, as it was a considered the most important of the crests to be depicted. This symbol was related directly to the personal life of the owner who was raising the pole.

Only now could the carver take up his carving tools—the vital one being the elbow adze. Chips flew in profusion, settling in a thick carpet around the pole. The rough diameter of the pole was reduced to a working scale and the basic outline of the figures defined as in figure 157B.

Other carvers started the top and bottom figures simultaneously, working first on one, then on the other, as they moved toward the middle figures. I suspect Charlie James used this approach to carve the Hunt "Raven" pole at Fort Rupert (fig. 153B). Notice, for example, the large eagle at the base followed by the whale occupying the space above it. Then notice the three topmost figures, raven, human, and bear. The central figure, that of another raven, seems pinched between those below and above it. It may very well indicate James was running out of space, forcing him to make the

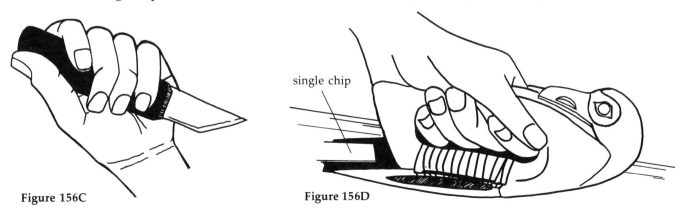

single chip

Figure 156C **Figure 156D**

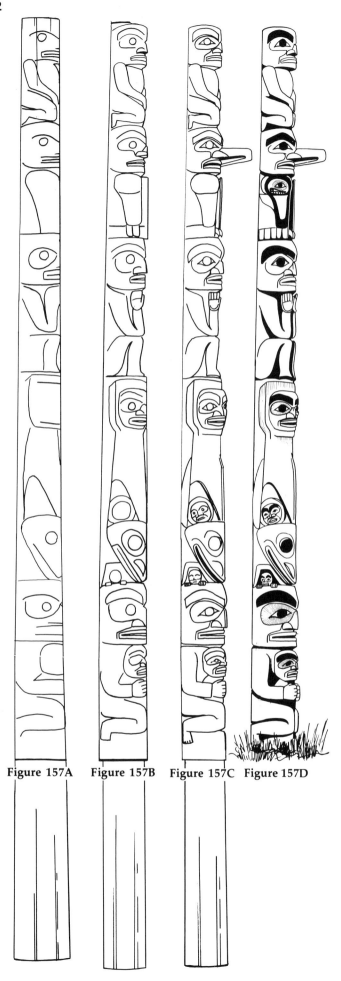

Figure 157A Figure 157B Figure 157C Figure 157D

raven smaller than he originally intended.

In figures 157B and C of the Gitlahdamsk pole, the figures become more sharply defined and details emerge more fully from the log. Charcoal lines were repeatedly redrawn to assist the carver in shaping the figures, using both the elbow and D-shaped adzes. The continuous redrawing with charcoal enabled the carver to stay close to the original space allotted for each figure.

When the pole carving had reached the stage seen in figure 157C, the D adze became the primary tool. The figures fleshed out still further with sharper detail. The limbs and facial features appeared with increased clarity. Finishing details required the use of many types of knives with different blade lengths and curves. The orb of the eyes, the shape of the nostrils, cheeks, and mouth were given further definition. Small crooked knife blades brought out further details in the filler spaces seen in the ears above the bottom figure (a bear) and the face on the pectoral fins of the fish or sea monster depicted above it.

The carver moved from one figure to the next, working further on each. He kept in mind the reference points that related to the size, shape, and posture outlined with charcoal. He continuously compared, matched, trimmed.

Eye patterns were especially expressive and required careful attention. Differences in eye patterns followed tribal lines and reflected many subtleties in shape. Eyes could be perfect convex ovals or rectangular with rounded corners (fig. 86B, C, D, E, F). They might be long and narrow as well as disproportionately large or small in relation to the rest of the face. The inner eye might be convex with a decidedly downward orientation, or they may be carved as flat circles that parallel the vertical plane of the pole.

Eyes had to be in balance with one another. To achieve this the carver cut a template with the design and size necessary for the figure from a piece of cedar bark. He traced one eye, then turned it over and traced the opposite eye, being certain they lined up horizontally. Carvers usually improvised the templates for each project rather than accumulating them for use in different jobs. The requirements differed.

The pole from Gitlahdamsk illustrated in figures 157C and D now approaches final shape. However, there were several steps that remained before it could be considered completed. The appendage constituting the nose of the second figure from the top was carved, then mortised securely into the space provided for it. The facial features were smoothed out with cutting tools and

sometimes sanded with an abrasive such as shark or dogfish skin.

Before the final stage was reached—that of painting the pole—there was one penultimate step. One might call it the extra mile the carver went in order to give his work a special stamp, a special finish of quality. This process was tedious and time-consuming. The pole surface was meticulously adzed with a richly patterned stippling. The tool for this purpose was the small D-shaped adze containing a narrow straight blade. Stippling demonstrated the carver's good adzing skills and his final mastery of the cedar. The surface of the wood emerged with a finely patterned texture of parallel adzing trails that moved along different planes—curving and straight-lined. They covered limbs, eyebrows, eye orbs, face, and body as well as accoutrements the figures might be holding (fig. 158A, B, C, and D). Figure 158A is a replication of stippling in an exaggerated way in order to see it more clearly. The example is redrawn from the lower figure of the Gitlahdamsk pole. Stippling required intense concentration. The D adze was used to remove small chips with each stroke (fig. 156D). The resulting pattern had not only intrinsic value but also helped unify the entire piece, in the same way a frame gives a painting an overall unity. One artist said that stippling on a pole was considered a carver's signature.

Historic photographs do not give good clues to the presence of stippling techniques. Whether the aging and weathering of old poles obliterated evidence of its presence, I cannot say. Perhaps the quality of the film used in those days or the light conditions which prevail along the Northwest Coast were not ideal to catch such subtleties. We see evidence of stippling patterns on some Haida poles but not on all. Stippling appears on some Tsimshian poles of more recent date but not on others. The superb stippling seen on the pole at Harvard's Peabody Museum, illustrated in figure 45, is from Kitkatla on the Coast, but it has been carefully sheltered in the museum for decades. Stippling appears frequently on Southern Kwakiutl examples, particularly on house posts and welcome figures that have been given a certain amount of protection from weather (plates 52 and 53). Having been housed indoors the surfaces have been better preserved and are easier to record in photographs.

The parallel fluted lines constituted the hallmark of finished carving. Stippling surfaces provide an opportunity to reveal the special techniques and skills of the carvers. Carvers examining the work of a rival made their judgments in

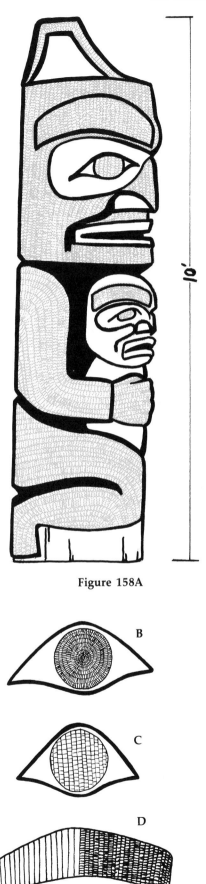

Figure 158A

substantial measure on the basis of the mastery of stippling. Here the carver showed his control of his tools and the finish of his creativity.

The final step in completing the pole was painting. Haida and Tsimshian carvers used paint sparingly; Tlingit and Bella Coola tended toward greater generosity; and the Kwakiutl, particularly in the more recent period, applied color with great relish. Contrast the limited use of paint in decorating the Gitlahdamsk pole in figure 157 with the raven pole at Fort Rupert in figure 153B. They derive from two different phases and styles, and also reflect the controlled expression in one and exuberance of color in the other.

In the early years of pole carving colors were naturally limited: black came from manganese or charcoal pigments; white from clam shells baked and reduced to a powder; bluish green from copper containing clay; reds and browns from various ochres. These materials were pulverized in mortars, then mixed with masticated salmon eggs, resulting in pastel shades. These naturally derived paints did not last long, fading after only a few years. It is perhaps surprising that a 50-year-old pole heavily weathered may still retain vestiges of such primitive paints. These vestiges can provide clues as to what colors were used and how poles were decorated.

By the late 1880s and 90s carvers had increased access to Western sources and forms of paint which, as with iron tools, they quickly utilized in their work. The Kwakiutl in particular covered poles with enamels in a variety of colors, giving them a shiny and lurid surface. This decoration was considered quite in vogue.

Brushes were made both of bristles taken from porcupine fur and of vegetable fibres. I have seen carvers pull hairs from their head, insert them into a small split stick 6–8 inches in length, trim them to a uniform edge, and begin painting. This practice was confined to the oldest carvers, for since the turn of the century commercial brushes have been easily available for such work.

We have examined a wide range of practices associated with totem pole activities: symbols, styles, techniques, mythology, history, and social practices, potlatching in particular. It is more difficult to offer even in a cursory manner an exposition of the content inherent in the poles. However, each pole does tell a story, although no pole is read as one reads a story in printed form. The Northwest Coast Indians were preliterate, in the sense that they had no written language such as has marked the more technologically advanced cultures familiar to us all. The pictorial representations of their legends, history, metaphysics, ethics, and aesthetics depended entirely on a body of traditional learning handed down through an oral tradition—subject to all the vanity and inexactitudes inherent in such a manner of recording matters of great moment. Hence, the symbols associated with particular characters and crests served only as reminders of roles played in a myth or tale critical to a lineage's identity. Bear Mother, for example, or Frog Woman, are but names that are associated with gripping, even heart-rending events involving tests of loyalties, deep emotional conflicts, and ultimate tragedies that can only be understood in the telling of them. Are they plausible? That depends on one's perception of reality.

Only those intimately familiar with the characters and events of the past can tell and, more importantly, understand the implications of the stories associated with them. It is a subject too vast to attempt in the present volume.

More to the point for our purposes, we have seen totem poles as symbols of a way of life that had deep spiritual and emotional roots. It enriched the lives of the people, giving them the energy to participate in events on a scale that commands our deepest respect if not necessarily our emulation. How could this way of life—suffused as it was with such energy, exuberance, and vitality—collapse so quickly and be nearly lost? What factors lead to such a catastrophic outcome? Let us examine some of them in Chapter V.

PART TWO

Photographs from the Past

British Columbia Provincial Museum, Victoria, B.C.: Plates 2, 3, 4, 5, 6, 7, 8, 9, 11, 12, 13, 14, 15, 16, 17, 18, 19, 22, 24, 25, 26, 27, 28, 29, 30, 31, 33, 34, 35, 36, 37, 38, 39, 40, 41, 42, 43, 44, 46, 47, 48, 49, 50, 51, 52, 53.
Provincial Archives, Victoria, B.C.: Frontispiece; Plates 1, 10, 21, 23, 32, 45.
Oregon Historical Society, Portland, Oregon: Plates 20A, 20B.
British Columbia Government: Plate 54.

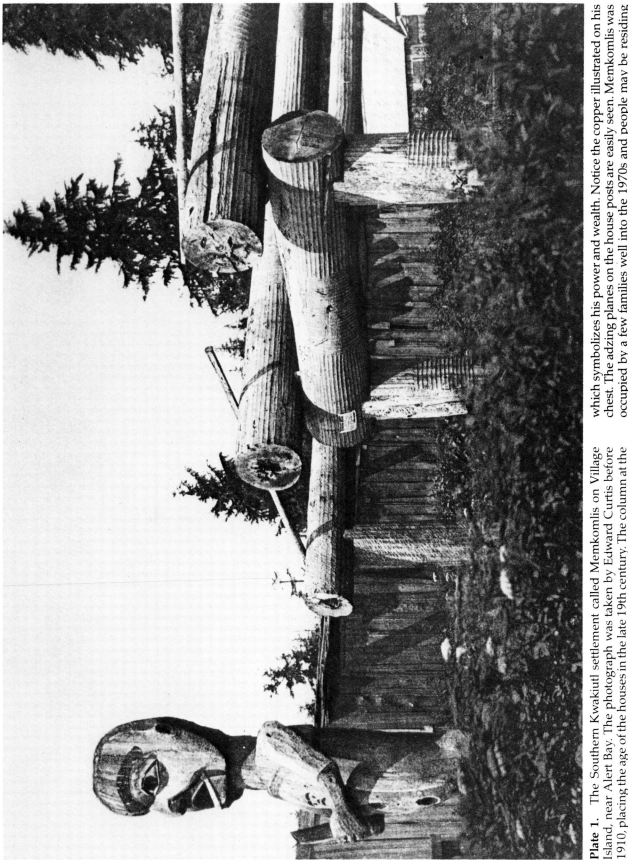

Plate 1. The Southern Kwakiutl settlement called Memkomlis on Village Island, near Alert Bay. The photograph was taken by Edward Curtis before 1910, placing the age of the houses in the late 19th century. The column at the left is a welcome figure representing a chieftain holding a slave killer knife which symbolizes his power and wealth. Notice the copper illustrated on his chest. The adzing planes on the house posts are easily seen. Memkomlis was occupied by a few families well into the 1970s and people may be residing there today.

108 Totem Poles

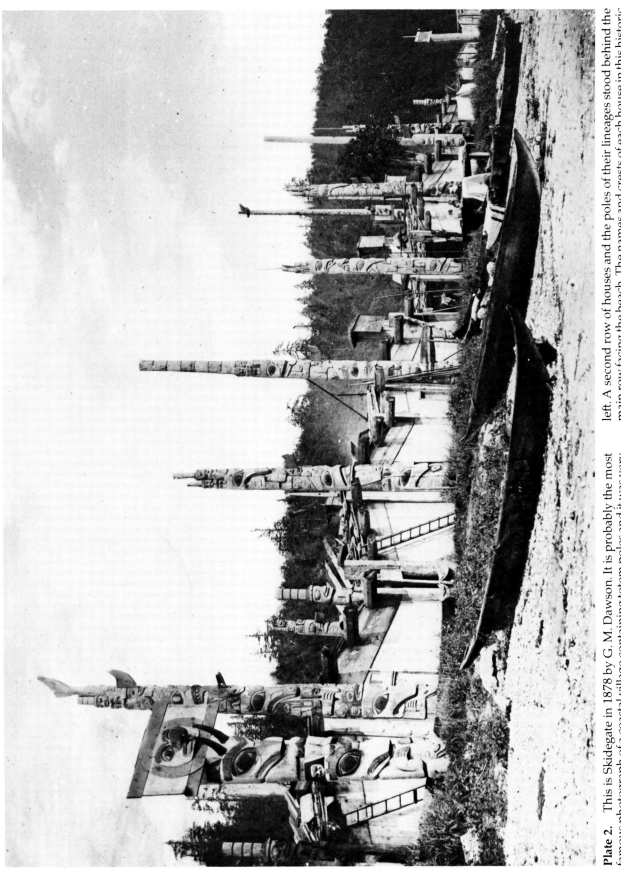

Plate 2. This is Skidegate in 1878 by G. M. Dawson. It is probably the most famous photograph of a coastal village containing totem poles and it was very impressive. Several additional houses and their poles are out of sight at the left. A second row of houses and the poles of their lineages stood behind the main row facing the beach. The names and crests of each house in this historic site are known and recorded as part of the records of this village.

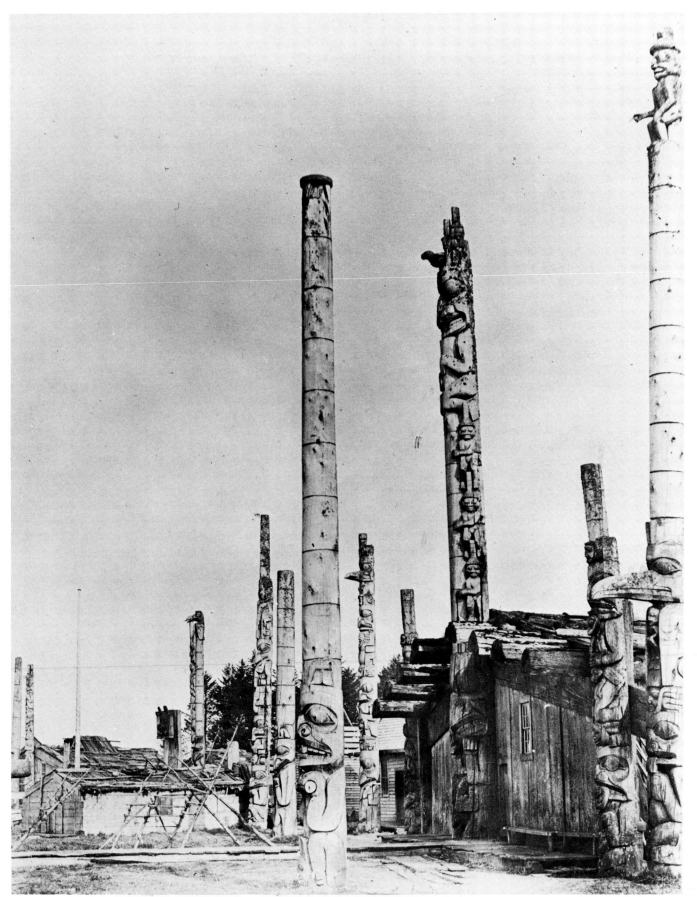

Plate 3. Masset village was located in the Northern Queen Charlotte Islands and was photographed by Maynard in 1884. The view reveals but a small part of this once extensive settlement. A few houses have installed glass windows by this date. A wide range of pole types are seen in this photograph. The house in the right foreground was known as The Monster House and belonged to the Haida chief named Wiah who had it built about 1840.

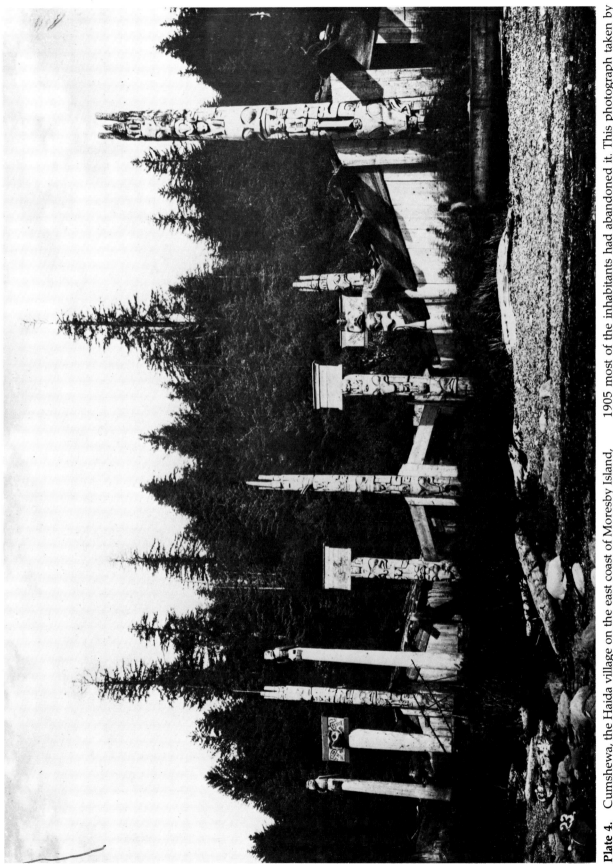

Plate 4. Cumshewa, the Haida village on the east coast of Moresby Island, did not have the dramatic setting seen in Ninstints or Skedans. It was, however, a fairly large settlement of more than 300 people at its apogee. By 1905 most of the inhabitants had abandoned it. This photograph taken by Dawson in 1878 reveals sculptures of considerable complexity and detail but in 1948 many were in a precarious state of preservation.

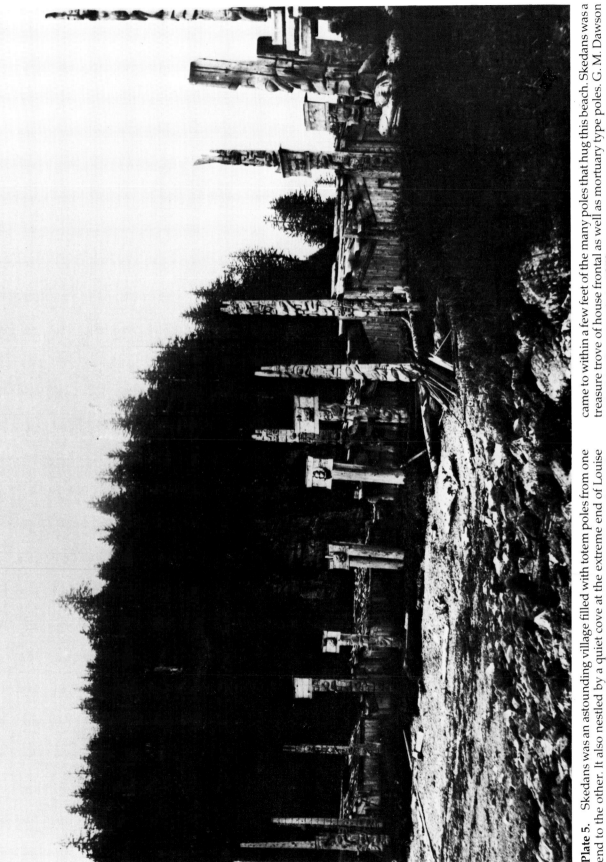

Plate 5. Skedans was an astounding village filled with totem poles from one end to the other. It also nestled by a quiet cove at the extreme end of Louise Island in the Queen Charlottes. The village spread out in a crescent shape, the bluff behind it giving it a dramatic setting. When the tide was in the water came to within a few feet of the many poles that hug this beach. Skedans was a treasure trove of house frontal as well as mortuary type poles. G. M. Dawson took this photograph in 1878.

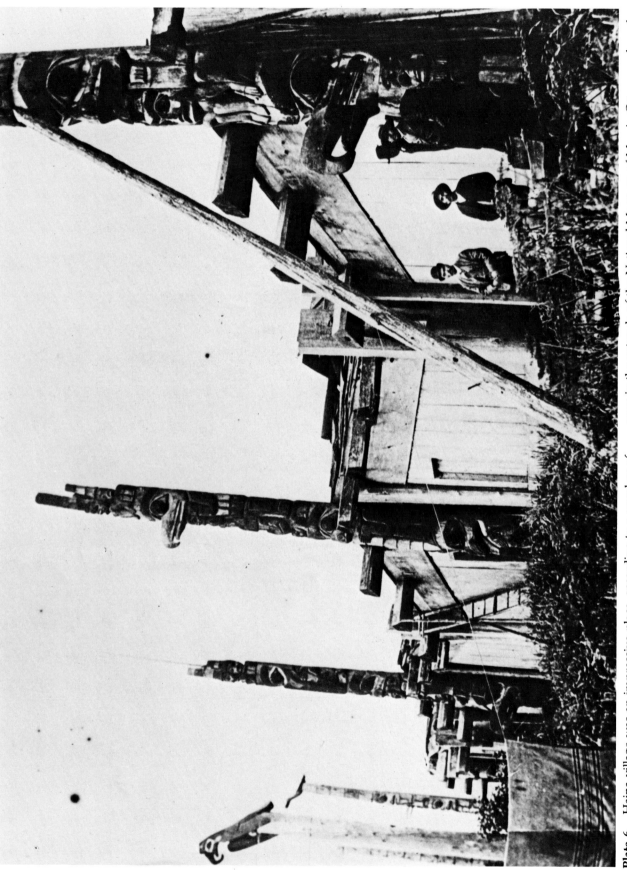

Plate 6. Haina village was an impressive place, according to a number of visitors who stopped there. It was photographed in great detail by Maynard and his wife in the 1880s. It was, however, not an old settlement, its roots probably not ante-dating the 1850s. The house frontal pole at the left center is now in the rotunda of the National Museum of Man in Ottawa and can be seen in greater detail in figure 42A. When I visited Haina in 1948 there was almost no trace of the community.

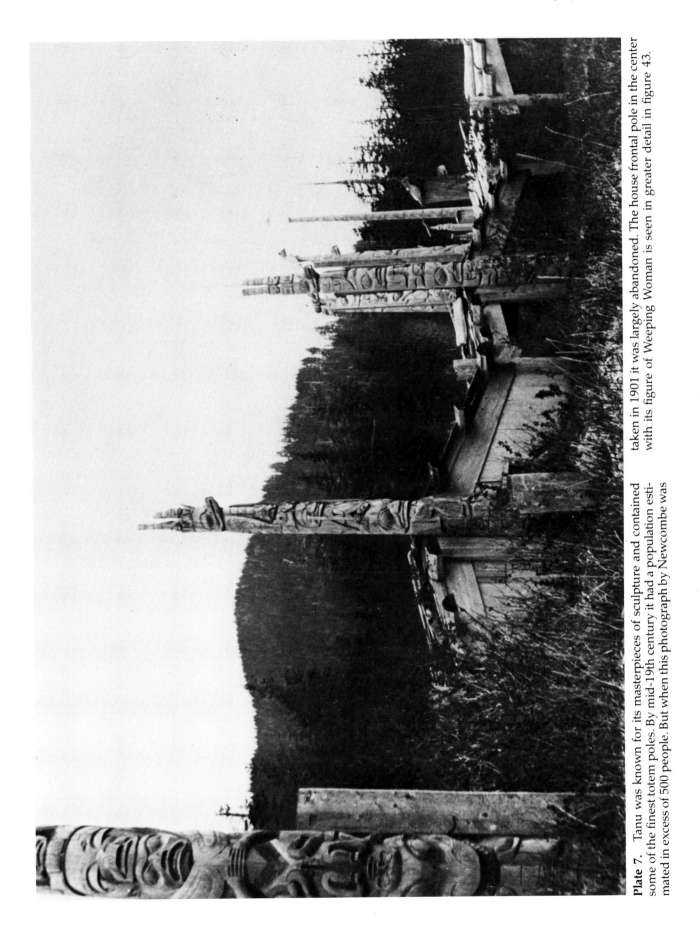

Plate 7. Tanu was known for its masterpieces of sculpture and contained some of the finest totem poles. By mid-19th century it had a population estimated in excess of 500 people. But when this photograph by Newcombe was taken in 1901 it was largely abandoned. The house frontal pole in the center with its figure of Weeping Woman is seen in greater detail in figure 43.

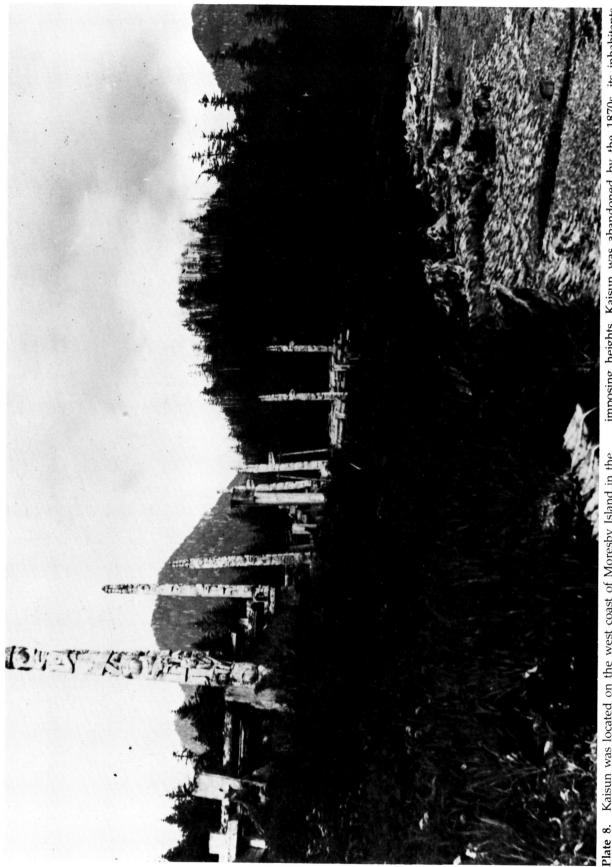

Plate 8. Kaisun was located on the west coast of Moresby Island in the Queen Charlottes but was not a large community. As this photograph by Newcombe reveals in 1897 it had many large poles of complex designs and imposing heights. Kaisun was abandoned by the 1870s, its inhabitants moving to another Haida village, near Skidegate.

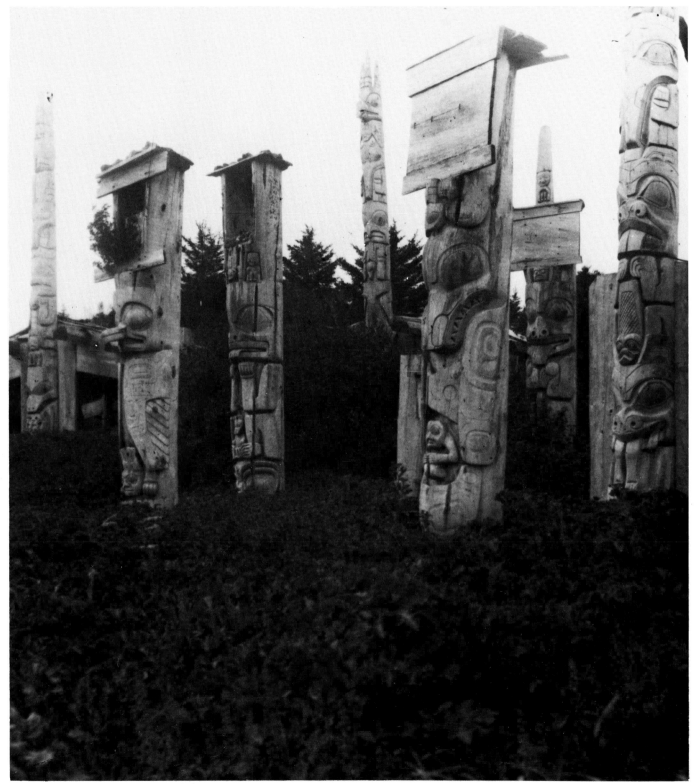

Plate 9. Ninstints village was the most isolated of the Haida settlements on the Queen Charlotte Islands. Its name, like names of other Haida settlements, was derived from the chief of one of the leading families. This particular settlement's history was both short-lived and bloody during contacts with Europeans. More than 40 monumental columns were know to have stood here in the mid-19th century as this Newcombe photograph taken in 1901 indicates. The Provincial Museum salvage operation in 1951–52 acquired many for future study and preservation. Ninstints suffered from smallpox epidemic in 1863 from which it never recovered and by 1875 it had been abandoned.

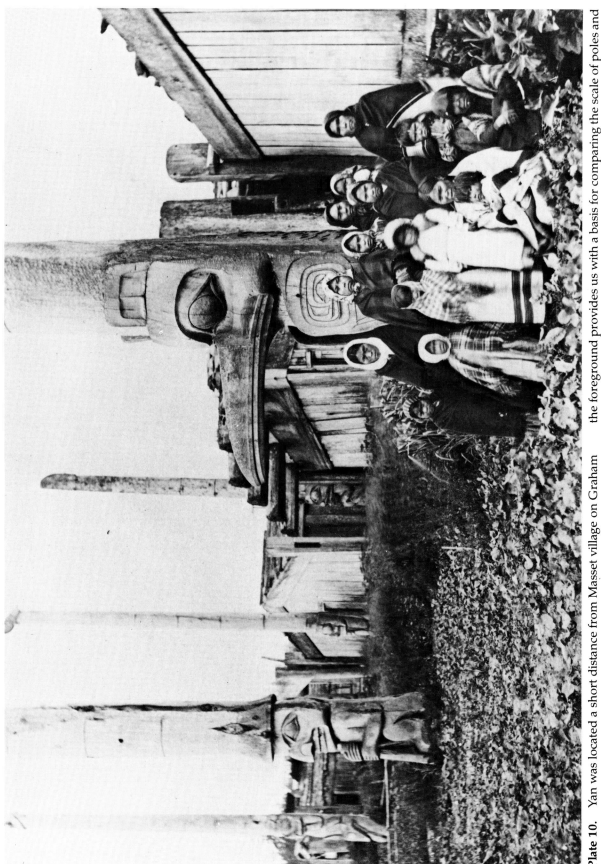

Plate 10. Yan was located a short distance from Masset village on Graham Island. Edward Dossetter made this photograph in 1881 where more than 50 large poles were seen standing from mid-19th century. By 1900 the place had been abandoned, its people having moved to Masset. The women gathered in the foreground provides us with a basis for comparing the scale of poles and houses. There is a little outward Western influences apparent in this photograph aside from the blankets and shawls being worn by the people.

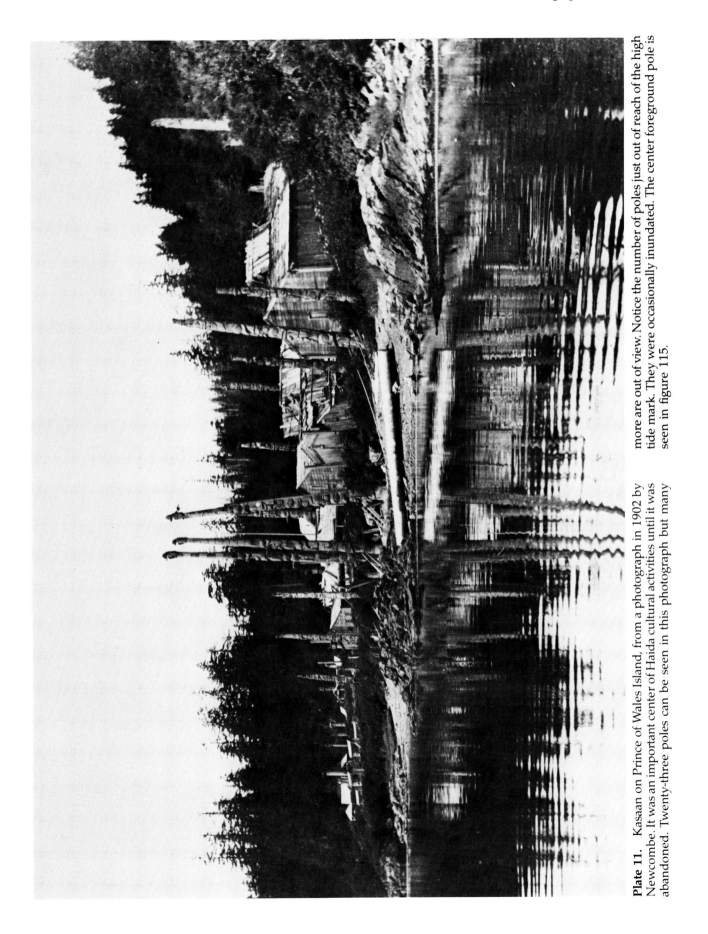

Plate 11. Kasaan on Prince of Wales Island, from a photograph in 1902 by Newcombe. It was an important center of Haida cultural activities until it was abandoned. Twenty-three poles can be seen in this photograph but many more are out of view. Notice the number of poles just out of reach of the high tide mark. They were occasionally inundated. The center foreground pole is seen in figure 115.

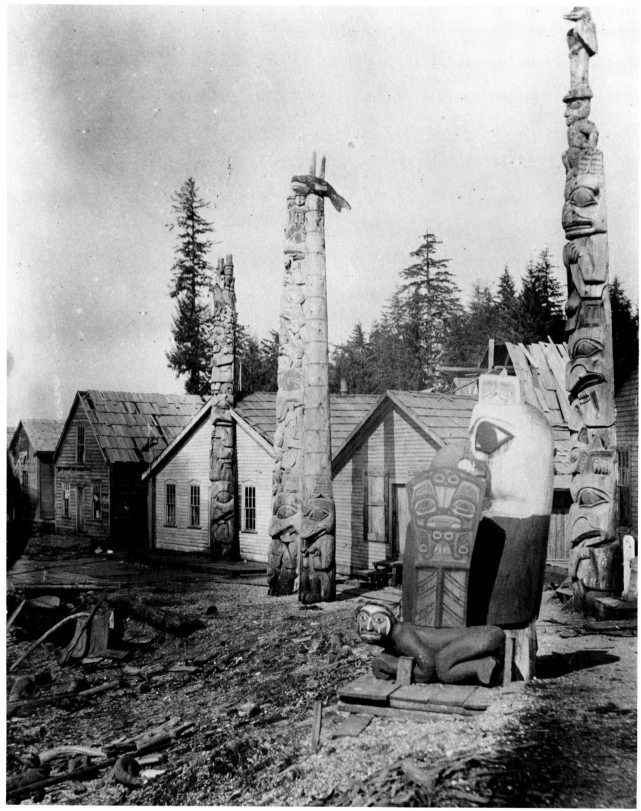

Plate 12. Howkan, a Kaigani Haida village in Alaska, was photographed by Newcombe in 1902. The poles here range from 25 to 35 feet in height and are seen in greater detail in figures 26 and 30. Notice the reclining figure in the foreground with the copper containing a raven crest painted on its surface. Intense missionizing efforts occurred here in the early 20th century.

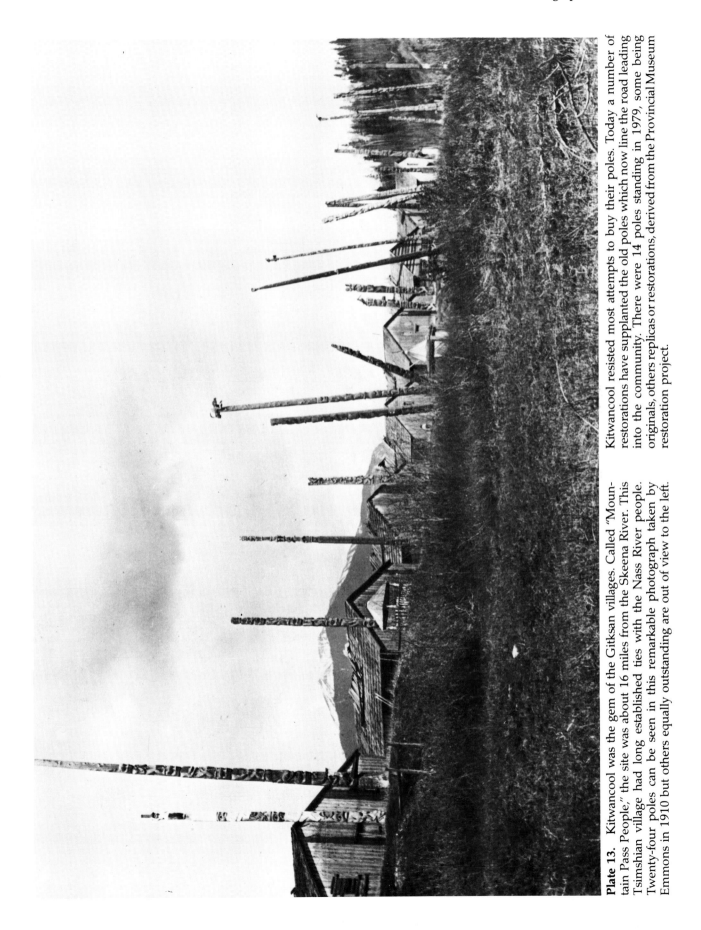

Plate 13. Kitwancool was the gem of the Gitksan villages. Called "Mountain Pass People," the site was about 16 miles from the Skeena River. This Tsimshian village had long established ties with the Nass River people. Twenty-four poles can be seen in this remarkable photograph taken by Emmons in 1910 but others equally outstanding are out of view to the left. Kitwancool resisted most attempts to buy their poles. Today a number of restorations have supplanted the old poles which now line the road leading into the community. There were 14 poles standing in 1979, some being originals, others replicas or restorations, derived from the Provincial Museum restoration project.

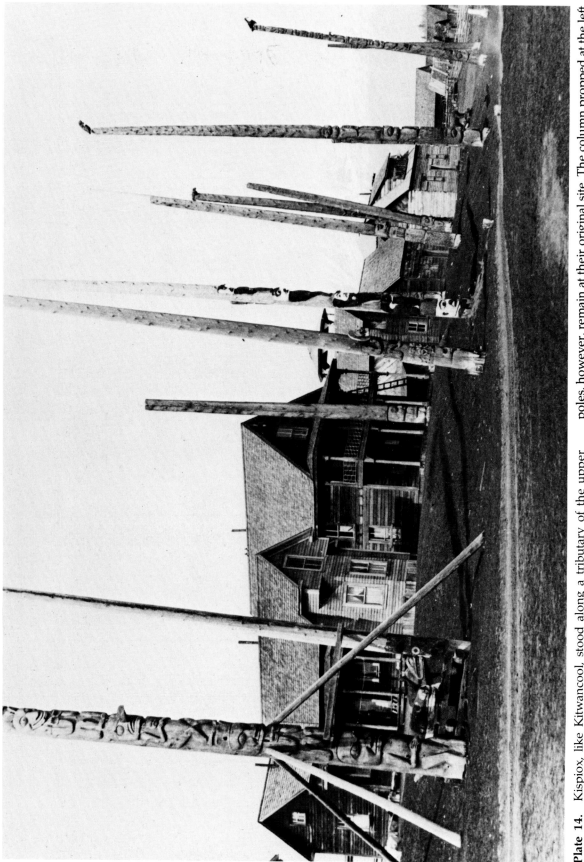

Plate 14. Kispiox, like Kitwancool, stood along a tributary of the upper Skeena River. This photograph by Walter Cotton taken in 1910 shows the village stood but a few yards from the water's edge out of view at the right. Repeated heavy spring run-offs inundated the site, eventually forcing the people to move their houses to a higher location a quarter mile away. The poles, however, remain at their original site. The column propped at the left dated to about 1880 or earlier and was called "Leading-In." It was raised anew by its owner, Bob Harris, in the mid 1970s. The fifth pole from the right is seen in figure 31. As of 1979 there were 14 carved columns standing in this site, six with a bare minimum of sculptural surfaces.

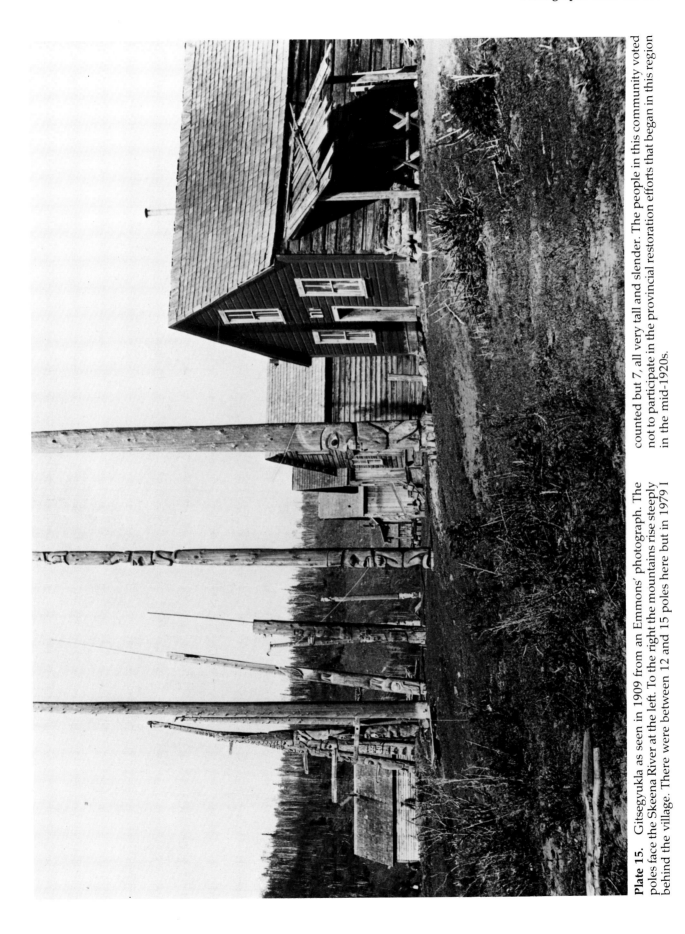

Plate 15. Gitsegyukla as seen in 1909 from an Emmons' photograph. The poles face the Skeena River at the left. To the right the mountains rise steeply behind the village. There were between 12 and 15 poles here but in 1979 I counted but 7, all very tall and slender. The people in this community voted not to participate in the provincial restoration efforts that began in this region in the mid-1920s.

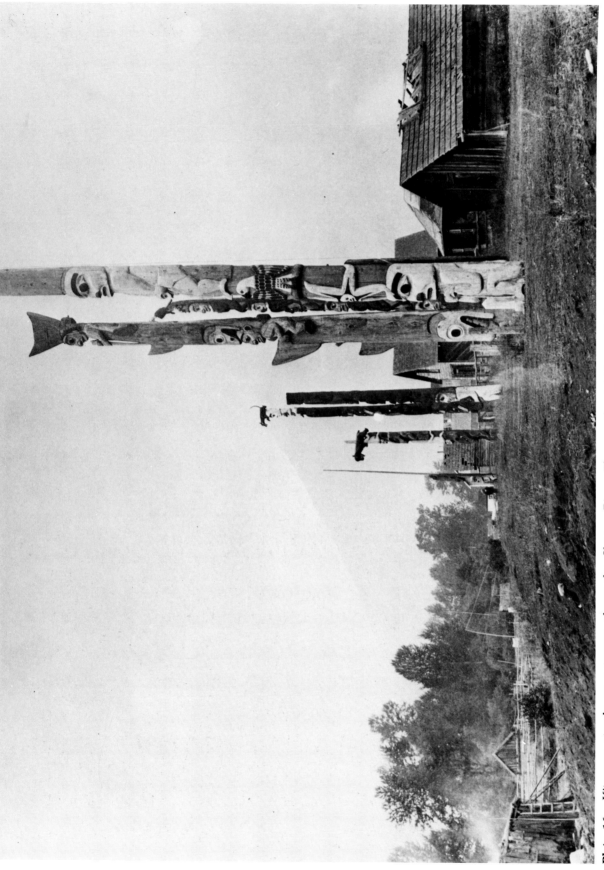

Plate 16. Kitwanga stands on a terrace above the Skeena River. The photograph taken by Walter Cotton in 1910 is looking Northwest. The village is surrounded by lofty mountain ranges. After preservation activities began in 1925 the poles were moved from the bank where they are seen here to a point where a road entered the village, about 100 yards distant. The 3rd pole from the right is seen in figure 127 and is known as Dog Salmon Pole. It probably was carved between 1870 and 1880 and had collapsed. A new pole based on the original composition was carved some time prior to 1979 and awaited ceremonies that would enable the owners to raise it. There were 13 poles standing in this village in 1979.

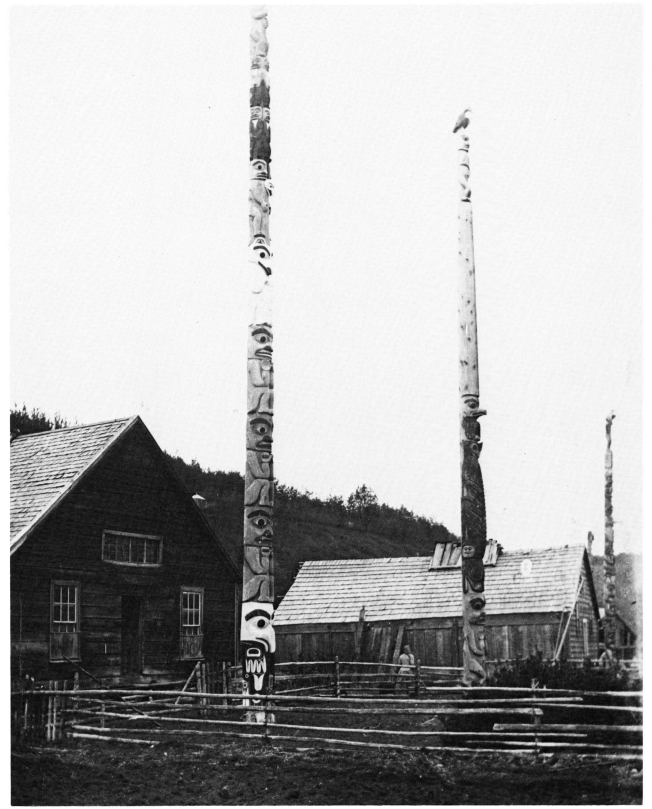

Plate 17. Gitlahdamsk, a Nass River village, was photographed before the turn of the century. The poles here were sold to numerous museums and the inhabitants moved elsewhere. The large pole at the left is called Eagles Nest with 2 eaglets perched at the top. It is now in a Canadian museum. It was duplicated in 1977–78 by Dempsey Bob, a Tlingit carver, and Freda Diesing, a Haida woman carver and stands in front of the museum in Prince Rupert.

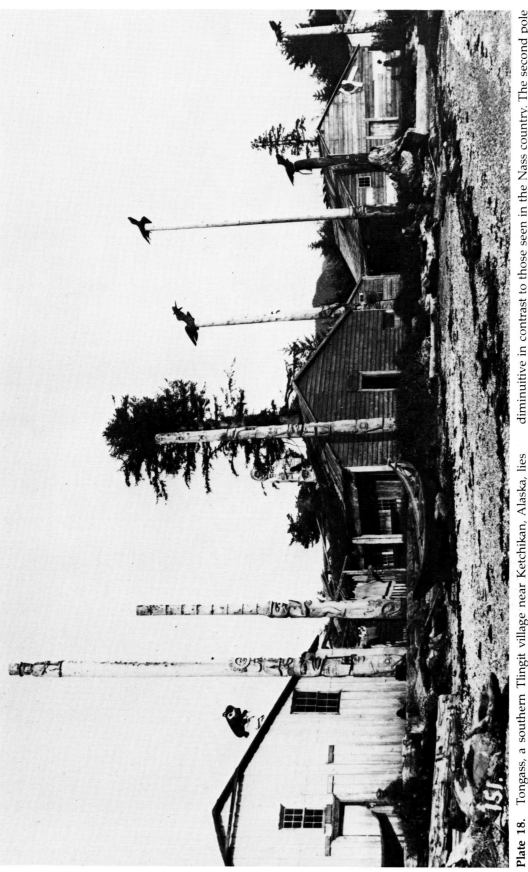

Plate 18. Tongass, a southern Tlingit village near Ketchikan, Alaska, lies close to the British Columbia border and the Nass River Tsimshian villages. G. T. Emmons photographed the village around 1900. These poles are diminutive in contrast to those seen in the Nass country. The second pole from the left bears a striking resemblance to one in Kitwanga (fig. 127) and may represent the work of the same artist.

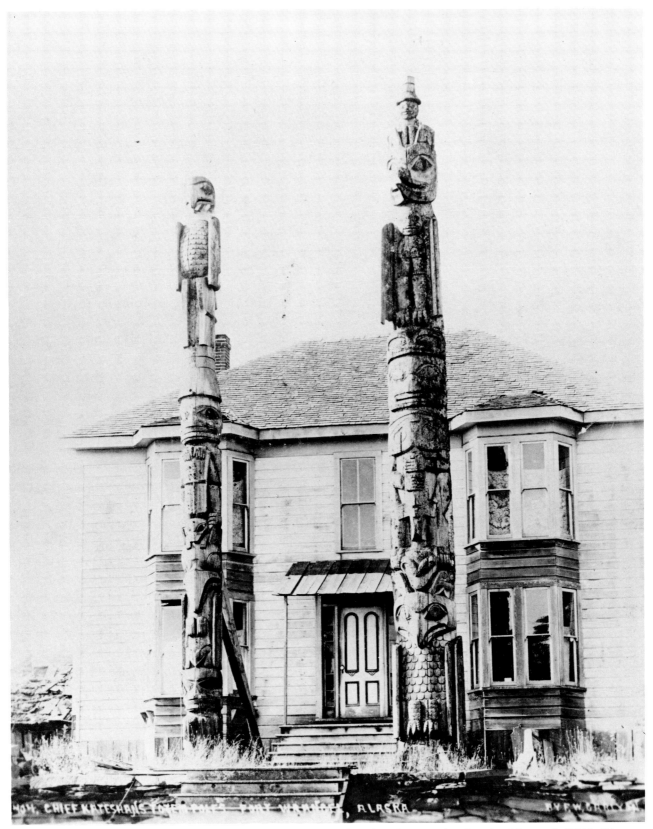

Plate 20B. Kadishan's house at Wrangell about 20 years after the photograph taken by Maynard (20A). Western influences swept into the Tlingit and Haida cultures literally overnight, changing the character of the way of life of its people and giving the poles an incongruity with the new surroundings. Photo by F. W. Carlyon.

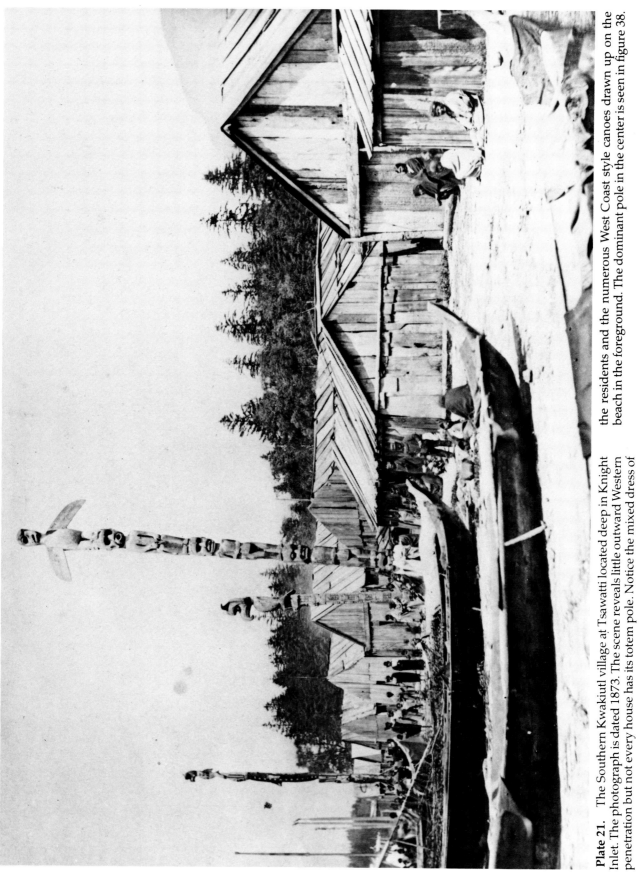

Plate 21. The Southern Kwakiutl village at Tsawatti located deep in Knight Inlet. The photograph is dated 1873. The scene reveals little outward Western penetration but not every house has its totem pole. Notice the mixed dress of the residents and the numerous West Coast style canoes drawn up on the beach in the foreground. The dominant pole in the center is seen in figure 38.

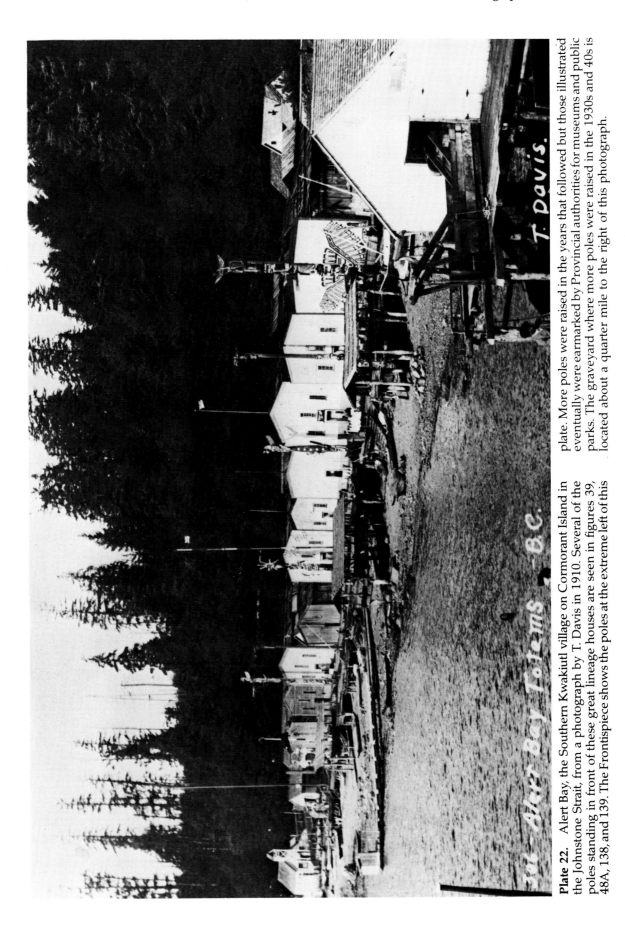

Plate 22. Alert Bay, the Southern Kwakiutl village on Cormorant Island in the Johnstone Strait, from a photograph by T. Davis in 1910. Several of the poles standing in front of these great lineage houses are seen in figures 39, 48A, 138, and 139. The Frontispiece shows the poles at the extreme left of this plate. More poles were raised in the years that followed but those illustrated eventually were earmarked by Provincial authorities for museums and public parks. The graveyard where more poles were raised in the 1930s and 40s is located about a quarter mile to the right of this photograph.

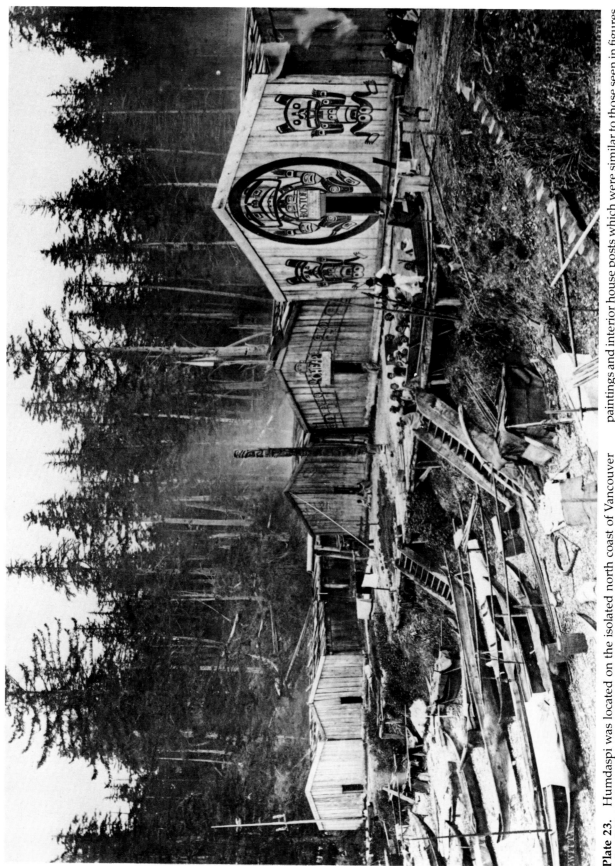

Plate 23. Humdaspi was located on the isolated north coast of Vancouver Island. This photograph was probably taken in the late 1880s and shows but one totem pole as the people placed greater emphasis on the house front paintings and interior house posts which were similar to those seen in figures 9, 10, and 13. This village had vanished by the early 20th century.

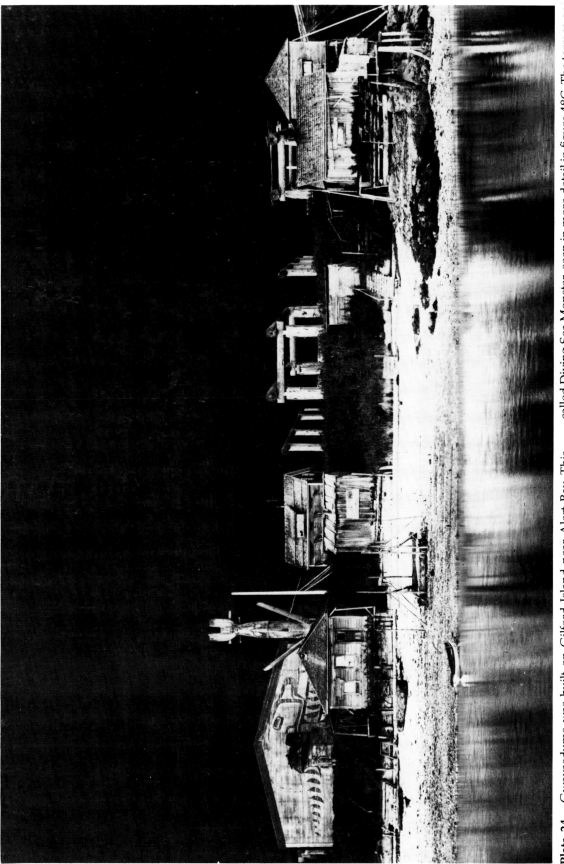

Plate 24. Gwayasdums was built on Gilford Island near Alert Bay. This photograph by F. J. Barrow in 1933 shows the gradual abandonment of many of the older style houses. The skeletons of two large houses can be seen with their prominent cedar verticals and crossbeams. The large house at the left belonged to Dick Webber and was called The Sea Monster house. The central beak was that of a raven; at the right of the house was a pole called Diving Sea Monster, seen in more detail in figure 48C. The terrace on which the village was built stands high above high tide mark but the background reflects the dense forest that rises abruptly behind it. The heavily white beach surface shows deep layers of clam shells revealing a long occupation period.

Plate 25. Fort Rupert on the northeast coast of Vancouver Island in 1881 from a photograph by Dossetter. This was not an old village but it was a large one occupied from the 1850s onward. Notice there are no totem poles at this time but several slender columns with single figures of humans or coppers. Smaller poles were erected as measures of the piles of blankets hosts distributed to guests during potlatches. Fort Rupert was a poor site as it took the brunt of storms coming off the Queen Charlotte Sound.

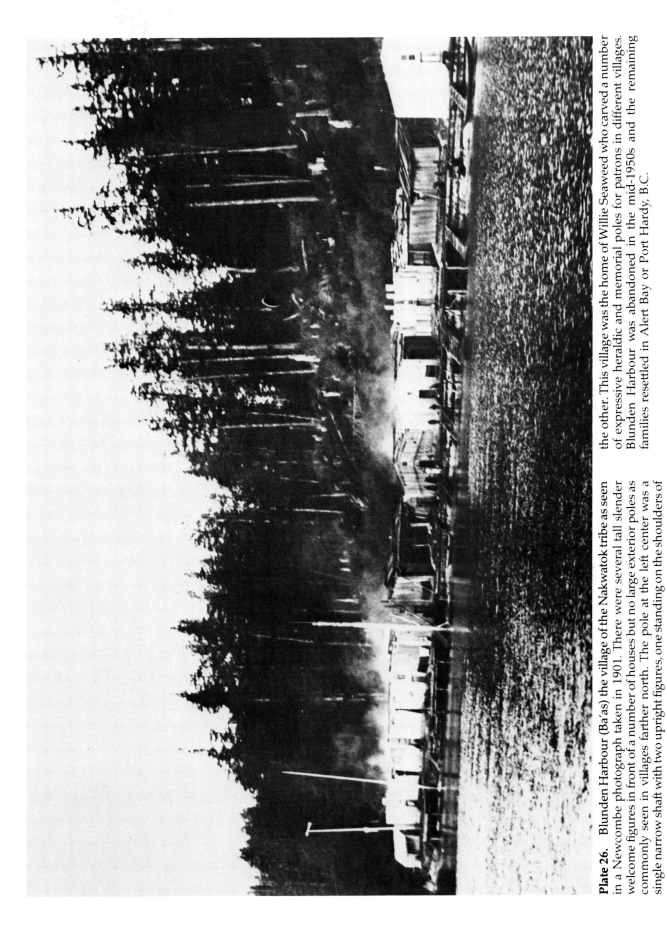

Plate 26. Blunden Harbour (Ba'as) the village of the Nakwatok tribe as seen in a Newcombe photograph taken in 1901. There were several tall slender welcome figures in front of a number of houses but no large exterior poles as commonly seen in villages farther north. The pole at the left center was a single narrow shaft with two upright figures, one standing on the shoulders of the other. This village was the home of Willie Seaweed who carved a number of expressive heraldic and memorial poles for patrons in different villages. Blunden Harbour was abandoned in the mid-1950s and the remaining families resettled in Alert Bay or Port Hardy, B.C.

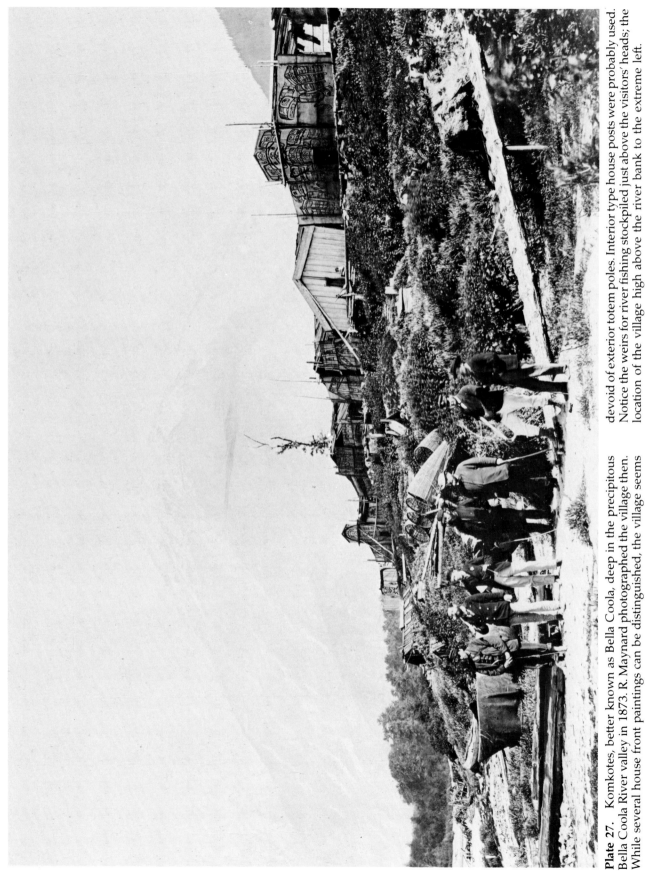

Plate 27. Komkotes, better known as Bella Coola, deep in the precipitous Bella Coola River valley in 1873. R. Maynard photographed the village then. While several house front paintings can be distinguished, the village seems devoid of exterior totem poles. Interior type house posts were probably used. Notice the weirs for river fishing stockpiled just above the visitors' heads; the location of the village high above the river bank to the extreme left.

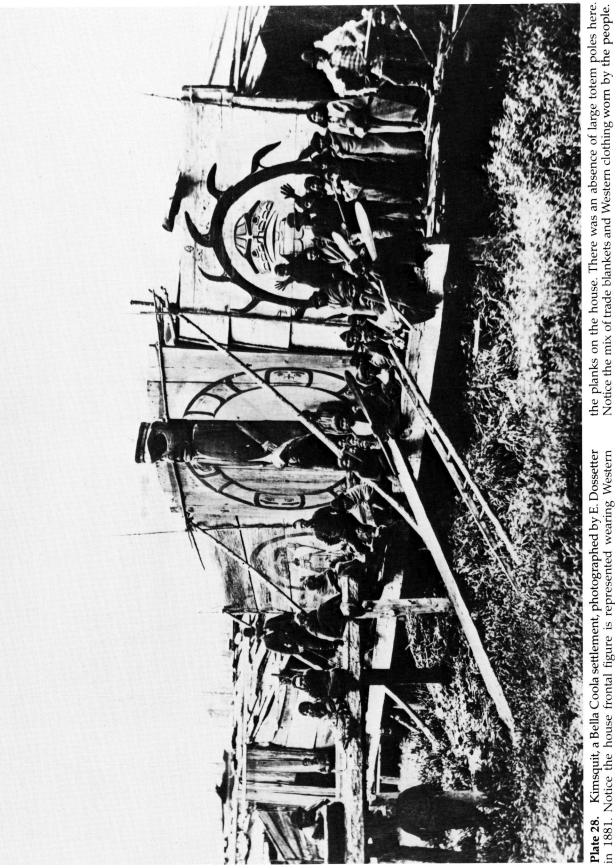

Plate 28. Kimsquit, a Bella Coola settlement, photographed by E. Dossetter in 1881. Notice the house frontal figure is represented wearing Western clothing, contrasting sharply with the traditional painted boards that decorate the planks on the house. There was an absence of large totem poles here. Notice the mix of trade blankets and Western clothing worn by the people.

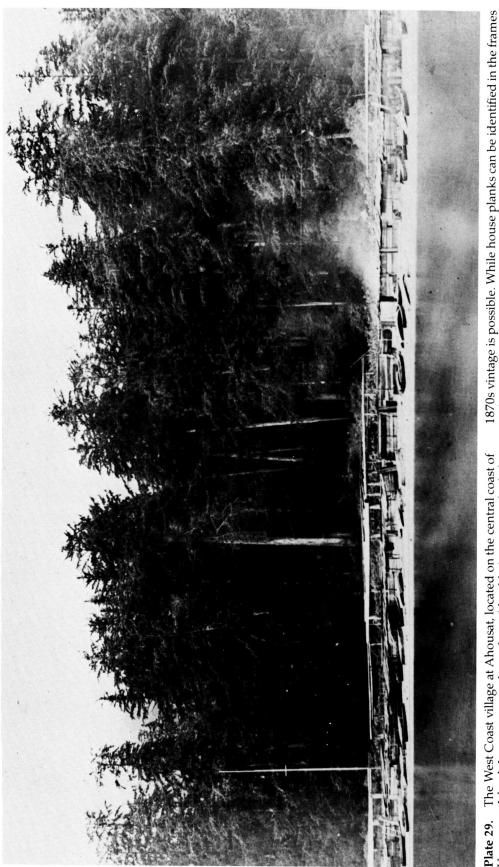

Plate 29. The West Coast village at Ahousat, located on the central coast of Vancouver Island. It was once a place of considerable importance both for whaling and for commerce including the sea otter trade. The photograph was taken by F. Dailey and dated 1866 which may be questionable although an 1870s vintage is possible. While house planks can be identified in the frames in the center they appear to be uncarved. No totem poles are visible standing in this village.

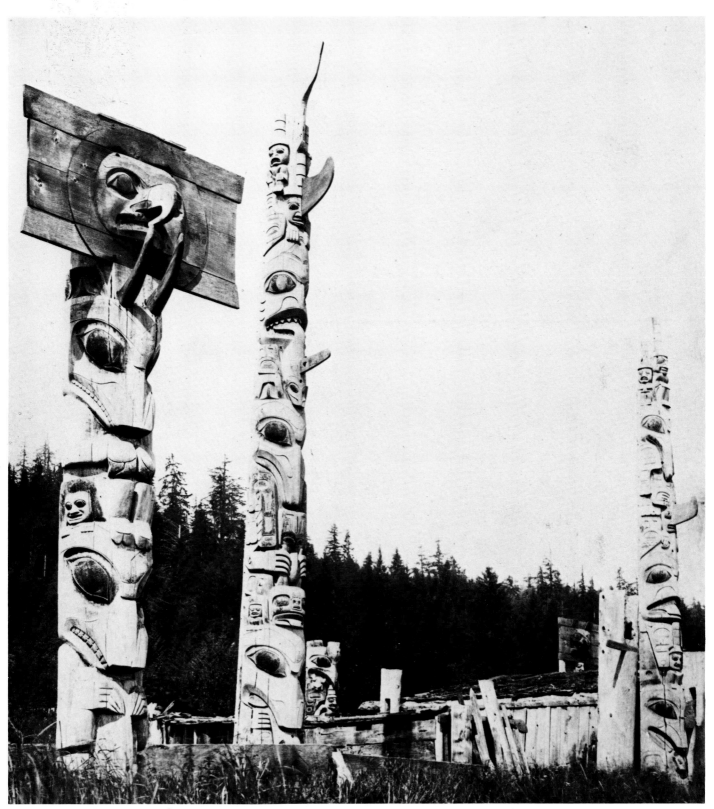

Plate 30. Skidegate totem poles from a photograph by R. Maynard in 1888. A particularly fine mortuary pole representing a hawk, mountain goat, and grizzly bear is seen at the left. The two other house frontal poles stand before houses that appear to have been torn down, to be replaced by smaller modern Western style cottages. Skidegate had suffered a population decline in these years. The mortuary pole was removed and placed in Stanley Park, Vancouver, and later duplicated. The pole in the center was duplicated at the Haida Village display at the U of British Columbia campus.

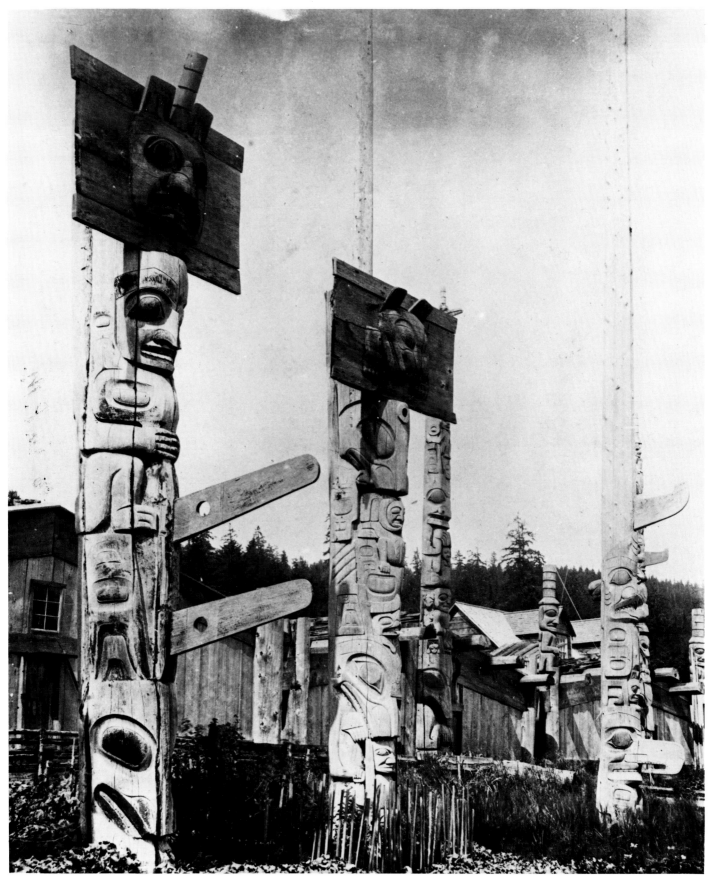

Plate 31. Another view of Skidegate poles by R. Maynard in 1884 or 1888. This gives the viewer a greater opportunity to appreciate the range of complexity seen in Haida monumental art. The mortuary pole at the left is similar to figure 20 from Cumshewa and may have been carved by the same person. Notice the large Western frame house in the rear (right), the type that was gradually to replace the older clan and lineage dwellings.

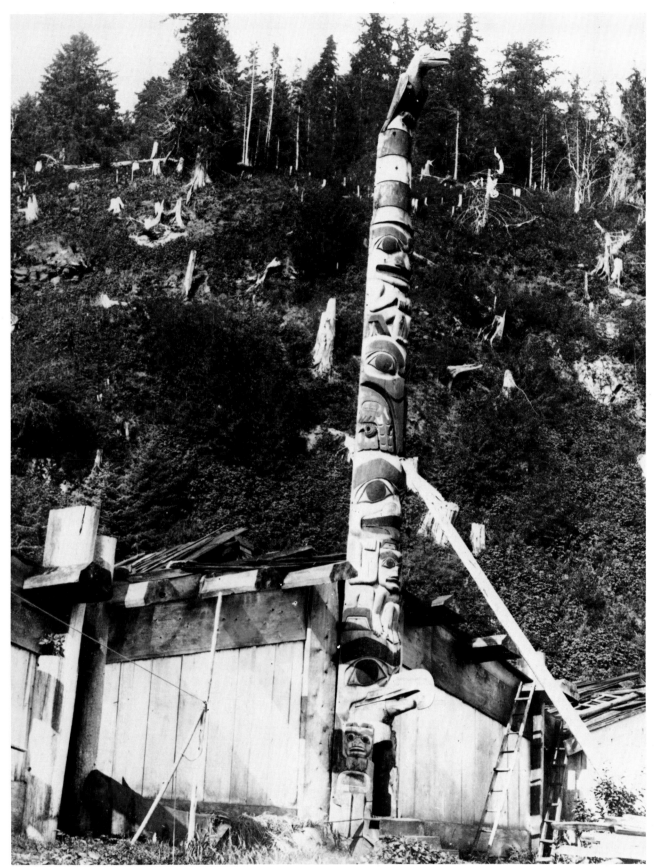

Plate 32. The fine column in a village of many of such quality is Job Wilson's pole located at Haina. It was photographed by R. Maynard about 1888. It is now one of several from this village sequestered in the Field Museum of Natural History, Chicago. The scope of this pole can be appreciated still further by examining the great eagle below and comparing it with plate 6 but photographed from the extreme right and facing East. The village faced Northward across the bay toward Skidegate.

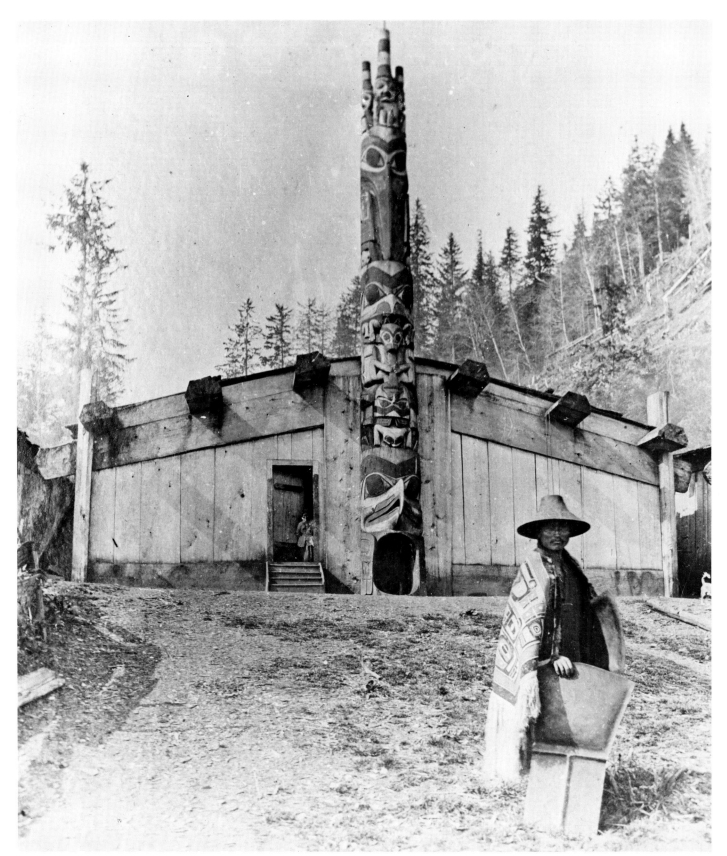

Plate 33. Another Haina house frontal pole photographed by Maynard about 1888. It also was acquired by the Field Museum in Chicago and makes an impressive display in the rotunda. The size of the human figure by the door gives the viewer an idea of the enormity of Haida type houses in contrast to those located elsewhere. The Haida man holding his two copper possessions and wearing the coveted Chilkat blanket draped over his shoulders signals a man who has great power and occupies important rank in the village. Notice also the denuded slope directly behind the village.

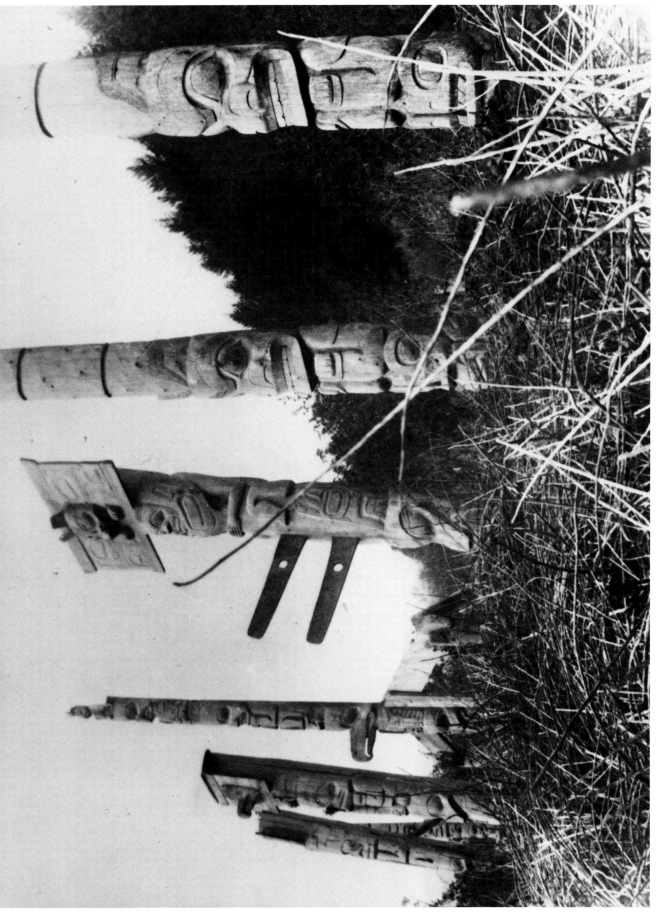

Plate 34. Cumshewa was already an abandoned village overgrown with brush when Newcombe took this photograph in 1901. The Mortuary pole in the center can be compared with figure 20 which helps reveal with more clarity the form and surface details of the pole.

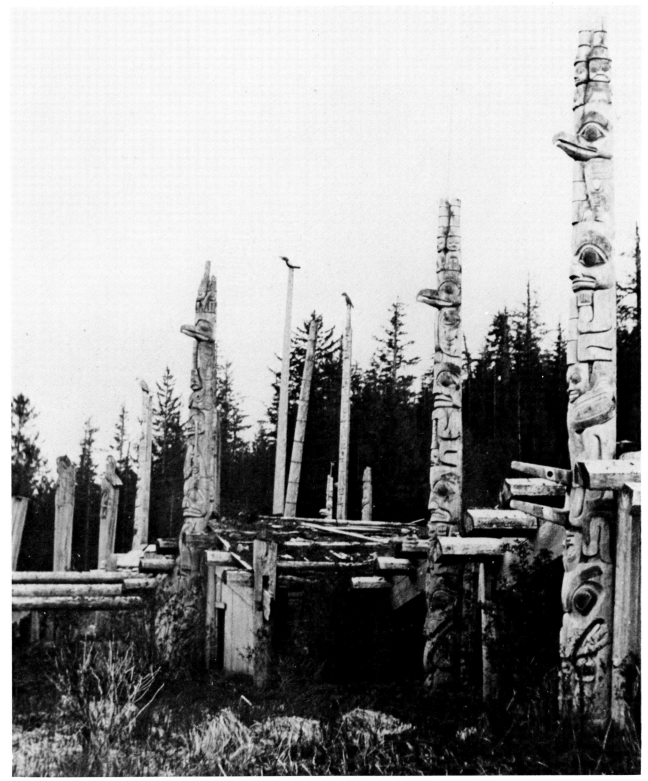

Plate 35. Tanu village was one of the most impressive places on the Northwest Coast but when Newcombe photographed it in 1901 much of it had already been abandoned and left to the elements. A cursory examination will reveal a place of outstanding sculptures, one following another. Several are already beginning a covering of mosses. Notice the house frontal poles with the complete carving from base to apex as well as the mortuary poles at the extreme left. Others taller but more controlled with carving are seen in the memorial type poles. The interior of each of these houses (three are easily seen) contained equally superb house posts.

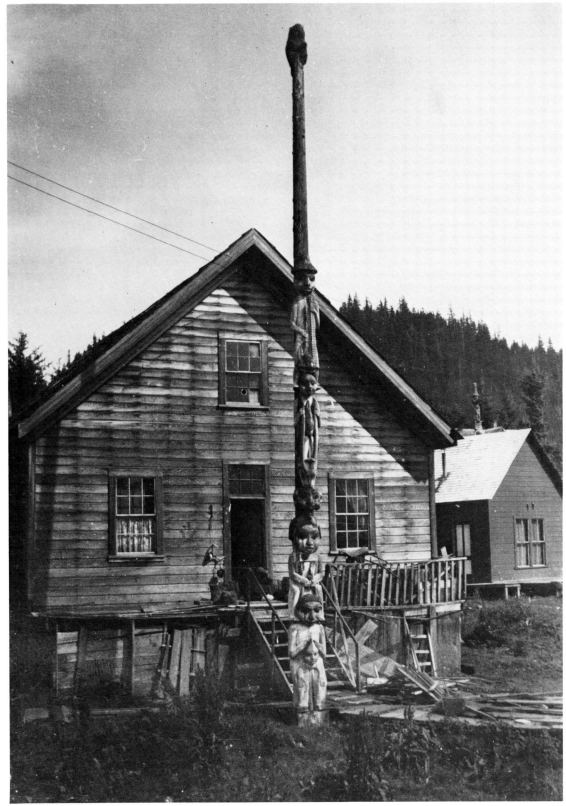

Plate 36. Wrangell was a Tlingit village settled by the Stikine Tribe. This photograph possibly in the 1910 period, already shows steady inroads of Western influences, making the pole in the foreground and one in the right distance anachronistic. The large pole in the front was later cut into several pieces and is now housed in the Alaska State Museum.

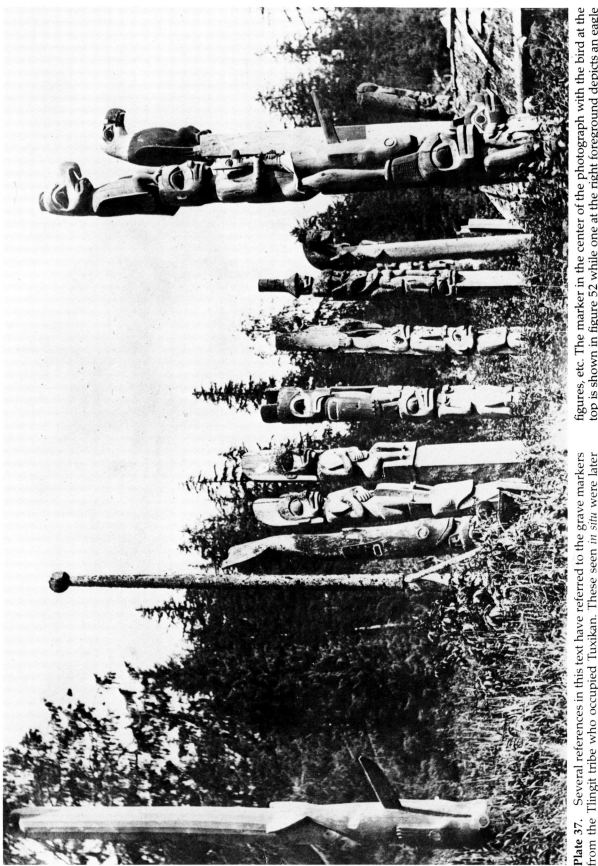

Plate 37. Several references in this text have referred to the grave markers from the Tlingit tribe who occupied Tuxikan. These seen *in situ* were later removed and placed in Klawak park. Many were disintegrating and others were duplicated. This photograph taken by Emmons in 1888 gives the viewer a cross section of the types: small sizes, up to 12 feet, limited number of figures, etc. The marker in the center of the photograph with the bird at the top is shown in figure 52 while one at the right foreground depicts an eagle surmounted on a human figure representing Strong Man, holding a sea lion, a variation of a motif seen in a pole at Kasaan (fig. 110).

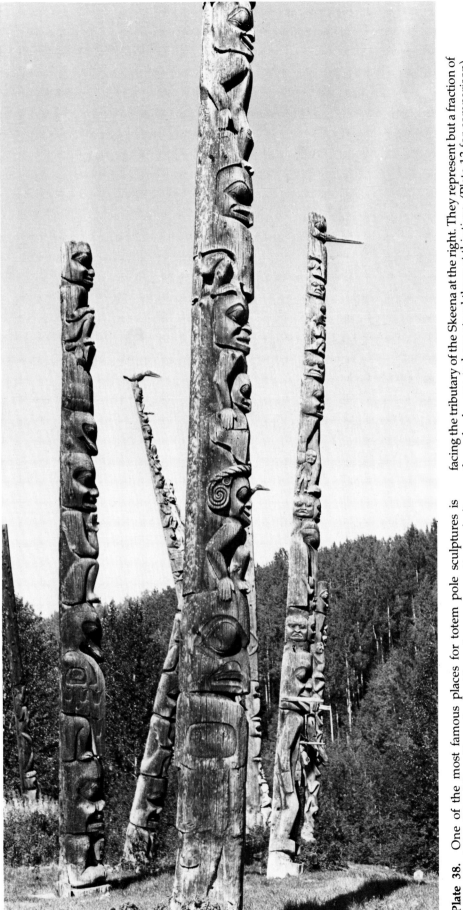

Plate 38. One of the most famous places for totem pole sculptures is Kitwancool, the Tsimshian village. It must have been an eyestopper in its time. The photograph captures Tsimshian poles at their best around the turn of the century. Tall, multi-figured, projecting up into the sky, weathered to a silver gray patina. This photograph by J. B. Scott about 1900 shows the poles facing the tributary of the Skeena at the right. They represent but a fraction of the poles known to have stood there at this time. (Plate 13 for comparison). Few poles were sold to outsiders, the bulk have been kept intact although some have been duplicated because of the extremely fragile condition.

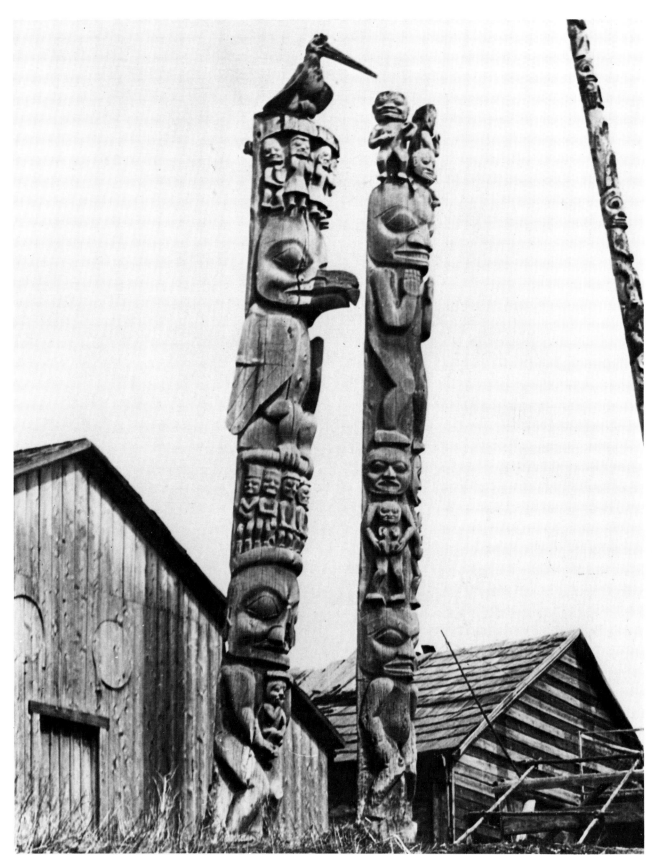

Plate 39. These Kitwancool poles date back to the latter half of the 19th century and are among the most important and prominent located there. The photograph is probably of 1910 vintage. The original poles were eventually removed as part of an agreement with the Provincial Museum, Victoria. They were replaced with exact replicas while the originals will be exhibited in major museum shows and protected from further destruction. The pole at the left is called Mountain Eagle, that of the right Split Person. Tsimshian poles are generally named, as are many Tlingit poles. Notice the extremely tall and slender pole with multiple figures at the extreme right. The band of figures at the top on the pole at left can be seen in figure 82 roll-out.

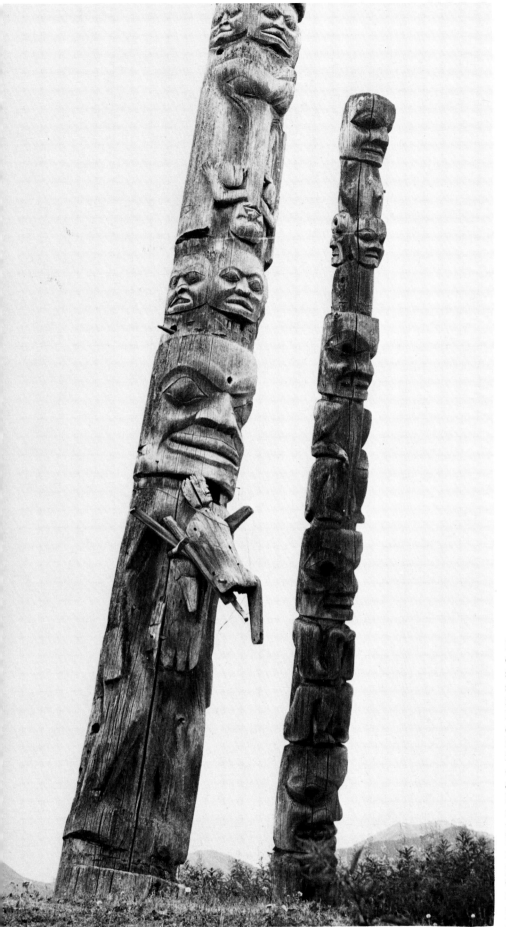

Plate 40. Once again the Kitwancool poles provide us with a cross section of types with a variety of subject matter, most originating from family myths and history. Notice the left pole repeats motifs at different space intervals. The faces in bands of 3 above the lowest figure are repeated above the head of the bird whose beak connects to an inverted human-like figure. The lower figure at the left also had movable marionettes tied to the pole that were wired so they could be animated, probably during pole raising ceremonies associated with potlatches. The pole at the right is called Skulls of People and commemorates the escape of a Tsimshian woman from her captor, a Haida man.

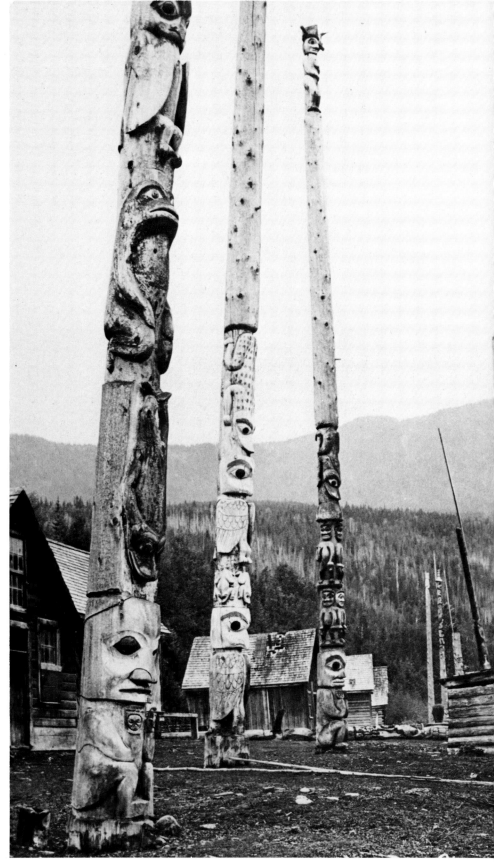

Plate 41. A view of Gitsegyukla village near Hazelton about 1900. The pole at left was still in the village in 1979 as was the one located at the extreme right with the tall hatted figure at the top. The 3rd pole from the left was acquired by the Provincial Museum and a copy had stood for years in the first Thunderbird Park, Victoria, in the mid-1940s and 50s. Since this site is extremely steep, part of the community lives above at the heights, behind the poles seen, others live closer to the Skeena out of sight to the right.

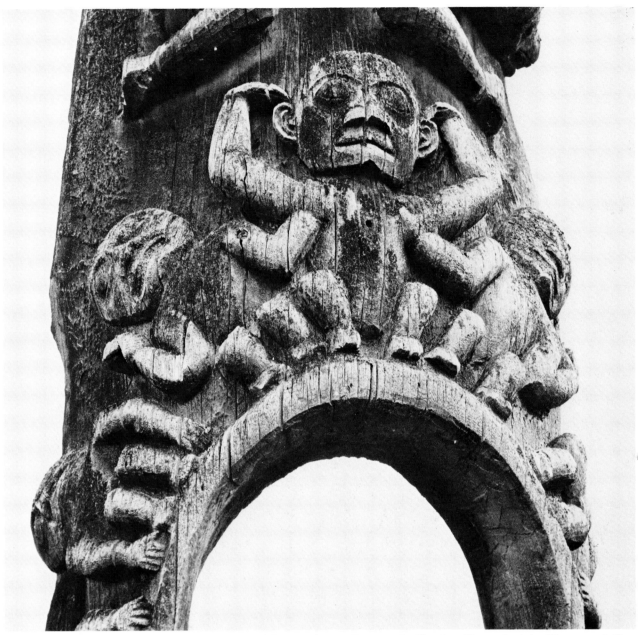

Plate 42. One of the most famous sculptures of the Northwest Coast and still at its village of origin, Kitwancool. The photograph was made by Wilson Duff in 1962 but photographs of the pole are extant going back 50 years earlier. This is the Place of Opening or more popularly Hole in the Sky Pole. There are twelve small figures centered around the opening (not a house frontal type pole) which are related to the horizontally-placed wolf above the top figure. They relate to a Wolf Pack Migration in the myths, the small figures symbolizing the children of the wolf who was a benefactor to the ancestors of this particular clan. The entire composition is a true masterpiece and can be seen today *in situ*.

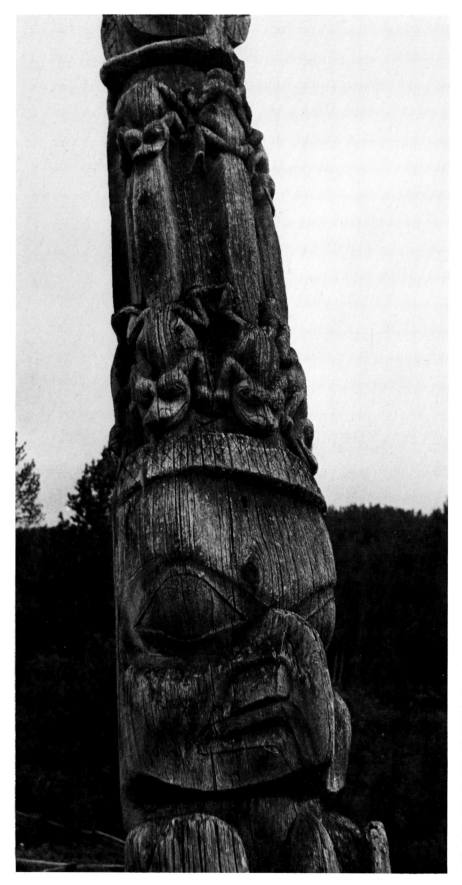

Plate 43. A detail from a pole in Kitwancool on the upper Skeena region. Photographed by Wilson Duff in the early 1950s, it shows the condition in which some early poles have survived to the present. All the sparsely painted surfaces have disappeared. Eight frogs repeated in 2 rows, one above the other, gives a delightful touch to the sculpture. The carver's effort to avoid monotonous repetition is seen in his handling of the row at the top, facing the frogs alternatively looking down and upwards.

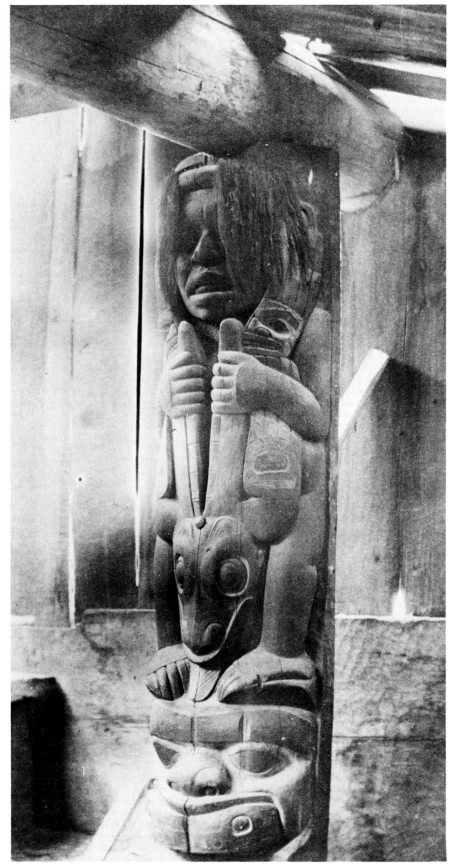

Plate 44. A house post from one of the famed Chilkat lineage houses in Klukwan. Photographed by Emmons in 1888, it is considered one of the rare Tlingit treasures. Human hair hangs from the large upright figure who represents Dirty Skin, a Tlingit hero. He is shown ripping a sea lion or sea monster apart to demonstrate his supernaturally-derived strength, an Indian Samson. The face on which the hero stands probably represents the rocky island where the action takes place (see also figure 110).

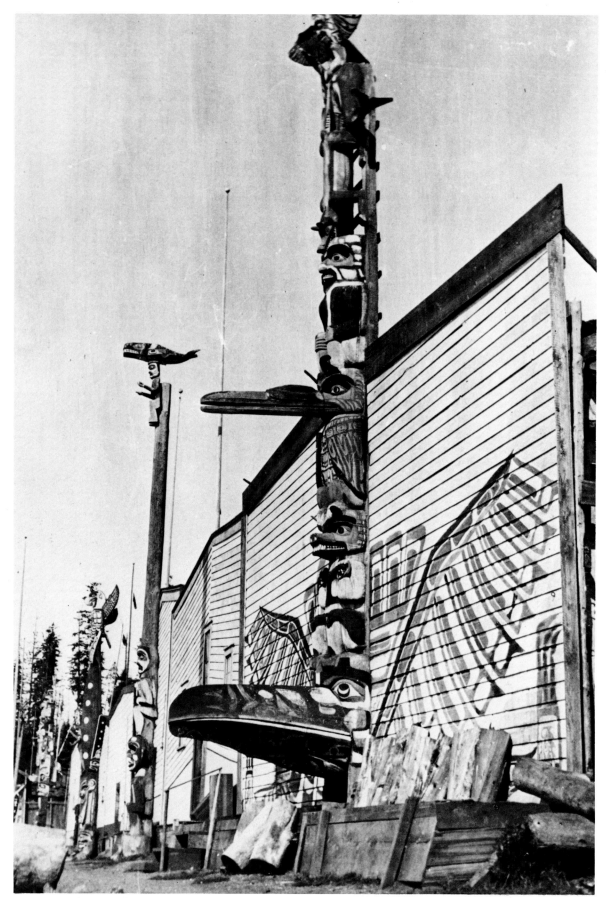

Plate 45. The row of lineage houses and totem poles that paralleled the single street at Alert Bay, taken between 1900 and 1910. The house in the foreground belonged to Chief Wakias (figure 48A). The third pole from the right, barely visible, can be seen in fig. 39. A great deal of activity was taking place in this village about this time resulting in a resurgence of cultural interests rather than an eclipse.

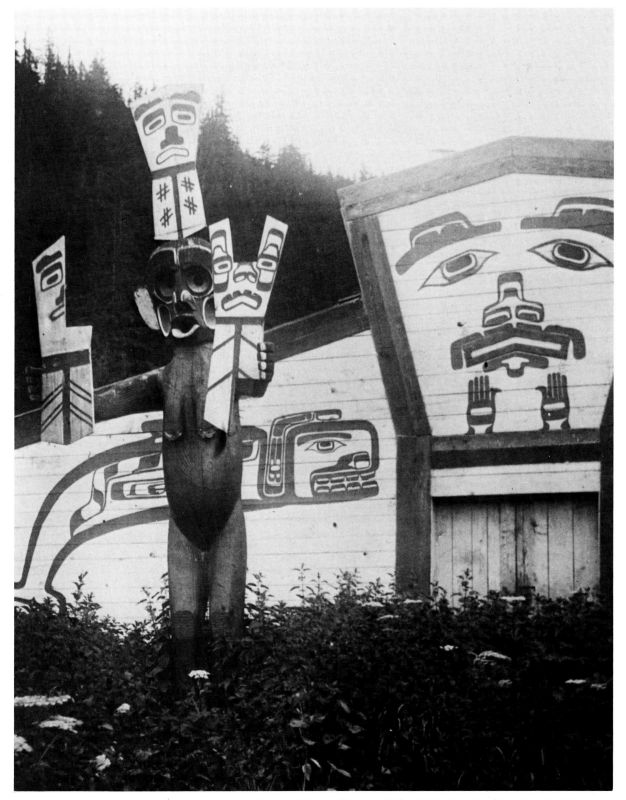

Plate 46. A view of Herb Johnson's house at Gwayasdums village on Gilford Island in Southern Kwakiutl territory, taken in 1912. The style of painted house fronts can easily be seen culminating in the entry way framed in the form of a copper. The welcome figure represents a variation of the Forest Spirit Tzonoqua (fig. 93). She brings wealth. One copper is attached to the head, and broken coppers are held in each hand. A copy of this fine welcome figure is on display in the Thomas Burke University of Washington Museum in Seattle.

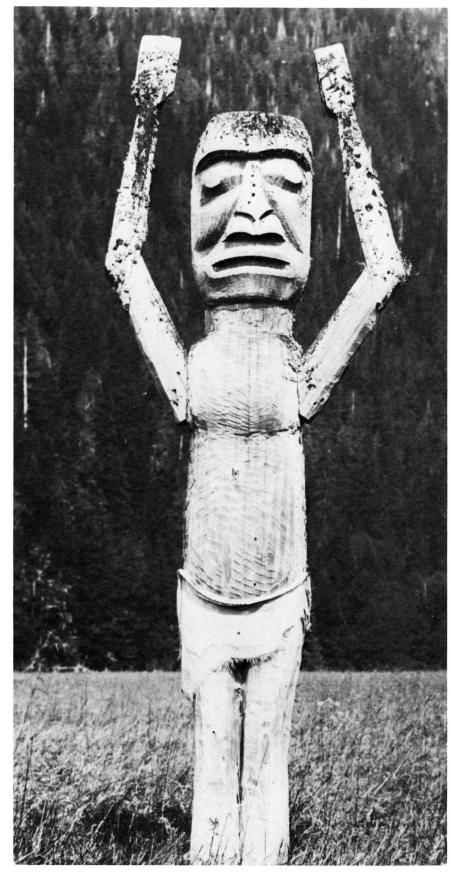

Plate 47. Another welcome figure with movable arms is shown from another Southern Kwakiutl village at Kingcome. It was photographed by F. J. Barrow in 1933. While it is crudely done in comparison with plate 46 it served its function quite well for the occasion. The effort to drape a cloth over the genital area effectively suggests the changing perceptions and cultural values of the increasingly dominant Western-influenced attitudes. These figures were often placed on the beach before a host's home in order to welcome guests coming for pot-latches and winter dances.

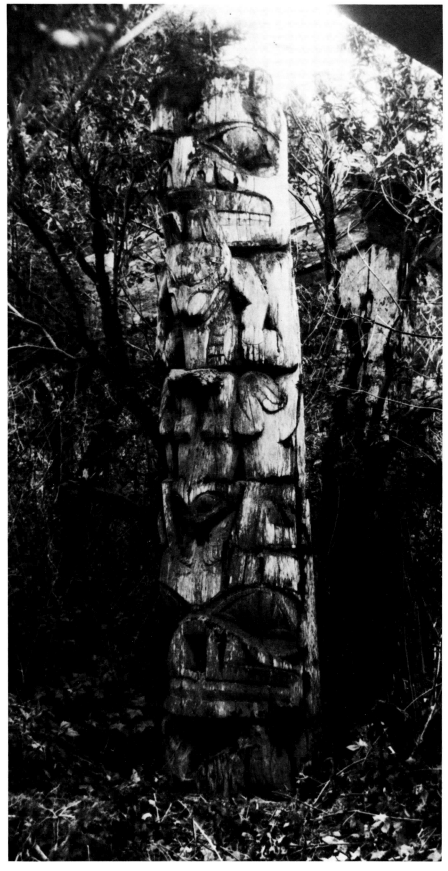

Plate 48. This scene was to become all too characteristic of the numerous villages along the Northwest Coast in the years following the turn of the century. This is a large Haida house post belonging to the Edensaw family at Kung village. It was photographed by Newcombe in 1913. The house roof and timbers were collapsing around it and the carving details are becoming blurred by the advent of mosses that begin to cover its surface. The top figures represent Bear Mother and her cub child, followed by a frog; the bottom figure probably a grizzly.

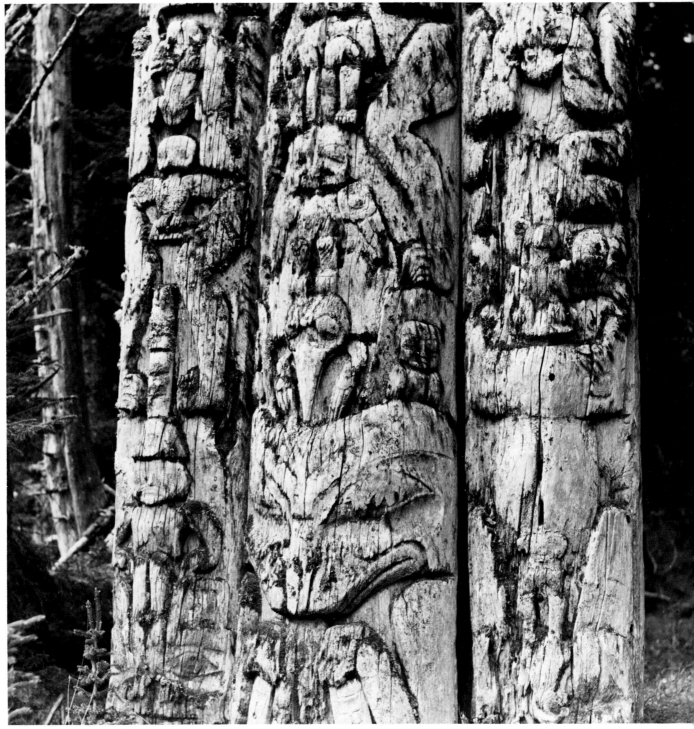

Plate 49. Haida poles from the village of Kiusta on Graham Island, taken in 1952 probably by members of the salvage operation for the Provincial Museum. While these poles are in a fragile state they can be rescued, preserved, and used for future study, research, and display purposes in controlled interior museum settings.

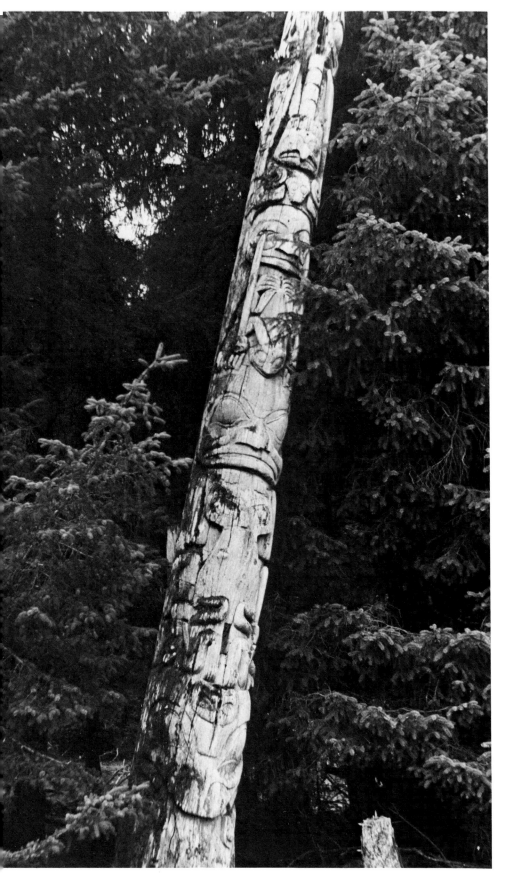

Plate 50. I consider this pole one of the masterpieces in a field of many. It is the famed Weeping Woman pole from Tanu. It is in an advanced state of decay and will shortly tumble to the ground. The photograph was taken by Wilson Duff for the Provincial Museum, 1952 (see fig. 43). Notice how the huge trees have grown around the towering pole indicating the number of years that have elapsed when it stood as a house frontal pole before a great lineage house (plate 7).

158

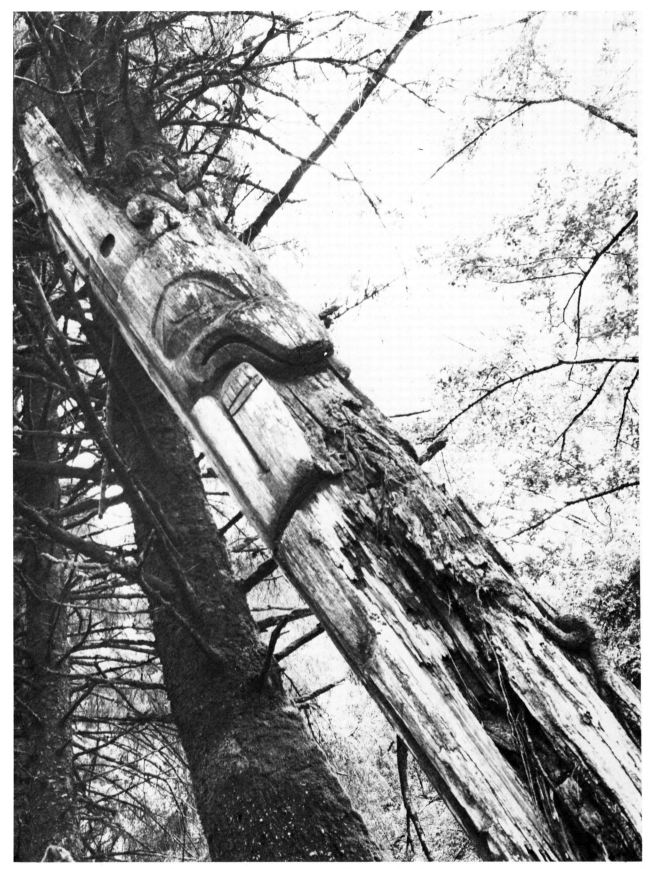

Plate 51. When a historic pole reaches this advanced state of disintegration, little can be done to salvage or preserve it. This pole was photographed surrounded by an enormous growth of trees at Cumshewa village about 1972. Most of the surface carving has rotted away and its reconstruction, if warranted, would require careful comparison with photographs taken of the pole at a much earlier time. Such an effort would be worthwhile, however, in order to keep a detailed record of the pole types from each village for future study and research.

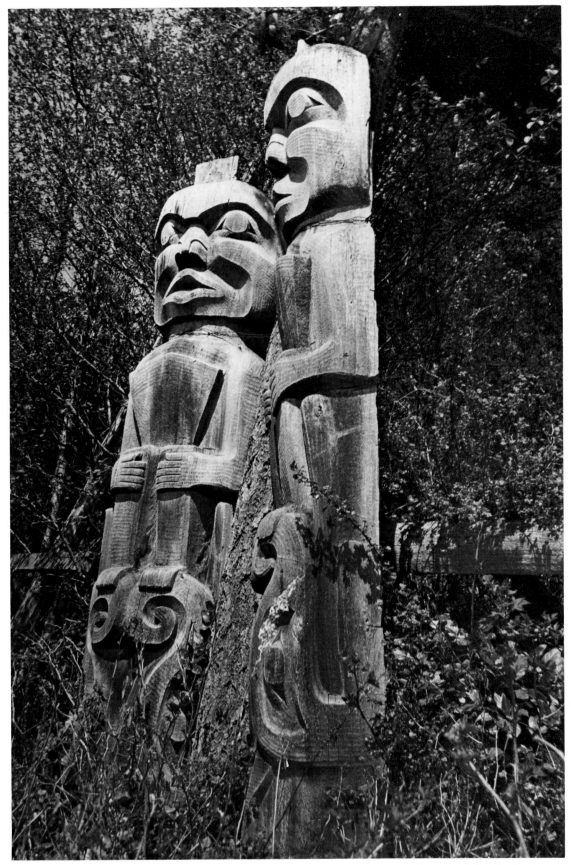

Plate 52. Two lineage house posts that formerly stood in a house at Gwayasdums on Gilford Island, grim reminders of an age when they represented mighty symbols. Each post represents a sitting chief holding a copper against the chest above a double-headed serpent crest. I wish to draw the viewer's attention to the fine adzed surfaces, the special stippling effects along the different planes of the wood. Such final details provide the ultimate finish to a carver's efforts. Photographed in 1955.

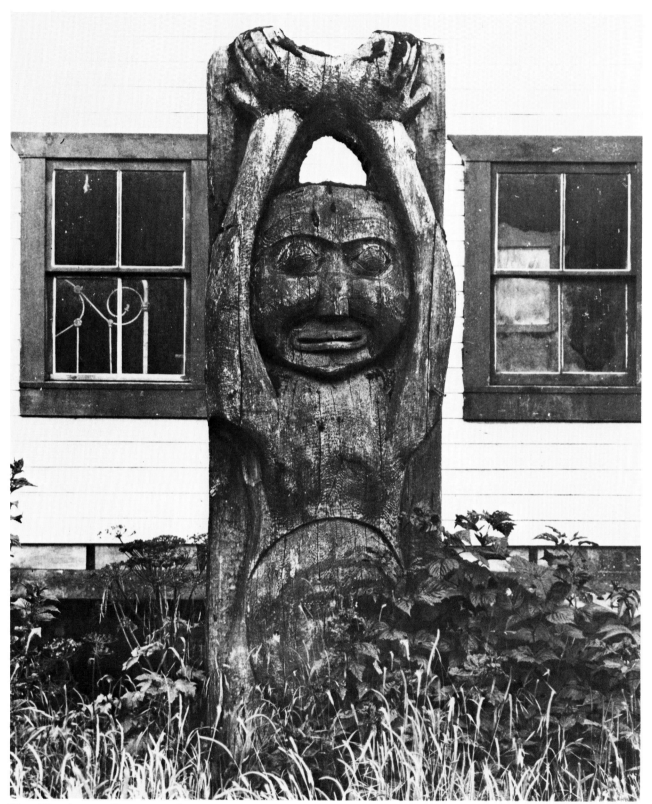

Plate 53. A carved house post from Kingcome Inlet deep in Kwakiutl territory, taken by F. J. Barrow in 1933. The figure's hands are raised to form a notch on which the cross beam of the house is rested. Notice the fine stippling effects which are not always discernible in photographs due to weathering, poor lighting conditions, or absence as a practice. The new house has replaced the old one with its symbolic accoutrements. The iron bed frame and mirror seen in the windows highlight the growing gulf between the two cultures that was taking place in the early 20th century.

PART THREE

CHAPTER V

Triumph and Tragedy: An Era Vanishes

What was destroyed here was not just a few hundred individual human lives. Human beings must die anyway. It was something even more complex and even more human—a vigourous and functioning society, the product of just as long an evolution as our own, well suited to its environment and vital enough to participate in human cultural achievements not duplicated anywhere else. What was destroyed was one more bright tile in the complicated and wonderful mosaic of Man's achievement on Earth. Mankind is the loser. We are the losers.

Wilson Duff
Provincial Museum
Report for 1957

There is no way I can describe the utter desolation that characterizes an abandoned Northwest Coast Indian village. I have seen several of them. It is not like the desolation resulting from a war, though it reflects battles of another kind. For one thing, most villages were remote from the new communities that were springing up as a result of the fusion of European and native societies. The disappearance of these Indian settlements left little impact on the environment. The forest quickly pressed in on the fragile sites; mosses and lichens took hold, speckling every cedar house and pole whether crumbling or still erect. On each prostrate cedar the rot spread—50 years hence they would provide the seed beds for future generations of trees.

From the 1880s to the 1920s and 30's countless such remains reverted to the wilderness: Tanu by 1901; Klinkwan 1902; Cumshewa 1905; Kasaan 1908; Angidah 1913; Tongass 1924 or earlier. By 1923 Tanu was moss-covered from one end to the other. Left behind were house shells, grave markers, and mortuary columns containing the remains of the deceased. Some poles were taken away to cities, others fell when their bases rotted out; some were cut into firewood; still others were burned down where they stood by their owners as a token of indignation or despair.

I remember the day a Haida man from Skidegate took me across the bay in his power boat to what remained of Haina. Called "Sunshine Town," Haina had grown out of a move in the 1850s and '60s by the remnant bands of two villages, Kaisun and Chaatl. Jacobsen visited Haina in 1881 and was deeply impressed by the carved columns he saw there, standing like ramparts facing the sea. He wrote that they were among the finest he had seen in any village. Maynard, the pioneer photographer, spent several weeks photographing their majestic beauty (plates 6, 32, and 33). But here I was in 1948 walking in shocked silence through the ruins of this historic place. The finest of the poles had been removed years ago to grace eastern United States and Canadian museums.

A single forlorn memorial pole faced the sea, its solitary raven crest perched at the top. It had been used for target practice by passing travelers and

bullets had riddled the figure almost to pieces. I was reminded of Napoleon's troops in Egypt using the Sphinx for similar and powerful exercises in empty-minded vandalism.

At Skidegate, one of the most remarkable and dynamic native villages (plate 2), a single badly decomposed column, the Beaver Pole (fig. 114), remained standing near the beach. In village after village—save for those in the Gitksan and some Kwakiutl settlements—the story was repeated with sickening monotony.

The mute, lichen-encrusted columns seen in plates 48, 49, 50, and 51 mirror the passing of a unique culture. The light had shown briefly, flickered, then went out! The death throes of this remarkable culture commenced in the same instant of its greatest achievements—in the 1850s and 60s. But the seeds of destruction had been planted decades earlier.

What happened to these villages and their crowning cultural hallmarks, the totem poles? To begin to answer such a question requires that we briefly return to their history, to the heyday of tribal life. Europeans and natives had become increasingly entwined in an assortment of relationships reflecting the changing times and the growing instability of the Indian society. During the early 19th century European influences centered primarily in the maritime fur trade and the activities of the Hudson's Bay Company that followed. The interests of the Russian government in Alaska, which went beyond simple commerce, were served by the Russian-America Company.

Relationships between Westerners and Indians had never been tranquil, and more often were volatile. The Russians exerted only limited political and social influences before their attention was diverted by the political turmoil occurring in regions closer to home in Eastern Europe. Trading remained as intense as when the Russian-American Company first occupied the land, however. The Hudson's Bay Company, on the other hand, was content to merely stimulate trade. The Company factors tampered little with the lives and customs of the people. Keeping the natives friendly was good for business and therefore the guiding principle of the Company.

But by mid-century, political and territorial claims and counter claims asserted by both United States and Canadian governments relative to the possession of the Pacific Coast had introduced a new element into the life of the natives. The Canadian government wished to consolidate its hold on the Pacific Northwest in the face of U.S. challenges by settling white immigrants on the land, so sought to relegate the natives to small reserves. Some efforts to conclude separate treaties with each tribe, in order to settle Indian land claims, were undertaken but soon languished. The Indians in the meantime were losing their hold on their homeland, and feeling against the White Man began to rise.

The purchase of Alaska by the United States from Russia in 1867 raised the controversy swirling around the region to yet a higher pitch, though at first only imperceptibly. Upon acquisition the United States government began to explore the prospects for developing this "frozen northland." The Navy Department was, for a time, charged with both the military and civil administration of the newly-acquired territory. Its policy was quite simple: if the natives became unruly ships were to be dispatched to warn them, and if necessary to bombard the villages in order to quiet things down a bit. Tragically, the policy left an indelible hostility in the attitude of the Tlingit toward outsiders.

As in British Columbia, the question of Alaska's development turned on providing the growing white immigrant population with homesteading land. Who owned the land? The United States or the native people? It was a volatile problem which led to growing contentiousness. Natives saw their usual and accustomed places—the rivers and salmon spawning streams among them—increasingly off limits to their own fishermen. They had been "claimed" by strangers. White settlers had come to Alaska to start a new life, be it commercial fishing, hunting and trapping, gold mining, or homesteading.

The benefit derived by the Indians from trade with Western entrepeneurs was at best a two-edged sword as it introduced a new vigor, improved material existence, and released a reservoir of creative energies. Potlatches were not only given more frequently but the amounts of wealth shared soared and in cases became positively extravagant. As we have seen earlier the carving and raising of totem poles was carried to previously unimagined heights.

The influx of iron tools and new materials of other kinds stimulated not only a new level of artistic achievement but also fueled the people's desire to acquire previously unthought of wealth. New homes with clapboard siding and glass windows were raised, supplanting the larger communal type dwellings, and no doubt creating a new locus of prestige (plates 14 and 53). Previously unknown foods were introduced; European clothing styles were adopted. Trading voyages to the nascent European towns on the coast excited their

restless spirit, thus shattering a former comfortable insularity. People traveled far and wide—some as performers in the various World Expositions taking place, while others signed on commercial whaling expeditions as crewmen. Increased contacts with whites brought the people gradually into a money economy, whetting their appetites for new forms of, and greater, wealth. Money became a Siren's Call beckoning men and women along new avenues of exploitation. The prospects for personal and tribal accumulation of wealth and its ostentatious display had never been brighter.

There was, however, a darker side to these changes. An, at first, insensible destruction of native values and practices had begun. The fabric of the traditional culture began to unravel.

Trading brought firearms which put a new and more deadly twist on tribal raiding as hereditary enemies settled old scores. Crippling losses of population struck repeatedly during the first several decades of the 19th century, resulting from the introduction of foreign diseases for which the Indians had developed no immunity nor means to treat medically.

In both Alaska and British Columbia smallpox led a fatal litany, followed by measles, influenza, and tuberculosis. Every wave of introduced disease reduced the native numbers significantly. Duff (1964) has calculated the losses sustained by each regional group in the period from 1835 to 1885: The Haidas (not including the Kaigani people), from an estimated 6,000 to 800; the Tsimshian, 8,500 to 4,550; the Bella Coola, 2,000 to 450; the Kwakiutl, 10,700 to 3,000; the West Coast Tribes, 7,500 to 3,500. The Tlingit suffered proportional losses.

The first smallpox epidemic took a heavy toll of lives in 1836 but it struck again with still greater force in 1862–63. More than a third of the native population of the Province of British Columbia disappeared. Venereal diseases, contracted by native prostitutes seeking the white man's wealth, hammered away at future growth by causing infertility and premature death.

The insidious, almost insensible nature of the destruction wrought by the Europeans is remarkable. There were no massacres or overt efforts to destroy the people—just a quiet undermining of life both physical and psychic by subtle, scarcely noted forces.

During the last years of the 19th century the cumulative effects of these great changes led to a crisis in the functioning of both village government and social order. Relationships between lineages and clans were distorted or dissolved. People, fearing supernatural wrath, fled, seeking protection and succor wherever they could find it. The collapse of traditional responsibilities and systems of cooperation was evident everywhere and in all relationships.

Sorting out and weighing the factors surrounding this collapse is difficult at best because there are so many sides to the problem. We can, however, review a microcosm of what happened.

I was engaged in ethnographic research in 1950 among the Quatsino Inlet group whose tribal homeland was the northern tip of Vancouver Island. The data gathered there provide some of the puzzle pieces needed to picture the plummeting fortunes of the tribes who had traditionally occupied the inlet—Koskimo, Quatsino, Klaskino, and Gopenox. All were Southern Kwakiutl but no members of the latter three groups survived into mid-20th century. The research developed the following evidence.

During the 1860s and 70s times were good. Food was plentiful beyond measure. Coveted Western goods were readily available by trading with the Hudson's Bay Company post at Fort Rupert, a mere 15 miles to the east.

The Quatsino Inlet people were skilled pelagic sealers and whalers. So American and English whaling and sealing vessels stopped frequently to recruit crews for expeditions to the Aleutian Islands and beyond. Contracts of one or two years duration were the norm. By Indian standards the pay was astronomical, so Indian crew members returned home ladened with goods and cash. Even commoners in rank might contemplate giving a potlatch—a previously unhoped for opportunity. Both men and women were recruited, the latter as sexual partners for the crew during the long intervals at sea. Women often joined the expeditions to assist their husbands acquire undreamed wealth. Many never returned, dying at sea from disease, accident, or shipwreck. Those who returned realized an unanticipated dividend in the form of venereal or other diseases. The downward population spiral had taken its first fateful turn.

Alcoholism became an increasing problem, not only wrenching families apart but also leading to premature death.

The physical undermining of the population was one thing, but combined with the erosion of the people's spiritual underpinings, the utter collapse of traditional life appeared assured.

THE ASSAULTS ON THE CULTURE

A true understanding and appreciation of the spiritual beliefs and expressions of Northwest Coast culture is an exceedingly complex matter. We can deal with it here only in terms of the broadest generalizations.

Native religious expressions collided head-on with the preferences of the Western administrations responsible for these newly-acquired territories. Officials and bureaucrats were deeply influenced by the doctrine of Manifest Destiny then in vogue. This collection of beliefs originated in the eastern United States and grew with the settling of the continent. Europeans and their descendants in North Amercia were viewed as ordained by destiny to rule the earth by virtue of their superior vigor and as representatives of a superior culture. They carried the mandate, as it were, from a higher authority to bring the less fortunate people of the earth to a proper stage of enlightenment and civilization.

The less fortunate people included the natives of the Northwest Coast. In order to save and elevate these peoples, the aid of various Christian denominations were enlisted: Russian Orthodox, Methodist, Presbyterian, Roman Catholic, Anglican, Salvation Army, Pentecostal, and several smaller sects. They were charged with the responsibility of advancing the natives' spiritual education.

The beliefs, customs, and practices associated with the native traditions were to be discouraged. Ceremonies that included dances or involved the display of crests, the languages, the social and religious arts—anything involving the tribal past, in fact, was to be targeted and rooted out.

The church's presence—regardless of the denomination—was felt in every way. Reformation affected burial practices and discouraged the use of native languages while encouraging English. Masked dramas, potlatching, even raising totem poles—all social rather than religious activities—were prohibited. The church declared these practices wasteful and therefore undesirable—even repulsive—excesses. The church encouraged the Indians to emulate Western social manners and eating and sleeping habits. The nuclear family was to replace extended family associations; saving one's resources and wealth instead of sharing it with others was encouraged.

The success of such efforts differed from place to place, even from village to village. Success was immediate and all-pervading in some places; in others reforming efforts were resisted for a time but then resistance flagged; still others were hold-outs against the pressures to convert and change.

This assault, supported both by provincial and federal administrations, led to the destruction of the culture in ways inter-tribal warfare could never have envisaged. It eroded the authority of lineage and clan chieftains, undermining their traditional forms of wisdom and counsel. It fractured clan solidarity and strained loyalties; it divided parents against children, elders against the on-coming generation. Put simply tribal populations were splintered into conservatives (those refusing to embrace the new customs), progressives (those willing to reject their cultural past in order to substitute something new), and those caught in-between.

The progressives were presented with a new-found opportunity to cast-off the constraints of tribal participation. People, they argued, were becoming increasingly indifferent to the customs and practices of the past anyway. Traditional ways were outdated. People chafed under the custom requiring them to support a potlatch to honor the dead; they were not interested in raising totem poles. Better to save the money and reserve wealth for one's immediate family rather than to share it with strangers.

Some converts to the Christian faith became zealots in their pursuit of church objectives. They urged their people to renounce tribal and kin ties, burn the trappings of the past including their crests and other clan heirlooms, ignore clan ties, burn down the totem poles. One Anglican pastor parlayed the cooperation of the people into cutting down the poles standing in a Nass River village to use them as a foundation for a church. In Howkan, a Haida town, another zealot convinced his people to cut down every totem pole in sight. (Ironically, this same person many years later was hired to teach the younger generation how to carve model totem poles).

The conservative factions, on the other hand, accused the progressives of selfishness and of shirking their moral obligations to family honor. Above all, they condemned the liberals for failing to respect the past. The older generations watched their way of life erode before their eyes. What was to happen to their venerable traditions, their children's moral and ethical education, the ideals of generosity and sharing, the need to perpetuate the family and ancestral names and crests?

BANNING THE POTLATCH

Tribal warfare, diseases, and the associated decline in population were one thing. The assault on the traditional spiritual values was something else. It destroyed the underlying reason for living—that body of shared beliefs each individual needs to explain the meaning and significance of being alive. Only an integrated World View can give a life coherence—without it all is madness.

The crowning blow came when the government officially banned the potlatch. Both government and church concurred that the potlatch thwarted efforts to civilize the people. The Canadian Indian Act of 1876 made potlatching illegal, as well as the winter dances associated with them. Jail sentences, confiscation of property, and fines were the sanctions imposed upon those who violated the law. The potlatch was after all the integrating event—the capstone which summoned and made outwardly visible the inner and invisible metaphysics of traditional weltanschauung. Banning the potlatch clearly foreshadowed the end of tribal life as it had been lived and explained through untold generations.

This prohibition brought pole carving to an end. Gradually the demand for the work of the craftsmen diminished. Some carvers found work making masks and canoe models to supply museum collectors and individual Indians determined to follow their conservative bent; others were reduced to carving miniature totem poles and model houses for the tourist trade. Other carvers put away their tools, turning back to fishing for an occupation.

CONSERVATIVE HOLDOUTS

The Haida of the Queen Charlotte Islands, the Coast and Nass River Tsimshian, the Northern Kwakiutl, and the Bella Coola groups turned their backs on the old ways or had little power to do otherwise. In contrast, Masset and Skidegate remain as traditional Haida settlements today. Those who had earlier occupied villages such as Kasaan, Klinkwan, Howkan, and other Kaigani places resettled in Hydaburg or other Alaskan communities, retaining to some degree their traditional ways.

With the Southern Kwakiutl the story takes a somewhat different direction. They experienced a new vigor and energy despite a population decline. This renewed cultural vitality seems at odds with the official efforts to stamp out the traditional cul-ture. These tribes succeeded by wisely choosing the path of non-confrontation and subterfuge rather than openly defying the authorities.

There is ample evidence to show that potlatching in Southern Kwakiutl country took on a renewed fervor at the turn of the century, fanned by growing opposition to the restrictive government policies. Nor did the totem pole raising slacken. Rather, the number of poles and related potlatches increased, as I pointed out earlier.

New poles appeared first at Alert Bay—in fact, the greatest period of pole raising took place during this time—followed by pole raising in several neighboring villages. All this activity occurred at the time when potlatching was officially discouraged or banned. Interestingly, the church made substantial progress among the Kwakiutl in terms of religious conversions, but in the eyes of their converts there was a difference between observing their newly adopted faith and practicing customary social activities. They had successfully divorced religious faith from cultural traditions which they viewed as social, *not* religious in nature.

The Kwakiutl leaders insisted potlatching was not a religious activity despite the church view to the contrary. The dances associated with exhibiting crests and other assorted prerogatives had nothing to do with religious beliefs or values; therefore, they constituted no conflict in loyalty and devotion to the church. Disapproval, legal sanctions, and social stigma failed to deter the Kwakiutl. They remained committed to potlatching, to raising memorials to deceased leaders, even if they were now being placed in Christian-type graveyard settings rather than before their houses. It was wrong for the people not to do such things. A Kwakiutl leader in 1890 stated it this way:

> It is a strict law that bids us dance.
> It is a strict law that bids us distribute our
> property among our friends and neighbors.
> It is a good law.
> Let the White Men observe their law.
> We shall observe ours.

Another Kwakiutl from the conservative village of Fort Rupert, Charley Nowell, was an exuberant, self-confident extrovert whom I met in the years 1946 and 1947. He once gave me a lift in his gill netter from that village to Alert Bay. Above the engine's din we talked about his potlatching experiences. He harbored little resentment for the misguided church efforts to change his people's customs despite having served a jail sentence (1921) for potlatching. In his autobiography

entitled *Smoke From Their Fires: An Autobiography of a Kwakiutl Chief* (1941) he tells the following story:

> When the Indian agent first came from Alert Bay to visit us he begins to talk to us about the potlatch and he says he is going to stop it because it is no good.
>
> I ask him how he knows. He says I know all about it. I know more than you know. I says to him, you must be older than I am because I have lived all my life among my people and I still don't know everything about it. The agent said, I've been told. And when I ask him who tells him, it is always another White Man.

The Kwakiutl resorted to various subterfuges to disguise potlatching. They left their villages ostensibly to forage, hunt, or fish but instead attended potlatches being hosted in more isolated places. Lookouts were posted against surprise intrusions by Indian agents. Further, potlatches were performed piecemeal in order to throw agents off the scent. The agent Halliday wrote in 1913 that "potlatching has the greatest hold on the people and they refuse to stop it."

Potlatches were given under the guise of church or hospital-sponsored fund-raising events. The Indians danced and wore their masks (thereby displaying their hereditary crests and other prerogatives). The hosts surreptitiously distributed money and material items as gifts resulting in the validation of the host's claims.

Another area of cultural conservatism at the end of the 19th century, and for some years thereafter, centered among the Tsimshian groups residing in the Gitksan region. Potlatches were given and poles were raised for many years. But these activities eventually waned and stopped for a time during the years of the Great Depression. Only in recent decades has potlatching and pole raising been resumed.

While change inundated several Tlingit tribes adjacent to the Haida and Coast Tsimshian groups, a few Tlingit villages maintained a conservative posture primarily centered around potlatches to honor the deceased leaders of respected clans and to name successors. Hoonah and Angoon were two such villages. The people continued to potlatch well into the mid-20th century but its form and character had undergone great modifications. Neither village, it should be noted, raised totem poles. Nor did Klukwan, perhaps the most intensely inward-looking community of all the Tlingit tribes. When I visited Klukwan for several weeks in 1949 as a member of an ethnographic-archaeological survey team, the great clan houses were still intact and held in proper reverence and respect. There were two Whale Houses. One was justly famed in the anthropological literature for the beauty of the treasures located within it. Recently some of these esteemed treasures were removed from the house by a progressive faction, and a litigation ensued in order to recover them. A final disposition awaits further court actions. Its irreplaceable properties of painted house screens, interior house posts, and clan costumes may be lost forever. The village was a veritable treasury of clan houses: The Frog House, Eagle House, Killer Whale House, Wolf, Raven Houses, even a Moose House. They contained some of the finest examples of Tlingit art, the pride and crowning achievement of their ancient tribal heritage.

THE TOTEM POLE EXPORTING PERIOD

The continuing downward spiral of native culture was accompanied by a massive shift of their material possessions to Western museums and private collectors. Nothing similar to it had taken place in other parts of the world over so short a period of time. These possessions involved both clan and tribally-owned properties and included hundreds of totem poles.

The transfer of possessions came about as a result of the emergence in both Europe and North America of the great anthropological museums. A three-pronged rivalry emerged at the turn of the 20th century among the major institutions in the United States, igniting a competition that spread to the far corners of the world. It involved the U.S. National Museum in Washington D.C., the American Museum of Natural History in New York City, and the Field Museum of Natural History in Chicago. This competitive, often abrasive, rivalry to acquire the finest objects from the Northwest Coast did not slacken or abate for decades. Nothing was to be spared in the efforts of administrators of these museums to gain control of the finest artifacts from the major tribal groups occupying the region. This acquisitive rivalry was further spurred by international competition from European institutions determined not to be left behind in the clamor for Northwest Coast material culture. Museums in Berlin, Hamburg, and Bremen competed with London and Oxford institutions; every major European capitol avidly sought the valuable remnants of this "dying culture." Poles were gathered by fair means and foul when necessary. The science of anthropological museums was literally rocketing to prominence and Northwest

Coast culture was to play a vital role in this growth. Curators hoped to document the best of the tribal culture for their respective museums.

Ironically, the museums of the world were bestowing recognition on the remarkable achievements of the Northwest Coast people at the very moment the government/church campaigns to civilize the people were reaching their apogee. Since the culture appeared to be in its death throes, the museum staffs pursued policies of extreme urgency to save all that was possible for future documentation and study. Museums were viewed as the guardians of the past, and each strove to present the very finest collections possible.

Museums, in part funded by wealthy benefactors, sent expeditions to collect a range of artifacts that represented the culture in its purest form. They hired professional collectors, giving them a mandate to collect examples of the material culture that ultimately were to number in the tens of thousands. Such was the prodigious output of the Indian tribes! Field collectors such as James Swan, C. F. Newcombe, and George Emmons among others bought artifacts from whomever would part with them. Entire villages were stripped of possessions representing the past when the prices were right. The shopping lists museum administrators provided these collectors grew at a phenomenal rate and included the acquisition of various types of totem poles. Each museum strained to outdo its competitors in acquiring as many fine examples of totem pole sculpture as was feasible. Their appetites were seemingly insatiable.

The Canadian museum authorities looked on such actitivies from outside institutions with growing dismay. Collections that they hoped were intended for Canada were siphoned off to foreign institutions because the Canadian museums often lacked the funds to purchase them.

Museums competed with each other to acquire a variety of pole types, house and mortuary poles as well as welcome figures used in potlatches. But the finest were the heraldic and house frontal poles and these were tracked down and purchased with little regard for expense or logistical problems incurred in shipment. Between 1890 and the late 1920s countless numbers of totem poles left the British Columbia and Alaska villages. Some had been acquired legitimately through purchase from their owners or their heirs. This often involved painstaking, laborious negotiations over time, and proceedings were fraught with countless pitfalls including disputes between claimants to the property. Other poles vanished from their sites and were unaccounted for, having been removed without consent when the villagers left to fish for salmon.

Professional collectors emerged by the scores, abandoning former professions in order to pursue such a lucrative and fascinating undertaking. These men roamed widely to bargain for and purchase what poles their owners might be willing to sell. Some owners simply refused to sell their lineage property. Not that they put any great value on such things as totem poles since their original purpose had been served but the conservatives wished to preserve the symbols of their culture. The problems of determining ownership or settling upon a reasonable sum with the claimants became so complex an ordeal as to repeatedly frustrate the collectors. Natives who had little interest in either the old culture or the collapsing poles suddenly came forward to claim a share of the proceeds from a sale. They too wanted a piece of the action.

Many natives thought it eminently reasonable to sell the poles that had been raised by their ancestors. The poles played no role in their changing life-styles; the poles had already served the purpose for which they were intended; they held no further value in the eyes of their owners, but the funds derived from their sale could help tide them over in the difficult financial times when their resources were stretched to the limit.

The Field Museum in Chicago acquired the very best from Haina (plates 32, 33) while the monumental examples found in the Pitt Rivers Museum in Oxford and the British Museum in London, include the finest examples of Haida poles extant.

Neither the government of Canada nor the U.S. were particularly concerned with totem pole preservation during this early 20th century period. Local white settlers saw little to recommend in saving them. These symbols represented a defunct past that might best be allowed to disappear. Only a handful of well meaning residents saw them as part of their country's cultural heritage. But their views had little immediate impact on local legislators so funds to salvage, preserve, purchase, or otherwise care for them were not appropriated. The time for such action had not yet arrived.

Old Kasaan, the Kaigana Haida village located on the east coast of Prince of Wales Island in Alaska (plate 11), was considered by museum authorities and collectors to be without question the peerless repository of monumental sculpture. Old Kasaan was abandoned and the poles, numbering in the dozens, left behind to rot. Their imminent collapse engendered few expressions of regret. The

agencies of government were apathetic. When pressures for preservation began to mount, officialdom urged further study of the question. Small wonder the majority of the poles left behind disappeared quickly or quietly decayed. Katherine Kuh, writing on "Alaska's Vanishing Arts" in the October 22, 1966 issue of *Saturday Review Magazine,* described the ultimate irony. At Kasaan, some 20 years earlier, a government official with whom she met assured her that new poles had been carved from the original models and "nothing had been thrown away but the originals."

It might be instructive to briefly examine where these totem poles were shipped from their villages of origin. The Field Museum in Chicago and the American Museum in New York probably accounted for close to 100 poles between them; the Canadian National Railways and the National Museums of Canada probably an equal number. Institutions large and small acquired at least another 100, perhaps even more. A survey might reveal over 300 totem poles housed in various institutions around the world. There is no way to tell how many are lodged in private collections. Twice that number, in all probability, were lost for a variety of reasons. Such numbers suggest the feverish tempo of museums' acquisition efforts.

The collectors Swan, Newcombe, Emmons—even the peripatetic Marius Barbeau—provided numerous poles for museums. The Soviet Union, England, Scotland, Germany, and France acquired them. More were shipped to Sweden, Switzerland, Denmark, Finland, Spain, Austria, Australia, New Zealand and Mexico. The major university museums in the United States and Canada took up the pursuit of Northwest Coast Indian art. The Peabody Museum at Harvard, Yale, Princeton, Toronto, Philadelphia, Berkeley, and Seattle became collectors. The large metropolitan museums followed suit: Montreal, Quebec, Victoria, Vancouver, Brooklyn, Calgary, Milwaukie, and Denver to name but a few. There were hardly enough quality totem poles to meet the ever-increasing demand.

Despite the enormous sizes of some poles—occasionally exceeding 60 and 70 feet—they were shipped by whatever means readily available to the collectors at the time of purchase: truck, steamship, rail, or a combination of all three. The poles were shipped via the Panama Canal to points on the east coast of North America or Europe. Some mighty poles, generally Haida or Tsimshian examples,

were cut into two and three segments to facilitate transporting them across the continent in boxcars. Many remain in their amputated state because the ceilings of the museums for which they were purchased were too low to accommodate them.

Upon reaching their destinations other poles were placed in storage until funds could be found to exhibit them. With the onset of the Great Depression, however, funds were not available so the poles languished in storage, destined not to see the light of day. Masterpieces were sentenced to dark and forbidding environments far from their self-contained and formerly dignified repose. Many continued to decay in such environments. Still others were vandalized beyond repair.

It is small wonder the upcoming generation of native children in the first third of this century had little familiarity with their cultural heritage. In order to see anything related to that past they were required to journey to museums in distant cities. They grew up learning little about the totem poles—being discouraged from doing so by the education policies in vogue at the time. They learned precious little of the role the poles played in the lives of their ancestors. They learned little about the place wealth played in the lives of parents and grandparents. They learned virtually nothing of the symbols of their past, less yet about the complex style, tempo, and subtle meanings of myths and stories associated with them. Their oral heritage had been replaced by a European weltanshauung which had little relation to the lives of their parents and grandparents.

The reader might assume that we have come to the end of the totem pole story. But in fact another chapter remains to be written. The intense interest in the cultural heritage of the Northwest Coast tribes—exemplified by the totem pole arts—has been gathering momentum for several decades. The formerly indifferent have begun to take another look at the life of the native people. The art museums which once rejected Native American Art began having second thoughts about such policies. The natural history and anthropological museums were not to be left as the sole interpreters or repositories of this particular heritage. Government agencies at all levels—federal to local—began reexamining their policies of civilizing and educating the native peoples. An increasing number of white citizens of the region were being added to the formerly thin ranks of those who saw much of value in the works of the indigenous peoples.

CHAPTER VI

New Poles For Old

If we Kwakiutl keep the art only for ouselves it will die. If we share it with the White Men it will live forever!

Mungo Martin

From a conversation about Mungo with Tony Hunt in Vancouver, B.C. circa 1965.

The survival of totem pole carving looked bleak indeed in the early decades of the 20th century. There were but a few pockets where the practice had survived, namely in a few villages located in the Gitksan region and among a handful of Southern Kwakiutl settlements. Given the vantage point of the times, people familiar with the decline of pole carving in Alaska and British Columbia could not avoid coming to the conclusion that the end was in sight. It would have been a foolhardy exercise to predict otherwise.

Scholars and scientists who best knew the circumstances surrounding this decline could do little more than lament its passing. An astute observer of and writer on Northwest Coast Indian ethnology, the late Wilson Duff, former curator of anthropology at the Provincial Museum in Victoria, envisioned imminent and total collapse of totem pole carving. In referring to the activities in the Gitksan he wrote in 1952, "the customs associated with pole carving will probably die out with the death of the remaining carvers."

Duff's comments were based on what he easily observed taking place. But a prophet's mantle rests uneasily on the shoulders of the best informed, revealing once again the futility of making accurate predictions about the future. Anything is possible

given the favorable combination of fortuitous circumstances.

Other factors not easily recognizable but no less significant were also operating, subtle, sub-rosa, amorphous. Two were particularly significant. First, government policies directed toward forceful change do not always realize the results desired; i.e., forcing an ethnic group to give up their most treasured cultural and psychological support systems. Moreover, such intrusions are often counterproductive, bringing about the opposite result. Such intrusions often serve to rally people to covertly or overtly resist the changes being forced upon them so the policy is subverted. The second and related factor is that the suspension of intrusive policies often leads to a weakening of opposition to change, inducing rapid modifications in the social and cultural behavior of the people. I believe these two factors were operating among some of the Northwest Coast Indian societies.

THE AWAKENING

Changes in Provincial and Federal policies toward the Indians were beginning to take shape as early as the mid-1930s. A greater degree of tolerance for cultural differences seemed to take root within the inner circles of government. Moreover, belated recognition of the unique character of Northwest Coast Indian culture was taking place, a recognition that included acknowledgment of their contribution to the history of the region. At first concrete results of these changes

seemed imperceptible but became more evident as time passed. Change involved not only efforts to stabilize the Native population following decades of decline, but also to provide the Indians more adequate health care, education facilities, and employment opportunities.

Specific to the subject of this book was the appearance of newly devised policies directed at the need to salvage and preserve totem poles as a part of the Indian heritage. While such policies were experimental in nature for a time, subject to the ebb and flow of changing political administrations in both countries, they were significant because the bureaucracy had at last awakened to the problem.

Plans to preserve the totem poles further stimulated an increasing awareness and interest on the part of the public. The increased support in British Columbia sharply contrasted with that seen in Alaska, perhaps reflecting the political and cultural immaturity of U.S. Federal officials at the time. There is little doubt that this increased interest in totem poles reflected a recognition of a vital link with the history of the Pacific Northwest. Here was a unique, vibrant cultural heritage in need of protection and saving.

Launching these salvage operations required much technical and administrative sophistication. There were no available "road maps" to follow. There were multi-dimensional factors to be weighed and understood. Federal policies encouraging the support of native arts and artists was one necessary factor. Increased interest in the cultures of the native peoples was further fueled by the population growth of the Northwest and the increasing mobility of the inhabitants. But salvage operations were not inspired by altruism alone. Self-interest was a significant factor. Policies were clearly tied to the need for developing economic opportunities, particularly those associated with tourism. If any one symbol epitomized the strange, wondrous, and enigmatic character of the Pacific Northwest, surely that symbol was that heroic figure, the totem pole. The image was there to be used.

Modest programs began to be funded by the respective federal governments. The initial focus centered upon gathering as many examples of totemic art as was possible and providing adequate storage facilities for their preservation. Time was running out if the poles that remained in many of these villages were to be saved. Conference followed conference at various levels of government as attention was drawn to specific issues: logistics, salvage problems, preservation techniques, funding needs, rights of heirs, compensation—all involving seemingly endless debates.

The first efforts to gather the totem poles were complicated by factors not readily recognizable during the initial stages. They related to the Indians' responses to saving their poles. One era had just passed which had urged the people to destroy or abandon them; the period that followed was an about-face in policies, encouraging them to help save the poles. Government agencies began to grasp the magnitude of the difficulties ahead before one pole could be moved and preserved. For example, in British Columbia the totem poles remaining in the villages required interminably complex negotiations with their owners or heirs. Some negotiations extended for months and even years. The poles were the property of specific individuals who represented definite lineage or clan lines. The problem was to find these heirs, who did not always live in the villages where the poles stood, and to negotiate permission to remove their poles. Poles also stood on Indian Reserve land. The integrity of Indian property—the Reserve—was guaranteed by Treaties with the Crown. Before a pole could be removed from its site, it was necessary to establish accurate ownership rights, acquire permission to remove it, and provide adequate compensation. Removal of any pole—regardless of its condition or state of preservation—without prior approval from its owners constituted an illegal act tantamount to theft and therefore subject to punishment under Canadian laws.

A wide range of sentiment about the value of the poles was also encountered. These ranged from outright rejection by their owners to sell or save them to interest in negotiating, provided compensation was adequate. Some groups easily compromised; others were adamant, their decisions irrevocable. Matters were seldom amiably resolved; more often negotiations exacerbated old suspicions and fears, causing long dormant rivalries to resurface, and stirring up factional disputes that might otherwise have remained dormant.

In Alaska a different set of circumstances were encountered, necessitating other approaches to salvage operations. Abandoned Indian communities came under the administration of the U.S. Forest Service. When natives moved away in order to pursue employment opportunities elsewhere, the sites reverted to the jurisdiction of the agency and the poles left in the villages became part of their control. The agency was given the task of determining what to do with the poles, whether any might be removed and preserved and whether

some should be left behind due to advanced decay. Saving them was not always a high priority in this period. The natives, on the other hand, often argued that the poles left behind still constituted part of their property and their move was in no way to be interpreted as denial of that ownership. A claim could be made for rightful compensation. It is understandable that feelings sometimes ran high when some poles were removed. Consequently, agreements were drawn up and signed by Forest Service officials and the Tlingit leaders, allowing their removal.

Other questions required solution if such programs were to go forward. Which poles should be given salvage priorities? Which were beyond saving? Who was to make such decisions? Did the poles warrant the expenditure of large sums in order to restore them? What storage facilities were available to prevent further deterioration? How much repair or refurbishing was necessary? Was it more desirable to have replicas carved of the old poles than attempt to save the originals? The questions seemed endless.

A host of questions also dealt with preservation techniques which were as yet little understood. How could poles be adequately protected from their deadliest enemies, moisture and insects? Without the support from provincial, state, and federal legislatures, operations could not be carried out for want of funds. There were bureaucratic problems to resolve: i.e., the inevitable time-lags between directives, funding, and field operations. It could take years to set proposals into motion.

THE BEGINNING OF SALVAGE AND RESTORATION PROGRAMS

Small-scale salvaging activities were at best a holding action. What was necessary to save the remaining poles was a comprehensive plan which involved rescuing all that remained and providing a proper setting for them. It is not the purpose of this chapter to pinpoint all the successive steps in such operations, but rather to focus upon some of the important breakthroughs and successes that followed, as well as the disappointments and failures. If we examine such activities chronologically, the increasing tempo of events and trends becomes self-evident.

One of the earliest efforts—one far in advance of the times—came about as a result of a long established friendship between John Brady, the Alaska territorial governor, and the Kaigani Haida groups who resided there. Brady envisioned

establishing an impressive public park which would honor the Tlingit-Haida heritage in Alaska. In 1890 a dozen or more poles from these villages were bestowed as gifts from the Indian people upon Governor Brady, making his dream for such a park possible. The site chosen was near Sitka. In the meantime the poles were placed on temporary loan to the Louisiana Purchase World Exposition to be held in St. Louis in 1904. The following year they were shipped to Portland, Oregon, for the Lewis and Clark Centennial Exposition in 1905. They eventually were returned to Sitka where in 1910 they were permanently installed in a forested area ultimately to become the Sitka National Historic Park. Many of the poles had meanwhile begun to disintegrate, so replicas were carved and raised anew.

The establishment of the park in Sitka set a precedent to preserve the poles in their natural coastal setting. Judge James Wickersham, a renowed political figure in the territory, attempted to build on this precedent. He had observed poles lying in a chaotic state in the abandoned Tlingit villages at Tongass, Gash (Cape Fox), and Village Island settlements. His efforts to gain support for another such park incorporating these poles proved ineffectual and the plan languished. A curio merchant named Walter Walters, however, operated a store in Wrangell and was able to successfully negotiate for the removal of a few Haida poles from their original sites. He installed them in front of his shop where they served as landmarks for many years.

Between 1934 and 1937 various Alaskan political figures endeavored to develop support for a U.S. Forest Service program to salvage totem poles. Activities were to be coordinated with the newly organized Civilian Conservation Corps or CCC, a program originating in the Roosevelt administration. The program was designed to provide gainful employment for the unemployed created by the Great Depression of the 1930s. Natives from several villages in Alaska were hired to assist in salvaging operations. Poles were collected and moved from Kasaan; others were taken from Sukkwan and Klinkwan. Forty-eight poles in various stages of decay were slated for restoration work while 55 found to be beyond salvage were to be duplicated by native carvers hired for this purpose. Another 19 poles were to be carved without reference to any specific historical models.

On Prince of Wales Island a new town emerged near a modern salmon cannery some 8 miles from Kasaan and called New Kasaan. In the mid-1930s several poles from the old village were removed

and placed in a public park in the new settlement under a U.S. Forest Service policy for such communities. Small clusters of poles were also gathered and raised at sites that later became known as Saxman and Totem Bight State Parks near Ketchikan. However, as late as 1971 a visitor to old Kasaan reported that two dozen or more totem poles were still standing, though much overgrown by brush and weeds. Without further efforts they were doomed to collapse and disappear.

One problem related to the restoration of the old poles and the recarving of replacement poles quickly became apparent. Few practiced and experienced Tlingit or Haida craftsmen had survived. The old apprenticeship system had collapsed so no new models were available to those who were interested in pursuing the carver's career. The few carvers volunteering for the work had little grounding in the principles of totem art— the skills had been lost a generation or more previously. Being of Indian birth proved not to provide adequate credentials for carving totem poles of authentic design. Yet these individuals were hired to restore them or create replicas. The results, as might be expected, were disastrous. They were lifeless, adhering to the originals neither with any degree of fidelity nor painted in the proper colors. As gross failures, they were an affront to the past, an injustice to the artists who originally created them, and unworthy of the funds that had been poured into producing them anew. But we must keep in mind these efforts were early gropings, following a course on an uncharted sea, as it were, without adequate guides or guidelines.

The Forest Service and the CCC program administrators could hardly be censured for their inability to find carvers of genuine skill and merit. In retrospect the program probably should have evolved first by preparing the artists for the tasks, then directing their talents to specific projects of restoration and duplication, step by step.

During the late 1930s and early 1940s rehabilitation programs involving the CCC crews followed absurd scenarios. Not only were the carvers poor technically, but they also lacked any familiarity with the crest symbols incorporated in the historic poles they were supposed to restore. The carvers resorted to heavily painted surfaces with which they coated their ill-conceived reconstructions, using colors which bore little or no resemblance to those used by traditional artists. Paints introduced for such purposes were not just garish, they were often outlandish. Refurbishing jobs were sometimes assigned to prisoners from the local jails. When replicas were made of some poles the ill-equipped restorers frequently altered basic design elements. Parts of the originals were lost, and records of the replicas were not made or were lost, thus further blurring questions of authenticity and historical value. Carvers took liberties with figures being restored that made experts cringe.

In 1939 Saxman Park was created in Ketchikan. It was to serve as a landmark for the display of Tlingit totem history. A dozen or more poles were eventually raised, including some which belonged to Chief Skowl from Kasaan.

While these operations were going forward in the remote areas of Alaska territory, a significant exhibition of Native American arts was held in the U.S. Pavillion at the Golden Gate International Exposition in San Francisco in 1939. Haida and Tlingit poles were placed in dramatic juxtaposition, evoking gasps and a sense of wonder from the audience. As a smashing international success that had no earlier parallels, the Exposition further stimulated public interest in totem poles.

A second major show followed in the wake of this triumph. The Native Arts Exhibition was mounted in 1940 at the Museum of Modern Art in New York City. Totems from the Northwest Coast villages were prominently displayed, provoking yet another thrust of interest in preserving the totem pole heritage of Alaska.

The onset of World War II interrupted the gathering momentum of the first phase of the early restoration. In 1947 the Forest Service resumed some of the early programs. Carver training programs were planned and gradually implemented while more poles were collected and stored in Ketchikan, Wrangell, Klawak, and other communities. By now, of course, the indifferent quality of the work done by the CCC carvers was all too apparent. Something of better and more authentic quality was necessary. So attention was now directed to the redress of the egregious errors and emptiness of the earlier restoration efforts. Copies had to be made of copies, as it were, in order to expunge the stigma associated with the inferior work of the past.

The initial efforts in Alaska were both haphazard and unproductive, as the programs lacked both long-range support and realistic goals. They also lacked that sense of urgency necessary to assure the preservation of the poles which still survived.

By contrast the plans developed by the Canadian government were far more substantial and better founded. They proceeded in a more

enlightened manner which yielded a greater return down the road. The thrust of the Canadian programs was to salvage and restore the totem poles with the approval and support—where this was possible, at least—of the Indians who owned them. Indians later shared in such salvaging operations in some cases, or at least cooperated with the government. Appropriate compensation was an integral part of the restoration efforts. Authorities also formulated a long-range funding plan depending on both public and private sources, people interested in seeing that the poles were saved. Salvage expeditions were of several years duration and planned in successive stages. There was an early recognition that a major element in the success of the program was an adequately trained carving staff.

To offer a detailed account of the Canadian efforts and achievements would take far more space than is available here. The program depended in the early phases on numerous experimental moves which gradually gained momentum with each success. A great deal of information was assembled before restoration efforts were undertaken. Negotiations with the owners of the poles involved ongoing, tactful discussions, low-key parleys, a non-threatening atmosphere, conducted over many years. Eventually a sense of trust between government representatives and the people gradually emerged. The program could not have been implemented without this preliminary spadework.

One of the first salvage efforts in British Columbia was the Skeena River project. It differed from earlier salvage efforts in that it was directed not to removing the poles, but rather to keeping them in their original sites and safeguarding them from collapse and disintegration. As noted earlier, this region had remained a conservative stronghold of the riverine type Tsimshian culture. A cluster of long established villages lying within a radius of some 50 miles contained over 100 totem poles, some of spectacular proportions and sculptural qualities (plates 38, 39, 40, 41 and color plates 9 and 13). The innovative plan devised for this area ultimately overcame the suspicions of most of the villages, though not all.

Three communities—Kitwanga, Kitenmaks (Hazelton), and Gitsegyukla—were located along the Canadian National Railway line to Prince Rupert about 150 miles to the west. Several other totem villages lay in close proximity to the railroad and so could easily be reached by rail travelers. A joint government and Canadian National Railways undertaking—including joint funding—underlay the project. Kitwanga was selected for the initial restoration effort. The plan required the consent and cooperation of the Indian people which was gradually obtained. In 1925 restoration work commenced and resulted in the raising of several old poles that had either collapsed or were in danger of doing so. A total of 14 poles eventually lined the street of the village (plate 16). Poles were not placed into the ground but bolted just above it to another log imbedded in the cement. This technique, it was hoped, would remove the pole from the ground moisture that accelerated the rotting process. While this experiment proved to be unrewarding in the long term, further experiments followed, some of which proved beneficial.

Much attention was devoted to determining the best ways of preserving the poles. Climatically, the Gitksan area was different from the coastal Tsimshian country in that the greater extremes in seasonal temperature prevailed. This kind of basic research was one of the primary reasons the Canadian program fared so much better than that of the U.S.

In the Gitksan region other programs followed. In Kispiox village (plate 14 and color plates 10 and 14) the old poles were left unpainted lining the original village site near the edge of a tributary of the Skeena. The knowledge acquired from Kitwanga and Kispiox efforts was devoted to restoring Kitwancool columns beginning in early 1951. Some of the best results of the Canadian program came out of this endeavor.

The Canadian Government and Canadian National Railways jointly sponsored efforts to locate more totem poles in Prince Rupert, the terminus of the railway and the hub of communication, economic, and political activities in the north of the province. Located in the heart of the Nass and Coast Tsimshian country and adjacent to Haida and Skeena territories, it became an important transportation and tourist center. Poles were first acquired from Skidegate, Tanu, and Masset villages in 1935 and placed throughout the city including a number of the public parks.

While a few of the 14 or more poles were originals, most were eventually replaced by restorations. These replicas were as badly painted, in some cases using jail inmates, as the unfortunate examples in Alaska.

In the early 1960s the city hired a Tsimshian carver named William Jeffrey to carve replicas of the disintegrating Haida poles. In my opinion it was a tragic choice. Between 1960 and 1966 Mr. Jeffrey carved 12 new poles, 9 of which were modeled from Haida originals, 2 from Tsimshian

originals, and one of his own creation. Jeffrey's replicas were inadequate, indeed tragic, attempts to reproduce the Haida masterpieces. He completely missed the mark capturing the characteristics of Haida sculpture. For all his good intentions, he not only did not understand Haida design, it is doubtful he understood the Tsimshian stylistic features.

Prince Rupert poles should be taken down. The task of duplicating the originals should be funded again and the job given to any of several fine contemporary carvers residing nearby. Among these talented artists two in particular stand out: Dempsey Bob, a Tlingit-Tahltan carver who makes his home in Prince Rupert and carves monumental Tsimshian poles, and Robert Davidson, a Haida carver who resides in Masset. The residents of Prince Rupert would be better served—and the province as well—if the poles presently standing were replaced by such qualified carvers.

While salvage activities were going forward in the northern part of the province, other projects were proceeding in Victoria, the capital, and in Vancouver. In 1941 Thunderbird Park was launched in space located across from the imposing Parliament Building in Victoria (color plate 5). The poles raised included those typical of many coastal tribes, a mixed-bag of Haida, Tsimshian, Kwakiutl, and Nootka types surrounding a life-size model coast house. The park became a major focal point for tourists visiting the city. This project served as a forerunner for other coast village plans yet to appear.

The University of British Columbia in Vancouver also embarked on a pole conservation project. In the late 1940s Totem Pole Park, featuring Kwakiutl poles acquired in part from Mungo Martin, was built in an untrammeled section of the campus. A few years later it was enlarged with the construction of a full-scale model Haida village consisting of a Haida style house, a smaller mortuary house, and several house frontal, heraldic, and mortuary-type poles of exceptional quality. Located in a moss and tree-filled glen, it had a stunning visual impact, a striking tour de force (color plates 1, 2 and 3). It had been conceived and executed in brilliant fashion by the Haida carver Bill Reid with the help of several Kwakiutl assistants.

IMPLEMENTATION OF TRAINING PROGRAMS

We must retrace our steps briefly at this point to dwell on a growing truth relative to the nature of restorations. In Alaska the CCC efforts by native carvers in the mid to late-1930s fell far short of the mark, as already discussed. There were painfully few carvers in the Territory so before further work could go forward better training programs were a necessary step. Such a requirement was obvious to the planners in British Columbia. The Haida and Coast Tsimshian carvers had also disappeared; there were few practicing pole carvers in the Gitksan but several were known to be working in the Southern Kwakiutl region of Vancouver Island. Most notable were Charlie James from Fort Rupert, his stepson Mungo Martin, and Willie Seaweed from Blunden Harbour. Charlie James and Seaweed provided the continuity of the skill which kept totem pole carving from disappearing, as did other Indians notable for keeping the tradition alive in this area.

If James and Seaweed provided the spark, then Mungo Martin was the fire which lighted the renaissance. Mungo learned carving from James, his stepfather, just after the turn of the century. His poles can be identified standing along the beach in Alert Bay in 1910 photographs. His stepfather's influence was profound, leading him to an understanding of the need for restorations. Mungo was able to revive the flickering by training apprentices. The Provincial Government came forward with a plan to support such efforts. The Museum in Victoria secured his services early in the 1950s. As its chief totem pole carver, Mungo, still vigorous at the age of 73 years, began a new career, revitalizing the carving arts of the province. His students came from several different tribal groups, the most prominent students being Bill Reid, Douglas Cranmer, Henry Hunt, and Tony Hunt, Henry's son. These men in turn stimulated a new generation of artists, Robert Davidson, Calvin, Frank, Richard, Tony Hunt Jr. as well as a white carver, John Livingston, among others. Following Mungo's teaching, the Kwakiutl carvers had begun to share their art with the White Man.

Mungo played a vital part in keeping the techniques of pole carving alive until they could take deeper roots. He was a bridge to the past, reaching out to the coming generations of the 1960s and 70s. He was steeped in Kwakiutl traditions, despite his part-white, part-Indian heritage. A man of rare talents, perceptive vision, and few words, he was also obstinate. When totem carving was dis-

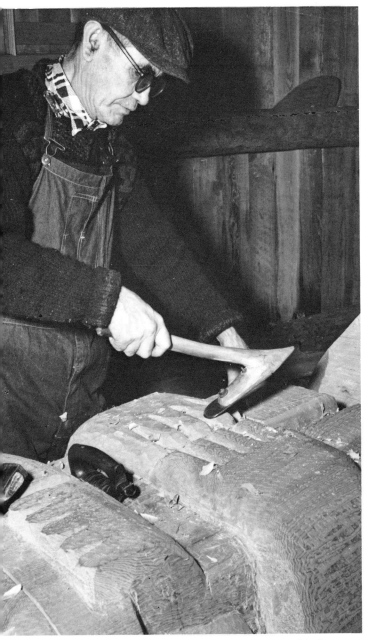

Plate 54. Mungo Martin, the master Kwakiutl carver, preparing a house post for the totem pole restoration program sponsored by the Provincial Museum, Victoria. He was about 75 years of age at this time, and was to enjoy an extremely active career of supervising totem pole restoration activities for another 8 or more years. The tool he is using to define the surface contours is the elbow adze.

appearing he refused to give up. He followed the long established techniques taught him by his predecessors when training apprentices. Students must learn all the rules and conventions associated with the traditional arts first. They also learn by doing and trial and error. This was the old way. Once the apprentices had demonstrated mastery of all the carving skills they were permitted to innovate to express their individual styles.

During the several years prior to his death in 1962, Mungo's team of carvers made poles and sent them to a variety of locations in the Province as well as sites abroad. The Provincial Museum Report for 1954 disclosed that replicas had been completed for 2 Haida, 2 Tsimshian, 1 Kwakiutl, and 1 Bella Coola pole while the Report of the following year disclosed 4 Haida poles, one of which was a mortuary type, and 1 Kwakiutl were produced.

Mungo's carving team completed a pole as a gift from the people of British Columbia to the Queen of England which was installed on the grounds of Windsor Park in 1957. It was 100 feet in height and weighed 13½ tons. Another enormous pole of 127 feet was raised in Beacon Park, Victoria in 1957–58. A third, slightly smaller, was raised in Maritime Park, Vancouver, shortly thereafter. A 30 foot pole was sent to Chapultepec Park in Mexico City in 1960 and several more of far greater size were shipped to the World's Fair held in Osaka, Japan, that same year. They remained in Japan as part of a permanent exhibition after it closed.

Mungo and his associates completed numerous restorations that were installed in the park at the University of British Columbia campus from 1947 on, and many additional poles of equal prominence and quality to replace decaying examples in Thunderbird Park, Victoria. In retrospect, the number of carved columns this group of experts produced for the Provincial Museum's restoration program alone is impressive indeed.

I last saw Mungo at Thunderbird Park a few weeks prior to his death in August, 1962. We had not seen each other for years, and I wondered whether he remembered my annual visits to his village between 1946 and 1950 as our paths had carried us in quite different directions. To my profound pleasure he did indeed recall our earlier times together. His satisfaction in achieving his objective, of saving and restoring the totem poles of his native land was evident throughout our conversation. His task had been enormous but he had triumphed. He waved farewell, saying, "Ed, I'm going back to Fort Rupert [he pronounced it Fort Lupert] to sit by the beach and listen to the waves and the cry of the raven."

The memorial pole raised in 1970 to honor his family crests was carved by Henry and Tony Hunt, his former students and son-in-law and grandson respectively. It stands today in the graveyard in Alert Bay (fig. 145).

At Hazelton, along the upper headwaters of the Skeena River, a restoration program was begun in 1968 with the deep interest and intense collaboration of several white settlers. It became known as the Ksan project (The Breath of Our Forefathers). A Tsimshian style village was constructed, composed of seven traditional houses and a number of large and impressive totem poles (color plates 4 and 8). This "village" was completed by 1970 and became a center for the renewal of Tsimshian cultural activities that included a museum, craft production and sales office, and a workshop for apprentice carvers. Totem pole carving was one of its primary activities. Experts in Northwest Coast sculpture and painting were recruited to teach the young students. The instructors were such eminent teachers and carvers as Bill Holm of the University of Washington and his former student Duane Pasco, himself a highly skilled carver residing in Poulsbo, Washington. From such programs another group of gifted, imaginative, and productive carvers emerged including Dempsey Bob, Ron Hamilton, Norman Tate, Bob Harris, and Freda Diesing, the latter a Haida and one of the few women actively engaged in pole carving.

Such talents recruited in the mid 1960s and onward not only renewed pole carving but assured its perpetuation through the remainder of the 20th century at least. How close a call it had been can be imagined. A premature loss of the handful of masters Seaweed, Martin, Henry Hunt, Cranmer, and Bill Reid would have been a catastrophic blow. The environment which permitted this remnant of master carvers to renew the tradition and help it take deep root required the joint efforts of many citizens, industrial benefactors, private contributors, and government support. The status and prestige of carving as an art form was renewed from these collective efforts. All this and more emerged, but I must pause as I am getting ahead of my story.

THE NEW INDIAN ACT

Training is but a phase of a multi-faceted picture. If pole carving was to re-assume its former role, what was to be done about the laws specifically prohibiting the customs associated with it? Poles cannot be properly raised without the potlatches that accompany them. Indian customs had not changed so dramatically that potlatching was no longer necessary.

An important step forward was new legislation enacted by the Canadian Federal Parliament in 1951. The articles prohibiting potlatching were removed in the New Indian Act. The native peoples gradually came to understand the full significance of this change with respect to their time-honored customs. A new page had been turned in their history, one which moved from prohibition to an acknowledgment of pluralism as an integral part of society and encouraging cultural self-expression. The passage of this new legislation was a critical event in the progression of events that followed.

Training programs multiplied. More totem poles were carved in part to train new carvers. Young artists began to understand that they could pursue careers as practicing native artists and wood carvers. They came to recognize that they could find patrons not only among their own people but governmental bodies, business organizations, and white patrons as well.

Next, the Canadian Federal Government sponsored a host of pole carving programs. Artists were retained to carve poles not only for restoration purposes but also for replacement in the villages where they had stood for decades. Wilson Duff negotiated a delicate agreement in 1951–52 with the Tsimshian at Kitwancool in which the Provincial Museum acquired the old, decaying poles in exchange for precise copies at no cost to the people. The new poles were raised by their owners *en masse* at a potlatch for this occasion. The Kitwancool agreement provided that the history and lore associated with each pole were recorded in detail and published by that institution, thus making this information a part of the permanent record held in both the village and the museum.

About the same time the museum in Victoria dispatched other salvage teams composed of experts to the Queen Charlotte Islands to gather the remnants of Haida totemic art located in Tanu and Skedans. The first expedition set off for the most remote and isolated of all the abandoned villages, that of Ninstints (plate 9). The purpose of these expeditions was to place the decayed poles in the sheltered sanctuaries of the Museum for special exhibitions with the understanding that full-sized replicas would eventually be carved and placed in specific outdoor locations and parks. Haida owners occasionally assisted in such rescue efforts or at least cooperated with the museum in other ways. In 1954 Mungo Martin and his carving team began

work on the replacements.

The New Indian Act stimulated the re-emergence of potlatching. While a great body of customs once associated with potlatches and the winter dances had been lost, much still remained in the memory of the older members of such tribes. The languages spoken by the different tribal groups were still understood as were many of the songs, dances, costumes, rituals associated with masked performances, theatrical devices, techniques, and oratory skills remaining. These resurfaced as potlatching activities accelerated.

Two years after the earlier Indian Act was rescinded, Mungo Martin, with provincial support, dedicated a newly-constructed traditional Kwakiutl style house at Thunderbird Park, Victoria (color plate 5). The housewarming was a momentous event; he had named the house Wa'waditla, "He orders them to come inside." One potlatch now followed another in quickened succession during the winter seasons. At Alert Bay, Gwayasdums, Memkomlis, Kingcome, Fort Rupert, as well as specific towns in the Gitksan, potlatching was on the increase.

Why this rapid upsurge of traditional practice once prohibitions were lifted? Potlatches provided vital emotional outlets for the people. They returned to traditional ways in order to proclaim their pride, respectability, and worth; to assert ownership rights in family crests and prerogatives associated with them. Potlatches identified status. Many elders had passed from the scene in the preceding 50 years and honors had long been overdue for them, so a spate of memorial potlatches followed. The people returned to these ceremonies in order to honor the memories of sons lost, parents who had passed away, and loved ones gone. People returned to potlatching to pay honor to deceased leaders. Potlatching provided once again the respectable and right way of honoring the dead. A family called its people together to ease the sorrow and comfort them in their grief. Pole raising was once again associated with potlatching in this cultural resurgence, further stimulating carvers and the use of them.

NEW POLES, NEW DIRECTIONS

Newly completed totem poles were raised in a number of locations throughout the Province of British Columbia and the state of Alaska. In the decades following the early 1950s they were placed in villages where poles had disappeared in the late 19th century, in ferry terminals up and down the marine highway, in front of as well as inside various government office buildings, in the foyers of commerical institutions and business organizations, in shops and restaurants, throughout the length and breadth of the region. It would appear every town or city had its Totem Motel or Totem Cafe with symbolic figures draped outside to further cultivate the image associated with the region. The totem pole image was secured at last! It had arrived following 50 years or more of decline as an outcast.

In Alert Bay a great community house modeled after the traditional lineage houses of the 19th century was raised in 1963. It was especially significant because different tribal groups came together to assist in its construction. The house became a focal point for both potlatching ceremonies and a host of other tribal and inter-tribal enterprises that included the formal presentation of dance performances to entertain passengers who disembarked briefly from passing steamships.

To honor his son David, who had died in a tragic sea accident, Mungo Martin potlatched. He raised a memorial pole (fig. 144) in his honor around 1959 at an Indian community house in Courtenay, B.C. In Masset, a place where numerous old poles once stood in proud array along the edge of the high tide mark, a new pole was raised in 1969 carved by Robert Davidson. Another was completed and raised about the same time by Bill Reid at Skidegate village not far away. The Provincial Government commissioned the carving of a number of poles that were placed along the east coast highway from Victoria to Campbell river on Vancouver Island.

Meanwhile, considerably increased activity in Alaska followed the Territory's transition to statehood. The U.S. Department of the Interior took an active role in developing the Tlingit-Haida cultural heritage in the post-war period. The Indian Arts and Crafts Board (IACB) was formed as an agency within the Interior Department, to promote the development of native arts and artists. Special congressional appropriations, spearheaded by Senator Ernest Gruening, enabled its staff to initiate demonstration workshops which attracted the participation of a number of talented Tlingit apprentices. Agency staff were instrumental in encouraging the emergence of native owned and operated arts enterprises in the 1960s and 70s.

The highly trained staff of IACB were familiar with the traditional sculptural styles and skills of the tribes of the region; they helped acquaint the Tlingit carvers with the intricate nature of their traditional expressions. An increasing number of

qualified workers emerged from such programs which happily revived the paucity of talent in the previous decades. Subsidized commissions for totem poles and carved heraldic panels followed, providing further encouragement to participants.

Artists of note included Amos Wallace, David Williams, George Benson, and Lincoln Wallace. Amos was the most heavily involved in totem pole carving and his work was in considerable demand. He completed a 36-foot pole for the Standard Oil Company of California refinery at Kenai, Alaska. He carved several poles for Disneyland, U.S.A. in Anaheim, California. Other commissions followed, from the Natural History Museum in Cincinnati, Ohio, to the Children's Museum in Boston, Massachusetts, including poles in Juneau, Pittsburgh, and Brooklyn. A 49-foot pole was done for the University of Alaska in Fairbanks. His work helped familiarize citizens of the United States unaware of the Canadian renaissance with totem poles. His work understandably helped popularize totem pole carving in the lower 48 states as well as Alaska during the 1960s.

Another active Tlingit carver is Nathan Jackson. After considerable travel outside his native land he returned to Alaska to resume his work. He created a number of monumental sculptures including a 40-foot pole for the Centennial Hall in Juneau. He carved two large poles for Angoon, a Tlingit village on Admiralty Island where earlier few if any poles had been enacted. Among his commissions was a large pole for Kobe, Japan, as well as numerous panels commissioned for a special exhibit entitled *Enter The Tlingit World* at the Peabody Museum of Archaeology and Ethnology, Harvard University, in Cambridge, Massachusetts.

In the meantime the Department of the Interior was involved in bringing Totem Heritage Center near Totem Bight Village Park in Ketchikan into being. Close by, a third site, Saxman Park, had been built earlier with 14 poles erected in a Tlingit-style setting after years of planning, coordination, and public pressure (color plate 7). Totem Heritage Center opened in 1976 exhibiting 35 preserved fragments as well as a substantial number of complete poles salvaged over the years from various Alaskan villages. Taken together, these three Ketchikan centers constitute one of the largest concentrations of totem poles in the Pacific Northwest.

In 1965 a Visitor Center, created and funded by the National Park Service, was completed adjacent to Sitka National Historic Park. In this modern setting several important exhibitions and demonstrations of Tlingit carving traditions were mounted. In 1969 the National Park Service, working with the Sitka Tlingits, started a workshop to train young carvers.

The Alaska Native Arts program derived its inspiration from the famed Chilkat Tlingit people who resided in nearby Klukwan. This undertaking grew into the Port Chilkoot development which provides training programs for carvers as well as other expressions of Tlingit cultural history. A large Tlingit style house was built on the site of former army barracks and parade grounds facing an arm of the Lynn Canal. A program of tribally-inspired dances is performed for the entertainment of visitors from steamship tours. Carvers associated with this group also received a number of commissions for totem poles for raising both nearby as well as across the Pacific.

At Klawak on the west coast of Prince of Wales Island, a public park was created on the hill overlooking the community. On this site 21 Tlingit columns, replicas rather than originals, were placed. They formerly stood as grave markers and receptables for ashes of the deceased at Tuxikan (color plate 12).

Poles were raised at Kake where few had formerly been used. One pole is what I call a "stunt" pole. Stunt poles are heralded as the "tallest pole in the world" or some such. I do not know why people would want to raise such poles, for certainly people should be able to see the crests and other figures on them but they are so tall the figures cannot be easily identified. One has to accept explanations of their symbolic content on faith, which, in my judgment, defeats the purpose of the pole. In any case, the Kake pole was 136 feet in height though another source reports it being 124½ feet. If the latter figure is correct it would be the third tallest pole after one located in Victoria, none of which need impress the reader. Quality should take precedence over sheer size. The Kake pole was carved by Alaska Native Arts of Port Chilkoot and was prepared for the Alaska pavilion of the World's Fair in Osaka, Japan, in 1960. Eventually it was returned to Kake where it was raised in 1971 amid great fanfare and a public potlatch witnessed by hundreds of visitors.

According to one source, it was necessary to use a pole of such height as it combined the crests of two separate divisions of the tribe—the eagle and raven clans. It thus symbolized the spiritual unity of the people.

In 1977 the 38-foot Haida pole, with special historical significance from the village of Sukkwan, was raised in a newly completed state office building in Juneau. It is reputed to be over 100

years old but had been sheltered in a building elsewhere for some time so was in a reasonably good state of preservation. It had been affectionately known as the "old Witch pole." Its startling placement in this modern building should not surprise us, however; such trend-setting locations have been employed elsewhere.

A major restoration effort also took place in the town of Wrangell. A Tlingit park containing a large house and several poles were erected on Shakes Island. A totem pole restoration project was started there also, funded by the State of Alaska in 1984 after reports that some of the priceless house posts located in the park—originals rather than replicas—were rapidly disintegrating for lack of protection from the elements. Such posts were estimated to be almost 150 years old and constitute a veritable treasure. The result was the construction of another exhibition hall where the famed posts could be more adequately safeguarded (color plate 6).

A variety of business concerns located in the Pacific Northwest incorporated traditional Northwest arts in their decor over the years, augmenting the use of totem pole symbolism. Wood products and timber firms often use totem poles as trappings for their executive offices and headquarters, symbolizing the source of corporate wealth. Restaurants and airport lounges acquired scores of modern poles to grace their decor. The superb quality of the totem poles of modern design produced by the Washington state carver, Duane Pasco, for the restaurants in Sea-Tac International Airport are but one example of quality and authenticity in modern settings.

Inevitably, as the use of these traditional forms spread, replicas began to appear. These pole imitations done by fly-by-night hucksters rather than mature craftsmen lacked even a rudimentary similarity to authentic design concepts. They were and are hacked out with chain saws and axes to a rough approximation of originals. After all, that was all that was necessary for the unsophisticated, untrained eye. Who would argue they were not totem poles?

Surely the highest form of flattery is imitation. A whole band of people knowing little about carving and even less of the symbolism involved turned to creating what can only be called fakes. They not only cut out poles with chain saws and other power tools but dared to advertise them as based on original examples. Not a few naive public school authorities, anxious to acquire a totem symbol, purchased these miserable fakes with the nickel and dime contributions of their students.

The recent construction or expansion of major museums in the Northwest—institutions which cost millions of dollars, I might add—accelerated public exposure and familiarity with totem poles. Every elementary and secondary school youngster at one point or another has participated in a field trip to a local museum to learn about the region's history, the native inhabitants, and their totem poles. The new Provincial Museum in Victoria, completed in this recent period, is a striking example of both the continuing provincial commitment to the traditional arts and to the creation of an outstanding institution dedicated to safeguard the region's heritage. Yet another example employing remarkably refreshing architecture to heighten the senses to the rich past is the University of British Columbia Museum of Anthropology. In my opinion this institution ranks in a class shared only by the world famous Museum of Anthropology in Mexico City. The exhibits of salvaged poles occupy blatantly vacant space revealing the striking textures and characteristics of weathered cedar in the sculptures, themselves arresting visual displays. The Thomas Burke Memorial Museum at the University of Washington, Seattle, while far smaller in scope, is a splendid example of the recent dedication to exploring the past and to its preservation. Two others with good collections of Northwest Coast sculpture should be mentioned: one at Campbell River, the other at Alert Bay, B.C. All these museums, whether large or small, house collections of salvaged, restored, or newly carved totem poles.

This story of totem poles has run a course of 100 years—1885 to 1985—from the beginning of the collapse to the resurgence and renewal. I suggest they are here to stay. No changing vogue, no diversion of public interest in either country will displace the significance of totem poles in the foreseeable future.

While I have come to the end of my story, the history of totem poles is far from ended. They will remain an ongoing phenomenon, subject only to the changes fueled by their own inherent dynamism. For 200 years, and possibly more, poles have been raised to enshrine symbols and concepts loftier than their own mundane existence. In looking up to those elevated figures which capture and depict the forces of nature, the people recognized an order far more complex and mysterious than one that merely sustained life. This is a vision not only of what is but of what all are striving to be. The totem pole symbols incorporate that vision, derived from ancient primeval depths. The poles and their symbols helped grasp a tiny fleeting

segment of a vast and complex universe and make it their own.

De Lillo wrote, "We start our lives in chaos, in babble. As we surge up into the world, we try to devise a shape, a plan. There is dignity in this. Your whole life is a plot, a scheme, a diagram. It is a failed scheme, but that's not the point. To plot is to affirm life, to seek shape and control. Even after death, most particularly after death, the search continues... To plot, to take aim at something, to shape time and space. This is how we advance the art of human consciousness."

The native peoples of the Northwest Coast were surely bent on a mission to do just that.

References

Barbeau, Marius. *Totem Poles.* 2 volumes. Bulletin 119, National Museum of Canada. Ottawa, 1950

Drucker, Philip. *Cultures of the North Pacific Coast.* San Francisco: Chandler Publishers, 1965.

Duff, Wilson. *Histories, Territories, and Law of the Kitwancool.* Victoria, B.C. Provincial Museum, 1959.

_____ . *The Indian History of British Columbia.* Victoria: Vol. 5. Provincial Museum, 1964.

Ford, Clellan. *Smoke From Their Fires: The Autobiography of a Kwakiutl Chief.* New Haven: Yale University Press, 1941.

Gunther, Erna. *Indian Life on the Northwest Coast of North America.* Chicago: University of Chicago Press, 1972.

Jacobsen, Johan Adrian. *Alaska Voyages 1881–83* (trans. E. Gunther). Chicago: University of Chicago Press, 1977.

Keithahn, Edward. *Monuments in Cedar.* Seattle: Superior Publishing, 1963.

Krause, Aurel. *The Tlingit Indians* (trans. E. Gunther). Seattle: University of Washington Press, 1955.

MacDonald, George. *Haida Monumental Art.* Vancouver: University of British Columbia Press, 1983.

McIlwraith, T. F. *The Bella Coola Indians.* Toronto: University of Toronto Press, 1948.

Nuytten, Phil. *The Totem Carvers.* Vancouver, B.C.: Panorama Publishers, 1982.

Oberg, Kaverlo. *The Social Economy of the Tlingit Indians.* Seattle: University of Washington Press, 1973.

Olson, Ronald. *Notes on the Bella Bella Kwakiutl.* Berkeley: University of California Press, 1955.

_____ . *The Social Life of the Owikeno Kwakiutl.* Berkeley: University of California Press, 1954.

_____ . *Social Structure and Social Life of the Tlingit in Alaska.* Berkeley: University of California Press, 1967.

Provincial Museum. Reports for the years, 1954, 1955, and 1957, Provincial Museum, B.C.

Siebert, E. and Werner Foreman. *North American Indian Art.* London: Paul Hamlyn, 1967.

Smyly, John and Caroline. *The Totem Poles of Skedans.* Seattle: University of Washington Press, 1973.

Stott, Margaret. *Bella Coola Ceremony and Art.* National Museum of Canada, Bulletin 21, 1975.

Suggested Reading

Barbeau, Marius. *Totem Poles of the Gitksan.* National Museum of Canada, Bulletin 61, 1973.

Cole, Douglas. *Captured Heritage: The Scramble for Northwest Coast Artifacts.* Seattle: University of Washington Press, 1985.

Drucker, Phillip and Robert Heizer. *To Make My Name Good.* Berkeley: University of California Press, 1965.

Garfield, Viola and Linn Forest. *The Wolf and the Raven.* Seattle: University of Washington Press, 1948.

Halpin, Marjorie. *Totem Poles: An Illustrated Guide.* Vancouver: University of British Columbia Press, 1981.

Holm, Bill. *Northwest Coast Indian Art: An Analysis of Form.* Seattle: University of Washington Press, 1965.

_____ . *Smoky-Top: The Art and Times of Willie Seaweed.* Seattle: University of Washington Press, 1983.

Malin, Edward. *A World of Faces: The Masks of the Northwest Coast Indians.* Portland, Ore.: Timber Press, 1978.

Stewart, Hillary. *Cedar: Tree of Life to the Northwest Coast Indians.* Vancouver, B.C.: Douglas & McIntyre, 1984

_____ . *Indian Fishing: Early Methods on the Northwest Coast.* Seattle: University of Washington Press, 1977.

Walens, Stanley. *Feasting With Cannibals: An Essay on Kwakiutl Cosmology.* Princeton, NJ: Princeton University Press, 1981.

Index